W9-BJP-679

A
THOUSAND
CRANES

TREASURES OF JAPANESE ART

A THOUSAND CRANES

SEATTLE ART MUSEUM

CHRONICLE BOOKS
SAN FRANCISCO

Copublished by
Seattle Art Museum
Volunteer Park
Seattle, Washington 98112
and
Chronicle Books
One Hallidie Plaza
San Francisco, California 94102

Distributed in Canada by
Raincoast Books
112 East 3rd Avenue
Vancouver, B.C.
V5T 1C8

This publication has been made possible by a grant from
the National Endowment for the Humanities. Additional
support was provided by the Asian Art Council of the
Seattle Art Museum.

Printed in Japan

Managing editor: Suzanne Kotz
Editor: Lorna Price
Design and Production: Ed Marquand Book Design
Photography: Paul Macapia

Front cover: *Scenes from the Tale of Genji* (detail), second
half 17th century, ink, color, and gold on paper, No. 53
Back cover: Buddhist mask in bodhisattva form,
12th century, wood, No. 22
Frontispiece: *Yatsuhashi*, Sakai Hōitsu, early 19th century,
color on gold-ground paper, No. 60

Slide sets of the works of art reproduced in this book are
available from the Seattle Art Museum, Volunteer Park,
Seattle, WA 98112.

LIBRARY OF CONGRESS CATALOGING-IN-PUBLICATION DATA
Seattle Art Museum.
 A thousand cranes.
 Bibliography: p.
 1. Art, Japanese to 1968 — Catalogs. 2. Art — Washington
(State) — Seattle — Catalogs. 3. Seattle Art Museum —
Catalogs. I. Title.
N7353.S36 1987 709'.52'074019777 86–43240
ISBN 0–932216–23–4
ISBN 0–932216–22–6 (pbk.)
ISBN 0–87701–461–2 (Chronicle Books)
ISBN 0–87701–457–4 (Chronicle Books : pbk.)

CONTENTS

FOREWORD

Stewardship of a collection of art involves many activities, only some of which are readily apparent to a museum visitor. The role of curator and educator carries with it the obligation and privilege to conserve, research, and interpret great works of art. The more illustrious the collection, the more profound these responsibilities become. The Japanese collection of the Seattle Art Museum may fairly be regarded as one of the finest and most significant outside Japan. For this reason we have elected to study it in depth in this volume, combining discussions of individual art objects with essays on the historical and cultural phenomena that directed the development of artistic endeavor in Japan from prehistoric to early modern times. This approach offers fresh insights into the historical, religious, and sociological currents that gave rise to the artistic modes, technologies, and design concepts characteristic of the arts of Japan.

That a collection worthy of such thorough explication resides in Seattle attests the foresight and wisdom of Richard E. Fuller, the museum's founder and first director. He shared his deep love of Asian art with his mother, Margaret E. Fuller, and together they built the Seattle Art Museum, which began with and maintains today a strong concentration on Asian art. The core of the collection, including major examples of Japanese art, is the Eugene Fuller Memorial Collection, established in 1933 in honor of Dr. Fuller's father, Dr. Eugene Fuller (1857–1930). During the years from 1948 to 1952, Sherman E. Lee, then the museum's Associate Director, added some of the finest examples of Japanese art in the collection, through the generosity of early benefactors such as Mrs. Thomas D. Stimson, Mrs. Donald E. Frederick, and Mrs. John C. Atwood, Jr., Dr. Fuller's sister.

The publication of this world-famous collection was a project of great magnitude, requiring tremendous dedication and a sincere appreciation of the works of art, in addition to a large reservoir of professional knowledge. These necessary ingredients were supplied in full measure by William Jay Rathbun, Curator of Japanese Art. We owe the success of this project to his sustaining passion. Sincere thanks are due as well to Michael Knight, Assistant Curator of Asian Art, for his significant contribution of scholarship and research. Paul Macapia's

outstanding photographs are the result of a keen assessment of the special qualities of each of the treasures described in the book. Also warmly appreciated are the efforts of Suzanne Kotz, until recently the museum's Media and Publications Coordinator, whose intelligence and goodwill maintained the collaborative nature of the project. Editor Lorna Price skillfully transformed the work of eight authors into a cohesive manuscript. Toni Reineke's and Willi Patzkowsky's nimble minds and fingers provided much more than word processing, and Glory Jones and Paula Thurman were scrupulous proofreaders. Ed Marquand's beautifully executed design serves the book's intention with exquisite sympathy. Recognition is also owing for the special support provided by a number of members of the Seattle Art Museum staff: Helen Abbott, Manager, Media and Publications; Deborah Oglesby, Darkroom Technician; Gail Joice, Registrar; and Lauren Tucker, Assistant to the Registrar. Our gratitude and thanks also are extended to the distinguished scholars whose contributions help to animate these art objects in the present, and to Dr. Miyeko Murase, Professor, Department of Art History and Archaeology, Columbia University, New York, who reviewed the entire project. The thoroughness of her critical review contributed in many important ways to the scholarly content and overall quality of this publication.

Truly a collaborative effort among all those mentioned above and many others, *A Thousand Cranes: Treasures of Japanese Art*, we hope, will set a new standard for the publication of museum collections. Further, we hope it will become a critical resource for art historians and other scholars in the field of Japanese studies, while remaining an attractive and accessible overview of that country's remarkable history, particularly as it relates to the Japanese art collection of the Seattle Art Museum.

Henry Trubner
Associate Director for Art and the Collections
Seattle Art Museum

Bonnie Pitman-Gelles
Associate Director for Program
Seattle Art Museum

PREFACE

The Japanese crane, *tsuru*, is a most auspicious symbol in Japan. It has figured importantly in Japanese culture and art since ancient times and has remained an abiding and popular motif, appearing over the centuries in almost every possible medium — a universal sign of goodwill. Cranes are used to signify happy occasions or to express congratulations, and as they were believed to live for a thousand years, they came to indicate a potent wish for longevity and the wisdom gained through great experience.

Cranes possess a stately grace and dignity to their movements which, along with the dazzling whiteness of their plumage, has linked them in popular perception with the superior qualities of the Daoist Immortals. The title "A Thousand Cranes" embodies the image of an incalculable level of goodness or an immeasurable wish for good and is a metaphor for the spiritual grace and dignity that imbue the art objects and cultural relics described in this book. It is our wish that *A Thousand Cranes: Treasures of Japanese Art* demonstrate the richness of the Seattle Art Museum's holdings to its readers and add to their appreciation of the beauty and spiritual depth of Japanese art.

To enhance the reader's understanding of the milieu in which these objects were created, we have incorporated object entries with essays on the archaeology, social and political history, and cultural ambience of Japan. The process required a true collaboration between the curators of Asian art at the Seattle Art Museum and five preeminent scholars from the United States and Canada who wrote the essays. The completed volume was more than two years in the making, with the text, of course, requiring the most time, generously given by my associates Henry Trubner, Associate Director for Art and the Collections, and Michael Knight, Assistant Curator of Asian Art, without whom I could not have completed the object entries. For the excellent essays, we are greatly indebted to our five colleagues. Dr. Richard Pearson, Professor of Anthropology, University of British Columbia, discusses the prehistoric and protohistoric periods from the standpoint of an archaeologist, while William H. McCullough, Professor of Oriental Languages,

University of California, Berkeley, highlights the classical taste of the Heian period. Martin Collcutt, Professor of East Asian Studies, and Marius B. Jansen, Professor of Japanese History, Departments of History and East Asian Studies, Princeton University, have provided essays recapitulating the turbulent medieval era and the dynamic early modern period. James C. Dobbins, Assistant Professor of Religion and East Asian Studies, Oberlin College, provides an elucidating essay on the Buddhist religion and its influence on Japanese art and culture.

The research and publication of this catalogue were made possible by a generous grant from the National Endowment for the Humanities, Division of General Programs, Humanities Projects in Museums and Historical Organizations, whose purpose is to foster an understanding of the humanities through public educational programs, principally museum exhibitions and catalogues. Since its inception in 1965, the National Endowment for the Humanities has worked to promote an appreciation of our cultural heritage. The NEH recognizes that museum collections are a vital national resource, and it is committed to the interpretation of those collections, so that people know not only what they are, but what they mean.

Additional support for this publication was provided by the Asian Art Council of the Seattle Art Museum. Formed in 1973, the Asian Art Council has generously contributed to a variety of activities that enhance understanding and appreciation of the arts of Asia, and we are grateful for its continuing support. A grant from the Andrew W. Mellon Foundation was instrumental in the planning and research stages of this important project.

Above all, we are indebted to our colleagues and friends in Japan for their generosity of spirit and willingness to share knowledge over the years. It is to them we offer our most profound feelings of appreciation and gratitude.

William Jay Rathbun
Curator of Japanese Art
Seattle Art Museum

CHRONOLOGY

Palaeolithic Period	c. 50,000 – 11,000 B.C.
Jōmon Period	11,000 – 300 B.C.
Yayoi Period	300 B.C. – 300 A.D.
Kofun Period	300 – 645
Early Nara Period	645 – 710
Late Nara Period	710 – 794
Heian Period	794 – 1185
Kamakura Period	1185 – 1333
Nambokuchō Period	1333 – 1392
Muromachi Period	1392 – 1568
Momoyama Period	1568 – 1615
Edo Period	1615 – 1868
Meiji Period	1868 – 1912
Taishō Period	1912 – 1926
Shōwa Period	1926 – present

Several dating systems are currently in use to designate periods of Japanese history. Individual authors have chosen to observe slightly different chronologies in their contributions.

MAP OF JAPAN

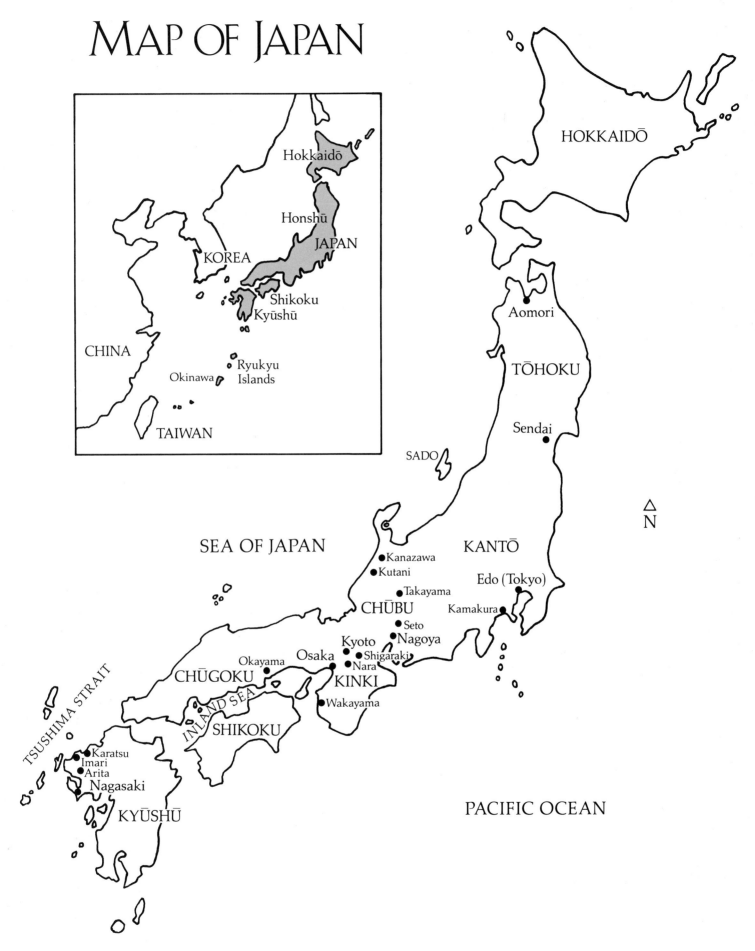

Hokkaidō

Honshū

KOREA

JAPAN

Shikoku

CHINA

Kyūshū

Okinawa

Ryukyu
Islands

TAIWAN

HOKKAIDŌ

Aomori

TŌHOKU

Sendai

SADO

SEA OF JAPAN

KANTŌ

△
N

Kanazawa

Kutani

Edo (Tokyo)

Takayama

CHŪBU

Kamakura

Seto

Kyoto

Nagoya

Osaka

Shigaraki

Okayama

Nara

CHŪGOKU

KINKI

Wakayama

INLAND SEA

SHIKOKU

TSUSHIMA STRAIT

Karatsu

Imari

Arita

Nagasaki

PACIFIC OCEAN

KYŪSHŪ

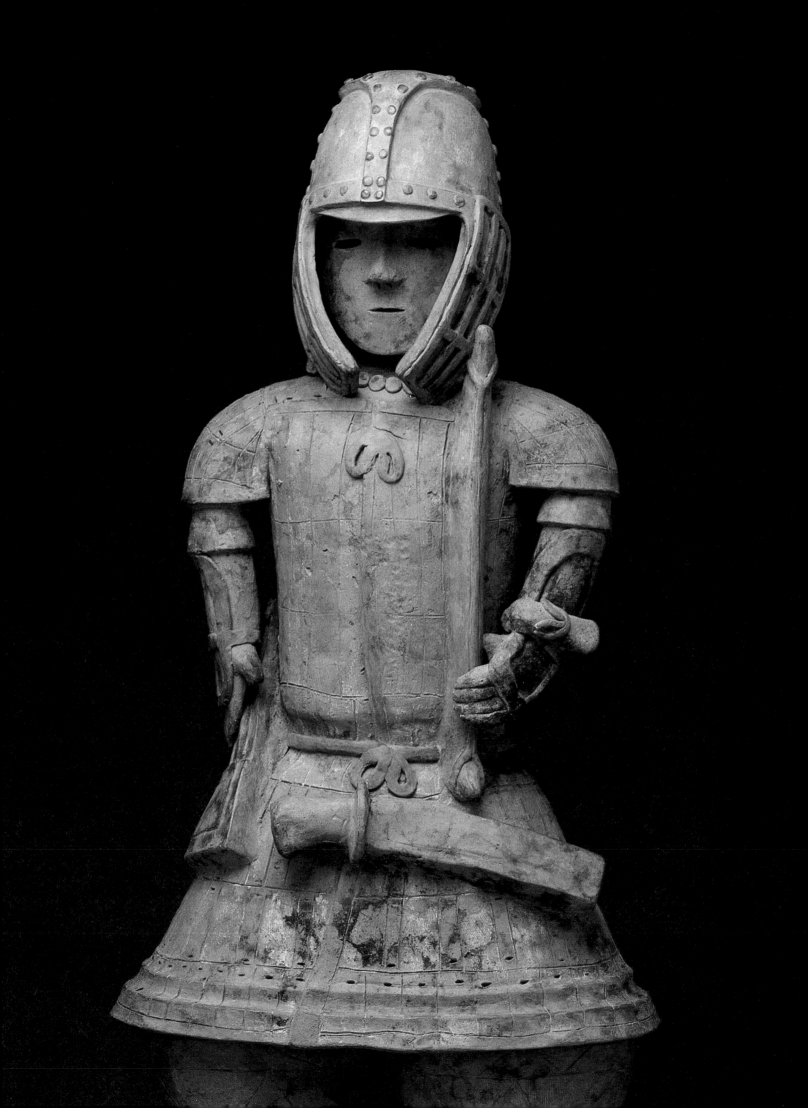

Archaeological Perspectives on Japan's Oldest Art

Richard Pearson

The understanding of prehistoric and proto-historic art requires knowledge of its purpose, context, and symbolism. With over 14,540 excavations by 1983, Japanese archaeologists have expanded our knowledge of all facets of ancient life. In particular, the realms of society, religion, and ritual, which require wide-area excavation and the excavation of special-purpose or atypical sites, have received considerable attention. Despite the great contrasts among the four archaeological periods before the advent of Buddhism in the sixth century A.D., strong threads of continuous development can be seen. The rise of social complexity, the gradual emergence of Japanese indigenous religion, and incremental steps in the establishment of the agrarian foundation of Japanese life are all part of a continuous local cultural evolution.

The four periods include the Palaeolithic, a period of hunting and gathering by small mobile bands; the Jōmon, a period of semisedentary "Mesolithic" intensive hunting and gathering; the Yayoi, with agricultural chiefdoms based on wet rice cultivation; and the Kofun, which embraces the emergence of Japan's first states (see fig. 1).

THE PALAEOLITHIC PERIOD

Since the discovery of the first substantiated Palaeolithic site at Iwajuku, about two thousand sites have been excavated. Our most secure knowledge of the first inhabitants of Japan comes from radiocarbon-dated sites of the last thirty thousand years. The volcanic nature of Japan and the lack of appropriate thick limestone deposits have greatly reduced the chances of finding preserved fossils as early as those of China—in fact, almost no human skeletons are known throughout the entire pre-Jōmon time span. Recently discovered sites at Babadan and Zazaragi, Miyagi prefecture, have yielded layers bearing stone artifacts that may be far in excess of thirty thousand years of age.

The Palaeolithic cultures of Japan roughly resemble other Upper Palaeolithic tool industries of Eurasia, with an abundance of small knives, blades, scrapers, and flake and blade tools. In the later Palaeolithic, from about 13,500 to 10,000 years ago, a microlithic industry existed in Japan.

Because of its volcanic nature, Japan is blessed with abundant obsidian. When this amorphous noncrystaline material is worked with sophisticated flaking techniques, very fine tools are produced. The multistage production of microblades from Hokkaido is a good example. A bifacial blank was first produced, then reduced to a prepared form from which tiny blades, only 1 to 2 centimeters long, were produced by applying pressure. They were used for engraving, although no examples of engraved bone or wood have survived Japan's acidic soils.

Palaeolithic hunters, following herds of big game, could have crossed what are now the straits of Sōya (from Siberia to Hokkaido) and Tsushima (from Korea to Japan) many times during the Pleistocene epoch. Other deeper straits in the northern Ryukus and between Hokkaido and Honshu were usable as land bridges for only short periods in these epochs. Thus, Palaeolithic groups probably entered Japan many times, bringing new cultural elements with them. Sites showing circles of pebbles that may have been used to anchor the edges of skin tents have been found in a number of locations.

THE JŌMON PERIOD

Following the Pleistocene, the Japanese islands underwent an environmental transformation. Sea levels rose, reaching their present levels six thousand years ago, from a previous maximum of 140 meters below this level some eighteen thousand years ago. The rising sea cut Japan off from the Asian continent. Climate ameliorated, achieving

conditions somewhat warmer than at present from eight thousand to four thousand years ago. From about 11,000 B.C., there emerged a culture based on hunting and gathering, termed 'Jōmon.' Its beginning is marked by the oldest ceramics in the world, which are decorated with thin applied lines of clay. The entire Jōmon epoch is divided into six periods which decrease in duration from early to late. Despite its great length, it should not be considered uniform or static. Jōmon people were remarkably well adapted to the various forests and shorelines of their islands.

Jōmon communities in the northeast of Japan and in the mountain basins derived their livelihood from coniferous and deciduous forests; those on the coast reaped the bounty of the North Pacific Current. People in the southwest developed ways of using the plants of the broadleaf evergreen forests and the aquatic resources of the Black Current running north to Japan from the Philippines. Inner bay fishing with nets and weights developed along the shoreline of Tokyo Bay, which was formed by the high water levels of the Middle Jōmon. Net fragments with a mesh size of 0.8 to 0.9 millimeters were recovered from Aichi prefecture and are known from other sites. Deep-sea fishing with hooks and harpoons developed in the Tōhoku region and northern Kyushu. Salt production, centered in the eastern Kantō, and known from Late and Latest Jōmon, was linked to the preservation of fish. In sites along the North Pacific coast, such as the Ōbora site in Iwate prefecture, 80 percent of the fish bones are from deep sea tuna.

Although each region of Japan produced an interesting local culture within the Jōmon, it was in the Tōhoku region, covered by deciduous forests, that particularly elaborate local variants arose. Here, methods of leaching tannins from nuts and roots were developed by the Middle Jōmon (some five thousand years ago) and gradually spread to Kyushu. The resulting meal, ground on stone mortars, was washed in running water and baked in special composite ovens. The communal house found in each village is thought to have been used for processing and storing food. Cultivation of some special crops, such as the condiment *egoma* (*Perilla frutescens*), occurred in the Middle Jōmon in the Nagano region of central Honshu. The Torihama site, Fukui prefecture, is an important example of Early Jōmon settlement in the broadleaf forest zone of southwestern Japan. It is waterlogged, on the shore of a river flowing into the Japan Sea. It has yielded plant remains of gourds, *Perilla*, and possibly beans. Lacquered wooden objects have been found, as well as a hollowed-out wooden boat some 6 meters in length, with a maximum width of 60 centimeters. Some other evidence of cultivation in the Jōmon period will be discussed below; however, the major subsistence mode remained hunting, fishing, and gathering throughout the Jōmon.

In some parts of Japan, people may have followed a seasonal pattern of transhumance — moving to different parts of their territory for seasonally available foods. However, in the Kantō region, it appears that population levels were too high to allow the unpopulated space necessary for seasonal migration; therefore, people lived in semipermanent villages, trading local specialties for food and raw materials that lay outside their territory. The villages were often located on natural raised terraces (*daichi*) and consisted of a cluster of semisubterranean houses. From Early Jōmon, these houses had interior fireplaces, often lined with stone slabs.

From the esthetic point of view, three categories of artifacts reflect the rich social and religious life of these hunters and gatherers — pottery vessels, figurines, and miscellaneous ornaments.

Throughout its span of many millennia and dozens of stylistic variations, Jōmon pottery falls into a number of major groupings. All vessels of the Incipient and Earliest Jōmon have pointed bottoms, thought to be a clue to early continental origins (although no prototype of compatible dating has yet been found). The pointed vessels are thought to have been propped up by stones or set in sand. By the Early Jōmon, most of the vessels were flat bottomed. The Tōhoku and southern Hokkaido region are characterized by wonderful cylindrical or chimney-shaped vessels (*entō*), with textured surfaces created by cord marking in many forms, while the Kyushu region produced vessels with incised decoration in herringbone patterns, some of which are very similar to roughly contemporary pottery from Korea. In Middle Jōmon, we find a wide variety of fantastic rim variations and complex combinations of surface treatments. The Umataka pottery of Niigata has rims like sculptured flames, while those of the Sori type of Nagano often have snake's-head motifs. Such zoomorphic decoration is rare in Jōmon ceramics; frogs also appear on some other vessel types. The earthiness and organic quality of the Jōmon pottery stands in contrast to the Neolithic ceramics of China, particularly those from the Yangzi delta and Shandong, which have complex, multicomponent symmetrical body shapes, and carefully calculated surface decoration, all suggesting a distinctive, componential, abstract way of organizing technology.

Cord-marked globular vessels with wide mouths and special decoration, and clay figurines found in such sites as Suchu Island in the Amur River, Khabaraovsk Territory, U.S.S.R., suggest communication between the Amur River region and Japan; some believe that Amur may be the area from which speakers of languages ancestral to Japanese may have migrated. The study of these similarities and their implications will be a fruitful area for future scholarly endeavor.

Late and Latest Jōmon pottery in the Tōhoku region reaches a second creative peak, with curvilinear carved decoration and zoned cord-marked decoration on small, globular vessels of the Kamegaoka style. Some of the Kamegaoka vessels have lacquered surfaces; however, surface color is not a decisive feature of Jōmon vessels.

Jōmon vessels were made for boiling, cooking, storage, religious offerings, and, rarely, as jar coffins. Particularly in the Late Jōmon a variety of shapes appears, including spouted vessels, globular narrow-necked jars, wide-mouthed jars, and vessels with flaring stands. A study of 952 vessels from the Kunenbashi site, Iwate prefecture, which belongs to the latter half of Late Jōmon, yielded some information on their use. Small, plain-rimmed, wide-mouthed vessels of about less than 0.5 liters capacity without carbonated traces are thought to be serving bowls, whereas large vessels with decorated rims displaying carbonated or burned food on the rims were used for cooking.

In the Kantō and Nagano regions, the custom of infant burial in jars at the entrance to the house began in the Middle Jōmon, spreading to nearby areas in Late Jōmon. Jars also seem to have been used for religious offerings buried between houses, in the large, stable, affluent Middle Jōmon villages on the flanks of Mount Yatsugatake in Nagano.

Clay and stone figurines are a hallmark of the Jōmon culture. In worldwide perspective it is rare to find such figurines so elaborately developed among hunters and gatherers. Incised stone pebbles with lines representing hair, possibly breasts, and belts have been found from the Incipient Jōmon site of Natsushima, which dates to more than 10,000 B.C. From Early Jōmon, the figurines are flat and triangular, often made without heads. In the Late period, both in the Kantō and Tōhoku regions, elaborate forms with surface decoration and hair ornamentation appear. One of the peaks of figurine development is the hollow, burnished type with elaborate curvilinear decoration, slit goggle eyes, and an openwork head decoration; it is typical of the Kamegaoka style centered in Tsugaru, Aomori

prefecture. At the Utetsu site, Aomori prefecture, one of these figurines, incomplete and 10.4 centimeters high, was found inside another 34 centimeters high.

Areas of the highest concentration of figurines are Aomori, Miyagi, Chiba, Nagano, and Kumamoto prefectures. In most sites they are found broken, suggesting to some scholars that they were used in curing rituals in which the infirmity was removed from a human and transferred to the figurine. In instances at a number of sites, such as Chōjōgahara, Gumma prefecture, Tochikura, Shimane prefecture, and Hiromi, Nagano prefecture, the figurines were purposely buried. In other sites, such as Gōhara, Gumma prefecture, the figurine was found buried in a small stone chamber. From the Kasori site, Chiba prefecture, one of the thirty-nine figurines excavated in 1964 was found in a pottery-lined pit left open at the bottom. Other figurines are associated with stone pavements or stone circles. The Tateishi site, Iwate prefecture, on a plateau at the junction of two rivers, yielded about 218 figurine fragments, along with pottery handbell-shaped objects, bracelet-shaped clay objects, and other clay ritual objects. Within the stone pavement, figurines were concentrated at two places; none was intact. Although some of the figurines have been found in ritual context, many have been found in village dumps, as in the Shakado site, Yamagata prefecture, which yielded four hundred figurines.

A large sample of over one hundred figurines from the Kaminambe site, Kumamoto, seemed to have weak joint areas between the head and neck, and body, arms, and legs, which were apparently made to be deliberately broken in rituals. If the figurines were naturally broken, the pieces should be relatively close together in the ground, but usually they are widely separated, suggesting that they were purposely broken and scattered.

In the Early and Middle Jōmon, dwelling areas, burial areas, and religious areas were clearly separated. In Late and Latest Jōmon, ritual and burial areas were combined in some cases in the erection of stone circles, with burials beneath the stones; these became sacred places. A huge ritual site of 8,000 square meters has been found at Kinsei, Yamagata prefecture. A stone phallus some 40 to 50 centimeters in height is surrounded by a stone circle about 1.5 meters high. To the north of this area is a group of dwellings. Artifacts found on the site include a figurine, numerous earrings, stone daggers, and burned deer bones. It has been suggested that this is a communal ritual site used by

several villages, perhaps as a center for the Kantō and Shinshū areas. Generally, artifacts of ritual significance, rather than daily use, were abundant.

With the advent of rice cultivation in Kyushu in the first millennium B.C., the long era of intensive hunting and gathering drew to a close. Not native to Japan or Korea, rice is known to have been intensively cultivated in the Yangzi delta region of China since at least 5000 B.C. New methods of cultivation, agricultural ritual, and religious beliefs were diffused to southwestern Japan from Korea. Rice cultivation was practiced in Korea from about 1500 B.C. New populations reached Japan in small numbers. Inland Jōmon populations with a diversified economy probably adopted wet rice cultivation earlier than coastal, specialized fishing groups. The old Jōmon religion of the Tōhoku region gave way to new values and rituals. However, the worship of natural places, such as mountains and cliffs, carried on from the Jōmon into the later periods. The Jōmon people physically appear to have been different from modern Japanese and from the Ainu; it is quite likely that there were ethnic or tribal subgroups in Japan during the Jōmon. The Japanese language, related to Korean and other Altaic languages, appears to have arrived in Japan during the Jōmon period. Some Japanese authors have postulated that Austronesian languages from Southeast Asia may have influenced the development of Japanese, but this is far from clear at this time.

Figure 1. Chronology of Japanese Prehistory

PALAEOLITHIC PERIOD
Early about 50,000 to 30,000 years ago

Late 30,000 B.C. to 11,000 B.C.

JŌMON PERIOD
Incipient 11,000 B.C. to 7,500 B.C.
Earliest 7,500 B.C. to 5,300 B.C.
Early 5,300 B.C. to 3,600 B.C.
Middle 3,600 B.C. to 2,500 B.C.
Late 2,500 B.C. to 1,000 B.C.
Latest 1,000 B.C. to 300 B.C.

YAYOI PERIOD
Early 300 B.C. to 100 B.C.
Middle 100 B.C. to 100 A.D.
Late 100 A.D. to 300 A.D.

KOFUN PERIOD
Early 300 A.D. to 400 A.D.
Middle 400 A.D. to 500 A.D.
Late 500 A.D. to 650 A.D.

THE YAYOI PERIOD

The Yayoi period (300 B.C. – 300 A.D.) is characterized by a new social order. In the Jōmon period, egalitarian society and communal ownership of facilities for processing food and for ritual activities prevailed. In the Yayoi, however, the beginning of social ranking, with the rise of powerful chiefs, can be seen. Wet rice cultivation, the hallmark of the Yayoi, is linked to higher population levels, which make feasible the communal intensive work of such agriculture. In the Yayoi, bronze casting and textile weaving appear for the first time. While the incursion of new populations with new ideas is important in initiating the Yayoi, there is also clear evidence of internal development within the Japanese islands, so that the transition is no longer seen as a dramatic break. In fact, not all of the new traits may have entered Japan at the same time. For instance, there is evidence that spinning and weaving arrived in Latest Jōmon. For the late Yayoi, we have the historical accounts of the Chinese, written in the *Wei zhi* (Record of Wei), completed in 297 A.D. This history of the Wei dynasty (221 – 265 A.D.) included in the *San guo zhi* (History of the Three Kingdoms) contains a description of a voyage to the people of Wa (Japan) and their customs. Since it was compiled soon after the end of the Wei dynasty, it is thought to be rather accurate.

The Yayoi period, some six hundred years, is divided into early, middle, and late subdivisions of about two centuries each (see fig. 1). On the basis of the stylistic changes of Yayoi pottery, it is sometimes divided into five periods. Ceramic artifacts of the earliest period, found in sites that have yielded burnt rice grains and even the remains of prehistoric fields, are found in Kyushu and areas of western Honshu as far as Okayama. In Periods IV and V, rice culture gradually spread to the Tokyo and Tōhoku regions. In 1981, however, the Tareyanagi site, Aomori prefecture, yielded rice paddy remains from the end of middle Yayoi, about nineteen hundred years ago. The rice was grown in small paddies 3 to 4 meters on each side, separated by paths (*aze*) about 14 centimeters wide. At the Itazuke site, in northern Kyushu, the oldest rice paddies are over 400 square meters in area.

In contrast to Jōmon villages, which were often on natural plateaus, Yayoi villages were often located in low-lying and naturally wet areas used for rice. Many villages were moated, some with double moats. Sahara has pointed out that in the whole span of Japanese history, the moated villages occur only in the Yayoi and in the Sengoku period (1467 –1568 A.D.). Warfare, apparently the reason

for such fortification, is thought to have occurred between individuals or families in the early Yayoi in conflicts over water or land, and between village units in the late Yayoi. At the end of the Yayoi there appears to have been a period of serious battles; in the Kinki area, a number of villages were apparently burned to the ground. In the late Yayoi, sites located on ridges seem to have been an adaptation for defense.

The Itazuke site near Fukuoka, one of the oldest settlements of the Yayoi, has a moated area of 220 by 90 meters, with about thirty houses occupied at one time. It was surrounded by a ditch some 4 to 5 meters wide and 2 meters deep. Outside the moat was a large cemetery. The famous Yayoi site of Karako in Nara prefecture had five ditches 6 to 10 meters wide, dug at different periods (the last one in the Kofun period). They yielded stone daggers, sickles, plows, and wooden agricultural implements.

Within each larger village were household groups which cooperated in some of their daily activities, forming a *mura*, or sub-village. The existence of large and small villages seems to show the process by which new communities split off from older ones. The small villages consisted of three or four households. The cluster of villages dominated by a central powerful village with one particularly large house, and with a cemetery yielding relatively rich grave goods, is referred to in the Chinese of the *Wei zhi* as a *guo* (Japanese: *kuni*); it must have been a chiefdom or early state.

In the early Yayoi of Kyushu, large bag-shaped pits as much as 2 meters deep were excavated near the houses. Each house appears to have had three to five pits, suggesting that food storage was a household responsibility and that food production was still primarily carried on by the household unit within the irrigation system. This type of storage pit is common in China, but was not particularly suitable for the moist climate of Japan. The Ōtsuka site, Yokohama, contained two storehouses built on piles and probably used for rice. The *takakura* storehouse, with gabled roof, was developed in the middle Yayoi.

Along with the techniques of wet rice cultivation and associated cultivating, harvesting, and storage technology, new ideas from the mainland included new pottery styles. Yayoi pottery has smooth lines and surfaces, displaying an esthetic different from the organic feeling of the Jōmon. While vessels from northeastern Japan, the stronghold of vigorous Jōmon styles, sometimes maintain the cord marking of earlier styles, the pottery of Kyushu and the Kinai (Nara-Osaka-Kyoto area)

generally lacks surface decoration except for painting and burnishing. The usual domestic pottery group is a cooking vessel or steamer, a serving bowl, and a footed cup or bowl. Experiments in reproducing late Yayoi pottery of the Kinai show that large lumps of clay were carried from their source in baskets. Such lumps have actually been found in the Onizuka site, Higashi Osaka, and weigh about 50 kilograms, enough clay to produce about twenty-five medium-sized jars (*kame*). No firing sites of Yayoi pottery have been discovered by archaeologists; however, it is thought that vessels were fired in the open air, using straw and oak twigs, at a temperature of 800 to 900 degrees centigrade. Black spots, or "shadows," are often observed on the sides of Yayoi vessels, where the hot pots touched wood or other organic materials before they cooled. Yayoi pottery is better finished and more attractive than its successor in the Kofun period, Haji ware. It appears that Haji was made quickly by specialized professional producers, while Yayoi pottery was made by part-time specialists who took time to elaborately finish each piece.

We know a little of the religious ceremonies of the Yayoi people from archaeological and historical sources. The emphasis on wet rice agriculture roused a concern for fertility; from it emerged ritual for giving thanks for the harvest. Religious places included megaliths and sacred stones, and rocky crags. The most important ritual objects are polished stone daggers, wheel-shaped round earrings, *takatsuki* (a footed serving dish), glass beads, comma-shaped beads (*magatama*), clay bell-shaped objects, and miniature clay vessels. In western Japan, a small number of remarkable figures, either of human form or violin-shaped with indented sides, and wooden replicas of swords, or of human figures, have been found. Ono states that many can be considered Shinto ritual objects. Shinto paraphernalia became further elaborated in the Kofun period. Some burials also include birds or wooden bird effigies as guides or spirit messengers for the departing soul. (The symbolic role of birds is also seen in ethnographic examples from Japan, Korea, Siberia, and Southeast Asia.)

The use of shoulder blades of the Japanese deer for divination occurs in the Yayoi and Kofun periods. Occasionally other types of bone — wild boar, even dolphin — were used when deer scapulae were not available. Evidence of this divination comes from the Tokyo-Nagano region, Osaka, and Nagasaki. The bones were usually scraped first; then a hot, pointed object was applied to cause cracking. Presumably portents were read from the

cracking pattern; unfortunately, no written inscription was supplied to elucidate the meaning of the prophecy, as it was in the Shang dynasty of China. Although the practice existed here much later than in China, it is thought that it may have been introduced along with paddy agriculture from the continent. This type of divination is part of contemporary Shinto practice; in the Yayoi period, it must have been a separate stream from shamanism. An oracle bone scapula fragment has also been found in a dwelling at the Puin-dong site, Kimhae, southern Korea, its date contemporary with the middle Yayoi. This raises again the possibility of continental origins of the Shinto custom, or sharing among the Wa people.

Special kinds of pottery were used as offerings. At the Itazuke site, pottery was found at the drains and catchment areas of the irrigation system, and offerings of vermilion-colored polished vessels were placed near rows of stakes in the rice paddies. The same ritual kinds of pottery were found near a middle Yayoi well at Itazuke (well digging was also a continental technique introduced in the Yayoi). Pottery with surface-incised drawings of animals, people, fish, and boats appears to have been used for ritual purposes as well.

From the beginning of the Yayoi period, new burial forms of continental origin appeared. In early-Yayoi Kyushu, the use of wooden coffins, stone coffins, and dolmens came from Korea. In middle-Yayoi Kyushu, burial in large jars oriented horizontally, mouth to mouth, was common. Burials often yield mirrors of Chinese and Korean origin, stone and bronze weapons, and semiprecious beads of tubular and comma shape. The bronze and stone weapons had symbolic importance but were also used in combat. Their broken tips have been found in graves, in some cases embedded in the bones of the deceased. In middle Yayoi, iron weapons developed greatly, yet in experiments, stone arrowheads were found to penetrate straw targets farther than their iron counterparts.

Kanaseki believes that rituals described in the Chinese *Wei zhi* for the Korean chiefdom of Mahan approximate the situation for Japan. The description speaks of agricultural rituals held in the village plaza and lasting for several days in May, at seed-planting time. Singing, dancing, and drinking of wine continued day and night to the accompaniment of handbells and drums. In the case of Mahan, we know of two deities that were propitiated, one good and one malevolent, as well as an ancestral spirit.

While the bronze swords, spearheads, and halberds were concentrated in Kyushu, southern Honshu, and Shikoku, the *dōtaku*, large bronze bell-like objects, were distinctive of the Kyoto-Nara-Osaka region and the northern reaches of the Inland Sea. These conical flanged objects, often as tall as 1 meter, appear to have been suspended from poles. Often they have panels of geometric decoration, or scenes of animals, houses, and agricultural activities such as rice harvesting. Their manufacture seems to have been restricted to the middle Yayoi; piece-molds of stone and soft sandstone, used in conjunction with a clay core, have been found. Tests of the metals used in *dōtaku* have produced a range of ideas about their source. Kōichi Mori cites analyses by Kakuichi Kuno stating that the Japanese used native copper without refining it, in a manner different from those alloys and methods used in China and Korea. However, other tests for lead isotopes have shown that the metal was imported from the Asian continent. The bells appear to have been symbols of ritually sanctioned political authority and may have been exchanged among members of political alliances, whose chiefly lineages also intermarried.

During the Yayoi period, wealth and power became concentrated in the hands of local chiefs. One dramatic find which seems to indicate this trend is a cache of 358 bronze daggers reported from Kojindani by the Shimane Prefectural Board of Education in 1984. They were found in a pit on the south side of a ravine at the edge of a small plain, packed in neatly arranged rows of 34, 111, 120, and 93 specimens. In 1985, 6 meters to the east, six bronze *dōtaku* bells and sixteen bronze halberds with sockets were found buried in a symmetrical arrangement. This somewhat isolated part of Japan along the Japan Sea coast must nevertheless have been the locus of considerable power. The hoarding of such obvious wealth seems to indicate some kind of centralized political control in the area. In Yayoi cemeteries, it is thought that people who were born in the village were buried in a segregated portion which was mounded, while people who married into the village were buried in the unsegregated area. Differences in styles of wooden coffins may have signified villagers and outsiders. However, in the late Yayoi, a new kind of status different from post-marital residence appeared in the cemeteries. In some cemeteries, the chief and his family group seem to be buried in the *hōkeishūkōbo*, or moated precinct, in burials consisting of a mound with ditches mark-

Dōtaku, 1st century A.D., bronze, No. 2

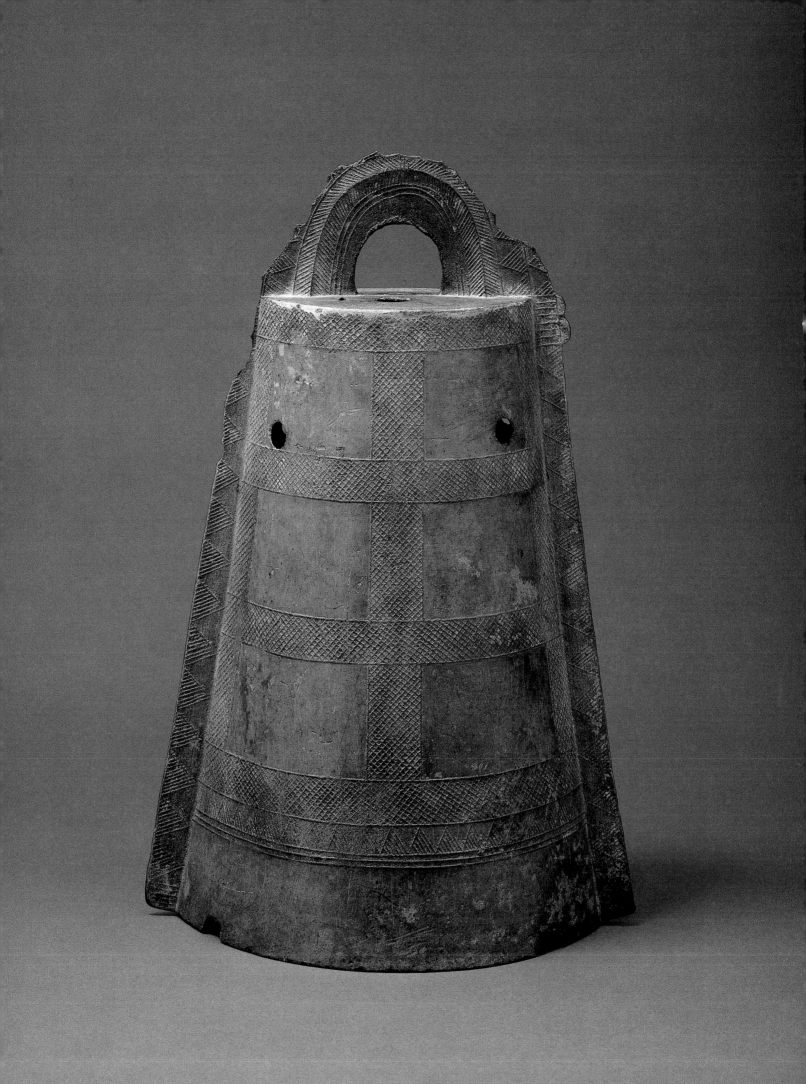

ing their sides. These ditches were not continuous, however; at each corner of the tumulus a section of earth was left to act as a bridge between the ritual burial area and the profane area. The earliest examples of the ritual precinct are actually known from the early Yayoi. In the late Yayoi, the chiefly burials took place in a separate area, removed from the village cemetery.

THE KOFUN PERIOD

The Kofun period, roughly 300 to 650 A.D., is characterized by massive burial tumuli built for powerful chiefs and emperors. The splendid remains blinded archaeologists to other important developments essential for society to flourish at this high level — changes in agriculture, craft production, and social organization. Recent excavations have greatly enhanced our knowledge of these aspects of Kofun culture, and have contributed to our comprehension of the social and symbolic life of the tumulus builders.

In the Kofun period, farmers opened upland areas for irrigation and dry cultivation. Early Yayoi cultivators used moist areas of a bluish green soil for rice. Fields at the Yayoi site of Toro, Shizuoka prefecture, some as large as 1,400 square meters, lay below the high water table, so there were few engineering problems with maintaining water over them. But a great deal of skill was required to make upland fields level; therefore, their size decreased drastically.

From the time of early Yayoi, rice culture expanded into brown and yellowish brown soils. From middle Yayoi, improvements in tools led to the use of metal hoes; from the middle Kofun, farmers used a U-shaped iron plowshare (from Korea) and also iron sickles. From 1965 on, archaeologists have found many field systems from the Kofun period buried under volcanic ash; in particular, Gumma prefecture has numerous examples. Fourth-century systems in Gumma seem to have allowed water to flow from one field to another over the small ridges which divided them. In the fifth century, farmers began to change the courses of small rivers and to build ditches and dikes. Two Japanese classics, the *Kojiki* and *Nihon shoki*, accounts of the time of the emperors Ōjin and Nintoku, describe the extensive construction of ponds and ditches. Increase in engineering expertise can also be seen in the construction of large burial mounds.

The *Kojiki* (Records of Ancient Matters), completed in 712 A.D., was compiled by the Japanese court to describe the origins of the imperial clan, and to legitimize their claims to power. It appears to have been based on two early documents, one

concerning genealogies, which is of sixth, and possibly fifth century A.D. origin, and the other, a collection of myths, legends, and song sequences. The *Nihongi* or *Nihon shoki* (Chronicles of Japan) was prepared between 714 and 720. It provides a history of the royal lineage, carrying the narrative to the close of the seventh century A.D. Both documents are composites of earlier materials, mythology, and fiction; their use in elucidating the archaeological record is a challenging task.

Along with greatly increased agricultural production in the fifth century A.D. came other changes. Sue pottery, a grey stoneware, was introduced from Korea for use in ritual. A soft red or greyish utilitarian ware, Haji, was used for everyday purposes. Propitiatory vessels with tall cylindrical bases and footed cups and bowls are found in abundance in tombs of this period. The oldest Sue kiln sites, located in the hillsides south of Osaka City (Sakai, Izumi, Kishiwada, and Sayama), have been recorded since 1961 in surveys connected with new suburban town sites. A professional potters' community, Suemura, was inhabited by Korean potters brought to Japan by the powerful clan leaders of the Kinai region. Over five hundred kilns dating from the fifth to the tenth centuries have been recognized in this community; its location was mentioned in the *Nihon shoki*. At least three different types of Sue can be distinguished — vessels imported from Korea, products of Suemura, and those of unknown kilns; the Suemura products show regulation and standardization. Later in the development of Suemura the potters were no longer full-time specialists, and production became intermittent, since the artisans also had to spend time producing their own food.

Advances in the refining of iron took place in the latter half of the fifth century. The site of Shimomaebara, Kumamoto prefecture, is thought to have been used for smelting. Sites such as Uruizaki, northern Kyushu, seem to indicate that high temperatures could be reached; thus, relatively pure iron could be achieved.

The iron was shipped from the production sites as ingots; large numbers in different standard sizes have been found in burial mounds. In the late 1940s, 282 iron ingots 35 centimeters long and 590 of 15 centimeters were discovered in Mound No. 6, Yamato, Nara prefecture. It is believed they were imported from the Korean peninsula, although some scholars have thought that they might have been locally made.

Other evidence of specialized professional groups comes from salt production sites in Ise Bay, Wakasa Bay, the Noto peninsula, and the Ariake

coast, in addition to the Seto Inland Sea. Salt production and distribution were controlled by powerful chiefs. The Kiheijima site, Kagawa prefecture, consisted of a large furnace built on a stone floor 2 to 3 meters long on each side. Huge piles of potsherds and lime carbonate lay everywhere. Seawater was evaporated by boiling in pottery vessels, which were repeatedly refilled until salt was precipitated; it was later baked to remove the impurities. Kiheijima is a small island with few beaches and granite mountains, with no good possibilities for cultivation. However, the inhabitants seem to have been quite privileged, judging from the *kofun* mounds in which some were buried. The Katayamatsu site, Ishikawa prefecture, consisted of six pit houses, five of which were jasper workshops of the early Kofun period. This type of site shows increasing social complexity, since the chiefs, under the authority of the central power in the Kyoto-Nara-Osaka region, had jasper bracelets made by these specialists and distributed through the members of the alliances.

Other kinds of production were carried on by part-time specialists. The manufacture of talc replicas as burial objects at the Natsumidai site, Funabashi, took place in only one pit house in a community of seven houses. The people seem to have made the objects on demand, rather than as full-time specialists in a factory.

The great burial mounds of the Kofun period display some continuities from the tombs of the Yayoi chiefs, among them a stone chamber for the deceased, pottery offerings, and the surrounding ditch. The characteristic *kofun* is keyhole shaped (*zempōkōenfun*) — a round tumulus, with a trapezoidal front portion used as a space for conducting ceremonies. Rectangular and circular mounds were also constructed.

The formalized pottery vessels of the Yayoi may be forerunners of the Kofun-period *haniwa*, the reddish clay vessels and figures placed around the perimeter of the tomb on its surface. In the early Kofun, *haniwa* were tubular, sometimes with flaring mouths of morning-glory shape; in the fifth to seventh centuries, *haniwa* representations of people, horses, animals, and ritual paraphernalia such as sunshades were created. Most authors believe that the *haniwa* are an independent Japanese invention, since there are virtually no Korean prototypes, and Chinese tomb figurines from the Han dynasty (202 B.C.–220 A.D.) are both too remote in time and function, and were also placed within the underground burial chamber. However, the finding of small figurines in the fourth- and fifth-century Jin

tombs of the Jiangsu and Zhejiang regions has opened up the possibility that some elements were diffused from China, while the recent discovery of a grey clay cylindrical stand from the early Paekche fortified site of Mongch'on T'osong in eastern Seoul suggests that the prototype of the tubular *haniwa* might be Korean.

The time of the establishment of the keyhole-shaped mounds was characterized by political alliances among the chiefs of various places. Distribution of grave goods, such as mirrors cast from the same mold and found in different burials, shows that chiefs exchanged objects of prestige. Also, the use of cut-stone coffins, manufactured by one group of artisans supported by a local elite and carried over mountain roads controlled by particular factions, shows the growth of political alliances. The keyhole-shaped tumuli also marked the creation of a unified type of burial ritual for the spirit of the chief and the beginning of state religion.

In the early part of the fourth century, relatively large *kofun* were concentrated in the southeastern part of the Nara basin. Many were longer than 200 meters. In the latter half of the fourth century, large mounds were no longer built in this area but appeared in the region around Saidai-ji, several kilometers to the west. At the end of the fourth to fifth centuries, large mounds were constructed on the Kawachi plain, which some scholars believe indicates the fall of the Yamato dynasty and the rise of the rulers of Kawachi. (The Kawachi floodplain, created by the Yamato River, lies to the east of Osaka Bay and is separated from the Nara basin, farther to the east, by the low mountains of the Ikoma range. Originally an inlet, it has been filling in from prehistoric times.) This gap was thought by Egami Namio to indicate the intrusion of horse-riding immigrants from Korea, who took over power. However, the shift in the concentration of the *kofun* does not necessarily mean a change of dynasty, nor does the appearance of Korean artifacts in burials mean that Koreans were in power. While the different states of Korea did not exercise hegemony over parts of Japan in the Kofun period, there is no doubt of close communication. Tumuli from the fifth to seventh centuries in Gumma prefecture show strong influence from Korea in the use of piled stones over the chamber. In Wakayama prefecture, the Narutaki site of the middle Kofun period consists of the remains of a huge elevated storehouse from the first half of the fifth century. The abundant Sue pottery from here is of Korean type. The site is near the Ōtani *kofun*, which shows strong Korean influence in its horse armor, and is

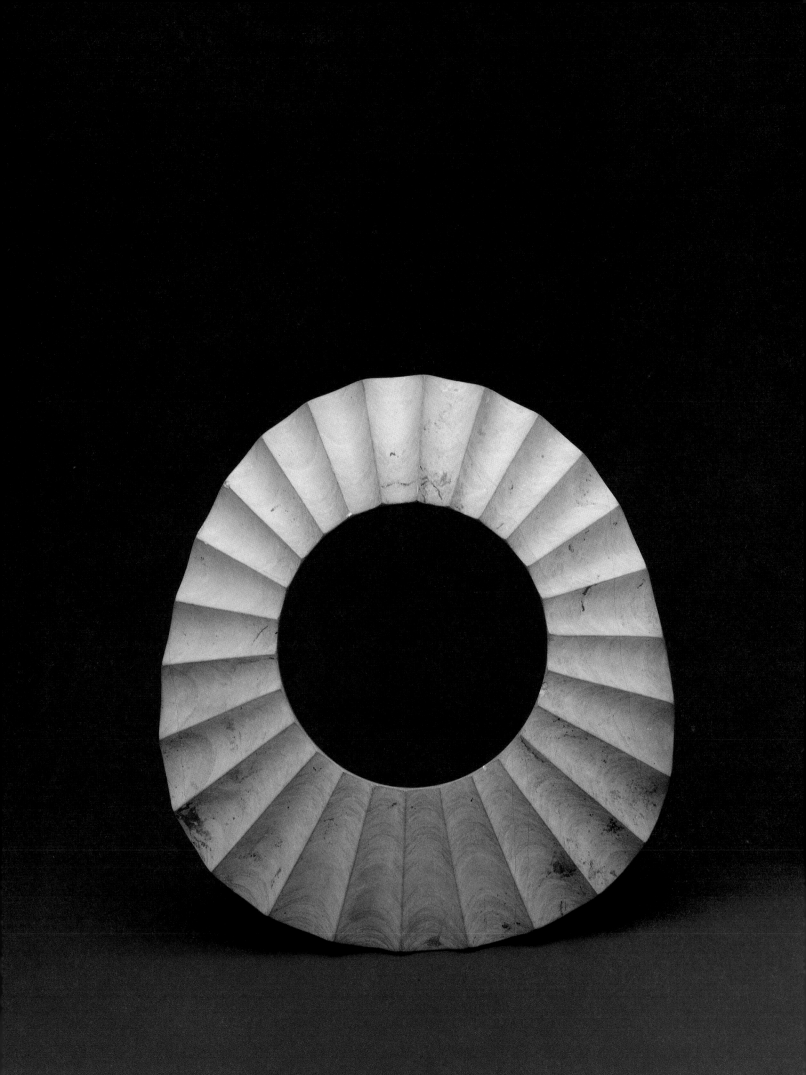

also very close to the old port of Kinominato. It seems to be either a trade warehouse or a cache for arms, because of its remote and secret location.

The most imposing example of the keyhole-shaped tombs from the fifth century is the mausoleum assigned by Tokugawa scholars to emperor Nintoku, the largest of its type in the world. Nintoku's tomb is larger in surface area than Cheops's pyramid in Egypt, and is longer but not quite so wide as the burial mound of Qinshihuang, the Qin emperor of China, whose terra-cotta warriors have stirred such interest. Surrounded by a triple moat, it is 480 meters long and about 35 meters high. The main tomb is unexcavated, as are the rest of the so-called imperial tombs thought to belong to the ancestors of the present royal family, which are held under the tight jurisdiction of the Imperial Household Ministry. Cylindrical *haniwa* appear to have been placed around the first moat; from the sample that was found, it is estimated that some seventeen thousand would have been needed for the entire circumference. In addition, on the tomb itself an estimated 21,440 *haniwa* would have been used. The production of *haniwa* must have involved a separate group of specialized craftsmen. Wide-area excavation around the Kyōmizuka tumulus, Shizuoka prefecture, dated to the latter half of the fifth century, uncovered two *haniwa* kiln sites near the moat around the mound. *Haniwa* sherds were found, including some that seem to come from the mound itself.

The construction of the very large *kofun* declined in the latter half of the fifth century. Local families, under the power of the central Yamato court, constructed tumuli with large amounts of grave goods, many of them gifts from the Yamato central power.

The Watunuki Kannonyama *kofun*, Gumma prefecture, provides a good example of the type from Gumma, a very powerful center. The subject of a display at the National Museum of History and Folklore, Sakura, Chiba, this is a double-moated keyhole-shaped tumulus with two steps on the sides. In the "neck" of the keyhole on the flat step, a row of *haniwa* was found. The burial goods included a Chinese mirror of the same kind as one found in the Paekche tomb of Muryong-wang (Korea), as well as a bronze water bottle of the same kind as those from the Northern Qi tombs in China. There is also a large sword with a gold and silver handle, iron armor, weapons, gilded bronze horse gear, and Sue pottery.

The arrangement of the *haniwa* on this tomb gives an impression of the burial rites. The human effigy *haniwa* were placed in a group. First comes a male with his hands clasped together, as in prayer. He wears a belt with a bell on it. Kneeling formally, a female sorceress faces him; these two are watched over by another woman. A third woman, carrying a leather bag, continues the line of figures. Then follow two men, one in full armor and one armed, then a farmhand, then a person carrying a shield. Within the whole group there is a male diviner and a female shaman, and also the new chief; the ritual portrayed by the *haniwa* confirms his power of succession. The chief buried in the tumulus has the same kind of belt with attached bell as the *haniwa* figure described above. Two representations of shields were found in the row with the human figures. Tubular *haniwa* continue all around the tomb, except for the end of the trapezoidal portion (the bottom line of the keyhole), where there is a line of about eight horses and a *haniwa* farmhand. Two house-shaped *haniwa* were found on the summits of the rear burial area, and one house-shaped *haniwa* was found on the front portion of the tomb.

The arrangement of house-shaped *haniwa* gives some notion of the power and the wealth of the families who built the tombs. The *haniwa* represent houses built on flat foundations, not pit dwellings; these are the residences of powerful families. It is thought that people of the Kofun period believed the spirit of the deceased resided temporarily in these houses before leaving for the other world. Ogasawara studied the styles and arrangements of houses on four large tombs of the first half of the fifth century — Akabori Chausuyama (Gumma), Shiraishi Inariyama (Gumma), Nagase Takahama (Tottori), and Tsukinowa (Okayama). Chausuyama, at its summit, had a main hall, two residences, two barns, and four storehouses. Boundary marker *haniwa* have been reinterpreted as a gate. The most common arrangement was to place the large house in the center, flanked by houses and storehouses. The relative importance of the buildings can be determined by the degree of elaboration of the roof and its beams or ridges. In front of the main and flanking houses was an open space for *matsuri*, ritual and political gatherings. The house arrangement is the same as that adopted in the seventh-century palaces. Since this arrangement cannot be seen in the villages of the Yayoi or Kofun, it most likely was introduced from China.

It is fascinating that the house-shaped *haniwa* in at least the Chausuyama and Shiraishi Inariyama *kofun* show evidence of two different sources of manufacture. Clay paste, decoration, and also the style of the bases differ. Ogasawara believes that

Fluted bracelet, mid-4th century, jasper, No. 4

they were made by two different craft groups, one controlled by people related to the deceased chief, and one by people related to the new chief. A great deal of ceremonialism was concerned with maintaining the ritual power of the chief throughout his life and at the time of succession.

In addition to the chiefly rituals of succession, many other religious ceremonies give us some idea of the organizing principles of the Kofun culture and the significance of the pieces we see in museum collections. There were ceremonies to propitiate the gods of the sea; the island of Okinoshima, in the Japan Sea, was a shrine for safe passage. From the latter half of the fourth up to the ninth century, offerings were placed in various cliffs and crags; at one site twenty-one bronze mirrors, as well as semiprecious objects and swords were found. Bracelets of talc stone and halberds were recovered from another. These objects are the same as those found in the large *kofun* in the Kinai area, but not the same as those from the local burials; they show that the ceremonies for overseas safety must have been controlled directly by the Yamato power. These ceremonies ended in the ninth century, with the ending of the tribute (*kentōshi*) expeditions to China.

Rituals for water gods have been inferred from offerings of pottery, mirrors, bronze arrowheads, talc stone replicas, swords, and jewels found in ditches, as at the Nagakishi site, Hyogo prefecture, or associated with stone pavement ritual sites. Other sites of stone pavements, with offerings of Sue pottery, talc replicas, and iron objects, are thought to have been used for agricultural rituals. Yet another group of sites, on which have been found replicas of wooden pestles, ladles, and strainers, are thought to have been associated with the brewing of sake.

The talc replicas found in the ritual sites are usually of mirrors, swords, and jewels, while in the *kofun* they are knife blades and jewels. The former, the three treasures of Shinto, seem to have been used to show subordination of chiefs to the central ruler. Iwasaki mentions that in the *Nihon shoki*, in

the account of the visit to Kyushu by Chūai Tennō, the chief Kumawani welcomed the emperor with branches of trees decorated with mirrors, swords, and jewels. It seems that this ritual came from the ceremony for welcoming the gods.

These descriptions leave no doubt that the Kofun period witnessed the shift from chiefdom to state, with increased centralization and regulation made possible by substantial local technological breakthroughs and increasing communication from the continent.

By the fifth century, the power of the Yamato state in the Kyoto-Nara-Osaka region was very strong. The Egenoyama *kofun*, Nagaoka, Kyoto, of this time, has recently yielded seven hundred iron swords from the chamber, which must be seen not only as the property of the deceased, but also as the tribute from allied or subservient groups.

The discovery of the famous inlaid sword from the early sixth-century Inariyama *kofun*, Sakitama, Saitama prefecture, and the similarity of its inscription to that of the Etafunayama sword from Kumamoto provide evidence of further centralization of power. The sovereignty of the Wa kings extended by this time from the Kantō area to the northern half of Kyushu. The sword, made of iron from South China, contains an inscription emphasizing loyal service to the court from a vassal, and also gives the owner's genealogy.

The sixth century witnessed increased contacts with Korea and China, and the advent of Buddhist high culture, particularly to western Japan. While the Kyoto-Nara-Osaka area abandoned the pre-Buddhist rites of mound burial and *haniwa* production, the old ways flourished in the relatively isolated Kantō region into the seventh century. Great *haniwa* were made in this area, while Buddhist sculptures were being produced for temples in the Kansai. The induction of Japan into the international style of Buddhism, the advent of local written records, and the strong development of a centralized state brought to a close the prehistoric and protohistoric eras.

Bibliographical Note

Acknowledgments: I thank Dr. Wakou Anazawa, Aizu-wakamatsu, Japan, for sending me some of the publications introduced in this paper, and also Kazue Pearson, who translated a number of them.

GENERAL SURVEYS: R. Pearson, *Image and Life: 50,000 Years of Japanese Prehistory*, Museum Note No. 5, University of British Columbia, Museum of Anthropology, Vancouver 1978; C. M. Aikens and T. Higuchi, *Prehistory of Japan*, New York 1982; R. Pearson, G. Barnes, and K. Hutterer, eds., *Windows on the Japanese Past: Studies in Japanese Archaeology and Prehistory*, Center for Japanese Studies, University of Michigan, Ann Arbor, 1986 (hereafter referred to as *Windows*). — PALAEOLITHIC PERIOD: T. E. Reynolds and G. L. Barnes, "The Japanese Palaeolithic: A Review," *Proceedings of the Prehistoric Society* 50 (1984). — JŌMON PERIOD: R. Pearson, "Palaeoenvironment and Human Settlement in Japan and Korea," *Science* 197 (1977); F. Ikawa-Smith, "Late Pleistocene and Early Holocene Technologies," in R. Pearson, G. Barnes, and K. Hutterer, eds., *Windows*, 1986. — YAYOI PERIOD: Hiroshi Kanaseki, "The Evidence for Social Change between the Early and Middle Yayoi," in R. Pearson, G. Barnes, and K. Hutterer, eds., *Windows*, 1986. — KOFUN PERIOD: G. Barnes, "The Yamato State: Steps Toward a Developmental Understanding," *Indo Pacific Prehistory Association Bulletin* 1 (1978); F. Ikawa-Smith, "Political Evolution in Late Prehistoric Japan (1)," in V. N. Misra and P. Bellwood, eds., *Recent Advances in Indo-Pacific Prehistory*, New Delhi 1985; J. E. Kidder, "The Archaeology of the Early Horseriders in Japan," *Transactions of the Asiatic Society of Japan*, 3rd ser., vol. 20 (1985); Wakou Anazawa and Jun'ichi Manome, "Two Inscribed Swords from Japanese Tumuli," in R. Pearson, G. Barnes, and K. Hutterer, eds., *Windows*, 1986; Seigo Wada, "Political Implications of Stone Coffin Production in Protohistoric Japan," R. Pearson, G. Barnes, and K. Hutterer, eds., *Windows*, 1986.

ARCHAEOLOGY OF RELATED AREAS: Mombushō (Kaigai Gakujutsu Chōsa: Nihon Gōdō Chōsatai), *Kankoku ni okeru Kankyō Hensen Shi — Shōwa 53 Nendo Genchi Chōsa Sōkatsu — (Kaigai Gakujutsu Chōsa Chūkan Hōkoku)* Tokyo 1980; Alexei Okladnikov, *Ancient Art of the Amur Region*, Leningrad 1981; Bong Kun Sim, *Kimhae Puin-dong Yujok*, Pusan 1981; R. Pearson, "The Ch'ing-lien-kang Culture and the Chinese Neolithic," in D. Keightley, ed., *The Origins of Chinese Civilization*, Berkeley 1983; Won Young Kim, "A Cylindrical Pottery Stand from Seoul: A Possible Relationship with Japanese Entō-Haniwa," in *Essays in Honor of Prof. Dr. Tsugio Mikami on his 77th Birthday*, Tokyo 1985; Hong Yang, "Wu, Dongjin, Nanchao di wenhua ji qi haidong di yinxiang," *Kaogu* 6 (1984); idem, "Riben gufen shidai Jiazhou qi he Zhongguo jiazhou di guanxi," *Kaogu* 1 (1985).

RECENT JAPANESE LANGUAGE PUBLICATIONS: GENERAL: Asahi Gurafu, ed., *Kodai Shi Hakkutsu*, Tokyo 1983; *Maizō Bunkazai Niūsu* no. 48, Nara 1982. — JŌMON PERIOD: Haruo Fujimura, "Doki yōryō no sokutei — banki Jōmon shiki doki o rei toshite," *Kōkogaku Kenkyū* 28:3 (1981); Tadashi Kinoshita, *Umegame: Kodai no Shussan Shūzoku*, *Kōkogaku Sensho* no. 18, Tokyo 1981; Teruya Esaka, Miyoko Ono, *Dogū no Chishiki*, Tokyo 1983; Makoto Watanabe, *Jōmon no Chishiki*, Tokyo 1983; Kōnosuke Maeda, *Dogū*, *Kōkogaku Raiburari* no. 21, Tokyo 1984. — YAYOI PERIOD: Sahara Makoto, "Yayoi jidai no shūraku," *Kōkogaku Kenkyū* 25:4 (1979); Hiroshi Tsude, "Zempōkoenfun shutsugenki no shakai," *Kōkogaku Kenkyū* 26:7 (1979); Yūichi Kanazawa, "Yayoi jidai no bokkotsu," *Rekishi Kōron* 8:9 (1982); Hisao Mabuchi et al., "Namari dōi taihi kara mita dōtaku no genryō," *Kōkogaku Zasshi* 68:1 (1982); Shin'ichi Ono, *Saishi Iseki*, *Kōkogaku Raiburari* no. 10, Tokyo 1982; Kaoru Terasawa, "Yayoi jidai (Nishi Nihon) 1981 nendo no dōkō," *Kōkogaku Jānaru* 208 (1982); Hiroshi Kanaseki, "Yayoi jidai no jujutsu to jugu," *Kōkogaku Kenkyū* 30:1 (1983); Hiroshi Tsude, "Kangō shūraku no seiritsu to kaitai," *Kōkogaku Kenkyū* 29:4 (1983); Shimane-ken Kyōiku Iinkai, *Kōjindani Iseki Shutsudo Dōkengun*, Shimane 1984; Yoshiaki Tanaka, "Yayoi jidai shūraku kenkyū no kadai," *Kōkogaku Kenkyū* 31:3 (1984); Fumitaka Yoneda, "Yayoi doki no seisaku: yōto jikken," *Kōkogaku Jānaru* 240 (1984); Nobuya Fukunaga, "Yayoi jidai no mokkambo to shakai," *Kōkogaku Kenkyū* 32:1 (1985). — KOFUN PERIOD: Namio Egami, *Kiba Minzoku Kokka: Kodai Nihon e no Apurōchi*, Tokyo 1967; Takuya Iwasaki, *Kofun Jidai no Chishiki*, Tokyo 1984; Itsuo Maeda, "Shingaimei tekken shutsudo kofun no gaiyō to Sakitama Kofungun — shūchō ken no hensen to seikaku," *Kōkogaku Jānaru* 201 (1982); Hiroshi Nakamura, "Sueki no seisan to ryūtsū," *Kōkogaku Kenkyū* 27:4 (1981); Yoshihiko Ogasawara, "Iegata haniwa no haichi to kofun jidai gōzoku no kyokan," *Kōkogaku Kenkyū* 31:4 (1985); Masaaki Ueda and Shūzō Tanabe, eds., *Uzumoreta Yamataikoku no Nazo* vol. 1, *Genshi, Kofun Jidai*, Tokyo 1981.

RECENT STUDIES IN ANCILLARY FIELDS: R. A. Miller, *Origins of Japanese Language*, Seattle 1980; Kazurō Hanihara, "Physical Anthropology of the Prehistoric Japanese," in R. Pearson, G. Barnes, and K. Hutterer, eds., *Windows*, 1986; R. A. Miller, "Linguistic Evidence and Japanese Prehistory," in R. Pearson, G. Barnes, and K. Hutterer, eds., *Windows*, 1986.

Richard Pearson is Professor of Anthropology, University of British Columbia.

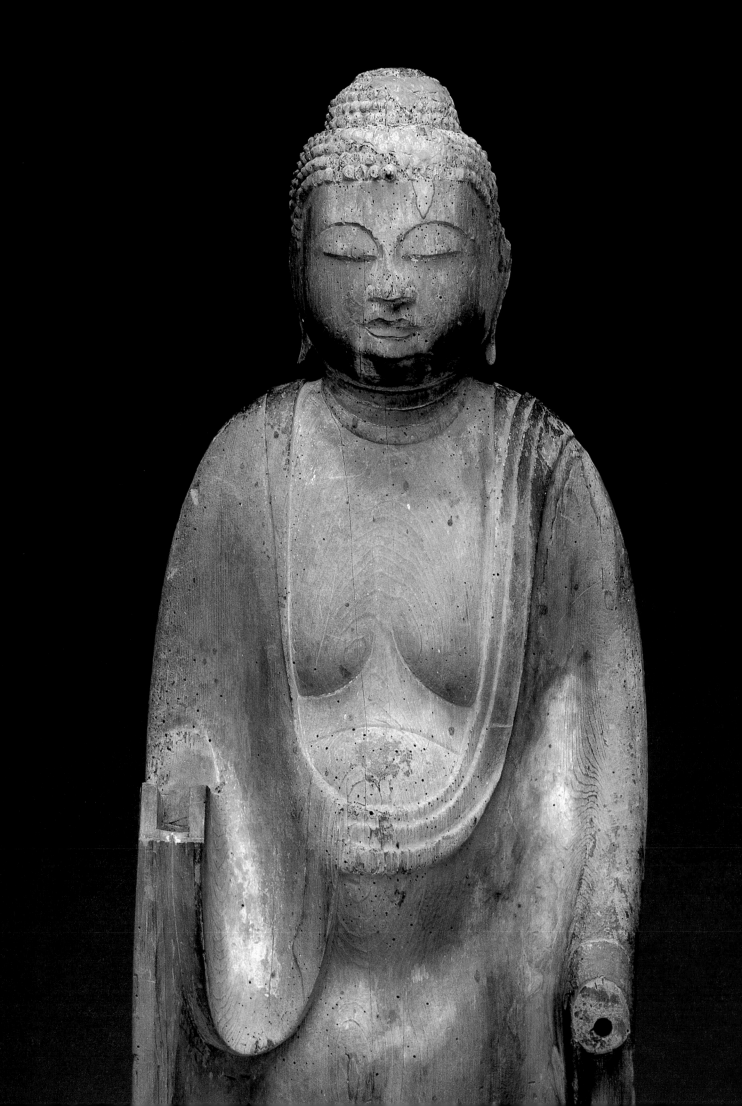

BUDDHISM IN JAPAN

James C. Dobbins

Buddhism has long been an inseparable part of Japanese culture. It has so permeated Japan over the centuries that it is difficult to imagine what the country would have been without it. In the earliest period, Buddhism functioned as a carrier of Chinese civilization to Japan and stimulated revolutions in Japan's intellectual and social experience. Buddhism itself was transformed during the long course of this encounter, and in its new guises produced religious convictions in Japan extending far beyond premises inherited from Asian neighbors. The heyday of Japanese Buddhism continued into early modern times, but with the diversification of society and the influx of Western thought, it gradually lost its monopoly on the Japanese imagination. Despite its eclipse in the modern period, Buddhism's influences endure today in the social rituals, cultural images, and thought patterns of the Japanese people.

Buddhism had its beginnings in India during the fifth century B.C., arising from the religious experience and teachings of Sakyamuni Buddha, a historical personage. According to tradition he was the son of a ruler of a small kingdom in northern India, but at age twenty-nine forsook his princely birthright and took up the life of a religious mendicant. At first he subjected himself to various religious austerities — fasting, self-mortification, and protracted meditation — but after six years "Sakyamuni came out of the mountains," as the Buddhists say. That is, he renounced the extreme harshness of his religious practice, adopting a more moderate approach between the self-indulgence of princely life and the severity of ascetic isolation.

At this point, one night while sitting under a tree in meditation, Sakyamuni experienced an awakening, an experience that freed him from all worldly attachments and imbued him with supreme knowledge. In short, he attained nirvana or enlightenment, and thereby became the Buddha. With this realization, he set about teaching others the path to enlightenment and eventually attracted a large and enthusiastic retinue. Many of these followers took up a homeless life like Sakyamuni's — relying on alms for food and clothing, observing strict rules of celibacy and moral conduct, and practicing meditation and mental cultivation — but others became lay devotees and supported his following with gifts and hospitality. This combination of mendicant and lay adherents made up the core of Buddhism's early constituency. The Buddha himself died of natural causes at age eighty, but his followers continued to spread his teachings, making Buddhism a powerful religious movement in India.

The teachings of the Buddha, frequently referred to as the dharma, are predicated on the belief that all living beings are locked in a cycle of birth, death, and rebirth (*samsara*). This is a cycle of impermanence and suffering, since in each rebirth death is inevitable and pleasures are momentary and without substance. To the extent that people long for something to cling to, they become enmeshed in this world, attached to it. This attachment, as well as the ignorance from which it springs, is the motive force behind actions, or karma, that perpetuate one's rebirth in sentient form. To break out of this cycle, one must abandon all clinging and perceive the true nature of reality — that both the self and all things are without substance and are therefore unworthy of attachment. When this is done, liberation is achieved; no longer bound by this world or its cycle of rebirth, one attains enlightenment, nirvana.

Buddhist teachings prescribe certain practices conducive to enlightenment. The first is ethical action, which typically involves not killing any living being, not stealing, not indulging in illicit sexual relations, not lying, and not consuming intoxicants. Such action lessens the suffering in the world and counterbalances karmic tendencies that would lead one to unfortunate rebirths. The second

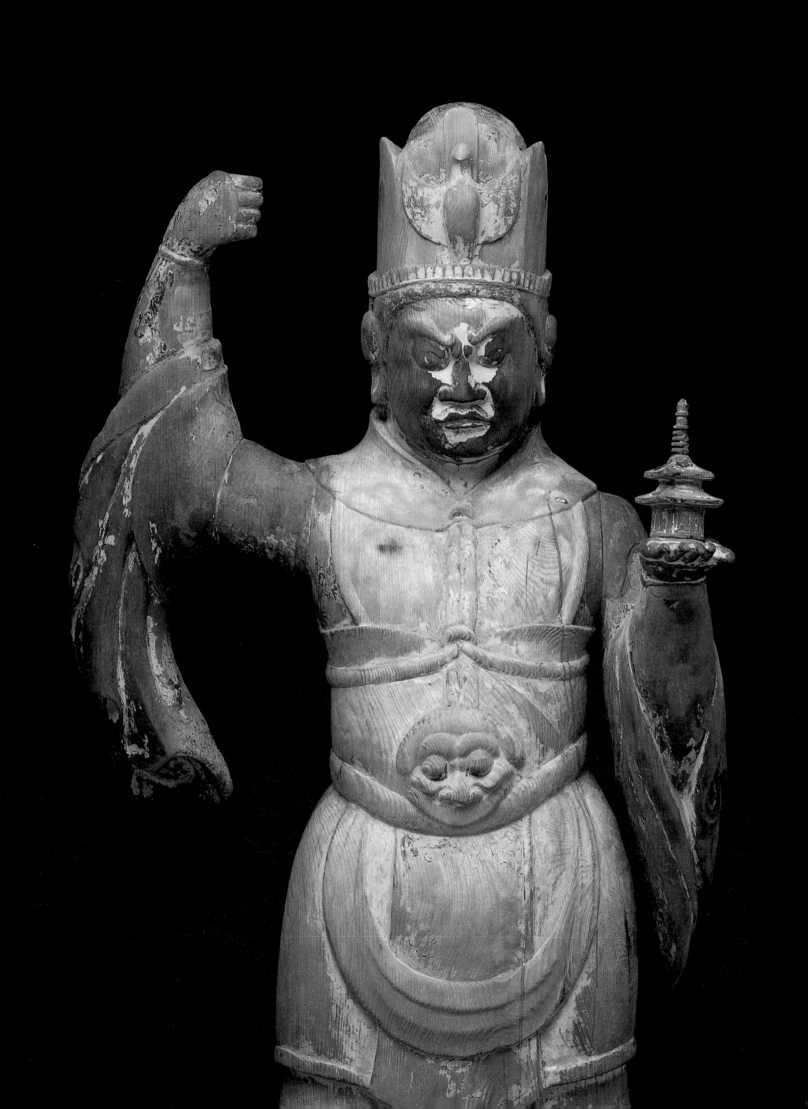

component is meditation, aimed at stilling the mind's incessant yearnings in order to clear it to perceive the nature of reality and the truth of the dharma. The third element is the cultivation of knowledge or wisdom. Ignorance is considered the root of attachment; when it is dispelled by wisdom, clinging also comes to an end. Wisdom is derived not only from correct meditation but also from the Buddha's teachings, preserved in the sutras or scriptures. These components form a religious path which became the backbone of the Buddhist tradition. From these elemental teachings Buddhism diversified in a number of directions.

One crucial event in the development of Buddhism was the rise of the Mahayana branch around the first century B.C. Mahayana, "the great vehicle," carries all living beings to enlightenment. Several factors led to its emergence. First, the Buddha came to be revered by believers. From the beginning, the Buddha was esteemed as a teacher, for the dharma he preached was considered the only hope for enlightenment. But he was also seen as an embodiment of that dharma, and thus became an object of veneration. Lay followers always worshipped the Buddha in this vein, and Mahayana clerical adherents came to do the same. Second, there emerged the sense that Sakyamuni is not the only repository of the dharma. Rather, Mahayana recognized a host of powerful, all-knowing, and compassionate Buddhas, consummate in wisdom, who lead sentient beings to enlightenment. Sakyamuni is the particular Buddha who brought the dharma into this world, but one can also receive it from many others.

Another prominent feature of Mahayana Buddhism is the bodhisattva, a word referring to someone on the path to becoming a Buddha. Previously it had described only Sakyamuni before his enlightenment. In Mahayana, however, Buddhahood was viewed as the goal to which all beings should aspire. Mahayana adherents claimed the bodhisattva path was more profound and more selfless than the so-called arhat or reclusive ideal of earlier Buddhism, which they denigrated as being "the lesser vehicle," Hinayana. The arhat achieves personal liberation by withdrawing from society and breaking all worldly ties. Mahayanists deplored the isolation of this path and advocated the essential compassionate values of the bodhisattva, as well as wisdom. Mahayana literature is filled with examples of bodhisattvas who vow not to accept enlightenment until all other sentient beings have done so. In religious art, they are frequently depicted with countless arms to aid suffering

beings. The great bodhisattvas that emerged in Mahayana afforded believers new objects of veneration and new paradigms of religious conduct.

In its fully developed form, Mahayana espoused a vast and varied pantheon deriving from multifarious sources. The most illustrious figures were, of course, the Buddhas and the bodhisattvas. In addition, innumerable heavenly deities and earthly spirits functioned as protectors, attendants, and messengers. Many were absorbed directly from Hindu mythology. Minor spirits such as Lamba and Vilamba (Japanese: Niramba, Biramba) acted as guardians of the faithful. More eminent deities such as the Four Heavenly Kings (or Four Directional Guardians, the Shitennō) commanded even greater powers. They oversaw the four cardinal directions from the summit of the mythical Mount Sumeru at the center of the world. Within the Mahayana pantheon, numerous figures were depicted with militant appearance and demeanor. Among the four, the northern deity Vaisravana (Bishamonten) became particularly popular as a patron deity of warriors. Their imagery supports the idea that many attachments and illusions are difficult to shatter and therefore require forceful means, such as are embodied in the warrior's character. Despite diversity of origin and nature, the Mahayana deities were united in the goal of bringing all sentient beings to enlightenment. They symbolized the variety of ways dharma works in the world to that end.

The Mahayana tradition in effect reversed several trends that had emerged in Buddhism up to that time. It countered the earlier pervasive conviction that the ascetic had spiritual advantage and gave lay believers more access to the ultimate goal of nirvana. The less eremitic bodhisattva path, emphasizing compassion, offered a place for both lay and clerical followers. Mahayana also generated a less dualistic view of the world, regarding nirvana not as a separate reality from *samsara*, but rather as an undistorted perception of a single reality. That is, nirvana and *samsara* are the same, though ignorance makes them seem different. Hence, nirvana became a transformed way of being in the world, rather than a flight from it.

Mahayana Buddhism eventually dominated East Asia. As a missionary religion, Buddhism spread from India via the trade routes extending from the South Asian subcontinent. About the first century A.D. it passed along the Silk Road of Central Asia into China, there to confront the Chinese with a religious world-view unimaginable in their own culture, which inspired both curiosity and perplexity.

Tobatsu Bishamonten (detail), late 10th century, wood, No. 12

The Chinese enjoyed an advanced civilization, with philosophical and religious traditions in Confucianism and Daoism. Buddhism had to come to terms with the this-worldly orientation of those traditions and with the pragmatic outlook of Chinese society. Mahayana generally lent itself to that way of thinking and hence became the form of Buddhism with widest appeal. Filial piety and respect for civil authority, propounded by Confucianism, and the idealization of the natural, emphasized in Daoism, gradually fused into Buddhism, giving it a Chinese flavor. Moreover, the coalescence of indigenous Chinese principles with Buddhist doctrine gave rise to new schools such as Tientai (Tendai), Huayan (Kegon), and Chan (Zen), forms without counterpart in India. This sinicized Buddhism gradually spread to countries in China's cultural sphere, such as Korea and Japan.

Buddhism arrived in Japan around the fifth or sixth century A.D., at first transmitted via the Korean peninsula but later, as contacts with China expanded, absorbed directly from the Chinese mainland. In Japan Buddhism commanded widespread interest, for it served as a vehicle for Chinese civilization. Japan was only just emerging from the shadows of its prehistoric period, so the cultural and technological advancements of China — writing system, imperial government, dynastic histories, literature, and of course religion — made an overwhelming impression on the Japanese. Some opposition to Buddhism arose in the beginning from a few powerful clans such as the Mononobe and the Nakatomi, the latter of which had sacerdotal functions in the indigenous Shinto tradition. They claimed that adoption of the foreign religion would anger the kami (Shinto native deities), thus causing epidemics and misfortune. The Soga clan, by contrast, avidly supported Buddhism and all the innovations brought in by immigrant Korean artisans. Moreover, the Soga clan was instrumental in introducing Buddhism into the imperial household. In 587 a political struggle broke out between the Soga on one side and the Mononobe and the Nakatomi on the other. With the triumph of the Soga, Buddhism and continental culture assumed a central place in Japanese society.

The person who, more than anyone else, assured the existence of Buddhism in Japan was Shōtoku Taishi (574–622), an imperial prince who had sided with the Soga and who championed Chinese culture during his thirty-year tenure as prince regent under empress Suiko (554–628). The life of Shōtoku is now so overlaid with legend that it is difficult today to separate fact from fiction.

Biographies from the ninth century onward depict him as a figure of consummate piety from infancy and as a bodhisattva born in Japan to establish Buddhism's message of salvation there. Apart from hagiographical embellishment, more substantial evidence suggests that Shōtoku had an intimate tie to Buddhism and was its staunch proponent. Specifically, three accomplishments are ascribed to him: 1) the composition of three commentaries on important Buddhist scriptures — the Lotus Sutra (Hoke-kyō), the Srimala Sutra (Shōman-gyō), and the Vimalakirti Sutra (Yuima-gyō); 2) the promulgation of a Seventeen Article Constitution, which enjoins people to revere Buddhism's "three treasures" (sanbō) — the Buddha, his dharma, and his religious order, known as the Sangha — and to uphold such Confucian principles as obedience to parents and ruler; and 3) the construction of the Hōryū-ji, one of the oldest surviving Buddhist temples in Japan. Despite some problems of attribution, long-standing tradition credits him with each. Whether or not Shōtoku was their agent, all three were products of the cultural climate he nurtured. Under his regency Japan sent envoys to China for the first time to study Buddhism; by the time he died, Japan had forty-six Buddhist temples and 1,345 ordained clergy. All this bespeaks the expansion of Buddhism in Japan under Shōtoku's leadership and gives substance to his legendary portrayal as the revered promulgator of Buddhism in Japan.

During its first three centuries in Japan, Buddhism spread as a religious institution, but it is unclear to what extent people understood its content. The earliest Buddhist temples were usually private establishments built by a clan for the protection and prosperity of its members — for example, the Asukadera of the Soga clan — or they were constructed for concrete benefits such as ending drought, achieving military success, curing illness, or pacifying the spirits of the dead — for example, the Shitennō-ji, allegedly built by Shōtoku Taishi in gratitude to Buddhism's Four Directional Guardians for the Soga victory over the Mononobe. Such uses of Buddhist temples suggest that Buddhist deities were propitiated much as were the Shinto kami, who could assist one in the needs of this life and the next. This approach to Buddhism fit compatibly with the vast pantheon and the compassionate values of Mahayana, but it overlooked much of the soteriological framework of Buddhism. One of the few indications of deeper understanding during this early period is a saying attributed to Shōtoku Taishi on his deathbed: "The world is illusory; only the Buddha is real." This statement, whether from the

The Infant Shōtoku Taishi, c. 1300, wood, No. 15

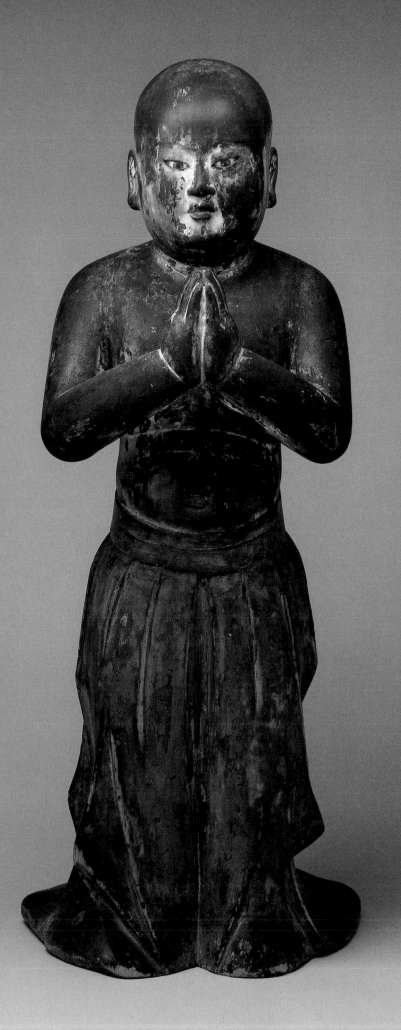

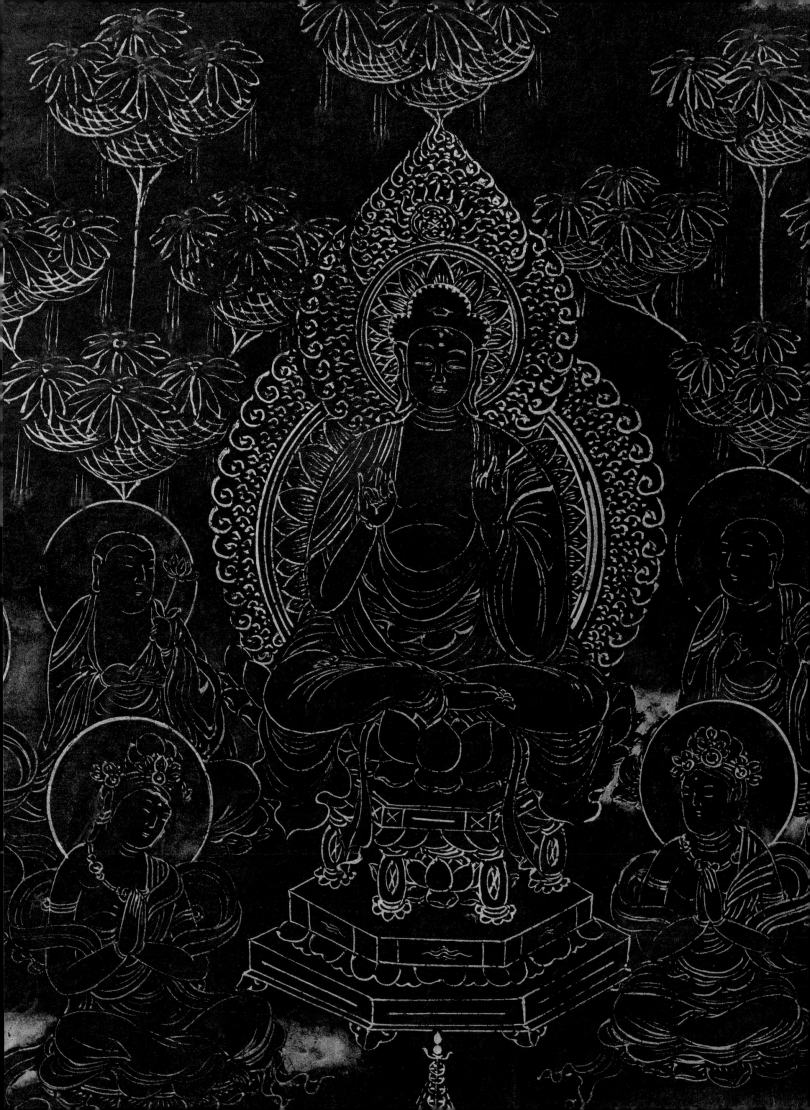

lips of Shōtoku or someone else, demonstrates that by the seventh century, the other-worldly outlook of Buddhism had penetrated some religious circles and certainly informed the belief of the many Japanese priests returning from China. No doubt their influence eventually fostered a profounder understanding of Buddhism in Japan. Nevertheless, "concrete benefits in this world" remained a dominant motif throughout the Nara period (710–794) and to a lesser extent throughout Japanese history.

The relationship between Shinto and Buddhism was largely one of accommodation and toleration, although the clash between the Soga clan and the Mononobe-Nakatomi faction is often interpreted, perhaps too simply, in terms of tension between Buddhism and Shinto. But such animosity dissipated quickly. By the mid-seventh century the Nakatomi clan itself, later known as Fujiwara, embraced Buddhism and built a Buddhist temple for the clan, the Kōfuku-ji, which it later relocated in Nara next to its tutelary Shinto shrine, Kasuga Jinja. From that period Buddhism and Shinto coexisted and even coalesced, right up until the rise of Shinto nationalism in early modern times. Shinto lacked Buddhism's well-developed scriptures and doctrines, so in that sense could not compete with its sophistication. Nonetheless, Mahayana Buddhism had always accommodated the native beliefs and deities of the cultures it transversed. Hence, it did not repudiate Shinto, but rather acknowledged Shinto kami to be efficacious spirits in assisting humans to the Buddhist goal of enlightenment. Harmony between the two therefore grew out of the incorporation of Shinto into Buddhism's religious scheme.

Buddhism's development in Japan is typically divided into three stages corresponding to three periods in Japanese history: Nara (710–794), Heian (794–1185), and Kamakura (1185–1333). Each stage represents a step toward Buddhism's assimilation and adaptation to Japanese sensibilities. Nara Buddhism was little more than a transplantation of Chinese forms to Japan. Heian Buddhism was also imported from China, but its doctrines were blended in new ways that distinguished them from their counterparts in China. Kamakura Buddhism took its inspiration from scriptures and practices received from China, but the religious conclusions derived from them differed significantly from China's and thereby generated a uniquely Japanese Buddhism. These three stages also trace the popularization of Buddhism, as it moved gradually from an elite few to the masses. Nara Buddhism was, for all intents and purposes, a state religion regulated and supported by the imperial government for the benefit

of the ruling class. Heian Buddhism likewise enjoyed state patronage, but it sought independence from government oversight. Its teachings struck a resonant chord primarily in the aristocratic and gentry classes. Kamakura Buddhism arose outside the pale of government support, and at first was considered heretical by both government and religious authorities. Its simplified forms of belief and practice appealed to all levels of society but found their most enthusiastic following among the lower classes. Within these three stages of development, a multiplicity of doctrines and a diversity of schools came into existence.

Nara Buddhism comprised six schools, which all originated in India and China: Kusha, Jōjitsu, Hossō, Sanron, Kegon, and Ritsu. Transmitted to Japan by Japanese priests who had studied in China, or by Chinese priests who came to Japan to spread the dharma, these six were not independent sectarian organizations so much as separate philosophies of Buddhism, nor were they competitors. Rather, the six Nara schools mirrored classical Buddhology as it had developed in India and China. Abstruse in doctrine, they thus had little popular appeal. Nonetheless, their existence demonstrates that an erudite core of Japanese clergy gained an accurate understanding of the philosophical intricacies of Buddhism, and in subsequent periods the six stood as a repository of Buddhist learning to which later schools would refer.

The Buddhism of lay adherents during the Nara period was a religion aimed at "concrete benefits in this world." Hence, devotion and patronage in Buddhism were seen as merit-generating mechanisms. Pious deeds included support of the clergy, commissioning the creation of Buddhist icons, constructing temples, copying sutras, and a vast array of simple reverential acts. The rewards sought through these actions might be recovery from sickness, transfer of religious merit to deceased relatives, or "protection of the nation." During the Nara period the most celebrated acts of piety were the casting of the great Buddha image at the Tōdai-ji and the creation of the Kokubun-ji system of state-supported temples in the provinces. Both were initiated by emperor Shōmu (r. 724–749) and the Nara government as supplication for peace and security throughout the nation. They are examples of how the government attemped to control Buddhism and to benefit from its spiritual powers. At the same time, it sought to deny the common people access to those powers. Despite these efforts, Buddhism began to reach the masses through the activities of itinerant holy men, of whom the most renowned was the priest Gyōki (668–748). He received his

Shaka Giving Sermon (detail), late 12th century, ink on paper, No. 30

early training at Nara's large temples, but later withdrew from them to preach in the countryside. Gyōki combined his teachings with public works projects — constructing roads, bridges, irrigation systems, wells, and so forth. Hence, concrete benefits were strongly associated with Buddhism even at the popular level. If there was one element in Buddhism that the Japanese understood accurately in the Nara period, it was the principle of karma — that virtuous action leads to felicitous results and reprehensible action to unfortunate consequences. Only in the following period, however, did Buddhism's more sublime goals penetrate the popular mind.

The Heian period (794–1185) marked the emergence of two more schools of Buddhism, Tendai and Shingon, and the blossoming of a more sophisticated religious consciousness incorporating Buddhism's transcendental goals. Both Tendai and Shingon were imports from China, like the six Nara schools, but once in Japan they quickly moved beyond the presuppositions laid down by the Chinese. Hence, they exemplify the gradual personalizing of Chinese models, which occurred in many sectors of Japanese society. The emergence of Tendai and Shingon coincided with a broader dissemination of Buddhist ideas among the populace, so that the two schools provided a context for the appearance of various religious movements among clerical and lay followers alike. From the beginning of the Heian period, Buddhist themes so pervaded the Japanese world-view that Buddhism became the dominant religion of Japan, absorbing even Shinto, and it so continued into modern times.

The person responsible for transplanting the Tendai school from China to Japan was Saichō (767–822), known posthumously as Dengyō Daishi. From its beginnings in China, Tendai stressed the teachings of the Lotus Sutra, especially the idea that all sentient beings are destined for enlightenment, and that the Buddha is eternally at work leading them to that end. The practices emphasized in Tendai include monastic discipline, study, and above all meditation, through which one can comprehend that "the three-thousand worlds are encompassed in a single thought" — in short, that all things are interrelated, and that nirvana is immanent in *samsara*. In Japan, Saichō sought to distance Tendai from the influence of Nara Buddhism by making it exclusively Mahayana. He adopted the so-called bodhisattva precepts as the sole vows for ordaining Tendai priests, in place of the Hinayana precepts used in the Nara schools. This was a monumental step in the history of

Buddhism, for it was the first time that the ordination precepts had been set aside in favor of the more lay-oriented bodhisattva vows. Saichō also altered Tendai by integrating esoteric teachings (*mikkyō*) into it. These were the beliefs and practices of the Shingon school, founded at the same time as Saichō's Tendai, which he expropriated for use in his school. Both the bodhisattva precepts and esoteric teachings had origins in India and China, but Saichō's incorporation of them into Tendai was uniquely Japanese.

In establishing his school, Saichō selected Mount Hiei to the northeast of Japan's new imperial capital Kyoto, created in 794, as his base. There he founded the Enryaku-ji, the head temple of the school. Though Saichō sought to liberate Tendai from the government strictures imposed on the Nara schools, he accepted the principle that Buddhism should serve to protect and uphold the state. He organized a twelve-year program of religious training for all monks at Mount Hiei, upon completion of which the most distinguished would remain there to become Tendai's leaders, and the others would be sent to the provinces to serve as Buddhism's teachers and functionaries. Saichō's vision was to make Buddhism the pillar of the nation. In his wake the transformative and liberating goals of Buddhism, neglected earlier, became as much a concern of adherents as its worldly benefits. Because of Mount Hiei's proximity to Kyoto, it gradually attracted the interest and involvement of the aristocracy and emerged as a center for their religious pursuits.

Shingon, which arose alongside Tendai in the Heian period, exerted an equally strong influence on the content and development of Japanese Buddhism. Kūkai (774–835), known posthumously as Kōbō Daishi, transmitted Shingon from China shortly after Saichō brought Tendai. The two were close friends for a short period, and many of the esoteric teachings and practices that Saichō adopted for Tendai he learned from Kūkai. Shingon is predicated on the idea that there is a transcendent and all-embracing Buddha named Dainichi (Sanskrit: Mahavairocana). All other Buddhas and bodhisattvas are transformations of Dainichi, and all realities — sentient beings, objects, and nature — are emanations from him. Hence, it is possible for a person to "attain Buddhahood in this very body" when the immanence of Dainichi is realized. Shingon advocated three forms of religious practice aimed at achieving this realization. The first is ritual movements of the hands called mudra (*ingei*). The second is secret incantations known as mantra and

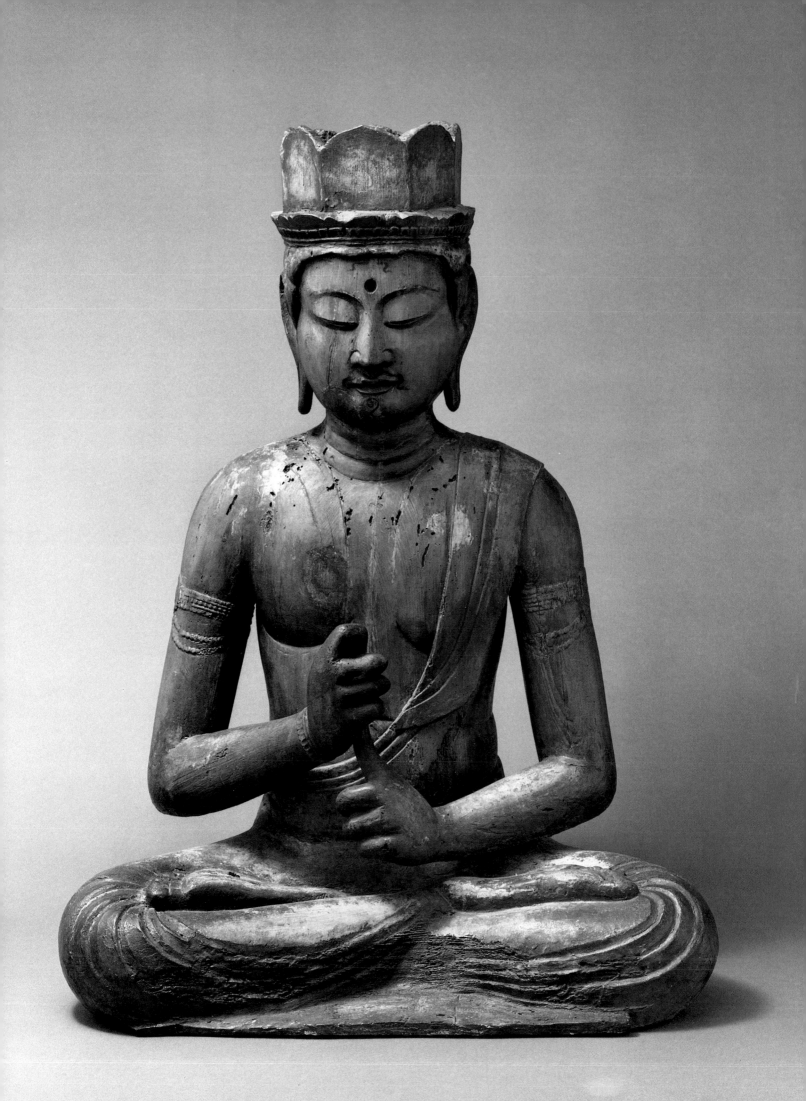

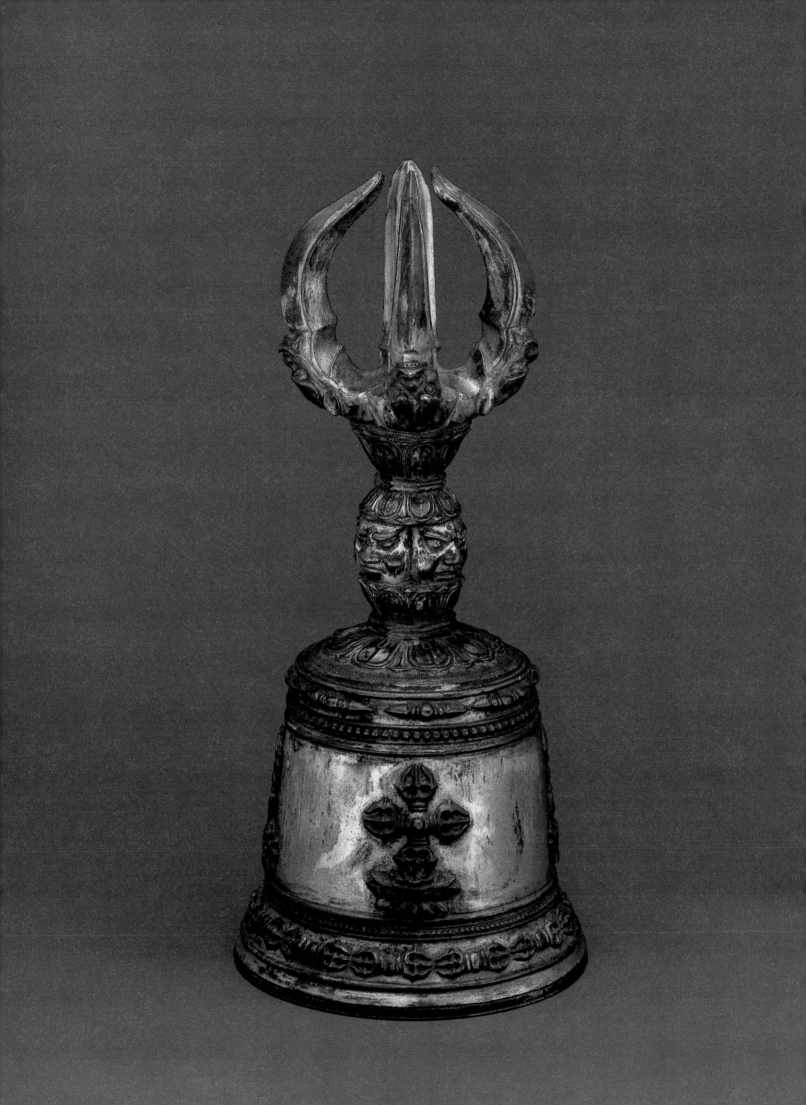

dharani (*shingon*). The third is meditation on two mandalas (*mandara*) — namely, the Diamond Mandala (Kongōkai) and the Womb Mandala (Taizōkai) — graphic representations of Dainichi's extension throughout the universe and his transformation into multifarious deities and forms. These three practices are regarded as Dainichi's actions, sounds, and thoughts emanating through the believer. Because Shingon treated these teachings as sublime and secret, to be imparted only to the ritually initiated, they were called esoteric teachings (*mikkyō*) in contrast to Buddhism's openly propounded or exoteric teachings (*kengyō*). The concepts and practices of Shingon were couched in an elaborate system of ritual that made a strong impression on the Japanese of Kūkai's day. Various implements used in conjunction with mudra were required in ritual, such as single-pronged, three-pronged, and five-pronged vajra, instruments styled after weapons of ancient India and used ritually to shatter the illusions. The sophistication of Shingon ritual gave it special prestige and appeal; through Kūkai's skill and sagacity it became the form of ritual performed at major temples in Nara such as the Tōdai-ji and at the imperial court. Kūkai and the Shingon school itself were granted an imperial temple in Kyoto, the Tō-ji, and later a monastic retreat on Mount Kōya as its institutional centers.

Subsequent developments in Tendai and Shingon arose partly from paradigms set down by Saichō and Kūkai and partly from historical exigencies and personal inclinations of believers. Tendai, for instance, generated an elaborate scheme of esoteric beliefs, practices, and ritual not simply by emulating Shingon but by importing esoteric Buddhism directly from China. Ennin (794–864) and Enchin (814–891) were pivotal figures in this enterprise, creating a Tendai esoteric form, Taimitsu, which easily rivaled its Shingon counterpart, Tōmitsu. Because of the extensive pantheon recognized in esoteric Buddhism, both forms lent themselves to Shinto-Buddhist syncretism, interpreting the kami as protective deities or as manifestations of the Buddhas and bodhisattvas. Esoteric teachings in Tendai and Shingon became the basis for a sophisticated system of initiations for clerics, involving extended training and ascetic practices. Besides this rigorous program of clerical discipline, various devotional movements also emerged, which attracted the participation of both ordained and lay persons. Among them, those focusing on the Buddha Amida and his transcendent realm known as Pure Land were particularly widespread. Religious societies such as the Kangakue or the Nijūgo

Zammaie, which arose in the mid-Heian period, met regularly to chant Amida's name, to recite Pure Land scripture, and to visualize Amida and his Pure Land in meditation. These practices, as well as a Pure Land deathbed ritual, spread throughout aristocratic society via a religious handbook entitled *Ōjōyōshū* (A Collection of Essentials for Birth in Pure Land), written by the Tendai priest Genshin (942–1017). In addition to these devotions, recitation of passages from the Lotus Sutra, participation in religious retreats, and clerical ordination upon retirement from worldly affairs were all ways in which aristocratic believers involved themselves in Buddhism during the Heian period. These activities reflect a concern for one's fate in the next life and an aspiration for Buddhist enlightenment, far more so than the mechanistic acts of piety found in the Nara period.

By the beginning of the Kamakura period (1185–1333) Tendai, Shingon, and the six Nara schools were commonly recognized as the orthodox Buddhist institutions in Japan and were frequently referred to as "the eight schools" (*hasshū*). Kamakura Buddhism — specifically Pure Land, Zen, and Nichiren Buddhism — arose in reaction to them. In fact, most of the founders of the Kamakura schools received training on Mount Hiei at one time or another, but eventually left to pursue their own religious concerns. The orthodox schools tended to be syncretic and inclusive; that is, they wove a vast number of religious practices into a complex and comprehensive soteriological system. There was room in it for virtually any type of religious path, though the strenuous clerical ones were generally considered more efficacious. The Kamakura schools, by contrast, were exclusive in that each advocated its own specific religious practice and renounced all others. For Pure Land it was the *nembutsu*, invoking the name of Amida Buddha. For Zen it was sitting in meditation. For Nichiren it was chanting the title of the Lotus Sutra. These practices were considered uncomplicated, available to anyone, and therefore universally applicable. Moreover, Pure Land and Nichiren proclaimed their respective practices to be the only hope of salvation in the present age, since they considered the world to be in a period of *mappō*, or eclipse of dharma, when all other practices are devoid of potency. The Kamakura schools alienated themselves from the Buddhist establishment, provoking charges of heresy against them. Nonetheless, the simplicity of their teachings and the accessibility of their practices gave them widespread appeal among the common people and eventually enabled them

Bell, 14th century, bronze, No. 16

to outstrip the older schools. The forms of belief and practice they produced represent the full adaptation of Buddhism to the Japanese context.

Pure Land Buddhism appeared in Japan during the mid-Heian period, but it first emerged as an independent school under Hōnen (1133–1212) in the Kamakura period. Pure Land is based on the idea that in this day and age it is no longer possible to perfect oneself through traditional Buddhist practices or to achieve enlightenment amid the proliferating corruptions of this world. One should instead aspire to birth in the next life in Amida's Pure Land, a transcendent realm created from Amida's wisdom and compassion, where all conditions are conducive to enlightenment. Pure Land Buddhism thus reoriented religious thinking from personal exertion to reliance on Amida Buddha. According to the Pure Land scriptures, Amida has not only established a realm where enlightenment can occur quickly and easily, but has also defined specific practices humans are capable of performing, which will assure birth in Pure Land. During the Heian period the practice of meditating on Amida and his Pure Land was regarded as foremost, but Hōnen shifted the focus to the *nembutsu* — that is, invoking Amida's name in the form *Namu Amida Butsu*, "I take refuge in the Buddha Amida." Hōnen considered the *nembutsu* sufficient to deliver anyone into the Pure Land, despite one's shortcomings. He dubbed the practice the "exclusive *nembutsu*" because it is to be embraced over all other practices for its superior power. Hōnen's preaching of *nembutsu* chanting gave impetus to a vibrant Pure Land movement at the beginning of the Kamakura period. The simplicity of the *nembutsu* and the assurance it offers of birth in Pure Land, even for the lowly, attracted countless believers who otherwise held little hope for enlightenment through conventional practices. As the movement burgeoned, a formal Pure Land school known as the Jōdoshū coalesced around Hōnen, and several ancillary schools emerged as well from other Pure Land proponents.

The most successful Pure Land schools to arise in addition to Hōnen's were the Shinshū established by Shinran (1173–1262) and the Jishū founded by Ippen (1239–1289). Both were influenced by Hōnen's teachings, but carried his ideas one step further. Shinran, a direct disciple of Hōnen, considered the efficacy of the *nembutsu* to lie not in the chanting of it but in the state of mind existing behind it — specifically, a mind of faith. Faith means for a person to realize that none of his own actions or beliefs earn him birth in Pure Land. Rather, everything making it possible to be born there —

including the *nembutsu* and faith — is bestowed on him by Amida. Hence, Shinran's concept of faith represents a reinterpretation of the ancient Buddhist principle of no-self. It is the abandonment of self to Amida's power without any pretense that personal effort wins salvation. This religious outlook prompted Shinran to forsake his clerical vows, to marry, and to beget a family, since he regarded clerical celibacy and discipline as an attempt to secure enlightenment through individual assertion. Shinran's example paved the way for marriage of clergy in the Shinshū, an epochal departure from established Buddhist custom. The marriage of clergy spread in later centuries to other schools, thereby giving Japanese Buddhism a character totally different from that of other countries.

Ippen, like Shinran, was an exponent of Pure Land Buddhism, but he presented a rather different view of the *nembutsu*. Ippen believed that the potency of the *nembutsu* is inherent in the thing itself, rather than in faith underlying it. That is, the *nembutsu* is a sublime and mysterious practice created by Amida to bridge the gulf between the Buddha and the believer. In uttering it, a bond is formed that unites the two inseparably. Because of its special power, Ippen invested all of his energies in propagating the *nembutsu* throughout Japan. Wherever he went he urged people to chant it, and he distributed amulets inscribed with it to them. Moreover, he combined *nembutsu* chanting with ecstatic dancing and thereby merged it with popular folk practices. Ippen's activities disseminated the *nembutsu* more widely than ever before. The straightforwardness of the practice he championed and the simplicity of salvation by faith as taught by Shinran eventually attracted a vast number of lowborn believers into their respective schools, the Jishū and the Shinshū.

Zen, the second form of Buddhism popularized in the Kamakura period, advocated one specific form of religious practice just as Pure Land did, but differed considerably in tenor and outlook. Zen stressed most the practice of meditation, and the context in which meditation could best be pursued was the monastery, with all its clerical rigors. Zen considered enlightenment or Buddhahood to exist primordially in all sentient beings, though they do not realize it so long as they look at the world through the filter of attachments and conceptualizations. To suspend them is to bring all distortion of the world to an end and to allow all things — including one's own inherent enlightenment — to be as they truly are. Meditation is the most sublime form in which that state occurs. Zen's idealization of meditation and the monastic routine it

entails were, in short, the antithesis of the devotionalism fostered by Pure Land teachings.

The two founders of Zen in Japan were Eisai (1141–1215) of the Rinzai school and Dōgen (1200–1253) of the Sōtō school. Both studied in China and brought back to Japan the forms of Zen they encountered there. In addition, scores of Chinese Zen masters immigrated to Japan and likewise left their mark on Japanese Zen. In this respect Zen drew its paradigm from China more than did the other schools of Kamakura Buddhism. Zen, like Pure Land, was suppressed at first because Mount Hiei and the rest of the Buddhist establishment considered it a religious deviation. It survived as a result of the sponsorship of the *bakufu*, or military government, which arose alongside the imperial government at the end of the twelfth century. *Bakufu* support led to the construction of numerous Zen monasteries in Kamakura and Kyoto, and these became the backbone of the Rinzai school. The close ties between the school and the government are one way that Rinzai differed from most other forms of Kamakura Buddhism. Under *bakufu* patronage Rinzai emerged not only as a religious focal point for the samurai rulers, but also as an arbiter of the fine arts in Japan. Ink painting, calligraphy, landscape gardening, tea ceremony, and other pursuits became ancillary disciplines in the prominent Rinzai monasteries known as the Gozan, or "Five Mountains." Though this artistic dimension is often taken as Rinzai's dominant persona in the medieval period, meditation and monastic rigors provided the backdrop for those activities. Eminent Rinzai masters of the period—Daikaku (1213–1279), Daitō (1282–1337), Musō (1275–1351), Ikkyū (1384–1481), and others—were known as much for their stringent meditative practices as for their artistic accomplishments.

In contrast to Rinzai, Dōgen's Sōtō school was less given to artistic concerns and concentrated instead on monastic training and meditation. Dōgen sought to avoid the political intimacies that bound Rinzai to the ruling class; for that reason he built his monastery, the Eihei-ji, far away from the capital in a mountainous area near the Japan Sea. Rinzai was innovative in its integration of Japanese arts into Zen, but Sōtō's innovation lay in the concept of meditation that Dōgen formulated. He interpreted meditation not as a tool to achieve enlightenment but rather as enlightenment itself in its most pristine state. Hence Dōgen urged his disciples to "Just sit!" for he considered the practice of meditation and the confirmation of enlightenment to be one and the same. This identification of meditation and

enlightenment was implicit in the Chinese Zen classic the Platform Sutra (Hōbō dangyō), but Dōgen articulated it explicitly, thereby going against the traditional means-end dichotomy that earlier Buddhism had used to differentiate meditation and enlightenment. Meditation thus became the core of Sōtō monastic discipline, though other actions in the monastery — eating, sleeping, working, and so on — were to be performed with the same immediacy and absence of intent found in meditation. In this sense they, too, are meditative acts embodying enlightenment. This idealization of meditation presented in Dōgen's teachings is exemplary of the central place meditation occupied in the entire Zen tradition.

The other Kamakura school, Nichiren Buddhism, was less monastic than Zen, and in that respect it resembled the Pure Land schools. Nichiren (1222–1282), its founder, was one of the most colorful and cantankerous figures in Japanese history. The heart of his teachings was the Lotus Sutra, which he regarded not only as the quintessential truth of Buddhism but also as the wellspring of spiritual and worldly power sustaining the believer. Nichiren looked upon the Lotus Sutra as the only efficacious teaching in the corrupt age of *mappō*. He considered himself to be the individual ordained to bring that message to the world and Japan to be the country where its truth would be established. Hence, there was a sense of personal destiny and an element of Japanese nationalism in his teachings, which had no prominence in the other Kamakura schools. The religious practice that Nichiren enjoined his followers to perform was chanting the title of the Lotus Sutra in the form *Namu Myōhō Renge Kyō*, "I take refuge in the Lotus Sutra." Nichiren believed that within this simple invocation are concentrated all the power and truth of the Lotus Sutra, as well as Buddhahood itself. Chanting it unites one with that truth and makes it manifest in the world. Nichiren also created a symbolic representation of it, much like a mandala, with the words *Namu Myōhō Renge Kyō* written down the center; it became the central object of worship in the Nichiren school. In propagating his teachings Nichiren was audacious and often acerbic. He castigated as heretical all other forms of Buddhism except Tendai, of which he considered his own ideas the culmination, and called upon the Kamakura *bakufu* either to embrace the Lotus Sutra's teachings exclusively or risk invoking disaster on the country. For his boldness Nichiren was twice exiled. Nevertheless, his fearlessness and determination on the one hand and his gentleness toward adherents of the Lotus Sutra on the other made a strong

impression on a core of followers, who eventually carried Nichiren's ideas and his practice of chanting the Lotus Sutra title to various parts of the country.

These new forms of Buddhism all came into existence in the Kamakura period, but the Muromachi period (1336–1573) witnessed their diffusion throughout the country. During this time the Kamakura schools outstripped Tendai, Shingon, and Nara Buddhism in number of converts. The established eight schools were at first belligerent toward the new Kamakura teachings and attacked them as aberrant and heretical, but by the fifteenth or sixteenth century they had little choice but to coexist, since the new schools drew prodigious followings throughout Japan. The Kamakura schools constituted a revolution in Buddhism, both in doctrine and in dissemination. They penetrated all levels of society and all regions of the country. Kamakura Buddhism succeeded not only because the beliefs and practices advocated by its founders were accessible to most believers, but also because each of the schools produced astute and effective leaders who knew how to organize a sectarian movement and how to popularize its teachings. The pervasive impact of Kamakura Buddhism is reflected in the fact that from the Edo period (1615–1868) the vast majority of Japanese claimed affiliation to one or another of its schools. Traditionally it has been said that Zen appealed to the samurai class, Pure Land to the peasant class, and Nichiren to the merchant class, but history does not fully corroborate that kind of stereotyping. Perhaps Rinzai is the only school with an unambiguous social identity, attracting samurai and aristocratic adherents in particular, but the others in fact seemed to cut across social strata, drawing members from all classes.

Depending on the period and the sectarian tradition, there was considerable variation in what it meant to be either a cleric or a lay Buddhist. Beginning in the Nara period, to be a priest or nun required taking religious vows, shaving the head, donning clerical robes, remaining celibate, and devoting oneself exclusively to religious pursuits. The ordination vows used at first were those from the Hinayana Vinaya, comprising 250 precepts for priests and 348 for nuns. With the founding of the Tendai school, Saichō substituted the bodhisattva vows, containing ten major and forty-eight minor precepts. The particular vows that one took made a difference in the concept of one's religious life — that is, whether it is patterned on the arhat or the bodhisattva ideal — but in practice the clerical activities of the Hinayana vows might not diverge

substantially from those of the bodhisattva vows. Both demanded celibacy, studying the scriptures, practicing meditation, performing ceremonies and rituals, and perhaps serving society. Consequently, it was not unusual in later centuries for priests to take both sets of vows at some point in their careers. In addition to fully ordained priests, there also emerged a class of unordained clerics who had taken only the preliminary steps of tonsure and novice vows. Although they seldom rose to high rank in major temples, they were instrumental in spreading Buddhism to the common people, for they frequently lived an itinerant life and preached wherever they wandered. Gyōki of the Nara period was the archetype of this so-called *hijiri* or "wandering holy man" ideal. The *hijiri* example of selflessness made a strong impression on several Kamakura founders — specifically, Shinran, Ippen, and Nichiren — who shaped their own religious activities around it. Hence, the role of the clergy was recast somewhat in several of the Kamakura schools. It was patterned as much on the wandering Buddhist preacher as on the formally ordained priest.

From the time Buddhism first arrived in Japan, countless people were attracted to its rituals, practices, and teachings, but the majority of them never took the monumental step of receiving clerical ordination. Remaining lay devotees of Buddhism, they promoted its goals through offerings and participation in religious activities. The image of the lay adherent, which prevailed up through the twelfth century, was that of the pious patron who supported the clergy and who benefitted from the encounter with Buddhism's truths but who had little hope of achieving immediate enlightenment, as the clergy did. In the Heian period this view motivated many lay believers to embrace the Pure Land teachings or to undergo clerical ordination in old age. Zen by and large perpetuated the superior status of the clergy, but the other Kamakura schools reversed this trend, maintaining that the lay person has equal access to salvation. Shinran took the most forthright stand in this regard, describing himself as "neither priest nor layman" and thereby repudiating the dichotomy. Despite his boldness, the distinction between clergy and laity did not disappear even in the Shinshū. But the Pure Land and Nichiren schools, with their promise of salvation for the ordinary believer, did much to lessen the gap between them.

The basic religious institution common to all brands of Buddhism was the *tera*, or temple. Over the course of Japanese history the temple appeared

Scenes from the Life of Gensei Shōnin (detail), c. 1360, ink and color on silk, No. 33

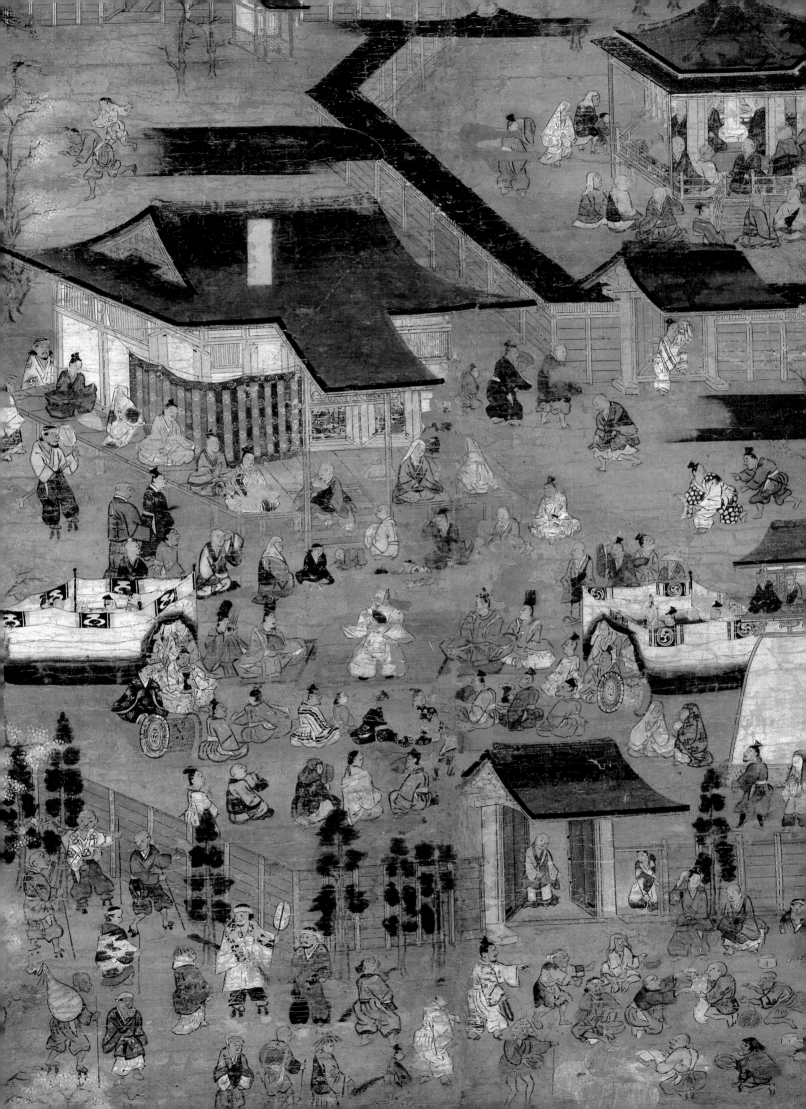

in a variety of forms and fulfilled a multiplicity of functions. The earliest were clan temples of the sixth and seventh centuries, built for the protection and good fortune of clan members. Such private temples continued to exist in later periods, though in different guises, the *bodai-ji*, or "enlightenment temples," established by powerful daimyo in the Edo period, are later examples. Public temples, by contrast, were erected for the good of all. Their financial support may have come from government or private sources, but their raison d'etre was to benefit society at large. The Tōdai-ji in Nara and the Tendai complex on Mount Hiei are examples of public temples. Whether private or public, temples traditionally shared a common architectural layout. At its core was a worship hall in which an image of the Buddha was enshrined, a lecture hall where teaching and ceremonies were conducted, and a pagoda commemorating and symbolizing the Buddha; other structures might vary from one temple to another. Lay adherents showed piety by supporting temple construction and the creation of icons, and derived religious merit from their beneficence. To the extent that temples were where the clergy went about its religious pursuits, they also displayed monastic features. Many had priests' quarters and a refectory, and in the Zen school a meditation hall was added.

As in other spheres of religion, temples underwent a transformation with the rise of Kamakura Buddhism. One conspicuous change was that *mieidō*, or "likeness halls," came to prominence — chapels where the school's founder was venerated and his likeness enshrined. The tremendous reverence shown to Hōnen, Shinran, and Nichiren resulted in the construction of huge *mieidō* in the major Pure Land and Nichiren temples, which dwarfed all other buildings. An even more profound change was the proliferation of *dōjō*, or congregational meeting places, in the various Pure Land schools. *Dōjō* were simple sanctuaries set up in private homes where Pure Land adherents would meet for *nembutsu* chanting and worship. In them the central object of worship was a wall-hanging inscription of the *nembutsu* rather than an artistic image of the Buddha, as in temples. *Dōjō* were in many ways a reaction against the formal Buddhist temple. They served the needs of the lay believer instead of the clergy, and they utilized simple religious objects instead of ornate icons and ritual implements. Though many *dōjō* adopted the appearance of Buddhist temples once Japan entered the Edo period, for the four centuries prior to that they stood as Pure Land Buddhism's institutional answer to the temple.

The Edo period (1615–1868) was at once a time of Buddhist efflorescence and Buddhist decline. During that period the religion attained complete diffusion throughout the country so that nearly every town and village had a Buddhist temple. Membership rolls swelled because the *bakufu* ordered all Japanese to belong to Buddhist temples as part of the government's program to crush Christianity. Moreover, Buddhist learning flourished as a result of government encouragement, rising literacy rates, and the dissemination of the written word through woodblock printing. In short, Buddhism enjoyed a period of stability and economic security unprecedented in earlier times. Nonetheless, forces were at work both within and without that would lead Buddhism to decline as well. First, the security of the times and the inflated temple membership lulled many priests into complacency, and Buddhism as a whole suffered from a decrease in morale and imagination among its clergy. Second, the government placed considerable strictures on Buddhism, as it did on all segments of society, in an attempt to consolidate its control, and furthermore banned all new and unorthodox doctrines for fear they would foment social unrest. This ban stifled religious creativity and undermined the vitality of doctrinal interpretation. In addition, there emerged in the Edo period Buddhism's first intellectual rivals in a millennium. None penetrated the popular consciousness to the extent that Buddhism had, but they challenged Buddhism in elite society and before the political authorities. The first of these rivals was Neo-Confucianism (Jugaku), which accused Buddhist priests of being unproductive and parasitic members of society. The second was Restoration Shinto (Fukko Shintō) which lamented Shinto's long-standing subservience to Buddhism and sought to liberate it and revive it as Japan's true religious tradition. The third was Western Learning (Yōgaku), which called into question Buddhist cosmology and presented European geography and astronomy in its place. All of these undermined the credibility of Buddhism and diminished the influence it exerted on Japanese society.

At the end of the Edo period, Buddhism's fate was very much tied to that of the *bakufu*. Buddhist temples had received government support and had even functioned as its population registry system through temple membership rolls. With the fall of the *bakufu*, Buddhism was cast in the unbecoming role of ally to an outdated regime. Shinto, by contrast, was seen as the movement of the day and as the religion of enlightened patriots. Consequently, in the name of purifying Shinto of syncretic Buddhist elements, Buddhism underwent the harshest

suppression of its fourteen-hundred-year history in Japan during the first four years of the Meiji period (1868–1912). Temples were dismantled, Buddhist images destroyed, properties confiscated, clergy defrocked or exiled, and ties between temples and their members severed. In short, Buddhism lost much of the wealth, political influence, and intellectual sway that it had enjoyed through most of its history.

Buddhism today continues as the largest religious tradition in Japan's predominantly secularized society. Its impact, however, should be measured not simply in terms of temples and adherents, but rather in the melding of its tenets into the popular consciousness. Buddhist ideas inform the way the Japanese look at the world philosophically, psychologically, and esthetically. There is, for example, no emotion that moves the Japanese more profoundly than the Buddhist sense of impermanence. It issues forth in moments of sadness such as funerals, and in times of delight such as the enjoyment of nature. Impermanence in fact underlies the traditional notion of beauty. When the Japanese speak of beauty in terms of *wabi*, melancholy, and *sabi*, decay, they link it directly to the transience of all things. An object that lasts forever has far less esthetic appeal than something fragile and short-lived. Impermanence in that sense makes it possible for beauty to exist. This intimate tie drawn in the Japanese mind between impermanence and beauty reflects in a prosaic way the Mahayana truth that nirvana is inseparable from *samsara*. That is, the pristine state of beauty cannot be found outside the sadness and evanescence of the world. Only this flawed world gives palpability to beauty's timelessness. The seed of Buddhism sown in Japan has allowed such esthetic reflections to blossom.

BIBLIOGRAPHICAL NOTE

JAPANESE BUDDHISM: Ichirō Hori, "On the Concept of the Hijiri," *Numen* 5 (1958); Joseph M. Kitagawa, *Religion in Japanese History*, New York 1966; Saburō Ienaga, Toshihide Akamatsu, and Taijō Tamamuro, eds., *Nihon Bukkyoshi* 3 vols., Kyoto 1967; Mitsusada Inoue, *Nihon kodai no kokka to Bukkyō*, Tokyo 1971; Yoshito S. Hakeda, *Kūkai: Major Works*, New York 1972; Stanley Weinstein, "The Concept of Reformation in Japanese Buddhism," in *Studies in Japanese Culture*, Tokyo 1973; Daigan and Alicia Matsunaga, *Foundation of Japanese Buddhism* 2 vols., Los Angeles/Tokyo 1974–76; Paul Groner, *Saichō: The Establishment of the Japanese Tendai School*, Berkeley 1984.

BUDDHISM IN INDIA: Edward J. Thomas, *The Life of Buddha as Legend and History*, 3rd ed., London 1949; Etienne Lamotte, *Histoire du Bouddhisme Indien*, Louvain 1958; Akira Hirakawa, *Indo Bukkyōshi* 2 vols., Tokyo 1974–79.

BUDDHISM IN CHINA: E. Zurcher, *The Buddhist Conquest of China* 2 vols., Leiden 1959; Kenneth Chen, *Buddhism in China, A Historical Survey*, Princeton 1964; Shigeo Kamata, *Chūgoku Bukkyōshi* 8 vols., Tokyo 1982 – .

BUDDHISM SCRIPTURES: *Sutta-pitaka*, *Abhidhamma-pitaka*, and *Vinaya-pitaka*, London 1882–1927; Junjirō Takakusu and Kaikyoku Watanabe, eds. *Taishō shinshū daizōkyō* 85 vols., Tokyo 1924–32; D.T. Suzuki, ed., *Tibetan Tripitaka*, Kyoto 1957; Leon Hurvitz, trans., *Scripture of the Lotus Blossom of the Fine Law*, New York 1976.

MAHAYANA BUDDHISM: Har Dayal, *The Bodhisattva Doctrine in Buddhist Sanskrit Literature*, London 1932; Akira Hirakawa, "The Rise of Mahayana Buddhism and its Relationship to the Worship of Stupas," *Tōyō Bunko* 22 (1963); idem, *Shoki Daijō Bukkyō no kenkyū*, Tokyo 1968; Leslie S. Kawamura, ed., *The Bodhisattva Doctrine in Buddhism*, Waterloo 1981; Akira Hirakawa, Yuichi Kajiyama, and Jikidō Takasaki, eds., *Kōza Daijō Bukkyō*, 10 vols., Tokyo 1981–85.

PURE LAND BUDDHISM: Harper Havelock Coates and Ryugaku Ishizuka, trans., *Honen the Buddhist Saint*, Kyoto 1925; *The Shinshū Seiten*, Honolulu 1955; Akihisa Shigematsu, *Nihon Jōdokyō seiritsu katei no kenkyū*, Kyoto 1964; Alfred Bloom, *Shinran's Gospel of Pure Grace*, Tucson 1965; Allan A. Andrews, *The Teachings Essential for Rebirth*, Tokyo 1973; Dennis Hirota, trans., "The Record of Ippen," *The Eastern Buddhism*, new ser. 11–14 (1978–81).

ZEN BUDDHISM: Heinrich Dumoulin, *A History of Zen Buddhism*, Boston 1963; Keiji Nishitani, ed., *Kōza Zen* 8 vols., Tokyo 1967–68; Dōgen, *Record of Things Heard — A Translation of the Shōbogenzō zuimonki*, trans. Thomas Cleary, Boulder 1980; Martin Collcutt, *Five Mountains — The Rinzai Zen Monastic Institution in Medieval Japan*, Cambridge, Mass. 1981.

NICHIREN BUDDHISM: Masaharu Anesaki, *Nichiren the Buddhist Prophet*, Cambridge, Mass. 1916; Eishū Miyazaki and Motai Kyōryō, eds., *Nichiren Shōnin kenkyū*, Kyoto 1972; Laurel Rasplica Rodd, *Nichiren: Selected Writings*, Honolulu 1980.

SHINTO: Daniel C. Holtom, *The National Faith of Japan*, New York 1938; Shūichi Murayama, *Shinbutsu shūgō shichō*, Kyoto 1961; Alicia Matsunaga, *The Buddhist Philosophy of Assimilation*, Tokyo 1969.

James C. Dobbins is Assistant Professor of Religion and East Asian Studies, Oberlin College.

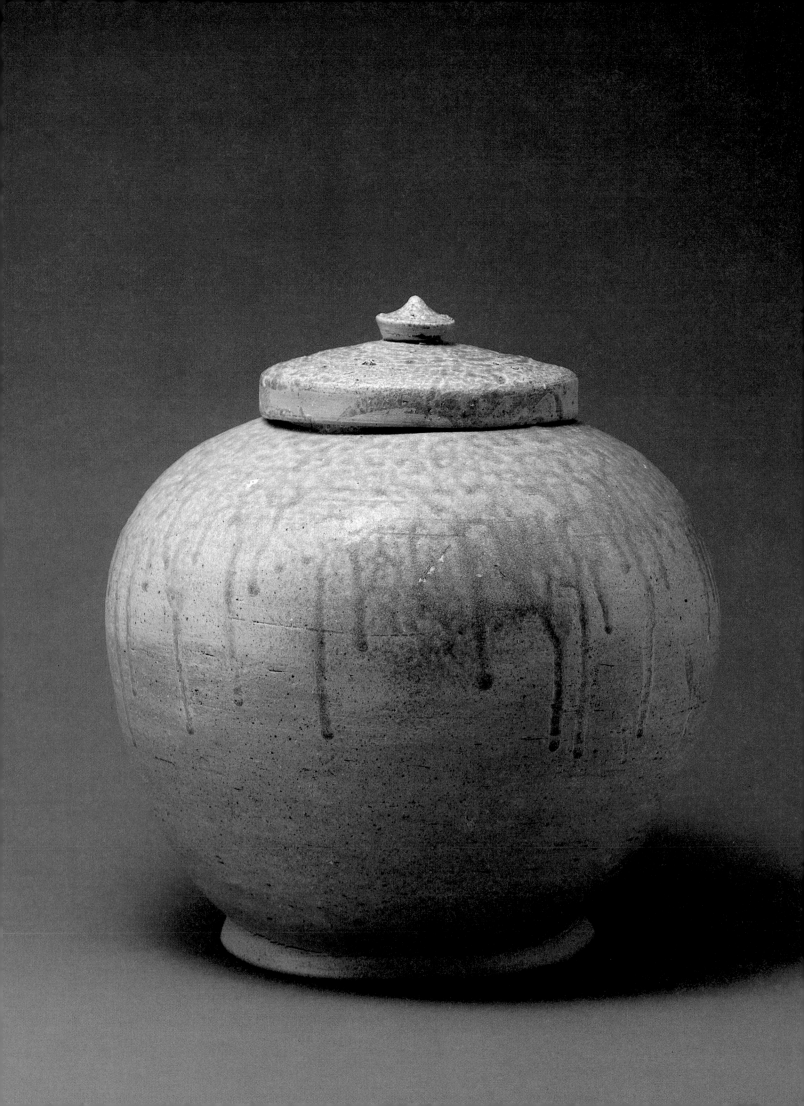

Heian Aristocratic Society and Civilization

William H. McCullough

Let wealth and commerce, laws and learning die,
But leave us still our old Nobility!
— *England's Trust, and Other Poems* (1841)

The sentiment expressed in that nineteenth-century verse manages to traumatize nearly every synapse in our modern consciousnesses, the more so because it is wholly self-serving, its author, John Manners (1818–1906), having been the seventh Duke of Rutland and a prominent follower of Disraeli — a quintessential member of the "old nobility" for which all else is to be sacrificed. Although the verse is perhaps simply further evidence of the fated silliness that H. D. F. Kitto, writing in *The Greeks*, has found to afflict aristocracies whenever they outlive their usefulness, the particular silliness of the verse's chutzpah depends to a good extent, naturally, on the reader's perspective. A Heian courtier, for instance, might have found much to admire in the underlying spirit of His Grace's lines, but the specific list of occupations selected for sacrifice would have doubtless struck him as absurd: to do away with wealth, law, and learning, in particular, would have been to do away with the Heian aristocrat himself. If he had been forced to choose something to sacrifice for the nobility, his choice might well have been the military, a profession in which he had no more personal interest than in those of others who occasionally served him at remote distances. Such a choice would have left the noble warrior-heroes eulogized in the poem hoist by the Duke's own petard, it is true, but war and its culture were, to paraphrase a twelfth-century member of the Heian aristocracy, no concern of theirs.

The unwarlike courtier in Japan who had so little use for a profession that was the very raison d'être of European nobility managed, nevertheless, together with a small group of peers, to rule his country during most of the period from the ninth to the twelfth centuries, living exclusively at the divinely descended sovereign's seat at Heian (within the modern city of Kyoto) and acting under his authority. There were probably seldom more than two hundred or so principal male members of the group at any one time, and the actual wielders of power were never more than twenty or thirty, and often fewer than half that number. It was an old group, its individual ancestries invariably traceable to the nobility of the Nara period (eighth century) and before, and the framework of its government and, in some vital respects, of its society rested on an old legal system, the eighth-century Statutory Code (*ritsuryō*). But the society itself contrasted markedly with the ancestral Nara-period nobility. The 120-odd clans composing the group in the eighth century had been reduced by the middle of the Heian period to no more than a dozen or so, and the great aristocrats, those who ruled the court and its government, were almost exclusively either members of the dominant house of the Fujiwara clan or, less frequently, of the imperially descended Minamoto. At the same time, the relative power of emperor and aristocracy shifted decisively during the ninth century toward the aristocracy, where it remained until the latter part of the eleventh century, often leaving the emperor little more than a pawn in the hands of a Fujiwara regent who was typically his maternal grandfather.

Aristocratic status was defined by two criteria: birth in a family belonging to a lineage bearing an imperially conferred clan name and title; and appointment to one of the five upper grades of official rank in the governmental system established by the Statutory Code (or, from the mid-Heian period on, such appointment combined with the privilege of attendance in the emperor's audience chamber at the palace). Provisions of the code assured that normally only descendants of aristocrats received appointment to the upper ranks, and the family composition of the aristocracy consequently changed very little from century to century, especially since polygyny and adoption were freely practiced to prevent the extinction of particular lines by early death or infertility.

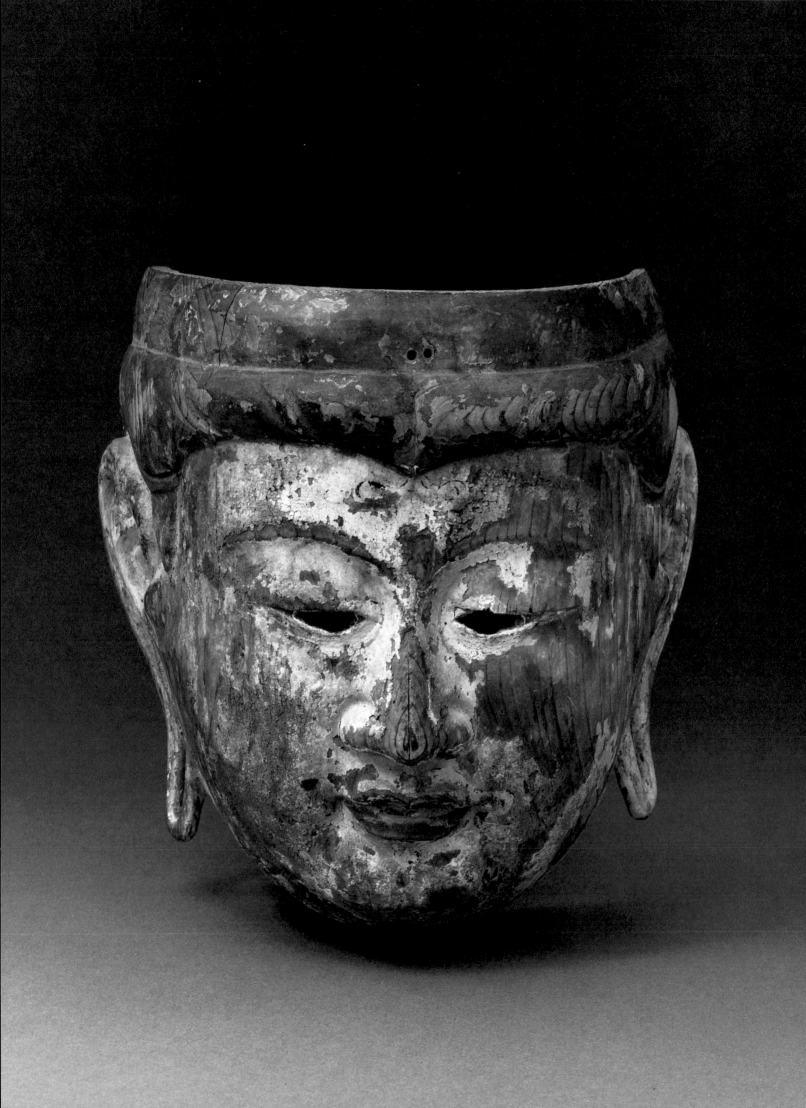

The wealth of the aristocracy came from various sources, but at least well into the eleventh century its mainstay was probably either directly or by derivation from the official income attached to rank and offices. In the eleventh century, however, the lower ranks of the aristocracy seem often to have received little or nothing in the way of official income, depending for their livings on service in the households of the great aristocrats, who had concentrated most of the government's resources in their own hands. There was, in addition, a certain amount of wealth obtained from landed proprietorships. But the essential point is that all aristocratic income, except that from landed proprietorships, was attached to positions and not to persons and places: an aristocrat obtained the bulk of his income not by heredity or inheritance (at least directly) but by official or private appointment.

It was that minuscule, ancient, completely urbanized society of aristocratic civilians living mostly on appointive incomes that produced either directly or through patronage most of what we think of today as Heian civilization. The "cold shade of aristocracy" that obscured the exploits of Wellington's soldiery in the Peninsular War has, in its Heian transformation, very nearly obliterated the cultural accomplishments of the remainder of the population, giving to the civilization of the aristocracy a prominence in our notions of the period that it may not wholly deserve; but the general absence of sources for nonaristocratic culture makes the distortion all but inescapable, and the political, economic, and intellectual dominance of the aristocracy tells us in any case that whatever distortion there may be, the age was nevertheless indeed aristocratic.

The Heian aristocrat whose tastes, values, and intellect shaped civilization at the peak of his age in the time of the preeminent Fujiwara leader Michinaga (966–1028) was in those respects characterized above all by his attitude toward religion and the supernatural, his concern with ritual and ceremony, his conception of the worthy man, his urban perspective, and, of course, the social hierarchy in which he lived. The mentality produced by those attitudes, beliefs, and circumstances largely determined the course of the contemporary civilization, including its arts and literature, and any attempt to approach the civilization may usefully begin with them.

Religion and the supernatural pervaded the life of the mid-Heian aristocrat, usually occupying some smaller or greater portion of his day with their rites and observances, and also providing most of his broader notions of life, the world, and the universe. The most profound influence in his spiritual life, in the sense that it gave him his ideas about the ultimate meaning and destination of existence, was Buddhism. By the mid-Heian period, Buddhism had emerged from the monasteries and the imperial court into the private lives of the aristocracy, offering the individual who professed faith in the Buddha Amida not lifelong arduous religious practice and deferred hope, but instant rebirth at death into the Pure Land of the Western Paradise, and the aristocracy responded with enthusiasm to that revolutionary doctrine. The notion of karma became a commonplace of the aristocratic mind, promising release from present misery in a future existence and supporting a fatalistic view of even the most insignificant particulars of life. Wealthier aristocrats turned to a multitude of pious works aimed at personal salvation, whether their own or that of a relative. Copying of the Lotus Sutra, the beautifully phrased and profoundly moving sacred text of Amidist belief, and the commissioning of painted and sculpted images of Amida were especially common, but many aristocrats also erected small Amida chapels in the gardens of their residences. Michinaga founded the great Hōjō-ji temple chiefly in honor of that Buddha, deploying an extravagance of wealth to create there a vision of the Pure Land itself that astonished the eyes of even his most jaded contemporaries. Michinaga is reported to have died before the image of Amida at Hōjō-ji, clinging to ribbons connected to the image and chanting the formula of faith as he awaited death and the joyous denouement of Amidist belief known as *raigō* (coming and welcoming), the arrival of the Buddha with his entourage of bodhisattvas and musicians to receive the expiring faithful.

But salvation and the hereafter tended for most aristocrats, like the ailing and aging Michinaga, to become a matter of pressing concern only in later life. In purely quantitative terms, the focus of spiritual attention during most of an aristocrat's life was almost certainly not on salvation in a future existence, but on his own and his family's physical and material welfare in the present. He turned almost daily to spiritual means for aid in his official career, for protection from disease, for recovery from illness, for the safe delivery of children, for the success of almost any project that he was undertaking, for the well-being of his family and clan, and occasionally even for the punishment of his enemies. Often his chief reliance in those matters was Buddhism, especially the esoteric rites conducted by accomplished practitioner-monks. Such

Buddhist mask in bodhisattva form, 12th century, wood, No. 22

rites were also employed for recovery from mental and physical illnesses, which were almost always ascribed to spirit possession, but the main therapeutic tool was a hybrid exorcistic procedure that incorporated elements of Buddhist esotericism, sinitic medical learning, and Japanese mediumistic practice.

Calendrical lore introduced from China governed broad areas of the aristocrat's life, determining the auspices for weddings, coming-of-age ceremonies, journeys, the erection of new buildings, and many other major and minor events, including the washing of one's hair. Similarly Chinese-derived thought placed a taboo on particular directions depending on the year of one's birth or the lodging of a deity who rotated through the points of the compass, and the aristocrat was not to travel in the forbidden direction — if he had to do so, he was required first to proceed in a tangential direction so that his final approach to his destination avoided the taboo. Impurity resulting from childbirth, menstruation, the presence of human or animal corpses, bad dreams, spirit possession, and other such ritually defiling events required a period of purification by seclusion and abstinence. Native deities were numerous, and the aristocrat showed respect to all within his ken in order to avoid the misfortunes they might visit on those with whom they were displeased, but his principal worship was usually reserved for his clan shrine and its branches, from which he could expect to derive support and protection. Spirits and goblins might be lurking almost anywhere ready to do harm, and gods of pestilence and other calamities might bring wholesale disaster.

The spiritual life of the Heian aristocrat, in its pattern of concern with the transcendental and the secular, was similar to that found in many societies. But its strong emphasis on this-worldly hopes and fears, and the diversity of practice and belief marshalled in support of secular goals, single it out as the product of a civilization that was perhaps as firmly materialistic as our own. The comforts, pleasures, triumphs, terrors, and griefs of life seem to have been more steadily present in the aristocratic mind than the ethereal delights of the Western Paradise.

The secular, materialistic emphasis of the aristocrat's religious practice was accompanied by a passion for ritual and ceremony expressed not only in the multitudinous, ubiquitous rites of Buddhism and the worship of native deities, but even more fully in ordinary public and private life. The passion was underlain by a notion familiar in Chinese thought and once common in the world —

that regular, proper, ceremonious conduct on the part of man ensured a regular, moderate, beneficent succession of natural phenomena — but it was pursued with an intensity that seems almost to have made rites and ceremonies themselves the chief purpose and end. The principal center of that interest was the imperial palace, where nearly every action, from the opening of the palace storehouses and the serving of an imperial meal to the bestowal of ranks and offices or the enthronement of a new emperor, was regulated by long-established, elaborately detailed custom, and where the great rites and civil ceremonies intended to assure social order and the safety of the realm and the imperial house filled the court calendar from the beginning of the New Year. But private aristocratic residences were little, if any, behindhand in the ceremoniousness of the lives lived there. An infant's birth was greeted with a burst of ceremonies and ceremonial banquets that continued sporadically for over three months, and each major stage of his life thereafter, from his coming-of-age, his marriage, and his aging to his death and burial or cremation, was similarly marked, while almost all aspects of his daily life and intercourse with others were also governed to some greater or lesser degree by ceremonial rules.

The devotion to ritual and ceremony was not simply one of praxis, as becomes abundantly clear in the voluminous Chinese-language diaries kept by some aristocrats. There the rites and ceremonies of court and aristocratic life are recorded and described with such amplitude and precision that many could very likely be restaged today without great loss of authenticity. The identity and position of each person participating in a ceremony may be recorded, his costume described to the last hem of his undermost robe, the actions and words of all participants precisely noted, the room and its furnishings described in every detail, and a sentence or two of comment or criticism appended. The maintenance of such records was one of the weightiest occupations in which the aristocrat engaged, creating for his descendants a guide and reference manual for a fundamental skill of aristocratic life: the proper conduct of ceremonies and rites.

When a man was called learned and able, the praise often had to do with his knowledge of precedent and his ability to follow court precedents in the performance of his duties. Since there was no area in which precedent was of more overriding importance than in the performance of ritual and ceremony, it was essential for the ambitious aristocrat to have access to the kind of information recorded in the diaries, for without it he could

Poems of Ki no Tsurayuki, 12th century, ink, silver, and mica on paper, No. 25

あつまちてきをみねはみさ
うくらうくらむ

ひきたにこそたのめたりにく
れておかたりいたたきます
われわたりつつあめく

いゝをたちしをいねのろ
たにねわゝけのつかはれたすれ
たまうそれれうつるのゝとりしふを

たけてすらまてはつふらしん

succeed neither in court nor in aristocratic life generally, and if he wished to be a leader, his knowledge of the subject needed to be deep and accurate. The crucial importance of ritual and ceremony led to the emergence of distinct "schools" of interpretation and practice in the houses of the great aristocratic leaders, schools represented and preserved in diaries and other writings, and each claiming the mantle of orthodoxy. Differences among the schools were usually of the most trivial sort, but they were taken with deadly seriousness by the Heian aristocracy and engendered more than one learned treatise. The existence of such schools and the extraordinary amount of intellectual attention devoted to their subject matter by senior governmental ministers may baffle or appall the casual modern observer, but they were the rational product of minds that conceived of ritual and ceremony as the chief means by which nature could be controlled, society regulated, and personal success achieved in a mysterious, imperfectly understood world.

Essential as a knowledge of rites and ceremonies was for the Heian aristocrat, it was only part of the ideal toward which most strove with varying degrees of success. The ideal was diffuse and never clearly formulated by the aristocrat himself, but if a single word must be chosen to express it, as with the *courtoisie* or *prudhommie* of the medieval European noble, the best choice might be *kokoro*, a word that denotes first both the heart and the mind and then the functions of those organs, sensitivity and understanding. For a man to "have *kokoro*" was for him to be emotionally sensitive to beauty and life and to have a sensitive understanding of the world and its affairs. He was what we should perhaps call a cultivated man. And it was by that image of the cultivated man, a man of *kokoro*, that aristocratic worth tended most often to be measured, although more vigorous virtues, especially those of courage and resourcefulness (referred to sometimes as *yamatodamashii*, 'Japanese spirit'), were also admired.

The cultivation the aristocrat sought implied above all education in the esthetics and learning of his civilization and the ability to express that cultivation adequately. The education was diverse in kind and extent, but for probably just about every male, the core of the curriculum consisted of at least some training in the reading and writing of literary Chinese (the language of government, religion, law, and learning), similar training in the Japanese scripts, the acquisition of approved elements of Chinese thought, history, and literature, and reading in the recognized models of Japanese

poetry. It was a highly literate education but at the same time almost entirely practical in the sense that it was aimed at providing the knowledge and skills needed for a successful career, and no part of it was more practical or more essential than the training in reading, writing, and literature. The medieval monk ignorant of Latin is no more conceivable than the Heian aristocrat without at least a rudimentary knowledge of literary Chinese, since the language (often badly deformed) was the medium of official and private business and a prerequisite for appointment to court posts. It was so firmly associated with the aristocracy that complete ignorance of it presumably would have put even a man's aristocratic status in question. Writing in Japanese (using the syllabary scripts) was equally essential, both because of literary needs and also because communication among the aristocracy relied heavily on the written note and letter, especially communication between the sexes. An illiterate aristocrat was unthinkable.

Apart from the more purely practical uses of reading and writing, the aristocrat's literacy was employed most conspicuously in the reading and composition of poetry, the chief vehicle for the expression and exhibition of his aristocratic nature, his *kokoro*. Continuing a long-held Chinese view that correctly inspired and conceived poetry had a unique power to set the world aright and was the proper employment of the educated man, the Japanese elite, abetted by a native enthusiasm for poetic expression, had long been prolific and sometimes brilliant practitioners of the art. But it was probably in Heian aristocratic society that poetry first became an important general measure of individual worth. An aristocrat who could not compose a poem in the accepted style on the expected occasions was professionally and socially crippled, a mezzo-soprano without a voice, a third baseman without an arm.

There were few occasions in either the public or private life of an aristocrat when poetry was not both appropriate and expected. At court, where most of the impetus for the serious study and criticism of the art originated, every banquet and ceremony was likely to be accompanied by the presentation of poems composed by the participants, and imperial consorts and princesses, especially, often organized poetry contests in which selected participants pitted their compositions against each other for critical judgment. Formal poetry-making was also common in private life, but there the art flourished most vigorously in informal letters and notes. Although almost any

The Poet Mibu no Tadamine (detail), 13th century, ink and color on paper, No. 26

三十六歌仙

ふるさとの
ならしのさとの
やへさくら
けふここのへに
にほひぬるかな

incident could elicit exchanges of letters and poems between an aristocrat and his acquaintances, the great occasions were courtship and the love affair, which, if we are to believe the literature, sometimes proceeded almost entirely through the medium of poetry, their outcomes often largely determined by its effectiveness.

Although in the earlier part of the period the poetry of the aristocrats had, with imperial encouragement, included a considerable amount of labored Chinese verse, by the tenth and eleventh centuries the almost exclusive mode of expression was again the *tanka*, the thirty-one syllable Japanese lyric that had dominated the literary tradition throughout most of its known history. Much of the vast outpouring of such poetry is still preserved in numerous collections of individual poets' works, in almost every piece of written prose from the period, and especially in a series of imperially commissioned anthologies, beginning with one of the most famous and influential works in Japanese literary history, *Kokin wakashū* (Collection of Early and Modern Japanese Poetry), compiled by the critic, poet, and official Ki no Tsurayuki (868?– 946) with others.

The poetry varied, of course, from the trivial or worse to some of the finest in Japanese, and there was some diversity of topic and treatment, but from the perspective of the aristocratic mentality, perhaps its most striking feature was its consciously sought conventionality, its intentional adherence to established usage and models. In diction, form, topic, concept, imagery, and literary aim, the Heian poet worked within limits so narrow that the bulk of his work has a fair degree of sameness to it, one verse distinguished from another often by subtleties almost too faint for the modern eye. The objective of even the gifted writer was not so much originality but the expert manipulation of the established tools and methods of the tradition in the pursuit of established critical goals. It was, more than most other poetic practices, an art of connoisseurship, demanding on the part of readers an exceptionally intimate knowledge of the literary tradition and critical theory for even a rudimentary appreciation of its accomplishments.

The more direct manifestations of the aristocratic *kokoro* in the poetry reveal, especially in private or informal composition, a liking for wit, playfulness, and spontaneity, but the most conspicuous quality and the one best regarded was a well-developed, highly selective emotional sensitivity to the human and natural world, a sensitivity that resonated not indiscriminately to any and every scene but in proper ways to particular, prescribed natural beauties — to the moon, certain kinds of blossoms, the cries of insects, a flight of geese, autumnal leaves, the cry of the cuckoo, the belling of a stag, snow — and was intensely susceptible to feelings of love and bereavement. The man of *kokoro* was also, the poetry suggests, acutely aware of the relentless passage of time and its devastating effects on human and natural affairs; his highest poetic achievement often came in the juncture of that awareness with a scene of natural beauty used to suggest or echo deeply felt emotion.

The high moral, ethical, and esthetic value placed on poetry was matched in no other art, nor was any other art as universally practiced, but the worthy aristocrat was also usually gifted in calligraphy, the vital sister-art of poetry; he was likely to be a skilled painter of the scenes represented or alluded to in poetry; he might be an accomplished musician and in his youth an inspiring dancer; and he could be expected to distinguish himself in incense judging. He was also a man of developed taste, not one to set new fashion, but a sure judge of what met the standards of the established esthetics in everything from his writing paper to the furnishings of his house, the layout of his garden, and, perhaps most of all, the rich silk clothing that made him one of the most magnificent figures in history. In the exercise of such taste and in the practice of art, it was the sensitive perceptiveness and responsiveness of the aristocratic *kokoro* that gave true distinction, a distinction that an ordinary painter or musician, for instance, could never hope to emulate.

The admired aristocrat was also a man of strong family affections who treated his wives and children with a respect and gentility uncommon in a world where the medieval mind elsewhere seems often to have feasted on cruel regimens and barbarous punishments for women and children. Family relations were permeated by a civility that appears never to have sanctioned violence, even under the most severe provocation. A woman, the literature tells us, might perpetrate some minor outrage against an erring husband (a pot of ashes poured over the head, in perhaps the most famous case), but the husband, as far as the sources reveal, never raised a hand against his wife, even if he surprised her in the arms of a lover. Restraint and dignity were also aristocratic virtues.

A pot of ashes over the head injured the dignity of a man and brought on what most aristocrats feared more than almost anything else: public derision and condemnation. The aristocratic hero was not a Calvinist clothed in righteousness marching

undeflected against the sinful tide of public opinion, but one who incorporated in himself the society's ideals and expectations and behaved accordingly. When a personal crisis arose, the aristocrat's first concern was likely to be not the intellectual or religious rightness of his actions, but what amounted for him to very much the same thing, their reception by society. To be laughed at, to become the butt of hostile gossip, was the ultimate punishment for the wayward aristocrat and the principal brace of his moral and ethical backbone.

The society whose opinion the mid-Heian aristocrat so highly valued was apt to take note of an outrage committed by an irate wife against her husband, partly because such an act not only offended the general disinclination toward violence and disturbed the rigidly observed heirarchy that placed every man and woman in a clearly defined order of relative superiority and inferiority, but more fundamentally because an aristocratic woman counted for something in the society. She was not a cipher, a wholly docile chattel of father and husband whose position depended on the whim and affection of male relatives, but in some degree an autonomous social being.

Her status can be gleaned from several indices, but none is easier to read than the conditions of her marriage. Although she usually married very young (thirteen, fourteen, and fifteen were common ages) and had but little say in the choice of her similarly youthful and choiceless husband, the initiation of the marriage relationship must have been considerably easier for her than it was for later generations of Japanese women. She normally continued to live at her parental home with her husband, at least for the first several years of the marriage, and if eventually she and her husband moved, it was not to an establishment shared with the husband's parents, but to an independent residence. That pattern of residence had important consequences for women. It gave them the protection and support of their families in the early stages of marriage; it frequently made them mistresses of their own households at an early age; and it allowed them to avoid the in-law tyranny that reduced many brides of later centuries to a state of near-slavery. The pattern also had one other striking effect that tended to enhance female status: it deemphasized the paternal-grandparent relationship with grandchildren while encouraging intimate ties between maternal grandparents and grandchildren, a circumstance exploited to the full by the Fujiwara regents in their control of the emperors. The rejoicing that often accompanied the birth of an aristocratic daughter was, no doubt, as often the result of political calculation as of unmixed parental affection.

The aristocratic woman's position was buttressed by a certain measure of economic autonomy, the estate of her parents usually devolving in whole or in part on her, and she was often the owner of the house in which she and her husband lived. She retained her own clan name after marriage, was buried with her fellow clan members, had and used the right of divorce and remarriage, kept her children in case of divorce or the death of her husband, and was not physically punished for sexual misconduct. She was unmistakably inferior in status to the aristocratic man — there were no female sovereigns in the period, no female ministers, no female religious leaders — and she was regarded both by men and by her own sex as also inferior in intellectual ability, but her existence, for all that, was clearly distinguishable from that of her men, and she had such a powerful influence on the contemporary civilization that it has sometimes been characterized as feminine.

Apart from the "proper" wife in the "proper" marriage, there were other aristocratic women who relied much more heavily on their own beauty, talents, and wit to make their way in the world. They were the orphans and the younger widows and divorcees who were forced to seek husbands without parental support, often as a secondary wife in a kind of visiting residential arrangement that brought the husband to the wife's residence only at intervals. Most such women, it is doubtless safe to assume, were satisfied to establish marital ties with any reasonably acceptable man of their own rank who could provide the security and protection that was available to them chiefly through marriage. But those of exceptional beauty, talent, or ambition sometimes sought finer things as the lover of a great aristocrat, or in service at the imperial court or at a leading aristocratic household. In those roles they were also frequently joined by women of their own superior kind from the middle and lower ranks of the aristocracy, especially daughters of the provincial-governor class, whose proverbial wealth (in the tenth and eleventh centuries) and ambition might propel their more promising female offspring into circles where useful ties and matches could be expected.

The lives of the exceptional women whose beauty, intelligence, and talents carried them into the highest court and aristocratic spheres were likely to be a good deal more interesting than those of properly married women, whose unromantic

OVERLEAF: *Scenes from the Tale of Genji* (detail), second half 17th century, ink, color, and gold on paper, No. 53

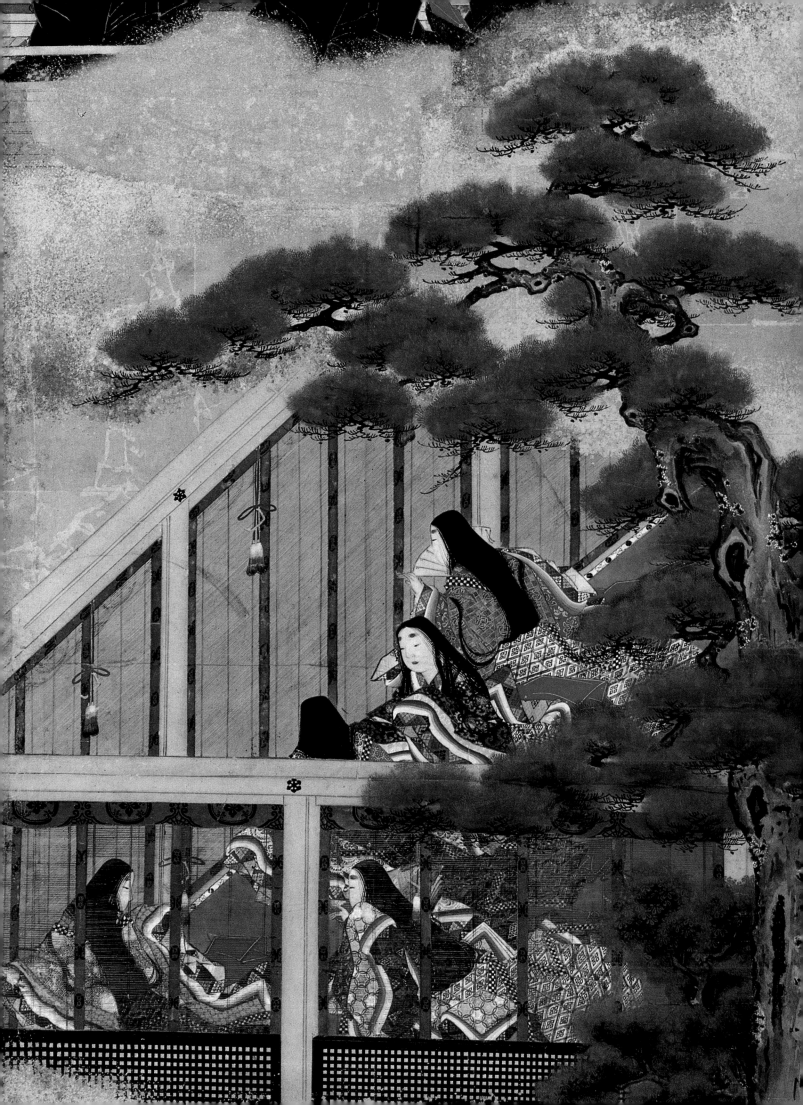

courtship and career of infants, piety, and eventual nunhood could have appealed but little to the imagination of an age that had yet to discover the verities of the quotidian. It was, in any case, the orphan, the widow, the provincial-governor daughter who used her wit and looks to make her way in high society, that attracted the attention of fiction writers such as Murasaki Shĭkibu, and it was women from the same group, including Murasaki Shĭkibu herself, who became the chief writers of the fiction and of some of the best poetry of the age. They tend consequently to loom disproportionately large in our overall picture of Heian society and civilization.

The literary accomplishments of Heian women rested on an education that had much in common with that of aristocratic men but usually omitted most of its sinitic elements, including the language, although it is clear that some women on their own picked up at least a smattering of Chinese and Buddhist-Chinese learning, after the fashion of Dorothea Casaubon and her study of Greek. Reading and writing in Japanese were the basis of the education, which, like that of the men, was both highly literary and also intensely practical, in that a woman's poetry and calligraphy were important elements of her worth and attractiveness for men, communication with whom, even after marriage, seems often to have been through verse and letters. Stringed musical instruments usually constituted part of her accomplishments, especially the *koto*, but she seems to have given little or no attention to the flute, an instrument on which men frequently distinguished themselves, and she neither sang much nor danced, except perhaps when she was a very small girl and unencumbered by the womanly restraints that made exhibition of her voice or person improper. Her other chief talent was probably painting, especially scenes from poetry and fiction.

The aristocratic woman's education attuned her to much the same values, tastes, and perspectives, to the same kind of *kokoro*, as the men's and gave her many of the same talents, but the society denied all but a very small minority any scope for the use of their wit and education outside the boudoir and the nursery. The great career, the career where fame and fortune awaited, was in the offices and ranks of court government, which were almost entirely closed to women. The courts of the emperor and imperial family members and the households of great aristocrats, however, provided in personal service a few windows on the world for the beautiful and talented few, especially for the accomplished poet and writer, who were assiduously sought out

by patrons for the display of their talents in surroundings that at times came to resemble a literary salon.

Out of these various circumstances, including those of the sequestered wife and the flamboyant mistress, a few female literary geniuses emerged to write some of the finest poetry and prose in the medieval world, including the unrivaled masterpiece of all classical Japanese literature, *The Tale of Genji*. Poetry, fiction, diaries, sketches, letters, a miscellany in the manner of *Thraliana*, and even probably a long chronicle of aristocratic life poured forth from the writing brushes of women, leaving most of the literary product of men, except for their poetry, in a lasting oblivion and providing the chief basis for the characterization of the age as feminine, since it is through the feminine perspective of female authors that the society most often has been seen and described.

That perspective, inevitably partial and skewed, stressed almost to the point of monomania the relations between men and women as spouses and lovers, the relationship that determined nearly all female lives, and it also gave particular attention to those talents, arts, tastes, attitudes, and character traits that shaped the course and outcome of love affairs, courtship, and marriage. In reading the literature, therefore, we are apt to come away with the somewhat false impression that the chief occupation of the Heian aristocratic man was gallantry, estheticism, and the pursuit of art, whereas he seems to have been in reality, as the preceding discussion has attempted to suggest, a considerably more down-to-earth figure, mainly concerned with his material fortunes and approaching the ideal of the men in *Genji*, for instance, only as the young Boswell in his more devout moments longed for the perfection of Christ.

In its portrayal of women's conditions, of taste, values, and attitudes, and in countless other ways, the female literature of the period is, nevertheless, a vital and enlightening record, and in no respect is it more enlightening or authentic than in the exalted position it gives to the capital city of Heian itself. The aristocrat was first and foremost a city dweller, more so very likely than even the dedicated Parisian of today, since the countryside usually held no attractions whatsoever for him. A great aristocrat might have a villa somewhere just outside the city, like that of Michinaga's son Yorimichi (992–1074) at Uji (part of which survives today as the Hōōdō, the serenely graceful Phoenix Hall of the Byōdō-in temple), but such establishments were used only for excursions and retreats. The aristocrat

ordinarily never of his own will left the city where he was born, bred, lived, and died, except to go on pilgrimages to shrines and temples. The notion of living in the countryside was abhorrent, an abandonment of everything that made life important and worthwhile for the crudest and most unrelieved rusticity.

The city that excited so much aristocratic attachment was, in modern demographic terms, hardly more than a village or town, its population in the mid-Heian period perhaps one hundred thousand or less. But its urban role was even more central to the society than a modern Tokyo or London, there being no other concentration of population in Japan of even remotely comparable size, and its urban character was unmistakable in concept and feature. Originating by fiat at the end of the eighth century as an imperial seat and central governmental center, the city had by the mid-Heian period lost something of its original company-town atmosphere and was evolving more freely in response to the demands and opportunities of the site and to the needs of the changing society. Its famous Chinese-inspired checkerboard layout of streets still largely intact but its perfect structural symbolism as an imperial seat of power long and appropriately gone, the city supported an increasingly urban population, mostly divorced from agriculture as the immediate, principal livelihood and engaged in a growing number of specialized occupations outside the government and the imperial court. Even the familiar urban problems of crime, fire, and the poor had made their insistent appearance.

The low buildings and decaying imperial structures of Heian in the tenth and eleventh centuries, the modest size of the urban population, and the absence of large-scale commerce might have struck a worldly visitor from the great Chinese capital and entrepôt of Kaifeng as, at best, quaintly picturesque, but for the Heian aristocrat the city was the center of the civilized world, and he left its straight, broad streets and avenues for the twisting, dangerous paths of the countryside only under order of exile, the imperative of economic need, or for the most pressing family reasons. Usually spending all of his life within the city limits or not far beyond,

even the wider-roaming male inhabited a physical world as small and confined as his society (most aristocratic houses were within a twenty- or thirty-minute walk of each other), and for a woman, whose daily life was ordinarily restricted almost entirely to her own walled-around residence, the world was even narrower, an unchanging horizon of interiors, gardens, sky, and perhaps a distant hill.

The aristocratic mental world was similarly confined, hedged about by well-entrenched conventions of belief, value, and attitude that seem never to have become the object of doubt or speculation. But for all their rigidity, the conventions also defined a coherent concept of life and human worth that nourished with hothouse exuberance a brilliant civilization remembered chiefly not for military conquest, political glory, or material opulence, but for a broad literary and artistic accomplishment that has perilously survived to the present, influencing and illuminating even the darkest periods of Japanese history.

BIBLIOGRAPHICAL NOTE

A comprehensive, reliable treatment of Heian aristocratic society and civilization does not exist in a Western language. The interested reader is probably best advised first to familiarize himself with the outlines of the period's history as found, e.g., in John K. Fairbank et al., *East Asia: Tradition and Transformation*, Boston 1973; John W. Hall, *Japan from Prehistory to Modern Times*, New York 1970; Arthur E. Tiedemann, ed., *An Introduction to Japanese Civilization*, New York 1974; or Conrad Totman, *Japan before Perry: A Short History*, Berkeley 1981; and then turn to some of its translated literature, especially the translation of *The Tale of Genji*, New York 1976, by Edward G. Seidensticker (the Waley translation is better avoided for the present purpose), but perhaps also the more prosaic, quasi-chronicle *Tale of Flowering Fortunes (Eiga monogatari)*, translated by William H. and Helen Craig McCullough, Stanford 1980. The volume on the Heian period in the forthcoming *Cambridge History of Japan* should also be useful. Three works that treat the poetry of the period may be recommended: Robert H. Brower and Earl Miner, *Japanese Court Poetry*, Stanford 1961; Helen Craig McCullough, *Brocade by Night*, Stanford 1985; and *Kokin wakashū: The First Imperial Anthology of Japanese Poetry*, Stanford 1985.

William H. McCullough is Professor of Oriental Languages, University of California, Berkeley.

Chūsei: The Medieval Age

Martin Collcutt

The long span of Japanese history between the tenth and sixteenth centuries, embracing the late Heian, Kamakura, and Muromachi periods, is generally referred to as Japan's medieval age, *chūsei*. Looking beneath historical details we can distinguish broad, long-term currents of change in politics, society, religion, and the arts. A few might be described as distinctively medieval; most, however, had antecedents well before the tenth century, or continued to be felt long after the sixteenth. Because the intermingling of these various currents shaped the larger features of traditional Japanese society, and since, in many cases, their impact can still be detected today, it is no exaggeration to say that the *chūsei* heritage is as important for Japan as the medieval heritage has been to the history of any European society.

Politically, we can distinguish three such long-term currents in the medieval age: the transfer of political leadership to a new elite, the erosion of stable central authority into decentralization and civil war, and, when political fragmentation had reached an extreme, a fierce drive back through warfare to reunification. The first of these phases involved a shift in political power from the imperial court to warrior chieftains in the thirteenth and fourteenth centuries, with the establishment of warrior governments, *bakufu*, on the one hand and the erosion of imperial authority and the power of the court nobility on the other. Whereas the early phases of warrior government, the Kamakura and early Muromachi *bakufu*, were relatively strong and stable, the late fifteenth and early sixteenth centuries saw a loss of central control by the Muromachi *bakufu* accompanied by provincial unrest, endemic warfare, and local control. This process has been referred to as the "lower toppling the upper," *gekokujō*, in an age of provincial wars. Eventually, from the ruck of warring barons there emerged men such as Oda Nobunaga and Toyotomi Hideyoshi, who were impelled by a larger vision of national unification.

In the tenth and eleventh centuries, the imperial court in Heian still held unchallenged political authority. While emperors, the *tennō*, reigned, members of the Fujiwara family ruled by monopolizing the highest court offices. Those few who challenged Fujiwara power did so by voluntarily abdicating in favor of a son, then setting themselves up as cloistered emperors with their own private offices of government and the ability to influence the official imperial office. The administrative, land, and tax systems were not working as well as in the Nara period; there was periodic unrest in the provinces. The uprising by Taira no Masakado in the eastern provinces between 935–940 was a problem for the court, but by calling on provincial warrior bands for assistance, the court was able to maintain its authority and political preeminence.

This preeminence was seriously threatened when warriors became embroiled in Kyoto politics and began to arrogate to themselves political power. The court sought to preempt this move by playing one warrior clan against another, especially the powerful Taira and Minamoto. This policy worked until the mid-twelfth century, when the Taira warrior family under Taira no Kiyomori wiped out their major rivals and established a virtual hegemony over the court. Much as the Fujiwara had done, Kiyomori and the Taira monopolized court offices and tried to rule through the existing administrative framework. In his efforts to dislodge the Taira, cloistered emperor Go-Shirakawa looked to the surviving Minamoto who were regrouping in eastern Japan under the young general Yoritomo and his brother Yoshitsune. Sweeping Minamoto victories over the Taira in the late twelfth century replaced one military regime with another; they did not restore power to the court. Yoritomo assumed the title of shogun and established his *bakufu* in

Hell of Shrieking Sounds (detail), c. 1200, ink and color on paper, No. 31

Kamakura in eastern Japan. As a warrior government, the *bakufu* was primarily concerned with the warrior order headed by Yoritomo and his vassals. In time, however, under Yoritomo and his sons and then the Hōjō regents, who dominated it after the extinction of the Minamoto line of shoguns in the early thirteenth century, the *bakufu* assumed more and more power over landholding rights, tax payments, and legal affairs affecting the whole of society. The Hōjō established a branch office of the *bakufu* in Kyoto and intervened in the imperial succession. They assumed authority, too, in foreign affairs, and it fell to Hōjō Tokumune to organize the defense of the country in the face of the Mongol invasions of 1274 and 1281.

Unreconciled to its declining authority, the court made several attempts to recover political power. In 1221 the Jōkyū War, an ill-fated uprising led by cloistered emperor Go-Toba, was easily crushed by the Hōjō, giving them the power to confiscate more lands, to punish courtiers and members of the imperial family, and to regulate the order of the imperial succession. In the 1320s resistance to the *bakufu* clustered around emperor Go-Daigo. With the support of the Ashikaga and several other powerful warrior families, Go-Daigo was able to overthrow the *bakufu* in 1333 and reestablish what he called direct imperial rule. This imperial restoration of the Kemmu era lasted for only three years. The court-centered policies of Go-Daigo alienated his erstwhile warrior supporters, and in 1336 he was forced to flee Kyoto, leaving Ashikaga Takauji to take the title of shogun and organize a new regime, the Muromachi *bakufu*, under a puppet emperor. For more than three decades the country was divided in a desultory civil war between supporters of Go-Daigo and his Southern Court and the Northern Court supported by the Ashikaga.

Thus, the Muromachi *bakufu* got off to an uncertain start. From the outset the Ashikaga shoguns, who had neither extensive landed nor military power of their own, had to rely on the cooperation of their leading vassals and provincial military governors, the *shugo*. Strong shoguns such as the third, Yoshimitsu, who healed the breach between the Northern and Southern courts, or the autocratic sixth shogun, Yoshinori, were able to dominate and use the military power of this coalition to the advantage of the *bakufu* and central authority. The assassination of Yoshinori in 1441 by an aggrieved *shugo* exposed the *bakufu*'s intrinsic weakness. The *shugo* and the local warriors beneath them began to compete to enhance their local power, while weak shoguns such as Yoshimasa retreated from active

political leadership into palace politics and cultural pursuits. A dispute over the succession to Yoshimasa's title sparked the Ōnin War in 1467, a ten-year conflict between two rival leagues of *shugo*, which laid waste to much of Kyoto and ushered in a century of sporadic provincial warfare.

In the confused conditions of the late fifteenth and early sixteenth centuries, what counted was not an official title or the backing of an increasingly powerless shogunate, but real power in terms of loyal vassals, tightly held lands, well-fortified castles, tactical ability, and constant readiness for attack and defense. In these circumstances many of the *shugo*, whose administrative reach was overextended, were toppled by local warriors beneath them in a surge of *gekokujō* which produced the small, tightly knit domains of the warring states barons, the *sengoku daimyō*. By the early sixteenth century there were some 250 of these *sengoku* domains throughout Japan. From an extreme of decentralization, the political pendulum began to swing back toward reunification. Oda Nobunaga, claiming to be going to the aid of the shogunate, won a series of brilliant victories and marched into Kyoto in 1568. He soon ousted the shogun, isolated and crushed rival daimyo and armed religious groups in central Japan, and made himself master of the realm. Nobunaga's conquests were ended by his assassination in 1582. His successor, Toyotomi Hideyoshi, pushed farther west and mounted invasions of Korea. Hideyoshi, like Nobunaga, chose not to take the discredited shogunal title but ruled as *kampaku*, a title in the old court hierarchy. At Hideyoshi's death a council of warriors was established to serve as a regency for his son. Not surprisingly, they vied among themselves for power. Tokugawa Ieyasu, in a great military victory at Sekigahara in 1600, destroyed his rivals and established a shogunate which endured until the nineteenth century.

These currents of political change in the medieval period left an important legacy. On the one hand, the idea of a warrior government detached from the imperial court and headed by a shogun had been firmly established. There were occasional departures from this model, as in the case of Nobunaga and Hideyoshi, neither of whom took the shogunal title, but on the whole it prevailed until the nineteenth century. Warrior rule was reinforced by warrior legal codes and by the notion of a shogun or military regent ruling under a reigning emperor. On the other hand, though weakened and financially hard-pressed, the imperial court survived. Once the idea of shogunal authority as the military expression

of imperial rule was established, the need to completely eliminate court and *tennō* was removed. Although the imperial office was enfeebled and reduced to a ritual and legitimizing role, it was not stripped of sovereignty, and its very weakness became something of a source of strength, or at least of durability. Politically, too, the country had survived external invasion and internal division. This left a legacy of unity and strengthened national identity. With the divine winds (*kamikaze*), typhoons which had actually scattered invading Mongol fleets in 1274 and 1281, came the belief that Japan was a divinely protected land. From the civil wars of the fourteenth and fifteenth centuries came the drive for reunification and search for renewed political stability.

In the areas of social and economic life, the medieval age saw the emergence of new classes, new patterns of landholding, growing agricultural production, increased market activity, more extensive commerce, greater use of coinage, and substantial urban development, all of which contributed to, and benefitted from, the release of new economic and commercial energies.

In the Nara and Heian periods prior to the tenth century, it is difficult to think of Japan as anything other than an aristocratic society, although of course other groups existed. Poor farmers tilled the fields of both private estates exempt from taxation as well as public lands (*shōen*) and bore the burden of taxation and labor service. The more powerful provincial families, a local warrior aristocracy, armed themselves, their kin, and their vassals. These less influential groups have left only faint traces in the historical records of the age; it was the court nobles who dominated the society and the historical record. Sustained by public and private lands and the peasants who farmed them, they held political power; legal institutions catered to them. Apart from monks and nuns, many of whom came from noble families, the nobility monopolized the intellectual and literary skills in the society. It seems fair, therefore, to describe the tone of Japanese society in these earlier centuries as aristocratic.

This aristocratic tone was diluted by the emergence onto the center stage of Japanese history first of warriors, then merchants and commoners. We have already seen how political power shifted during the medieval centuries from courtiers to warriors. As *bushi* gained political power, they began to set the tone for the society and culture. On the one hand, *bushi* were practitioners of the martial arts, *bu*, or "the way of the bow and arrow."

On the other, they had to master skills of government and local administration which involved some measure of literacy and learning, *bun*. By the end of the thirteenth century, the ideal of the warrior as one who had mastered both *bu* and *bun* was already firmly established. Throughout the medieval period, and especially in times of war, most rural *bushi* could not devote the time needed to meet the literary standards of this ideal, but the *bushi* elite certainly did. Learning from courtiers and consorting with them, the Hōjō regents, the Ashikaga shoguns, and Sengoku warrior-leaders like the Ōuchi and Hosokawa became exponents and patrons of the arts of peace as well as students of the tactics of war.

In the twelfth century the only local commerce was carried on by itinerant peddlers. There was little, if any, use of coinage and hardly any market activity in Japan. Economic exchange was mostly in kind or in service, and the most common economic activity was the payment of *nengu*, or annual taxes, in rice or other products to *shōen* proprietors or to the agents of the central government. *Shōen* economies were largely self-contained economic worlds. The bulk of farmers' output was absorbed in subsistence or tax payments. There was little surplus to sell in a market or to traveling merchants.

This rather static economic world began to change during the thirteenth century. One long-term economic and social transformation taking place during the medieval age was the steady dismemberment of *shōen*. The control formerly exerted over *shōen* by nobles or temples was undercut or denied by warrior families living within or close to *shōen*. Erosion was already underway in the Kamakura period. *Jitō*, the military-caste land stewards imposed by Yoritomo and by the Hōjō after the Jōkyū War, entrenched themselves and diverted more and more of the tax yield away from the proprietors. Nobles and temples were forced to make compromise settlements with *bushi* or to partition their estates. The warfare of the mid-fourteenth and late fifteenth centuries brought further dismemberment to *shōen* as *shugo*, local warriors, and *sengoku daimyō* all sought to exert their authority over lands in their locality held by absentee proprietors. The loosening grip of nobles and temples over *shōen* released more farmers' and artisans' labor for market-directed production. Although it is difficult to document, it is possible that Japan was producing an agricultural surplus during these centuries. There were also improvements in agricultural technology and farming

practice. Greater use was made of draft animals and double cropping became more widespread. Markets within *shōen*, at crossroads, and temple gates became more widespread and more regular. Thrice-monthly markets were held in many areas, and permanent shops began to appear. These remote markets were linked with the cities of Kamakura, Kyoto, Nara, and Hakata by peddlers and merchants. Markets such as the Horikawa lumber market in Kyoto or the Yodo fish market drew produce from far afield and became wholesale markets. Forwarding merchants (*toimaru*) established themselves in port cities around the Inland Sea. Guilds of merchants (*za*) trading in specialized commodities such as salt, oil, paper, silk, or lumber under the protection of *shōen* proprietors, temples, and shrines were active in the Kinai region.

This expanding economy was fostered by the growing availability of coinage. By the late thirteenth century copper cash were being imported from China and were coming into use in the Kinai and along the eastern seaboard. Until Hideyoshi, Japanese rulers preferred to import specie from China rather than minting it themselves. Although the supply of coins, especially good coins, was thereby restricted and subject to dislocation and hoarding, the use of money to conduct transactions became steadily more common. Taxes were increasingly paid in cash, and moneylending by merchants, sake brewers, and temples became a feature of daily life. Both the Kamakura and Muromachi *bakufu* found themselves under pressure to issue debt moratoria edicts to assist *bushi* who had gone too deeply into debt to moneylenders. The activities of moneylenders added fuel to the uprisings by *bushi* and farmers, which became a feature of the fifteenth and sixteenth centuries.

Commercial and market activity continued to flourish during the Muromachi period. The location of the *bakufu* and shogunal court in Kyoto spurred a recovery of vitality in the capital, which became in the late fourteenth and early fifteenth century a national market and a major stimulus for trade. Unlike the Kamakura *bakufu*, the Muromachi shogunate did not have a strong landed base. The more active of the Ashikaga shoguns turned to foreign trade and the promotion and taxation of domestic commerce to make up for this deficiency. Ashikaga Yoshimitsu sent official trading missions to China and fostered merchant groups in order to tax them. In the shadow of the official missions went pirates, who were treated as marauders by the ruling authorities in Korea, China, and Japan but who, no doubt, thought of themselves as freebooters and traders.

The warfare of the late Muromachi period was destructive, but not necessarily depressing to economic activity. Kyoto was badly damaged in the Ōnin War and much of its population dispersed. Recovery came quickly, however, and the city was clearly flourishing again under Nobunaga and Hideyoshi. Both of these hegemons, particularly Hideyoshi, engaged in major building projects in the city. The Jesuit missionary João Rodrigues, who was in Kyoto in the late sixteenth and early seventeenth centuries, described the capital as "the noble and populous city of Miyako." Rodrigo de Vivero y Velasco gave its population as "over 800,000 people, while according to different estimates between 300,000 and 400,000 folk live in the vicinity." The same observer reported: "The viceroy told me that in the city of Miyako alone there were 5,000 temples to their gods, as well as many hermitages. He also said there were some 50,000 registered public women, placed by the authorities in special districts."

In other respects, the warfare and many of the policies adopted by *sengoku daimyō* and the unifiers were a spur to commerce. Provision merchants were needed to supply arms, armor, and horses for larger armies; food, drink, and clothing for garrisons; building materials for fortifications and castles; timber for bridges and ships. During the sixteenth century, merchants of Sakai grew rich on the China trade and the provision of guns for Nobunaga and other warring daimyo. Early castle towns served as commercial centers for their domains, as daimyo favored local merchants whom they could more easily control than the older guilds.

The century between the mid-sixteenth and mid-seventeenth is frequently referred to as the Christian century. Until Hideyoshi turned against the Christian mission effort in the 1580s, it looked as though millions of Japanese would be converted to Christianity, and that the Catholic church would establish a powerful presence in Japan. Trade accompanied the cross. Portuguese, Spanish, Dutch, English, and Chinese merchants put Japan in contact with the commerce of Europe, the Indies, and Asia. Japanese merchant houses, too, ventured further afield. Licensed Japanese trading vessels sailed for Luzon and South Asia, where groups of Japanese merchants established themselves. The sixteenth century also saw an outpouring of gold and silver from newly opened mines in Japan. Hideyoshi, well aware of profits to be derived from trade and commerce, took first choice of imported items, imposed levies on traders, and directly controlled mines and set up gold and silver mints. As part of their drive for unification and legitimacy,

Battle Scene (detail), 14th century, ink, color, and gold on paper, No. 29

both Nobunaga and Hideyoshi destroyed barriers, moved for a uniform system of currency, reassessed and revalued land, encouraged Chinese and European merchants, shared in the proceeds of the overseas trade, and engaged in conspicuous consumption and castle building on a grand scale.

The social and economic changes witnessed by Japan in the medieval period were therefore substantial. Warriors set their imprint on society, but even more, merchants and farmers also made their presence felt. Until the *sengoku daimyō*, especially Hideyoshi, began to separate samurai from their villages, Japanese medieval society was relatively fluid. Warriors lived in the villages and managed lands, if they did not actually farm them. Intermarriage among the various groups in Japanese society was relatively unrestricted. But the separation into status groups, which has been characterized as a mark of early modern society, was already under way in late medieval Japan. In an effort to rationalize the military and economic potential of their domains, many *sengoku daimyō* had sought to draw their vassals more tightly around them; Hideyoshi was not the only daimyo to see the dangers of village-based armed uprisings.

In the Edo period, the population of the country and the scale and complexity of economic life increased. In large part this owed to the unification of the country by Tokugawa Ieyasu, the solidity of the Tokugawa *bakufu*, and the effects of the *sankin kōtai* system requiring daimyo to attend the shogun in Edo during alternate years. Medieval Japan did not have cities on the scale of Edo or Osaka — medieval castle towns were fewer and smaller — nor did it have a rice market like the Osaka Dojima market, nor the commerce generated by the fully developed *sankin kōtai* system. The merchant groups of the late Muromachi period in Kyoto, Sakai, or Nara were not so numerous, well organized, or prosperous as the later Edo and Osaka townsmen. But allowing for these differences of scale, it is also fair to suggest that most Edo-period developments were already evident in the medieval age. It is hard to think of features of the Edo-period economy, other than perhaps the ripple effects of the *sankin kōtai* system, that were not also present in the late medieval economy.

Japan's international relations have been marked by periods of active contact, with relative openness toward the outside world, and periods of relative withdrawal. In contrast with the preceding late Heian period, when official embassies to China were abandoned, and the succeeding Edo period, in which relations with the West were drastically curtailed, the medieval centuries were relatively open. The Taira reopened active commercial contacts with China. The Mongol invasions interrupted these relations but they were revived by the Ashikaga shoguns, and by trade-conscious daimyo such as Ōuchi and Hosokawa. The sixteenth century, with the arrival of Western traders and a vigorous Asian trade in which Japan was an active participant, was perhaps the most "open" era in Japan's premodern history.

The medieval centuries also witnessed far-reaching changes in religious and cultural life, changes that were to lay the foundations of modern Japanese spirituality and esthetic sensibility. From the late twelfth century there was a surge of revival within Buddhism that was to carry hopes for salvation to the mass of the population, a movement which, in effect, "popularized" Buddhist practice and observance in the ensuing three hundred years.

By the sixteenth century the Pure Land schools were firmly and fully established as the major schools of Japanese Buddhism. In particular, the True Pure Land school was revived and reorganized by Rennyo (1415–1499), who brought many disparate groups of followers (*monto*) under the leadership of the Hongan-ji temple. The tightly knit *monto*, most of which included local samurai, came to be known as the Ikkō-shū, or singleminded school. In many areas of central Japan they challenged the local political authorities in armed uprisings. In Kaga province in 1488 the Ikkō-shū overthrew the *shugo* and ruled the province for ninety years. In the sixteenth century they proved a thorn in the flesh to *sengoku daimyō* and to Oda Nobunaga, who devoted much of his conquering energy to crushing the military strength of the Hongan-ji followers. The Hongan-ji itself was a wealthy temple whose abbots became major patrons of the arts.

The medieval centuries were the great age of Buddhism in Japan. This period has been called a Buddhist episteme, an age in which Buddhism was the dominant mode of thinking for all members of the society and a vital source of cultural expression. This is a fair characterization, but Shinto, Confucian, and Daoist threads also remained part of the intellectual fabric of the age. By the sixteenth century, Buddhism's former spiritual vitality was declining. Most schools showed signs of weakness and secularization. Throughout the medieval period, Enrayaku-ji and other great Buddhist monasteries built up military forces which continually challenged secular military power. In the

Landscape (detail), attributed to Tenshō Shūbun, late 15th century, ink and color on paper, No. 44

sixteenth century, warriors such as Oda Nobunaga appeared, able and eager to crush the power of Buddhist monasteries wherever it ran counter to their hegemonic ambitions. Nobunaga's savage burning of Enryaku-ji was only the most violent expression of this secular determination to bring Buddhism to heel. On the intellectual front, too, Buddhism faced new challenges in the sixteenth century. The temporary success of Christianity was a setback for Buddhism on the one hand, while Neo-Confucianism was attracting the attention of monks and scholars on the other. In spite of these challenges to the religious, social, and intellectual supremacy of Buddhism, it would be misleading to suggest that it had declined completely by the end of the sixteenth century, or that its influence was nullified by the reforms imposed by Nobunaga and Hideyoshi. It continued to exert a powerful influence on the spiritual lives of the people; the use by the Tokugawa authorities of Buddhist temples as registration centers in the effort to eradicate Christianity enhanced its social position.

In contrast to the ancient period, in which most discernible cultural activity was the province of the court nobility or Buddhist temples, medieval culture was very much the product of all social groups. We can distinguish a blending of the cultural interests of courtiers, warriors, monks, merchants, and country people. Japan's renewed contacts with the continent brought a powerful cultural influx from Song-, Yuan-, and Ming-dynasty China. And the arrival of the so-called Southern Barbarians (Namban) and the Christian missionary effort in the sixteenth century put Japan for the first time into direct contact with the culture of Europe.

Although the court was being pushed aside politically during the medieval age, its cultural preeminence survived. Emperors and courtiers remained the arbiters of taste in literary expression, especially in Japanese poetry. Emperors like Go-Toba, Hanazono, and Go-Mizuno acquired reputations as scholars, poets, and patrons of the arts. Male courtiers were schooled from childhood in the Chinese classics and in Chinese and Japanese history. Their wives and daughters were adept in Japanese literary pursuits. They were patrons of Buddhism and students of Confucianism, and they set the style in etiquette and polite behavior. Through association with them, the upper echelon of warrior society was introduced to the whole range of courtly learning and culture, as well as to the arts of government. This association began even before the Taira imposed themselves upon the court

in the twelfth century. Yoritomo deliberately established his *bakufu* outside the orbit of court politics. He and later warrior leaders warned of the debilitating dangers of too close an association with the court and constantly asserted the duty of warriors to maintain their martial heritage. At the same time, Yoritomo and his warrior successors needed and enjoyed the literary and administrative skills of which courtiers were the masters. Thus, even after courtiers had lost much of their political authority, they maintained their social position and cultural influence as the mentors and associates of powerful warriors.

In many ways, as we have seen, the medieval age was the age of the warrior. Warrior values came to the fore, and a martial lifestyle took shape. Fortified warrior residences and hilltop castles became architectural features of the age. Paintings such as the *Obusuma Saburō Scroll*, contrasting the lives of Obusuma, a martial-minded eastern warrior and his esthetically inclined elder brother, or the Mongol Invasion scrolls, depicting the exploits of a Kyushu warrior against the Mongol fleets, illustrated details of warrior lifestyle and dress. The making of swords, armor, helmets, and horse trappings reached the highest technical and artistic levels. A developing warrior ethic of heroism, loyalty, and willingness to die for one's lord was fostered by warrior chieftains and lauded in war tales such as the *Heike monogatari* or *Taiheiki* (Chronicle of the Great Peace). At the same time, warriors were mastering those civilian arts essential for government, for easier social intercourse with the nobility, and for cultural enjoyment. Many warriors were literate. Some, including Minamoto no Yoritomo, his son Sanetomo, and several of the Hōjō regents, wrote poetry sufficiently accomplished to be included in major anthologies. Many other warriors participated in literary salons with nobles and monks and patronized painters, dramatists, and craftsmen. Ashikaga shoguns like Yoshimitsu and Yoshimasa, provincial warrior families like the Hosokawa and Ōuchi, and the unifiers Nobunaga and Hideyoshi were all lavish patrons and practitioners of the arts. It was under this kind of warrior patronage that the Nō theater and tea ceremony (*chanoyu*) developed. Palaces, castles, and provincial warrior residences were decorated with screens and wall paintings by masters of the Kanō and other schools of painting. Warriors became devotees and patrons of the new branches of Buddhism, especially Zen, and acquired from monks some understanding of the secular as well as the Buddhist culture of China.

The Four Accomplishments (detail), Kanō Takanobu, early 17th century, ink, color, and gold on paper, No. 49

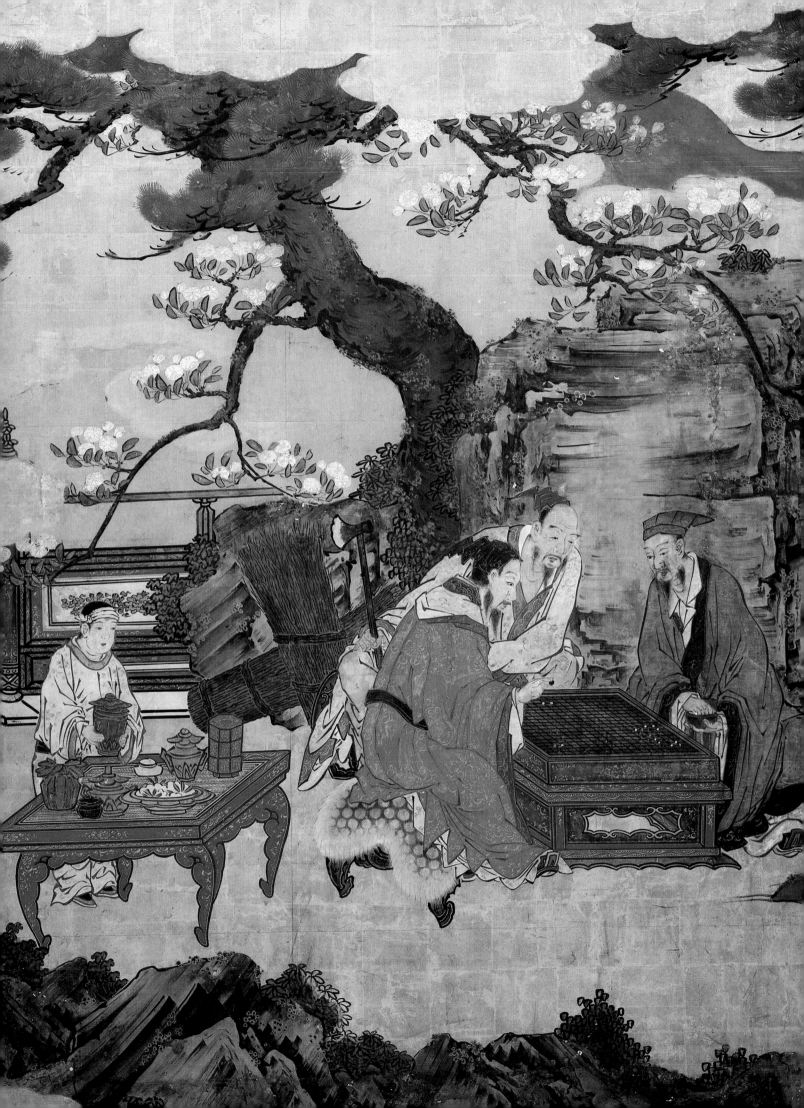

A vogue for "Chinese objects" (*karamono*) ran through the medieval period. Ink landscape paintings, portraits, books, silks, ceramics, and tea utensils from China were all in great demand. Shoguns and daimyo called upon monks and secular experts for advice in connoisseurship. There were few warlords who did not in one way or another seek to enhance their political and military power with trappings of cultural legitimation. Hideyoshi, with his castle building and commissioning of massive painting projects, his patronage of tea masters and Nō actors, his avid collecting of Chinese and European artwork, and his capture of Korean potters, was only one of many warlords who were patrons of the arts.

Buddhist monasteries, especially Rinzai Zen monasteries, were also major nodes in the medieval cultural fabric. Monks, nobles, and warriors mingled on equal terms at literary salons in the palaces of emperors and shoguns. Moreover, the abbots' buildings of Buddhist monasteries were also centers of learning and cultural exchange between monks and their lay patrons. Zen monks in China and Japan shaped a new esthetic out of the conviction of the universality of Buddhahood and the insights of meditation. Refined within monastic walls, this esthetic proved so attractive to lay artists, patrons, and men of culture that it quickly infused the cultural style of the medieval age. Zen monasteries incorporated in their layout and monastic buildings the styles of Song architecture. Their gardens introduced and refined the concept of "dry landscape," *kare sansui*, in which raked gravel, sand, moss, and stones replaced water, flowers, or borrowed scenery. Zen monks brought to Japan mastery of the Song-dynasty ink painting, *suiboku-ga*. Zen portraits and portrait sculpture (*chinsō*) sought to capture the spirit of the Zen masters they depicted. Religious paintings of Rakan, Zen patriarchs, Zen encounters, or scenes from the life of the Buddha used in religious ceremonies or daily monastic life were also a stimulus for artists inside and outside the monasteries. Painters like Josetsu, Shūbun, Oguri Sōtan, Kanō Masanobu, and Sesshū, all of whom had close ties with Zen monks and monasteries, mastered and transcended Chinese ink painting techniques to establish a Japanese tradition of *suiboku-ga* that had a profound influence on medieval cultural style. The late medieval period saw a shift away from the monochromatic world of Zen ink landscape to the large gilded wall and screen paintings employed to decorate the wall panels of the great castles like those at Azuchi, Fushimi, and Osaka. Painters of the Kanō school flourished on these commissions. Zen monks were also scholars and poets. They transmitted to courtiers and warriors knowledge of Song Confucian thought and of Chinese poetry. The practice of drinking tea also spread from Zen monasteries to secular society. Daimyo and merchants, especially those of Sakai, consorted with Zen monks in tea gatherings. Tea masters like Murata Jukō, Takeno Jōō, and Sen no Rikyū secularized and refined the practice of tea drinking through the incorporation of a Zen esthetic of simplicity and rusticity known as *wabi*. The passion for tea ceremony which infected late medieval society served as a spur to a range of related arts and crafts. In ceramics, rough Japanese ware, especially Raku, gained pride of place alongside elegant Chinese porcelains. Tea room architecture, interior and garden design, flower arrangement, lacquer ware, metalwork, and the use of bamboo were all powerfully influenced by the developing set of esthetics generated within the tea rooms.

No comment on the medieval age and its culture would be complete without acknowledging the growing cultural visibility of the common people. Messages of Buddhist salvation and retribution and tales of military heroism were carried into the provinces by traveling priests and minstrels. The Nō theater and Kyōgen had their origins in popular rural and religious entertainments. Even after its elevation by Kan'ami, Zeami, and their successors into a refined dramatic form, Nō continued to be performed at village shrines throughout Japan. Tea likewise was enjoyed in villages as well as in the castles of warriors or the teahouses of wealthy merchants. Wandering linked-verse (*renga*) poets like Sōgi exchanged verses with their village hosts. On urban riverbanks, free from taxation, lived a restless urban proletariat known as the *kawaramono*. They included dropouts and outcasts who made a living slaughtering animals and tanning hides. Among them were poor artists, craftsmen, and popular performers. The vitality of popular life and culture in the *chūsei* period is evident from scenes in scroll paintings like the *Ippen hijiri-e* (dated 1299) or the Namban screens and genre paintings of the late sixteenth century. These vigorous colloquial strains, reflected especially in the popularity of Kabuki dance and drama, continued to emerge ever more forcefully in the Edo period.

Bibliographical Note

Government and Society: John W. Hall, *Government and Local Power in Japan, 500–1700: A Study Based on Bizen Province*, New Haven 1966; H. Paul Varley, *Imperial Restoration in Medieval Japan*, New York 1971; John W. Hall and Takeshi Toyoda, eds., *Japan in the Muromachi Age*, Berkeley 1977; Jeffrey P. Mass, *The Development of Kamakura Rule, 1180–1250: A History with Documents*, Stanford 1979; John W. Hall, Keiji Nagahara, and Kozo Yamamura, eds., *Japan Before Tokugawa: Political Consolidation and Economic Growth, 1500–1650*, Princeton 1981; George Elison, and Bardwell L. Smith, eds., *Warlords, Artists, and Commoners: Japan in the Sixteenth Century*, Honolulu 1981; Jeffrey P. Mass, ed., *Court and Bakufu in Japan: Essays in Kamakura History*, New Haven 1982; Mary Elizabeth Berry, *Hideyoshi*, Cambridge, Mass. 1982. — Recent works in japanese: Masaharu Kawai, *Chūsei buke shakai no kenkyū*, Tokyo 1973; Kyōhei Oyama, *Kamakura bakufu*, Tokyo 1974; Yoshihiko Amino, *Mōkō shūrai*, Tokyo 1974; Keiji Nagahara, *Sengoku no dōran*, Tokyo 1975; Fujiki Hisashi, *Oda-Toyotomi seiken*, Tokyo 1975; Haruko Wakita, *Muromachi jidai*, Tokyo 1984; Akira Imatani, *Muromachi bakufu kaitei katei no kenkyū*, Tokyo 1985.

Cultural and Intellectual Developments: George Sansom, *Japan, A Short Cultural History*, London 1952; Helen Craig McCullough, trans., *The Taiheki: A Chronicle of Medieval Japan*, New York 1959; Donald Keene and Hiroshi Kaneko, *Nō, The Classical Theatre of Japan*, Tokyo 1966; Donald Keene, ed., *Twenty Plays of the Nō Theatre*, New York 1970; H. Paul Varley, *A Chronicle of Gods and Sovereigns, the Jinnō shōtōki of Kitabatake Chikafusa*, New York 1980; Martin Collcutt, *Five Mountains: The Rinzai Zen Monastic Institution in Medieval Japan*, Cambridge, Mass. 1982; W. R. Lafleur, *The Karma of Words: Buddhism and the Literary Arts in Medieval Japan*, Berkeley 1983; J. Thomas Rimer and Masakazu Yamazaki, trans., *On the Art of the Nō Drama, the Major Treatises of Zeami*, Princeton 1984; H. Paul Varley, *Japanese Culture: A Short History*, Honolulu 1984; Neil McMullin, *Buddhism and the State in Sixteenth-Century Japan*, Princeton 1985. — Recent works in japanese: Tatsusaburō Hayashiya, *Chūsei geinō shi no kenkyū*, Tokyo 1960; idem, *Machishū*, Tokyo 1964; Kiyoshi Yokoi, *Chūsei minshū no seikatsu bunka*, Tokyo 1975; Takeshi Moriya, *"Kabuki" no jidai*, Tokyo 1976; Isao Kumakura, *Sen no Rigyū*, Tokyo 1978; Kiyoshi Yokoi, *Higashiyama bunka*, Tokyo 1979; Toshio Kuroda, *Jisha seiryoku*, Tokyo 1980; Takeshi Moriya, *Chūsei e no shiza*, Tokyo 1984.

Foreign Contacts: George B. Sansom, *The Western World and Japan*, London 1950; Michael Cooper, *They Came to Japan: An Anthology of European Reports on Japan, 1543–1640*, Berkeley 1965; George Elison, *Deus Destroyed: The Image of Christianity in Early Modern Japan*, Cambridge, Mass. 1973. — Recent works in japanese: Takeo Tanaka, *Chūsei kaigai kōshō shi no kenkyū*, Tokyo 1959; Arimichi Ebisawa, *Nihon kiristan shi*, Tokyo 1966.

Martin Collcutt is Professor of East Asian Studies, Princeton University.

KINSEI: EARLY MODERN JAPAN

Marius B. Jansen

The period from the sixteenth to the nineteenth centuries is usually referred to in Japan as early modern (*kinsei*). The age begins with the great unifiers whose conquests restored unity to the land after a century of intermittent civil war and extends through the institutions worked out by Tokugawa Ieyasu, founder of the third and longest-lived shogunate, its sway extending to the Meiji Restoration of 1868. The peace, order, and bureaucratic rule of this era explain the "modern," but its rigid feudal social and political institutions require the qualification "early." This remarkable period began with unprecedented violence, followed by 250 years of peace. Rigid rules divided society into closed status groups designed to prevent challenge to the hereditary ruling samurai caste. Political regulations which segregated the warrior class in urban centers hastened commercialization and eventually brought about the social change and challenge against which the founders had tried to guard.

UNIFICATION

The Tokugawa policy ended a dualism that had characterized official status since Heian times by cutting the imperial court off from political power. For centuries the warrior class, which had its own status in law, property, and dress, had sought additional prestige through association with local officials who claimed the authority of the court. Neither the Kamakura nor Muromachi (Ashikaga) shogunates destroyed this dualism completely, and in the disorder of the sixteenth century the priority warring lords gave to emperor and shogun was determined by the particular features of their geographical and historical setting. As sovereign and shogun were both in Kyoto, however, the dualism of the structure was moderated by the fact that both were ineffective and located in the same place.

At the end of the sixteenth century the three unifiers simplified this authority structure by ending the dualism of court and camp. Oda Nobunaga (1534–1582) marched into Kyoto, ostensibly in response to requests from the emperor Ōgimachi and shogun Ashikaga Yoshiaki, but once there, he placed the shogun under such strict controls that he ended in exile. Nobunaga claimed full authority over the warrior class and gained additional status from the court. He first received and then resigned high bureaucratic posts under the old order, after which he turned relations with the court over to a deputy. Toyotomi Hideyoshi (1536–1598) continued these policies. He first utilized the court, accepting the highest court ranks and then passing them on to his infant son. He also combined moves to pacify the countryside with steps to secure greater control over the military houses. With military unification came orders to collect weapons held by the populace; farmers were told that their swords would be melted down to construct a Buddha, which would do them more good. In 1591 sweeping edicts forbade commoners to harbor samurai, and lords to take unattached samurai into their employ. Full-time samurai now replaced the sturdy farmer-soldiers of the past, and movement between classes ended. Hideyoshi's desire to consolidate and use the enormous power he had now assembled combined with his vaulting ambition, producing plans for the conquest of China via Korea (1592 and 1597); when these expeditions failed, the Hideyoshi era came to an end.

Tokugawa Ieyasu (1542–1616, shogun 1603–1605) completed the unification of the authority structure his two predecessors had begun. Until his defeat of Hideyoshi's heir, Hideyori, at Osaka, he had to share control and influence over the imperial court. Of his twenty-nine months as shogun he

spent twenty-one in the Kyoto area, vying with young Hideyori in shows of respect for the court while he carefully developed his network and secured exclusive control over court appointments. His final attack on the Osaka castle in 1615 was explained in part by Hideyori's failure to clear with him the appointment of some of his vassals to court offices. By then Ieyasu had passed on his own court honors and titles, together with the office of shogun, to his son. In that same year he issued regulations for the military houses and for the court and nobles. Control of the former would have been imperfect without control over the court, which was henceforth walled off from interference with and from the samurai chiefs. The emperor was now reduced to a purely symbolic role, and the shogun no longer functioned as a court official. The unifiers had thus sought the embrace of the court, then restricted, and finally cut its access to the military houses that held political power.

The unifiers also sought, profited from, and then abandoned contacts with the maritime West. Portuguese trading vessels had come to Japan in the 1540s bringing Chinese goods, Jesuit missionaries, and firearms. Japanese feudal lords tolerated the missionaries for the sake of the guns, and both Catholicism and the manufacture of firearms prospered in the years that followed. Firearms changed the nature of warfare; Nobunaga was particularly quick to devise tactics appropriate to the new weapon. Massive castles with clear fields of fire were situated on hills in the center of the plains they controlled, and bodies of foot soldiers armed with muskets were schooled to provoke and destroy charges by mounted knights against fixed positions. Firearms were manufactured in large numbers, but after Ieyasu's victories at Sekigahara (1600) and Osaka (1615), the need for them came to an end and with that, their production. Guns remained listed in the inventory of arms throughout the Tokugawa period, but in centuries of peace the prerogatives and honor of the samurai sword relegated the foot soldier's musket to lower-class uses such as hunting and the suppression of an occasional peasant rebellion. When warfare returned in the 1860s, armies of men carried their ancestors' weapons, and it was not long before renewed import and manufacture of guns replaced the sword, this time permanently.

The Catholic missionaries who brought knowledge of sixteenth-century Europe to Japan were figures of interest to the feudal lords they contacted, and objects of fascination for the artists who depicted them on Southern Barbarian (Namban) screens. Their accounts cut through the formal histories of the time to give us living pictures of Japan's military leaders. Nobunaga, who took terrible vengeance on Buddhist sectarians who resisted his will, thought well of the Jesuits, and in Hideyoshi's years the dress and ritual of the visitors become objects of faddish interest. The Jesuits worked with skill and patience, and they and the Dominicans and Franciscans who followed in Spanish ships later in the century found Japan a fertile ground for their teaching. Some of Hideyoshi's finest generals were converts, and the entire port of Nagasaki was turned over to the Iberians by the local daimyo for their use and his profit. After his conquest of Kyushu in 1587, Hideyoshi turned on the missionaries and ordered them out of Japan, but except for scattered martyrdoms, systematic persecution did not come until Tokugawa times. In the 1630s a rebellion in Kyushu took on Christian tones from samurai converts, who joined in after having been dispossessed because of the punishment of their lords. Thereafter Christians were hunted down mercilessly in a persecution so thorough that the teaching survived largely as a form of folk religion in attenuated form in southern Japan among villagers, who adopted elaborate methods to conceal and camouflage their practice and belief. Both Japanese and Westerners were startled to learn of this community when foreigners returned to Nagasaki in the 1860s; its adherents never fully returned to formal churches, even after this became possible in modern times.

The unifiers also experimented with overseas commerce, but never found a way of reconciling it with their concern for stability and security. Nobunaga spoke of mainland conquest, and Hideyoshi staked his reputation and power on campaigns designed to conquer China. The effort failed when his armies, initially victorious in Korea, foundered for lack of naval support and were defeated by Chinese armies that crossed the Yalu to protect Korea. Tokugawa Ieyasu devoted much effort to restoring relations with Korea. A trading station at Pusan, maintained by the daimyo of Tsushima, provided a channel for the export of Japanese silver bullion in exchange for Chinese goods. Korean missions came to Tokugawa Japan to congratulate new shoguns at their accession, and in the early decades they provided evidence of the shogun's international standing for the daimyo. Japanese trade and commerce with Southeast Asia also grew. Temples and merchants joined to sponsor trading ventures which, after the Tokugawa victory, were authorized

Tray, early 17th century, Oribe stoneware, No. 78

Portable cabinet, late 16th–early 17th century, lacquered
wood, No. 42

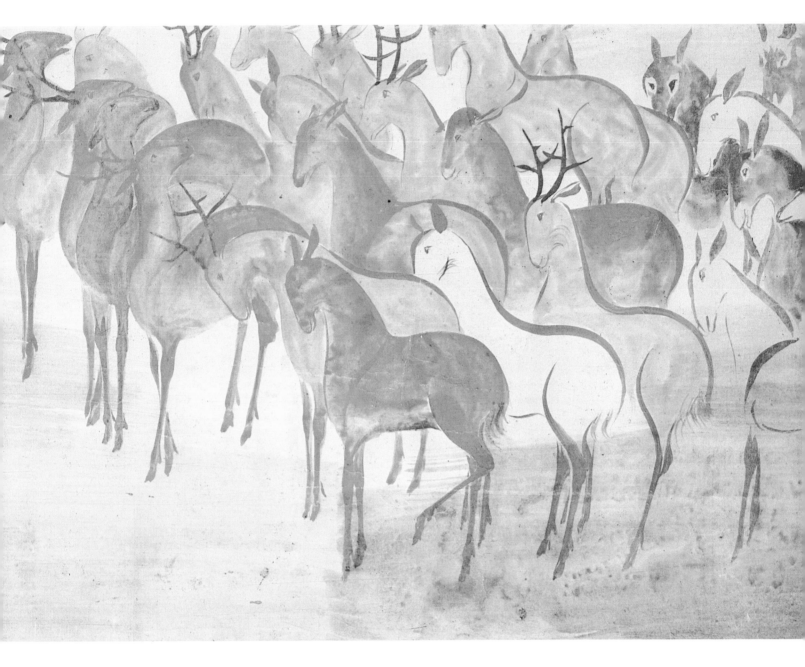

Section of the *Deer Scroll* (detail), Honami Kōetsu and Tawaraya
Sōtatsu, early 17th century, ink, gold, and silver on paper, No. 58

by shogunal permits. The fortunes of war and persecution of Christians also provided numbers of Japanese travelers and emigrants to Southeast Asia. Japanese communities dotted the area; the Dutch considered utilizing them as mercenaries for the conquest of the Indies, and the leader of a Japanese community in the Thai kingdom of Ayuthia, Yamada Nagamasa, was for a time the most powerful official there. The Tokugawa examined the possibility of direct relations with China, only to conclude that it would be impossible to arrange them on a basis of equality. In 1609 the conquest of Okinawa, chief island of the Ryukyu (Liu-Chiu) chain, by the daimyo of Kagoshima in Satsuma provided indirect access to mainland China, as the kingdom was permitted to maintain its tributary status with the mainland. After the proscription of Christianity in Japan, the Southeast Asian world also seemed to present risks of contamination and subversion by expatriates who had defected to Christianity. The final break with Christianity was accompanied by a decision to cut off Japanese stragglers there, and the edicts of that decade forbade the construction of ocean-going ships and the return of Japanese abroad on pain of death.

From 1640, Japan was thus closed in word but not quite in fact. Tsushima maintained trade with a Korea that continued to send missions on a basis of equality, and Satsuma controlled Okinawa. At Nagasaki the Protestant Dutch, who were fully prepared to reinforce Japanese suspicions of Catholicism, were permitted to bring ships on a fixed schedule to a trading station located at Deshima in Nagasaki harbor. Also at Nagasaki, Chinese ships, smaller than Dutch vessels but far more numerous, came throughout the period. Moored at the "China station" (*Tōjin yashiki*) were ships from Southeast Asia as far away as Thailand, as well as from coastal China. Thus, the Japanese had chosen not to go abroad and "closed" their world, but not their country, as goods from Korea, Southeast Asia, and the China coast came to Nagasaki, Kagoshima, and Tsushima.

One would expect an age of such energy, conquest, and upheaval to reflect the vitality and excitement of its time in flamboyant decoration and magnificence. The military despots might claim genealogical ties with the nobles of the past (Nobunaga with Taira, Hideyoshi with Fujiwara, Tokugawa with Minamoto), and profess to follow the cultural fashions to which they fell heir, but the Momoyama age of cultural splendor was also one that abandoned the restraint of the earlier esthetic in its desire to show the grandeur of its power. Traditional schools of painting — the Tosa and the

Kanō — flourished under the patronage of the new nabobs, and tea implements and the theatrical arts delighted them. The dim interiors of massive buildings shone with gold-leaf screens and elaborate sliding panels. Lacquer and architecture saw the same delight in lavish display. Hideyoshi responded with a parvenu's delight to gifts of gold and silver from his vassals, and designed for himself a gilded tea room before announcing a massive tea party designed to attract the precious tea goods of those who came. He himself practiced the chant and dance of Nō and performed before a long-suffering emperor.

It was above all the Tokugawa victory of 1600, followed as it was by construction of the massive castles and residences that dotted Japan into recent times, which provided unmatched opportunity and commissions for skilled artist-craftsmen, whose imagination soared with the dimensions of the surfaces they were asked to cover. The Kyoto Nijō palace, headquarters for the Tokugawa deputy who dealt with the imperial court, survives as a reminder of the splendor of the times. Screens depicting the glory of the capital indicate the fascination the old city had at a time when younger Edo (modern Tokyo) was only beginning to become a town of any size. Most of all, it was an age of decorators whose skills have never been surpassed. The artist Tawaraya Sōtatsu and his associate, Honami Kōetsu, and followers like Ogata Kōrin (who gave his name to the Rimpa school) combined calligraphy and decorative design in an exquisite tradition that came to represent new dimensions of perfection and of taste. Beginning in Kyoto, moving to Edo with Ogata Kōrin and Kenzan, and ending there with Sakai Hōitsu, the Rimpa masters illustrate the shift from courtier to samurai and merchant patronage that characterized the Tokugawa period.

THE EDO BAKUFU

The Tokugawa administrative structure centered at Edo and the term *bakufu* (military, literally: tent, headquarters) symbolized the fact that it was a military government that was to rule Japan for 250 years. Before Hideyoshi ordered Tokugawa Ieyasu to take Edo as his headquarters in 1590, the town had been a remote provincial center; under Tokugawa rule it became the most populous city in the world, with a population over one million. During the period the economic and cultural center of Japan shifted from the Osaka-Kyoto area to the Tokyo plain.

Once the Tokugawa were firmly in power they adopted a series of steps to retain that primacy. The regime's founders were limited by their experience and imagination, and their goal was more to per-

petuate hegemony than to achieve centralization. Ieyasu and his successors made continuous changes in the map of feudal holdings, but they never doubted the necessity to maintain that political fragmentation. They posited an agrarian society with rice productivity as its basis. Scholars of politics were aware of Japan's contrast with the centralization of China, and cited it as proof of the wisdom and benevolence of the Tokugawa founder.

Tokugawa Ieyasu was content to remain the largest of the daimyo, with direct holdings, amounting to almost one quarter of the assessed national yield in rice, dominating the most strategic plains and including the major cities. Domains rated in *koku* (approximately five bushels) of rice were entrusted to vassals; the minimum rating for feudal lords (daimyo) was ten thousand *koku*. Several dozen were lords of imposing domains, the largest of which rated at one million *koku*, but the great majority of daimyo ruled over postage-stamp-size principalities barely adequate to support them and their retainers. The daimyo were divided into categories. Ieyasu's sons and family collaterals were granted major domains of strategic importance; the three largest (Mito, Nagoya, Wakayama) controlled the principal routes to Edo and Kyoto, and were expected to provide sons eligible to succeed the shogun if he lacked an heir. The stability of the political structure was based on the loyalty of the Tokugawa house vassals, the hereditary (*fudai*) lords. From them were chosen members of the *bakufu*'s senior council (*rōjū*), a body that ruled on matters of national importance, while lesser *fudai* staffed the junior council, a body concerned with Tokugawa house interests. Some 80 of the 260 daimyo were termed "outside" (*tozama*) lords to indicate that they had entered the Tokugawa fold only after the defeat of the Toyotomi cause. While treated with ceremonial deference, they were denied any participation in Tokugawa councils. The administrative structure was thus dominated by hereditary Tokugawa vassals, and the greatest lords — collaterals as well as *tozama daimyō* — were unrepresented in discussions of national affairs. In the nineteenth century, the leaders of the Meiji Restoration sprang from southwestern *tozama daimyō* domains which had long resented this exclusion from influence at the center.

The *bakufu* lived on the revenue of its own territories, and did not tax the lords of autonomous domains, but they were expected, as loyal vassals, to render the equivalent of military service in peacetime. This included providing money, materials, and men for the massive construction and fortification projects of the early years. More important by far,

however, was a system of alternate attendance (*sankin kōtai*) designed to bring all daimyo to the shogun's capital in alternate years in a complex pattern of rotation. Even during periods when they were not on duty in Edo, daimyo and their principal vassals were expected to leave their families there as hostages. The long ceremonial processions that wound along the narrow but crowded roads were already remarkable to the German Engelbert Kaempfer when he visited the Dutch station at Nagasaki in the late seventeenth century; in the nineteenth century their rhythm and pomp were captured in prints such as Andō Hiroshige's series on the fifty-three check stations that monitored official travel along the Tokaido.

The system of alternate attendance was the single most important measure adopted by the Tokugawa regime. It limited and ultimately dominated the life of the daimyo, who had to maintain an average of three large estates in the Tokugawa capital, each garrisoned with samurai and financed by domain taxpayers. After the first generation of daimyo, heirs to rule were born in the Edo mansions and were unable to visit their domains until the off-duty years following their accession to rule. No device could have unified the experience and outlook of a ruling class more effectively. The Edo mansions came to absorb more and more of the disposable income of the ruling daimyo, and ostentation and competition replaced the frugality on which the samurai class was supposed to pride itself. Life in the barracks of the Edo estates also dominated the experience of the samurai who accompanied their lords.

The system made Edo a nerve center for the country. Provisioning so vast a section of the ruling class at great distances from home (the Kagoshima procession took just short of two months to reach Edo) required the transfer of tax grain in the form of currency. Daimyo were not allowed to reside in Osaka, which was set aside as a merchant city, but most of them needed warehouse agents there to merchandise their tax surplus. By 1700 Osaka had developed a rice market whose prices set national standards; agents sold and bought rice on speculation in this great commodity market, and merchant houses were involved in loans, guaranteed by future harvests, to even very great lords. Daimyo were also forbidden residences in Kyoto, but many major lords had agencies for the purchase of textiles and other products of the ancient capital's crafts. In this manner the descendants of the warrior chiefs of Sekigahara and Osaka became urbanized aristocrats who ruled by inherited authority instead of demonstrated ability. Even for their samurai, they

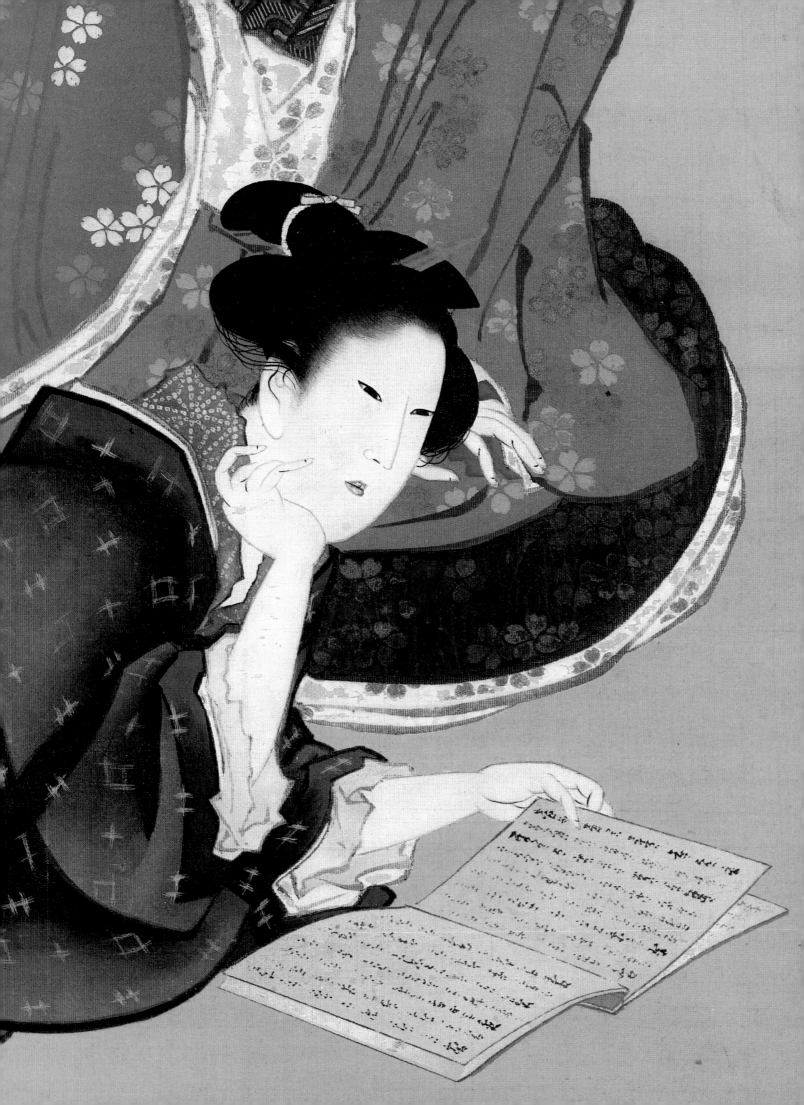

became more symbols of authority than wielders of power.

In place of the personal and sometimes capricious rule of earlier warrior chiefs, a structured and systematic bureaucratic order developed. However modest their domains, the lords had to develop parallel structures of officials for their household and public needs; they had to be represented at home when away and in Edo when home. Precedent and report replaced private decision and discretion. This required preparation. By the end of the seventeenth century it was becoming rare to find an illiterate samurai of any but the very lowest rank, and a century later, especially in the years after 1790, domain schools for samurai were being matched by private academies and parish schools for commoners. Skills of record keeping had become essential to the daily life of most Japanese family heads. After the proscription of Christianity, the *bakufu* periodically required of its vassals lists showing the Buddhist temple registration of all Japanese, to ward off the danger of Christian continuity. These lists, submitted with the householder's personal stamp and complete with information about dependents' ages and numbers, provide invaluable materials for modern studies of village population. They also illustrate the necessity and quality of village leaders' literacy.

Literacy provided readers for fiction produced in the *bakufu's* great cities. The Genroku era (1688–1704) witnessed an extraordinary flowering of narrative prose for commoners in the Osaka culture zone. A century later evidence of ever more pervasive literacy could be found in Edo popular culture. Inexpensive, block-printed illustrated books were distributed through the city after 1750 by commercial lending libraries; by the end of the century there were well over 650 in Edo alone. In the countryside, book vendors and lenders carrying libraries in back-pack boxes circulated even in remote mountain areas. Although most fiction (as *gesaku* — playful literature — suggests) was frivolous, handbooks on agronomy, which explained efficient methods of cultivation for crops such as tea, cotton, and tobacco, also circulated in hundreds of copies. The village elite concerned itself with poetry and native lore as well; indeed, into the late nineteenth century it was common to send newly minted poems to urban teachers who offered corrections at a set price per line.

What was true in the great cities was true to a lesser degree in provincial castle towns. Each daimyo maintained an administrative center according to his means, and domain castle towns had populations that averaged approximately 10 percent of the domain. Here the daimyo kept his residence and those of his collaterals, and housed, educated, and managed his army of samurai. His administrators did what they could to increase the supply of special and local products for sale in the cities in the interest of the domain treasury. For local samurai, as for their lord, periods of service in Edo naturally offered particularly satisfying service, but for the most part, men in the larger domains remained "provincial nationalists," becoming conscious of a larger, national loyalty only after the return of the West in the nineteenth century.

Domains also made efforts to develop local specialties for national urban markets. In ceramics the ware known as Imari provides an example. When Hideyoshi's generals returned from Korea on the eve of Tokugawa rule, some, impressed by Korean arts, brought Korean artisans home with them. Over time, the legacy of these Korean artisans transformed Japanese pottery making. Their innovations in kiln structure, firing, and glazing techniques are evident in the finest porcelains of the period, and of any age — Kakiemon, Imari, Nabeshima ware. A lower quality line of blue and white, exported through the Saga port of Imari, became widely used throughout Japan. The Dutch East India Company also exported it from Nagasaki, first as ballast and then as valued cargo that inspired European potters in Meissen and Delft.

In this manner Japanese artists and craftsmen, denied ready access to the goods of the outside world, responded to the spur of internal markets and rising standards of living to achieve new levels of skill and sophistication. Textiles, embroidery, lacquer, and metalwork also made giant strides in quality. Women's kimono and obi changed with the seasons and developed with the fashions. Dress for the stage and pleasure quarters provided demand for brocades of gorgeous tones. Sumptuary laws were designed to restrict elegance in commoner and especially in merchant dress, as they did in domestic architecture, but the ingenuity of fashion found ways to evade these restrictions by embellishing linings of garments and interiors of buildings.

The result of all this was a society increasingly commercialized and economically centralized, though still bound by institutional patterns worked out prior to these new circumstances. Agricultural productivity rose, particularly in the seventeenth century, but the formal tax rating of domains and actual assessments never fully took notice of this

Five Beautiful Women (detail), Katsushika Hokusai, early 19th century, ink and color on paper, No. 57

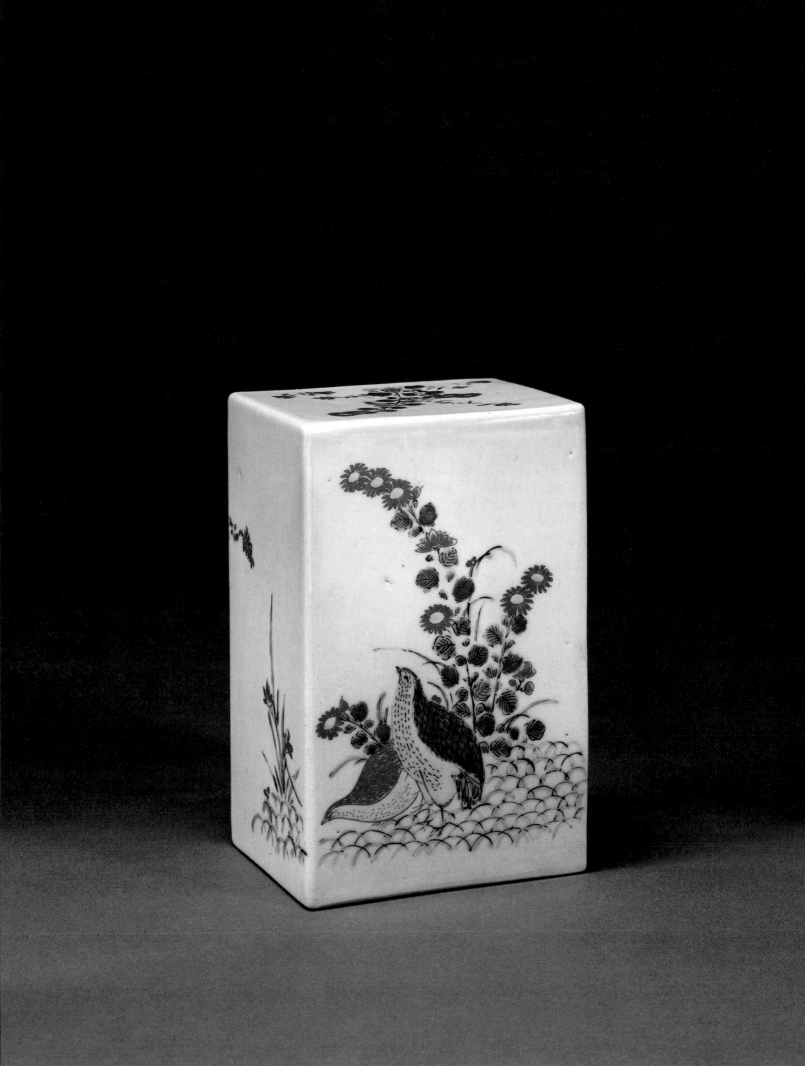

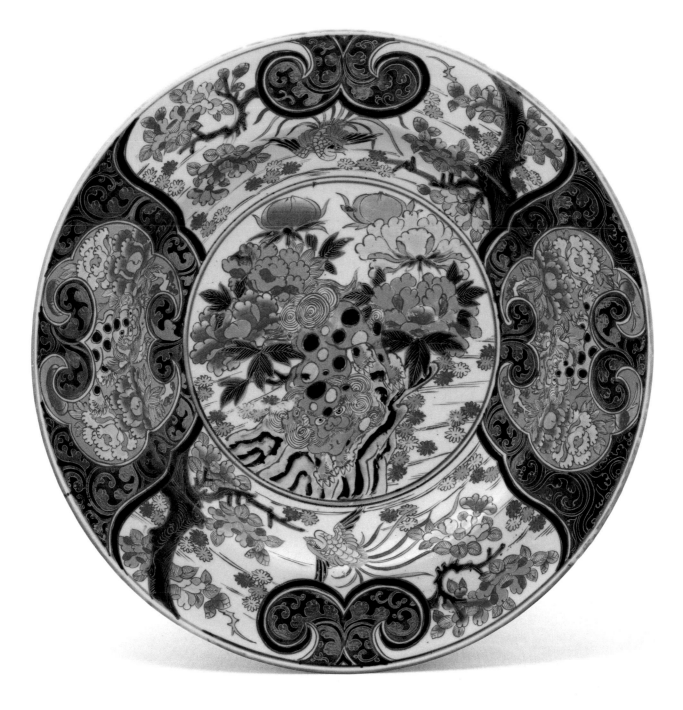

Plate, late 17th century, Imari porcelain, No. 86
FACING PAGE: Headrest, c. 1680, Kakiemon porcelain, No. 83

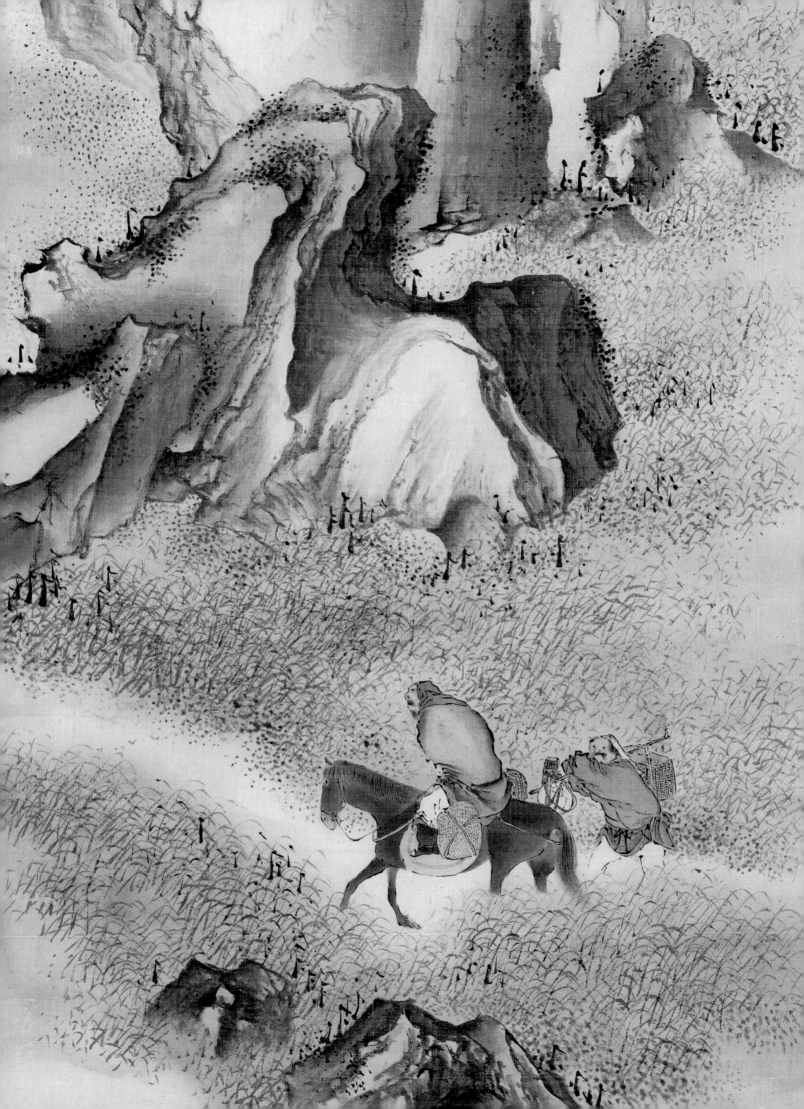

additional income. In the audience halls of Edo, daimyo were still arranged according to the ceremonial honors appropriate to income as recorded in 1600, and local administrators never developed a way of tapping urban wealth. Merchants, after all, and merchant wealth, were theoretically beneath the dignity of samurai intent on honor. Urban administrators were also poorly situated to extract the rural surplus from villages they rarely entered. The advantage lay with the village elders and landholders, who allocated the tax among the villagers. Samurai moralists' complaints of village leaders' luxury and pretentions make it clear that much of the agricultural surplus remained in the countryside, and village disputes and peasant protests — several thousand have been recorded for the period of Tokugawa rule — also reveal that that surplus was not shared equally. The village was an extremely competitive world, and the wealth of farm families rose and fell. Official efforts to resurvey and reassess were almost certain to spark protestations of indigence on the part of the farmers. At many times and in many areas those complaints were based on fact, especially in less progressive and less commercialized areas. In the 1730s, 1780s, and 1830s unfavorable weather and crop failures brought famine to most parts of Japan, each time provoking much talk of crisis and reform. Most proposals, however, were retrograde rather than progressive, and spoke of returning the samurai to the countryside so that the institutions of feudal decentralization would work better. But *bakufu* control measures demanded their presence in the cities. In any case, in an increasingly centralized and commercialized economy, proposals for greater domain autonomy were doomed to fail.

Tokugawa Institutions and Early Modern Culture

Early modern cultural developments were influenced in important ways by the institutional pattern of the Edo *bakufu*. Japan's unprecedentedly rapid urbanization under the social restraints of hereditary status groups produced a distinctive culture for commoners in the cities. The rapid growth of literacy made possible a flourishing publishing industry. Printing by movable type was known, but Japanese preferred the fluid lines of block printing and its possibilities for illustration; a publisher's establishment included engravers and printers as well as authors.

During the eighteenth century there was a gradual shift from amateur to professional writers, and by 1800 it became possible for successful authors to live from their writings. In the Kabuki and puppet theater professionalism had come a good deal earlier. Many writers were also successful engravers. In this setting woodblock printing made rapid strides. In the visual arts, paintings and prints of celebrated beauties, famous actors, and scenic spots acquainted buyers with recreational possibilities. Genre art was an important product of Tokugawa urbanization.

Poetry also responded to the leveling of tastes. The seventeen-syllable haiku associated with great figures like Bashō (1644–1694) and Buson (1716–1783) sought, through simplicity in vocabulary and directness in form, to capture the permanent in an evocation of evanescence. A tradition of what has been called haiku painting (*haiga*) accompanied this, with an emphasis on principles of abstraction in which only some of many features were delineated, with a wedding of word to image beautifully captured in the work of poet-painters like Bashō, Buson, and Goshun (also called Gekkei, 1752–1811).

Tokugawa restrictions and severity also contributed to an appreciation of the present and an awareness of the absurd. Censorship forbade publication dealing with current affairs, and a plethora of hortatory rules tried to bend people's attitudes and lives into patterns of disciplined conformity. Art and literature provided ways of standing apart from this pressure, sometimes inverting its values, more often stressing the commonalities that underlay status division. Not even stern restrictions on movement could prevent the development of a culture of travel with crowded roads, ubiquitous hostels, and rustic pleasure spots. Poet-pilgrims like Bashō and civilized samurai officials like the artist Watanabe Kazan (1793–1841) had little difficulty finding kindred spirits for evenings of poetry, sketching, and discussion in the communities through which they passed on their travels. Domains and the *bakufu* tried to keep their people at work at home, but pilgrimage, business, and health offered possibilities for excuses and escape. Travel books abounded; the prints of Hokusai and Hiroshige capture this passion for scenery and famous places. Other artists concentrated on figures of the stage and licensed quarter in booklets that lured travelers from afar.

The status system had the effect of compartmentalizing and perpetuating tastes and styles at times. The high feudality continued to patronize the artists of the Kanō lineage, and its classical landscapes inhabited by sages in the Chinese manner continued popular long after the great figures who inaugurated the style in the early seventeenth

Travelers in a Winter Landscape (detail), Yosa Buson, c. 1778, ink and color on silk, No. 61

century had passed from the stage. The appeal of this art for the nineteenth-century philosopher Ernest Fenollosa (who had himself adopted by Kanō Hōgai) guaranteed for it an important place in American collections and libraries.

Tokugawa restrictions on access to knowledge of the outside world also led to growing interest in what might lie beyond the oceans. Japanese interest in Chinese civilization was never greater than during the Tokugawa centuries. Confucian studies flourished and left a permanent imprint on ethics and morality. The educated were able to write in Chinese as well as in Japanese, and the greater length of Chinese verse forms made Chinese poems (*kanshi*) appropriate vehicles for thoughtful reflection. The import of Chinese books via Nagasaki never stopped. A school of sinophiles who styled themselves *bunjin* (literati) modeled their behavior and painting on certain Ming- and Qing-dynasty artists. Not a few adopted Chinese names (Baitei, 1734–1810, for example, born in Kyoto and known for his landscapes) to signify their admiration for Chinese civilization. Ike Taiga (1723–1776), sinophile, eccentric, and Zen enthusiast, also collaborated with Buson to produce a much-praised album of illustrations for a series of Chinese poems. Unlike most house-centered artistic lineages, the *bunjin* were individualists who did not organize themselves.

In the eighteenth century the import of Dutch books also fueled new interest in Western learning, and in the 1770s a translation movement got underway which grew steadily until the Tokugawa fall. For a time trips to Nagasaki, where foreigners were to be seen, had almost the romance of travel abroad for study. The shogunate punished scholars who used their learning to criticize its policies, but it also coopted the most renowned to work in its own translation projects. These "Dutch scholars" went beyond medicine and warfare, the two sciences of the greatest interest to the authorities, to study perspective, copper-plate engraving, and other subjects. Watanabe Kazan drew on this knowledge to enrich his own painting, but also he fell victim to charges of undue admiration for the West and political subversion.

The extremes of sinophilism produced a vigorous countermovement of affirmation for the priority and superior morality of the original Japanese tradition. Scholars of "national learning" (*kokugaku*) established new benchmarks in the study of Japan's literary classics, and went on

from this to derogate foreign, especially Chinese, influence. They pointed to the virtues of the imperial institution as proof of the greatness of the native tradition. The artistic dimension of this effort was a revival of the ancient Tosa school of painting, called *fukko yamato-e*, in a focus on classical traditions of the imperial court; the political dimension was a flowering of imperial loyalism in the nineteenth century.

Many great figures of late Tokugawa art moved freely within this fluid scene to utilize what appealed to them. Maruyama Ōkyo (1733–1795) studied with a Kanō master and learned from European perspective and from Ming examples, becoming known for a style and school that combined classical Muromachi *suiboku* with close observation of nature. Watanabe Kazan began, as a student of Tani Bunchō, with Qing techniques of painting flowers and learned from Western examples available to him, using chiaroscuro and perspective, though he restricted himself to Japanese painting media. Increasingly involved by Western civilization, he painted some striking portraits, but his sketches were in *haiga* style while other paintings owed much to China.

LATE TOKUGAWA

By the early years of the nineteenth century Japanese society had changed almost beyond description from the society that sixteenth-century warrior unifiers had tried to structure. Outwardly its institutions were unchanged; status restrictions between classes and rank restrictions within the samurai class remained to frustrate the hopes and ambitions of the able. The upper rungs of samurai society had become more aristocratic and culturally sophisticated, while at lower levels (as the modern educator Fukuzawa Yukichi recalled) ordinary soldiers were more like workers, poorly educated and rough of speech, expected to assume a subservient attitude toward their superiors, and very poorly paid. Leading rural and urban "commoners," by contrast, whether officially denigrated as peasants, artisans, or even merchants, lived in far greater affluence and educated their children better than could most samurai. Japan had become more urbanized, better educated, and far more productive. Cultural associations and poetry-writing groups saw members of different status groups interact on a basis of near-equality. The majority of samurai had become virtually irrelevant to the operation of society. Merchant lenders and rural leaders were

Scenes of Life in and around the Capital (detail), second half 17th century, ink, color, and gold on paper, No. 52

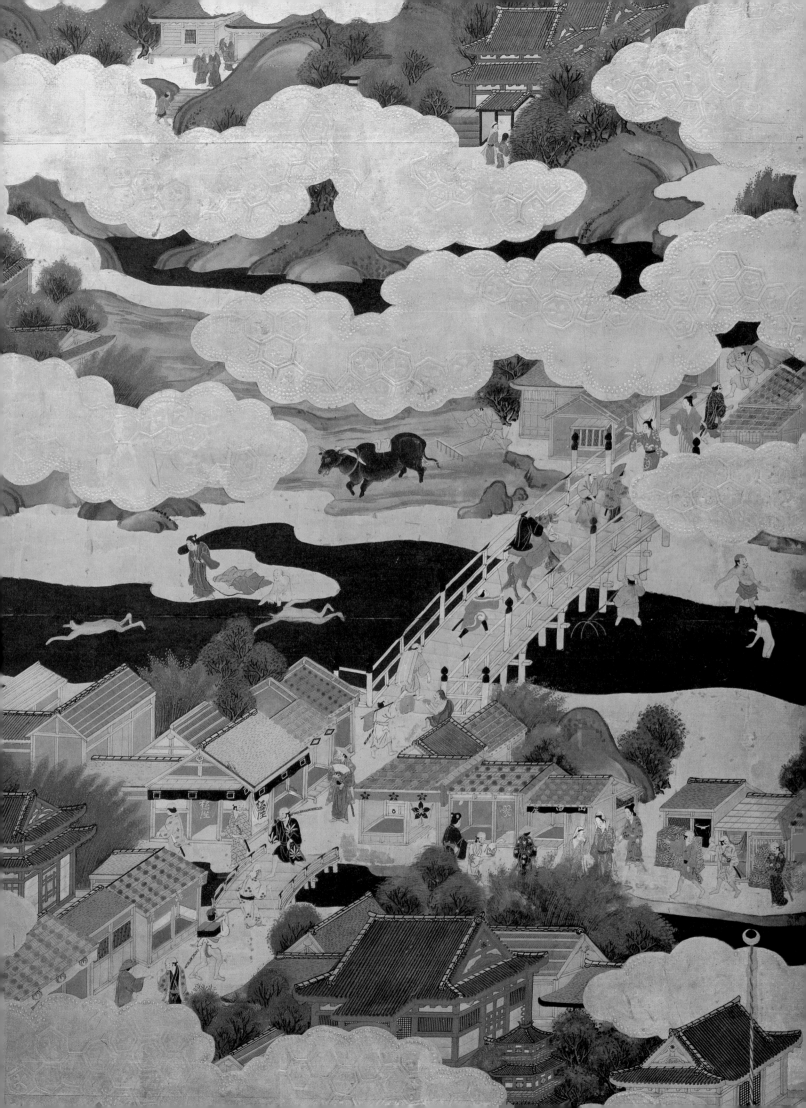

frequently granted the dignity of surnames and swords, while poverty-stricken samurai were often reduced to pawning theirs.

In the nineteenth century an awareness of the approach of the Western world began with Russian requests for trading rights, and with the news relayed by the reluctant Dutch, whose country had fallen to France, of the Napoleonic upheavals in Europe. The shogunate and its leading vassals put new effort into gaining and monopolizing the information available through Dutch books. The study of English and French was begun. In the early 1840s word of the English defeat of China in the Opium War came as shattering evidence of impending danger. Accurate information was soon at hand from Chinese as well as from European sources, but rigid and uncertain *bakufu* bureaucrats were unable to bring themselves to respond. During the 1830s devastating crop failures also brought famines and efforts for economic reconstruction. This double set of crises began to activate a long-dormant politics; the coming of Perry in 1853 speeded this. Young samurai in southwestern fiefs were suffused with a growing sense of crisis, but in the face of evidence of shogunal faltering, they also felt stirrings of opportunity for themselves and for their domain. News of *bakufu* indecision and failure could not be suppressed, for Japanese society had become unified to a greater extent than ever before. At Edo the gathering of retainers from all parts of the country provided a hothouse atmosphere for rumor and alarm, one with transmission lines to every domain in the land. Goods, tastes,

rumors, and discontent could spread along the lines of communication and supply. In the face of the truly foreign, the depth of local antipathies and jealousies began gradually to be transformed into a national response to external stimulus.

The appearance of Commodore Perry, followed by the treaty proposed by Townsend Harris, thus led to an ever-quickening cycle of *bakufu* response and vassal confrontation, which brought the regime to an end in 1868. Feudal divisions lingered on briefly, but they also were doomed. The return of the West had proved the need for greater centralization and efficiency, and the Meiji Restoration of 1868 produced a national state that soon disarmed the samurai as effectively as Hideyoshi had disarmed the peasants.

The samurai who led that movement were of modest rank but impressive cultural sophistication. Kido Takayoshi (1833–1877) prided himself on his poetry and calligraphy; his diary is full of references to paintings he purchased, and during his tour of the West he sent for a favorite scroll to sustain him during his travels. His disciple Inoue Kaoru (1835–1915) was quick to use his advantages to purchase the art works of disestablished daimyo, thereby establishing one of modern Japan's major private art collections. It was in their own interest, as well as that of their countrymen, that Kido and his associates worked out the wording of an Imperial Charter Oath in 1868 that promised that "evils of the past" would be abandoned, all classes would have the opportunity to achieve their "just aspirations," and knowledge would be "sought throughout the world."

Bibliographical Note

UNIFICATION: A. L. Sadler, *The Maker of Modern Japan: The Life of Tokugawa Ieyasu*, London 1937; Delmer M. Brown, "The Impact of Firearms on Japanese Warfare, 1543–98," *Far Eastern Quarterly* 7:3 (1948); George Elison and Bardwell L. Smith, eds., *Warlords, Artists, and Commoners: Japan in the Sixteenth Century*, Honolulu 1981; John Whitney Hall, Nagahara Keiji, and Kozo Yamamura, eds., *Japan Before Tokugawa: Political Consolidation and Economic Growth, 1500 to 1650*, Princeton 1981; Mary Elizabeth Berry, *Hideyoshi*, Cambridge, Mass. 1982.

WESTERN CONTACT AND SECLUSION SYSTEM: C. R. Boxer, *The Christian Century in Japan 1549–1650*, Berkeley 1951; T. Volker, *Porcelain and the Dutch East India Company ... 1602–1682*, Leiden 1954; idem, *The Japanese Porcelain Trade of the Dutch East India Company after 1683*, Leiden 1959; Michael Cooper, S. J., ed., *They Came to Japan: An Anthology of European Reports on Japan, 1543–1640*, Berkeley 1965; George Elison, *Deus Destroyed: The Image of Christianity in Early Modern Japan*, Cambridge, Mass. 1973; Ronald P. Toby, *State and Diplomacy in Early Modern Japan: Asia in the Development of the Tokugawa Bakufu*, Princeton 1984.

GOVERNMENT AND ADMINISTRATION: John Whitney Hall, *Tanuma Okitsugu (1719–1788): Forerunner of Modern Japan*, Cambridge, Mass. 1955; Toshio G. Tsukahira, *Feudal Control in Tokugawa Japan: The Sankin Kōtai System*, Cambridge, Mass. 1966; Conrad Totman, *Politics in the Tokugawa Bakufu 1600-1843*, Cambridge, Mass. 1967; John W. Hall and Marius B. Jansen, eds., *Studies in the Institutional History of Early Modern Japan*, Princeton 1968; Harold Bolitho, *Treasures Among Men: The Fudai Daimyo in Tokugawa Japan*, New Haven 1974.

ECONOMIC AND SOCIAL CHANGE: Thomas C. Smith, *The Agrarian Origins of Modern Japan*, Stanford 1959; C. J. Dunn, *Everyday Life in Traditional Japan*, London 1969; William B. Hauser, *Economic Institutional Change in Tokugawa Japan: Osaka and the Kinai Cotton Trade*, Cambridge, Eng. 1974; Susan B. Hanley and Kozo Yamamura, *Economic and Demographic Change in Preindustrial Japan, 1600–1868*, Princeton 1977.

KINSEI CULTURE: Robert N. Bellah, *Tokugawa Religion: The Values of Pre-Industrial Japan*, Glencoe, Ill. 1957; Donald Keene, *Major Plays of Chikamatsu*, New York 1961; R. P. Dore, *Education in Tokugawa Japan*, Berkeley 1965; Donald Keene, *World Within Walls: Japanese Literature of the Pre-Modern Era 1600–1867*, New York 1976; Burton Watson, trans., *Japanese Literature in Chinese: Poetry and Prose in Chinese by Japanese Writers of the Later Period*, vol. 2, New York 1976; Richard Rubinger, *Private Academies of Tokugawa Japan*, Princeton 1982; Ekkehard May, *Die Komerzialisierung der japanischen Literatur in der späten Edo-Zeit (1751-1868)*, Wiesbaden 1983; Peter Nosco, ed., *Confucianism and Tokugawa Culture*, Princeton 1984.

REDISCOVERY OF THE WEST: C. R. Boxer, *Jan Compagnie in Japan 1600–1850*, The Hague 1950; Donald Keene, *The Japanese Discovery of Europe, 1720–1830*, Stanford 1969; Calvin L. French, *Shiba Kōkan: Artist, Innovator and Pioneer in the Westernization of Japan*, New York 1974; Marius B. Jansen, *Japan and Its World: Two Centuries of Change*, Princeton 1980; Grant K. Goodman, *Japan: The Dutch Experience*, London 1986.

Marius B. Jansen is Professor of Japanese History, Princeton University.

OVERLEAF: *Bamboo and Poppies* (detail), Kanō Shigenobu, c. 1625, ink and color on gold-covered paper, No. 50

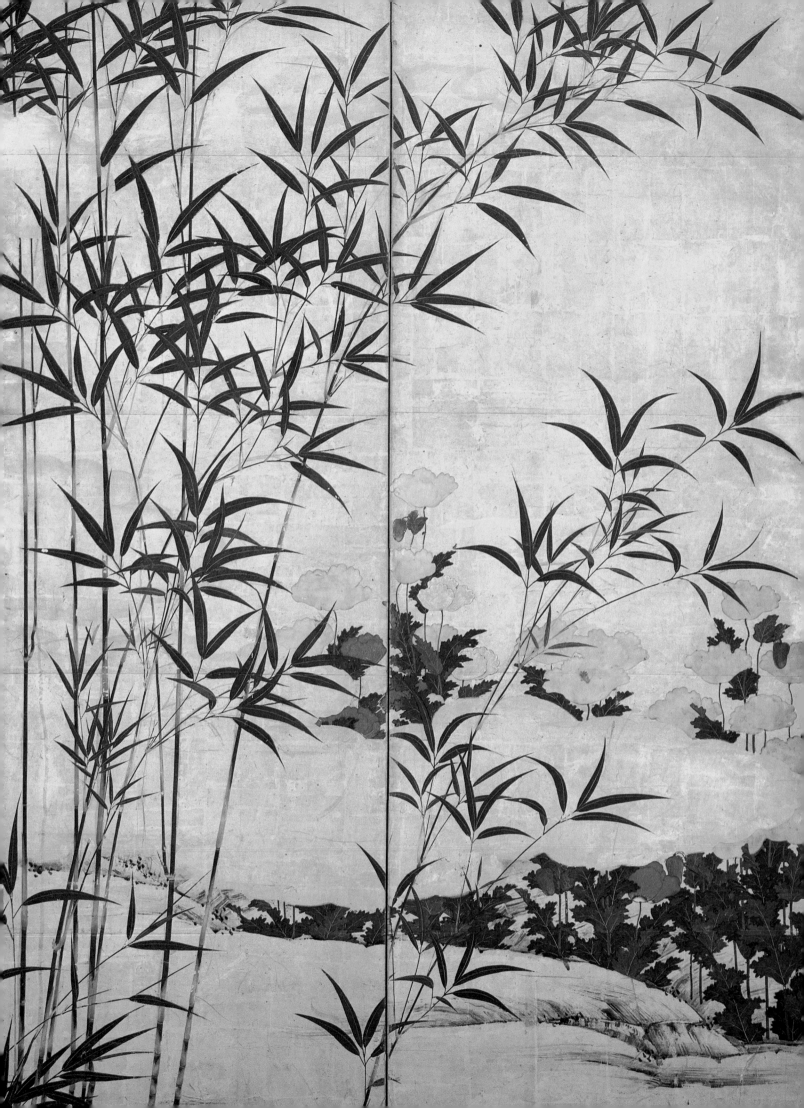

Treasures of Japanese Art
in the Collection of
the Seattle Art Museum

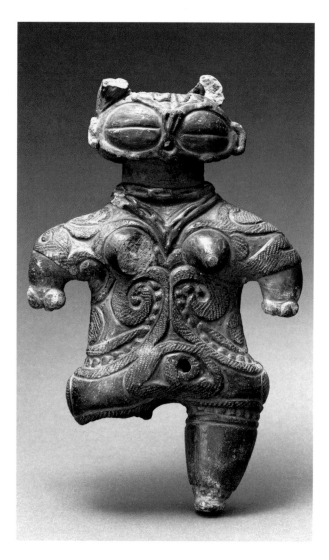

1.
Jōmon figurine (*dogū*)
Latest Jōmon period, c. 800 B.C.; from the Tōhoku region,
 reportedly from Kamegaoka
Jōmon ware, pottery with incised and cord-impressed
 decoration
H. 9¼″ (23.5 cm)
Floyd A. Naramore Memorial Purchase Fund 76.35

Ceramic figurines made during the Jōmon period are called *dogū* (literally: pottery doll, or puppet). They were produced in varying degrees of complexity from the Early Jōmon period, but reached elaborate forms from the Middle Jōmon onward. Such figurines have been found at many sites, principally throughout central and northern Japan; the majority date to the last millennium of the Jōmon period. During the nineteenth century, a Late Jōmon site was dug at Kamegaoka, Aomori prefecture, in northern Honshu; it revealed an enormous amount of pottery, including a very large number of these distinctive figurines. The site had been known since the seventeenth century, when the castle at Tsugaru was being constructed. Much material had been unearthed over time, and, beginning in the twentieth century, much was distributed around the world. By now, the site has been disturbed and picked over to such an extent that, although it is well known and produced a great amount of material, it is no longer suitable as a type-site. Other sites proved more rewarding for archaeologists; in particular one at Ōbora (or Ōhora) in Iwate prefecture has revealed, under scientific excavation, all the types found at Kamegaoka. Egami says that the larger, hollow types such as the one illustrated here appear in the Ōbora BC phase and the early part of Ōbora C_1.

The Seattle figurine, with its stubby, down-turned arms and vestigial hands and feet, belongs to one of the most impressive types found at Kamegaoka and displays a characteristic broad-shouldered, wide-stance pose. Despite its stance, the type seems not to have been designed to stand alone, although examples considered to be earlier and also later were apparently designed to stand independently on broad feet. The larger versions of this type, like this one, have hollow bodies with scrolling patterns marked with cord impressions, a decorative technique popular in Jōmon-culture ceramics from almost the earliest times. Its widespread use and persistence led to assigning the name *jōmon* (literally: cord marking) to this extraordinarily long-lived prehistoric culture phase in Japan. Cord marking restricted to scrolling bands, such as seen here, is characteristic of Latest Jōmon ceramics. Other decorations at the neck and down the front of the figurine suggest jewelry.

The prominent breasts are undecorated, as are the thick legs that appear below what seems to be the hem of a garment. A crownlike headgear, usual on this type of figurine, is now missing from this example. The eyes are perhaps the most impressive feature about these figurines. The wide stare was quickly recognized as a common characteristic of this type and led, through some misunderstanding, to use of the term 'goggle-eye' when such figures were first studied, in the belief the eye form represented goggles worn for protection against the glare of the sun on the northern snows — an explanation no longer generally accepted. This particular type is distinctive for its surface decoration and eye treatment, and also for the exceptional size of some examples — the largest reaching over 12 inches in height.

Among the large number of Jōmon pots recovered from northern Honshu sites are many surely intended for ritual use. Paralleling the increase in ritual pots is an increase in the number of effigies. Their prominent breasts and abdomens recall fertility goddesses found in prehistoric Europe and elsewhere. The purpose of these figurines is not known exactly; however, among the latest types are some that show clearly recognizable human females in poses suggesting an association with birth rites.

Hiroyuki Kaneko discusses the late *dogū* briefly in terms of their relationship to symbolic burials. He notes that *dogū*, wherever found, are damaged, apparently purposely, usually about the head and chest. The figures seem to have been assembled from the various parts, so that even though baked whole, their components would break apart easily. He further notes that both damage and ritual burial suggest a desire to insure the repose of the soul of a woman who died in childbirth. Buried examples, whether found in the north or as far afield as Kumamoto prefecture in Kyushu, appear to have been designed to be broken before burial. Somewhat similarly, others equate the figurines with sympathetic magic to transfer pain and suffering to the *dogū*. These enigmatic icons, with their hieratic gaze and ritualistic distortions of limbs covered with esoteric designs, suggest a magical medium, enabling the living to contact and even perhaps influence the unseen forces controlling life and death.

Dates for the earliest phases of Jōmon culture are still somewhat in dispute among scholars. The late phases, especially the Latest, or Banki, are generally accepted as dating from about 1000 B.C. to about 300 B.C., when the Yayoi culture began intruding into Japan. Jōmon culture lingered in the far north of Honshu somewhat longer than elsewhere; yet for practical purposes the Jōmon culture was no longer a force after about 250 B.C. The Seattle figurine has been dated scientifically by thermoluminescent testing. Examination in 1976 at the Research Laboratory for Archaeology, Oxford, England, determined that the piece had been fired between 2,480 and 3,960 years ago; the report dated the piece to c. 800 B.C. This span of time clearly relates the piece to the latest phase of the Jōmon culture, a time consistent with the accepted dates for the Kamegaoka site where this figurine is said to have been collected.

William Jay Rathbun (WJR) *is Curator of Japanese Art, Seattle Art Museum.*

The people of the Jōmon period led a hunting and gathering style of life, obtaining their necessities by pursuing game and fish and gathering shellfish, berries, and nuts in season. Subsequent migrations of peoples from the Asian continent, beginning in about the fourth century B.C., introduced into the islands new technology and concepts that greatly altered life there. Wet rice cultivation, introduced at approximately the end of the first century B.C., and a culture of settled habitations, social ranking, and a knowledge of metalworking were among the dramatic innovations. Weaving and a new type of pottery making also developed. Some elements of the older Jōmon lifestyle were adapted in the new. Not everything from outside that came to make up this new cultural matrix arrived at once, nor from the same source, nor was the level of development, once in Japan, uniform. But over time, the change from the standards of the Jōmon was pronounced, and in terms of the history of civilizations, these changes occurred with great rapidity. The period from about 300 B.C. until about 300 A.D. — termed 'Yayoi,' after a district in Tokyo where archaeological materials were initially identified — witnessed such dynamic development that by the fourth century, the people in the islands were poised for the unification of the country during what is now called the Kofun period under the command of the strongest of the newly emerged clans.

The settled life of agriculturists, made possible by the wet rice techniques, was perhaps the single most influential factor in promoting the development of other aspects of the culture, such as social ranking and a clearly identifiable ruling class. Workers were grouped by specialty; among the most prominent specialists, from the standpoint of archaeology, were the potters. By the middle of the Yayoi period they were using the potter's wheel to make restrained and understated ceramics, the antithesis of the flamboyant Jōmon pottery. Bronze workers were another important group of technologists. Bronze objects imported at this time from China and Korea included both mirrors and weapons. These objects took on a special value in the society of the Yayoi and were obviously highly treasured, probably as symbols of rank and power. Many bronzes produced by Japanese craftsmen were fashioned like real weapons, but were of unwieldy size and of insufficient temper to be effective in combat. These imitation weapons seem to have been designed for magical and ceremonial use, for they have been found in ritual burials. Both real imported weapons and locally made symbolic

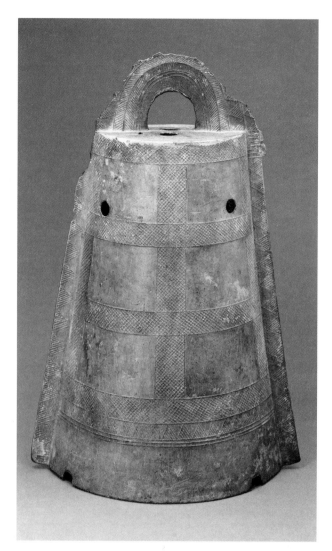

2.
Ceremonial object (*dōtaku*)
Yayoi period, 1st century A.D.
Bronze
H. 15½" (39.4 cm)
Eugene Fuller Memorial Collection 51.104
Plate on p. 17

ones were also placed in burials of the ruling elite. Chinese mirrors were also imitated in bronze in Japan; similarly, these mirrors possessed powerful magical properties and were prominent among burial goods.

The most fascinating and artistically imaginative Yayoi bronze objects are the mysterious bell-shaped *dōtaku*, which have been found buried either singly or in groups. The number in a given burial has ranged up to fourteen. These deposits were not part of human burials but were placed apart, usually on promontories, in relation to

Yayoi-period sites; the burials were made, it is theorized, to propitiate deities in order to achieve good crops and to forestall difficulties.

Dōtaku were cast in carved stone or clay molds formed in two halves, with designs appearing as low relief on the surface of the *dōtaku* carved into the recessed spaces of each half. The two halves were fitted together and a core piece inserted, which served to reserve a narrow space between the inner and outer forms, into which the molten bronze was poured. The core was held in place by posts which, when the bronze was poured, created holes that appear in the upper portions and as notches along the bottom edge. These holes and notches are found in all *dōtaku*. These bell-shaped bronzes appeared about the first century B.C., and production persisted to the end of the Yayoi period.

Japanese archaeologists recognize four distinct periods of development in *dōtaku*. The earliest type was relatively smaller than the Seattle example and somewhat heavier, both in thickness and in proportions. In the second phase, the fin along the sides and the flaring line of the body appeared and characterized the *dōtaku* profile thereafter. The semicircular handle became a featured decoration; it grew more emphatic in size, with a flat extension which merged with the fin along each side of the body. The third phase, to which the Seattle *dōtaku* belongs, was a period of extreme standardization in shape and design, and the latest phase was characterized by great size and elaboration of decoration. Some examples reached as much as 4 feet in height, and the heavy, raised lines and multiple pairs of flanges became the new standard. The handles in the latest forms were often embellished with additional flanges totally unrelated to function.

Japanese archaeologists have also classified *dōtaku* by type of decoration. This example belongs to the group called *kesa-dasuki*. This term refers to the panels dividing the body of the bell, which resemble the divisions on a Buddhist priest's robe, a *kesa*, and to the crossed line-patterns, which recall the criss-cross of *tasuki* cords, used to hold kimono sleeves up out of the way during work. In line with the top horizontal band of crossed lines appears a pair of small flanges; corresponding flanges also once projected on the other side. The simple fin or ridge along the edge of the bell carries a typical sawtooth pattern. A considerable portion of the handle has been lost; however, the original width, characteristic for this type, can be determined where the handle joins the body of the bell.

The decoration of this *dōtaku*, while characteristic of an important type, is restrained and perhaps simple in comparison with others, such as those with panels of symmetrical wavy lines thought to represent flowing water. The most detailed and imaginative *dōtaku* bear depictions of humans and animals, and have been a valuable resource for scholars investigating life in Yayoi times. These decorative elements show humans in many activities: with bows and arrows and spears pursuing deer and other animals, pounding mortars, climbing ladders to storehouses, and engaging in fights; other figures shown in boats suggest warfare. The animals depicted include deer, wild boar, dogs, and fish, as well as birds resembling cranes or herons. Other creatures include frogs, lizards, snapping turtles, praying mantises, and dragonflies.

The first recorded find of one of these bells was in 668, and by then no one knew their purpose. The term *dōtaku* was first applied to an eighth-century find, which was noted to have the sound of a musical instrument. *Dōtaku* have remained a fascinating mystery, despite new finds and new information in recent years. The shape immediately suggested an interpretation as a bell; however, when struck, *dōtaku* emit a sound far from modern expectations for a bell. Examples with clappers have been found, making it quite certain that at least some people thought they should be made to sound, and typically there is a bead inside the lip, believed to be a striking surface for a clapper. An imperfect mastery of bronze-casting technology, making it impossible to cast a sonorous bell, might account for the lamentably dull sounds they make. Yet as a ritual object of primarily symbolic or magical importance, the bell's sound was perhaps considered of secondary importance to its shape and decoration.

The origins of *dōtaku* also remain a mystery. For many years archaeologists have believed *dōtaku* were an indigenous Yayoi invention, because the finds were concentrated away from Kyushu, where, as the contact point with China and Korea, it would be normal to observe the introduction of new technology and its transformation. Recently an ancient type of simple Korean bell resembling a *dōtaku* and well known from finds in Korea has been discovered at a Yayoi site in Ōita prefecture, Kyushu. This has led to speculation that, indeed, the *dōtaku* did spring from a Korean prototype. The elaboration and cult importance of the *dōtaku*, however, remain unique to Japan.

WJR

The ruling class of the period between the fourth and the late sixth centuries were warriors who buried their deceased in large earth-mound tombs. This tomb building, a dominant cultural characteristic, has given rise to the use of the term *kofun* (literally: ancient tumulus) for this period. The tombs seem related to Silla-dynasty traditions of Korea; moreover the Kofun period witnessed, along with importation of objects, the introduction of high technology from Korea. In migrations of the fifth and sixth centuries, the presence of Korean craftsmen was instrumental in the advancement of technology in Japan.

Kofun were first built in the Kinai district (Nara-Osaka-Kyoto area), but the practice spread to areas as far away as Kyushu in the south and the tip of Honshu in the north. The earliest tombs were dug into the tops of existing hillocks. By the fifth century, this practice was superseded by a scheme of mounding up an enormous quantity of earth and surrounding it with one or more moats. The burial chamber was at first a stone-lined vault in the upper part of the mound. This type was followed by a stone-lined corridor-type vault set into the side of the mound. Shapes varied among the early and the late tombs, but the characteristic type consisted of a rounded hillock with a rectangular or flaring extension, which in plan resembles an old-fashioned keyhole. The most spectacular keyhole tomb is that constructed for emperor Nintoku, who reigned at the beginning of the fifth century.

Some tomb vaults were decorated with colorful, stylized, and often quite spectacular paintings. However, the most conspicuous tomb decorations were the pottery effigies placed about the surface of the mound. This effigy form had its origins to the west of the Kinai district (in modern Okayama prefecture on the Inland Sea), where ritual pottery vessels were embedded into the top of the tomb mounds, apparently to set off sacred precincts. The earliest examples were simple ritual vessels resting atop undecorated cylinders. As the mound-building practices evolved in the Nara-Osaka area, the pottery forms that had been developed in the Inland Sea area were incorporated and subsequently became greatly elaborated into cylindrical tiles surmounted by sculptured forms. In time, human-form *haniwa* appeared, and while they seem to have originated in the Nara-Osaka region, it was in the Kantō district, the great plain on which Tokyo is situated, and north to modern Saitama and Gumma prefectures that a tomb style featuring such figural *haniwa* reached a highly developed form during the sixth century. In this eastern area,

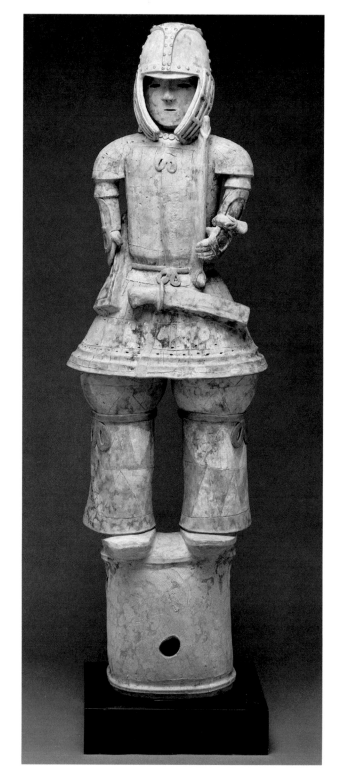

3.
Haniwa warrior figure
Kofun period, 6th century
Pottery with polychrome traces
H. 53¼″ (137.8 cm), H. of figure 41½″ (105.4 cm)
Eugene Fuller Memorial Collection 62.44
Plate on p. 10

the number of human-form *haniwa* proliferated beyond that of any other. Profoundly striking among the figural types in the Kantō region was the armor-clad warrior.

Early types of *haniwa* elaboration were limited to copying house forms, small birds, or animals, or objects from the lives of the ruling class, such as ceremonial sunshades, quivers of arrows, swords, and shields. The term *haniwa* means literally 'clay ring' or 'clay circle,' and is applied equally to the simple early forms and the later complex ones. The *haniwa* were made by a guild (*be*) of potters known as the *haji-be*; they were also responsible for making pottery for everyday use, known today as *hajiki*, or Haji ware.

In contrast to the fantastic and mystical appearance of Jōmon figurines (see No. 1), these *haniwa* replicas of humans and everyday objects, while not idealized physically and sometimes animated in pose, were highly literal. Excavated examples of armor attest the accuracy of these warrior representations. The warrior figure's armor (No. 3) is a type called *keikō*, a fitted covering for the upper body and thighs composed of numerous small iron or bronze plates laced together; the other basic armor type, *tankō*, was composed of large solid plates. Although weighty, the *keikō* type, with articulation made possible by the laced metal strips, allowed the wearer greater freedom of movement. The helmet, heavily riveted and with cheek pieces coming far down in front, protected the head and face. The figure wears a pair of loose-fitting trousers bearing traces of red and white pigment, perhaps imitating painted leather. His weapons are a bow in the left hand, a quiver of arrows in the right, and hanging in front, a sword.

Haniwa were formed of unrefined iron-bearing clays; consequently, the bodies are often rough and, owing to the iron in the clay, almost always range in color from tan to bright orange, depending on the conditions of the firing process. Made up of simplified geometric forms and created with great speed and directness, these *haniwa* figures nevertheless possess vitality and project a complex psychological makeup. The essentially columnar form of the *haniwa* works to the advantage of the potter-sculptor in the case of the warrior, for his erect form and impassive gaze clearly project the ideal of a commanding military image. Many types of warrior *haniwa* are known; however, a number of warrior figures excavated in Gumma prefecture are strikingly similar in appearance and size to the Seattle figure, suggesting that the warrior *haniwa* was something of a specialty in the area.

These tombs were not merely dramatic resting places for people of rank. While they were, on one hand, enduring symbols of power, the inclusion of potent magical objects in the vaults strongly suggests they were also intended to serve as the place to which the spirit might return in dealing with the living. At close range, the tombs must have been impressive, their mounds sheathed with smooth river rocks and sprouting orange-colored *haniwa*; when glimpsed from afar, they must have been awesome. Backed by mountain peaks and reflecting the heavens in the circling moats, such a tomb, rising resolutely above a deserted plain, would appear as a symbolic mountain, a sacred island surrounded by a sacred sea.

4.
Fluted oval bracelet
Kofun period, mid-4th century
Jasper
L. 4¾" (12.2 cm)
Gift of Mrs. John C. Atwood, Jr. 56.249
Plate on p. 20

5.
Rectangular bracelet
Kofun period, mid-4th century
Tuff
L. 7⅝" (19.4 cm)
Eugene Fuller Memorial Collection 62.46

The vaults in tombs of the middle and late Kofun period characteristically contained a variety of objects carefully arranged about the corpse. Among these items armor, including swords, spear heads, helmets, and bows and arrows, predominated. Bronze mirrors, too, were a major item among the grave goods. Articles of personal adornment, such as combs, beads, and bracelets, were more likely badges of power or rank.

The manufacture during the Kofun period of replicas in stone or bronze of earlier Jōmon- and Yayoi-period shell bracelets suggests they represented something beyond mere adornment for the body. The apparent value of the Jōmon and Yayoi shell pieces is indicated by the close approximation in the Kofun period, in stone initially, of the shell pieces; however, the shape changed and the original form was forgotten in time. Eventually, little resemblance to the original form of the shell material remained, and variations occurred, as in the Seattle examples, resulting in the stylized forms of the fourth century.

The oval bracelet (No. 4) of polished blue-grey jasper with fluted spokelike ridges is termed *sharinseki* and is thought to imitate a limpet shell (*kasagai*). The round opening with radiating lines is remarkably reminiscent of the limpet, which characteristically shows a dark center with radiating dark lines in the shell surface extending in a generally circular shape. This circular shape, termed a sword-guard shape (*tsuba-gata*), is perhaps the most frequently encountered of all the stone and bronze bracelet forms in the Kofun period.

The rectangular bracelet (No. 5) is made of green tuff, a porous volcanic stone. Its shape suggests a hoe (*kuwa*), and for this reason the type is termed a *kuwagata-ishi*. The form is sometimes described as a variation of the jasper bracelets that imitate the limpet shell type; however, comparison with a Yayoi-period conch shell bracelet indicates the Kofun-period examples also are more likely stylized renderings of conch shell bracelets.

Whatever their purpose, these bracelets display in their ritualistic distortion a highly refined decorative esthetic enriched by the fine polishing of the jasper and the delicate detailing of the tuff. The practice of making tomb-mound burials with *haniwa* and masses of grave goods disappeared subsequent to the introduction of Buddhism in the sixth century. The Buddhist preference for cremation left no room for the elaborate and expensive *kofun* interment.

WJR

These three vessels illustrate the development of early Japanese ceramics: the simple, unglazed Sue pottery of the Kofun period, the first experimentation with natural ash glazes in the sixth century, and the very sophisticated, high-fired Shirashi ware of the early ninth century.

The shoulder of the tall Kofun-period vessel (No. 6) is decorated with figures of humans and animals interspersed with a series of miniature vessels termed *ko-mochi* (literally: child holding). It is an example of an important group of ceramics collectively known as Sue ware (*sueki*). The name may derive from the verb *sueru*, 'to offer,' a reference to the original use of these wares for religious and ceremonial purposes. It is also possible that the term comes from the Korean word *sue* (iron), an allusion to the ware's plain grey surface.

Sue ware superseded Yayoi hand-built pottery and overshadowed Haji ware, which had derived from Yayoi pottery. Sue ware appeared as a direct result of the importation of techniques from Korea and was initially produced by Korean artisans. As Sue ware became predominant for ritual objects, the Haji pottery pieces, which had served ritual functions, became the everyday ware of the common people.

Sue ware originated about 400 A.D. in the ancient Osaka area, home of the ruling elite; by the first half of the sixth century, production had spread as far as Kyushu as well as to the northern provinces. More than two thousand *sueki* kilns have been discovered, extending from the Tōhoku region to Shikoku, with the largest number concentrated in Niigata, Fukui, Aichi, and Gifu prefectures. The tall pedestal base of the *ko-mochi* vessels relates directly to ritual vessels of Korea. These tall bases were originally separate stands that supported round-bottomed jars. The original shape is repeated in the miniature jars on the shoulder, which also features a miniature hunting scene of animals and figures pinched out of bits of clay, a technique also seen in Korean tomb wares of this date.

The introduction of *sueki* also brought Korean kiln construction, which effected major changes in production and firing techniques. Jōmon and Yayoi ceramics had been fired at low temperatures of about 700–800 degrees centigrade using open trenches, or at best, primitive trench kilns. *Sueki*, however, was fired in sloping, semisubterranean kilns of the *ana-gama* type, built parallel to the hillside and constructed by roofing over an open ditch that followed the incline of the hill. These sloping *ana-gama* kilns created much stronger drafts and permitted longer, hotter firings. *Sueki*

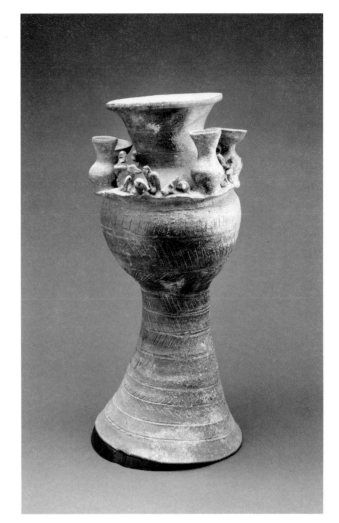

6.
Vessel
Kofun period, mid-6th century
Sue ware, unglazed stoneware
H. 17½" (44.5 cm)
Eugene Fuller Memorial Collection 56.119

was fired at about 1200–1300 degrees centigrade, temperatures comparable to those achieved in the firing of modern stoneware. As a result, *sueki* is distinguished by very thin, brittle bodies which sometimes emit a clear ringing sound when tapped. The use of higher firing temperatures produced bodies far superior to those of Jōmon and Yayoi.

Jōmon and Yayoi wares had been manually formed by coiling, but *sueki* was the first Japanese ware to employ the potter's wheel, another important technical innovation from Korea. The wheel permitted faster production and much tighter control over form. Some of the earlier examples of *sueki* might still have been produced by a combination of coiling and subsequent finishing on the

wheel; however, the precise, firm contours typical of *sueki* would not have been possible without the widespread use of the wheel.

Much *sueki* ware, especially that dating from the seventh century and later, is embellished with an ash glaze, usually of greenish color, produced by firing in a reducing (oxygen-deprived) atmosphere. Both the flask and the Shirashi-ware covered jar feature ash glazes. In the jar, this light green glaze takes on a luminous quality. Sometimes unintentional glazing, as on the flask, was produced in the kiln during firing by particles of wood ash from the fuel falling on the vessel's body, then fusing and fluxing. By the ninth century, potters were able to exert better control over the flow and quality of the ash glaze.

The Kofun-period flask (No. 7), with its rounded, flattened body, short, flaring neck, and everted rim, shows the use of the potter's wheel in the regularity of the linear design and tight spirals encircling the body. As in the case of the earlier Kofun-period *sueki* vessel, the flask demonstrates again the potter's continuing interest in incised surface decorations.

In the early Heian period, the center of production for *sueki* shifted from the ancient Kinki district to the area around Nagoya, where some of the earliest *sueki* kilns had been established. The covered jar (No. 8) is a splendid example of a type of early Heian stoneware with green ash glaze termed 'Shirashi' (literally: white ware). A prime example, the Seattle jar was probably made at a kiln in the Sanage district, near Nagoya. Similar vessels were, however, also produced in Ibaragi prefecture north of Tokyo.

The jar is distinguished by a high-fired grey stoneware body, almost white in tone and of nearly porcelaneous quality. An applied ash glaze covers the upper portion and shoulder and runs in streaks and droplets over the sides of the jar, greatly enhancing its esthetic appeal.

Examples of large Shirashi jars with ash glaze are very rare, even in Japanese collections; because the Seattle jar is complete with cover, it is an even more significant piece. On the basis of its wide, rounded body this jar can be dated to the ninth century.

This ash-glazed ware, deriving on the one hand from Korean prototypes and on the other influenced by contemporary Chinese ceramics such as the three-color glazed wares, parallels the Ko Seto wares of later times, which also appeared directly as a result of continental influences (see No. 72).

Henry Trubner (HT) *is Associate Director for Art and the Collections, Seattle Art Museum.*

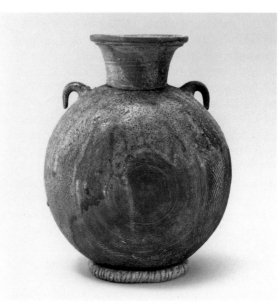

7.
Flask
Kofun period, 6th century
Sue ware, stoneware with natural ash glaze
H. 12" (30.5 cm)
Eugene Fuller Memorial Collection 56.120

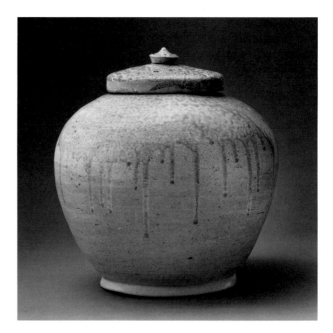

8.
Jar with cover
Heian period, early 9th century
Shirashi ware, stoneware with green ash glaze
H. 11" (28 cm)
Margaret E. Fuller Purchase Fund, Asian Department
 Restricted Funds, Asian Art Council Purchase Funds,
 and Helen Seymon Memorial Fund 85.28
Plate on p. 42

The Parinirvana, or death of the historical Buddha Sakyamuni (Shaka), was a major theme in early Japanese Buddhist arts. The Parinirvana depicts the death of an enlightened being, such as the Buddha, as a release from the constant cycle of rebirth and death that is the karma of all sentient beings. The earliest surviving sculptural example of this theme in Japan is one of the four scenes found in the pagoda at the temple complex of Hōryū-ji, where the Parinirvana is represented by a series of unbaked clay figures in a landscape setting. The pagoda, storage place for relics of the Buddha, was an appropriate site to depict this theme. Among representations of the multitude of followers of Shaka in the Parinirvana are members of other religions who had adopted Buddhism and who were often depicted as its fiercest defenders.

Among these defenders are the Eight Guardians of Buddha, the Hachibushū: Ashura, Gobujō, Kubanda, Shakara, Hibakara, Karura, Kendatsuba, and Kinnara, all of whom have Hindu prototypes. This sculpture represents Karura (Sanskrit: Garuda), who in the Hindu religion was a golden birdlike creature, king of the birds, who served as the vehicle for Vishnu; as one of the Eight Guardians, he had the ability to devour poisonous snakes. In most Japanese representations, this figure has a human body combined with a chickenlike head and, in keeping with his role as a guardian, wears full body armor.

Similar to the Hachibushū of the Hōryū-ji Parinirvana, this Karura kneels with hands clasped. His aspect as a fierce protector seems overwhelmed by grief at the Buddha's death; the figure conveys a sense of quiet melancholy. It is similar in scale to the clay sculptures at Hōryū-ji, but the method of construction and certain details are quite different. The Hōryū-ji figures were created in a method derived from mainland sources, in which a wood and straw armature was covered first with coarse clay and then with several layers of finer clay. Additional details were added in gesso and polychrome to the unfired clay body. The Seattle Karura has a solid body of gritty grey clay which was gessoed and painted. There is no indication of an armature; the figure's appearance is somewhat less refined than those at Hōryū-ji. Its armor, very similar although less detailed than that worn by the Hōryū-ji figures, consists of plaques and straps with a shawl around the neck. The somewhat coarser treatment and difference in technique may indicate a local variation and a slightly later date, perhaps early to mid-eighth century.

Michael Knight (MK) *is Assistant Curator of Asian Art, Seattle Art Museum.*

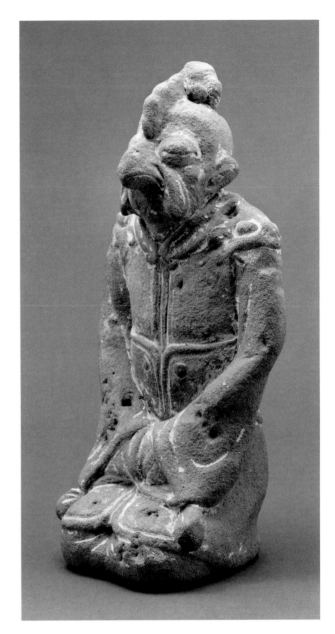

9.
Karura
Nara period, early 8th century
Pottery with gesso and polychrome traces
H. 13⅝″ (34.6 cm)
Eugene Fuller Memorial Collection 50.57

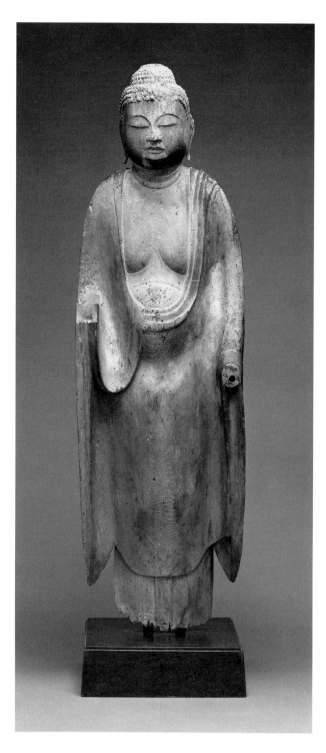

10.
Standing Buddha
Heian period, 10th–11th century
Wood
H. 49″ (124.5 cm)
Eugene Fuller Memorial Collection 60.74
Plate on p. 24

The movement of the capital from Nara to Heian (modern Kyoto) at the beginning of the Heian period was brought about in part by the almost incestuous relationship between the Nara aristocracy and the members of that city's Buddhist temples. The sway held by the Buddhists in government was considered inappropriate by many, both officials and clerics; in order to prevent its recurrence at the Heian court, Buddhist temples in the city were limited by edict to two, Tō-ji in the east and Sai-ji in the west. Although these edicts soon broke down, at the beginning of the Heian period a number of Buddhist priests and artisans found themselves without a means of support because of them. Many priests moved to provincial temples where they evolved their own unique interpretations of late Nara art styles. This movement was paralleled by a major influx of Buddhist *mikkyō* (esoteric) teachings into Japan. Mikkyō Buddhism was commonly practiced in smaller temples in remote settings far from court. With it came fresh Indian influence, a new iconography, and a new set of exotic images presenting unique artistic problems. The interplay of these two traditions — the conservative following of late Nara styles and esoteric religious practices and art styles — was the driving force behind much innovation in the Buddhist arts of the early Heian period. The standing Shaka Buddha and the seated Dainichi Nyorai reveal some of that interplay and contrast.

During the Heian period, wood was the primary material for sculpture. The Seattle standing Buddha (No. 10) is carved from a single block of wood in a technique known as *ichiboku*. The columnar body and the full face, with little deviation from the shape of the tree trunk and little deeply carved detail, present a sense of serenity and volume. The styles for *mikkyō* sculpture survived and continued to evolve in more provincial areas throughout the Heian and into the Kamakura. Comparisons of the Seattle piece with examples from Zenmyō-ji and Shonen-ji may indicate a provincial source in Shiga prefecture and a date in the eleventh century.

Although also likely to be from a provincial temple, the somewhat later Dainichi Nyorai (No. 11) is created in a style quite different from that of the standing Buddha. In Shingon sects of esoteric Buddhism, Dainichi (literally: *dai*, great; *nichi*, sun) was the central image of the Diamond Mandala, the main figure in the Womb Mandala, and thus a frequently reproduced figure. Believed to embody dharma and to be the source of all incarnations and forms, Dainichi Nyorai is the secret manifestation of Dainichi. He is represented as a bodhisattva

with bared chest, jewelry, and crown, with his hands in the gesture of *dharmadhatu-samadhi-mudra*. The complexity and often magical quality of *mikkyō* is clearly seen in the multiplicity of meanings given these hand gestures. This mudra, in which the five fingers of the right hand encircle the index finger of the left hand, symbolizes nonduality, the union of man and godhead, male and female, and the union of the world of form, composed of the five elements fire, earth, water, wind, and space, with the world of mind. The bared chest, jewelry, and soft rounded forms of this figure further indicate the exotic imagery esoteric Buddhism brought to Japanese sculpture.

This figure is carved in a less severe form of the *ichiboku* technique. The iconographic demands of the Dainichi Nyorai stretched its limits. The original block from which this figure was carved had a diameter large enough to encompass the shoulders, arms, and the crossed legs; parts of the knees are separate pieces. The gentle, moon-shaped face and broad, flat legs indicate a late eleventh-century date. By that time a more flexible technique of assembling blocks to create sculpture had been fully developed in Japan (see No. 14); the continued use of the *ichiboku* technique and the relatively stiff and frontal approach indicate a provincial source for this piece.

MK

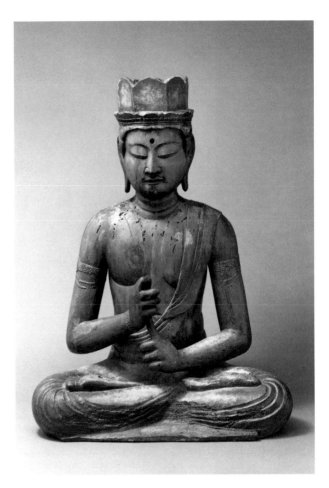

11.
Dainichi Nyorai
Heian period, late 11th century
Wood
H. 35½″ (90.2 cm)
Eugene Fuller Memorial Collection 35.70
Plate on p. 33

Bishamonten is the Buddhist Guardian of the North, one of four who guard the cardinal directions. The Tobatsu type is distinguished from other representations of Bishamonten by the presence of a small figure of the earth goddess Jiten (Sanskrit: Prthivi), who is accompanied by the two demons Niramba and Biramba. Tobatsu Bishamonten frequently wears a tall crown decorated with a bird. The origins and exact iconography of the figure are complex and unclear. The Four Directional Guardians originated in Indian Hinduism; by the second century B.C. they had been incorporated into Buddhism. Early representations at Bharut show them in their roles as subjugators of the enemies of Buddhism as they trample earth demons. This act remained a primary part of the iconography of the figures in later developments. However, the guardians at Bharut are presented as members of the Indian aristocracy and lack the armor and fierce demeanor of Chinese and Japanese examples.

A substantial change in the representation of the Four Directional Guardians occurred as Buddhism spread throughout Central Asia to China. In the sixth-century wall paintings of Central Asia and at the Buddhist caves of Dunhuang, the guardian figures are clothed in contemporary Central Asian armor and display the fierce appearance associated with later Chinese and Japanese representations. It is possible that the origins of the Tobatsu manifestation of Bishamonten can also be traced to Central Asia: certain legends from Khotan in particular indicate that Bishamonten was worshipped as an independent deity in that region, and that his association with the earth goddess developed there. However, a designation corresponding to Tobatsu has not been found in Central Asian sources describing this figure, nor does this name occur in extant Chinese sources. A stone sculpture of Tobatsu Bishamonten, dated to the mid to late ninth century and unearthed at Qionglaixian, Sichuan province, provides a Chinese example of the guardian's fully developed iconography. This figure wears a tall elaborate crown, armor that appears to be of chain mail, and stands over a very small representation of the earth goddess; it is one of the very few examples of this type that has survived in China.

The earliest example of Tobatsu Bishamonten in Japan, now in Tō-ji, is also of Chinese origin and is quite similar in style and development to the figure from Sichuan. This figure served as a model for other examples, most notably that at Seiryō-ji. Later examples are less directly associated with

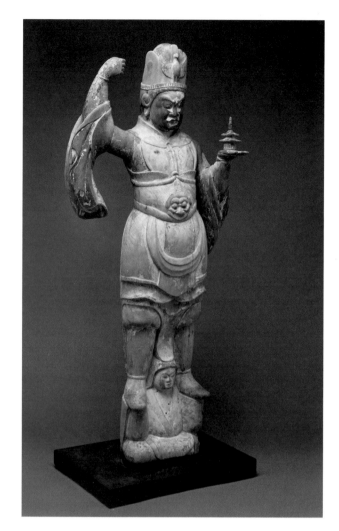

12.
Tobatsu Bishamonten
Heian period, late 10th century
Wood with polychrome traces
H. 48½" (123.2 cm)
Eugene Fuller Memorial Collection 48.179
Plate on p. 26

Chinese models, and types of armor other than mail prevail.

In China and India north was considered the direction from which came the greatest danger and evil. Thus Bishamonten played a unique role in the Buddhist practices of these two countries and in Japan: of the four directional guardians, only he was worshipped independently. As Tobatsu Bishamonten, his role expanded beyond the purely directional to include guarding the most important gates and entries into cities and temples; he was particularly popular at times of military conflict.

The Seattle Tobatsu Bishamonten (No. 12) is carved from a single block of *hinoki* (cypress) and

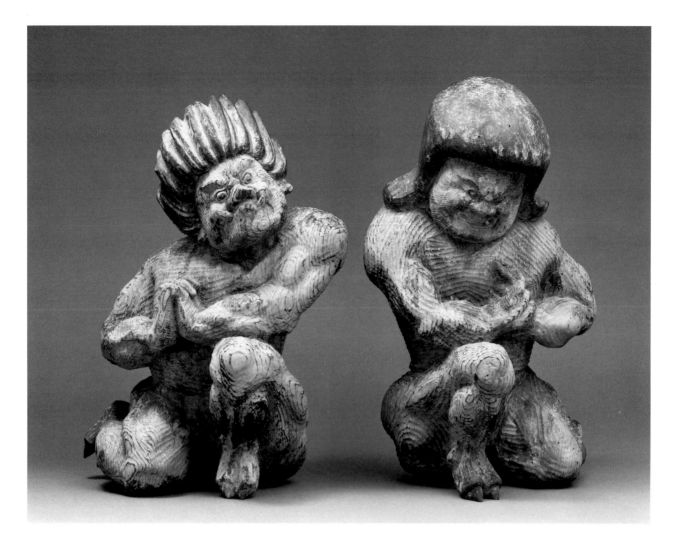

13.
Pair of dwarf demons (Biramba and Niramba)
Late Heian–early Kamakura period, 12th–13th century
Wood with gesso and polychrome traces
Biramba: H. 16½″ (41.9 cm), Niramba: H. 17¼″ (43.8 cm)
Eugene Fuller Memorial Collection 60.62

has traces of color on his clothing; there is some repair to the arms. He wears a tall crown with bird, bears a stupa, symbol of the Buddha, in his left hand, and stands on Jiten, all standard iconographic features of the Bishamonten type. The two demons that usually accompany Jiten are not present; they have either been removed because of damage, or were created as separate sculptures. Stylistically this figure is related to the Jōgan style of the ninth century and is thus quite different from earlier Chinese-inspired examples (see No. 10). The body is small and compact, with massive legs and a large head. The armor is not developed as fully as in earlier examples, and the sculptor seems to have relied on painted decoration to depict details. The

growing independence from Chinese sources and a closer relationship between Buddhism and the native Shinto religion is clearly seen in the depiction of Jiten, who closely resembles contemporary sculptures of Shinto goddesses. The scale of this figure and a somewhat mannered approach to the carving suggest a regional source and a date near the end of the tenth century.

The two demon figures (No. 13) were also once part of a set, perhaps with a Bishamonten and Jiten. They are created in a style known as *natabori*, in which the entire surface of the figure is decorated with chisel marks. This style seems to have been focused in the Kantō region and further north; it first appeared in the late tenth and eleventh centuries and became increasingly rare during the Kamakura. The sophistication of the carving and the vitality of these figures suggest a date in the late Heian or early Kamakura period.

MK

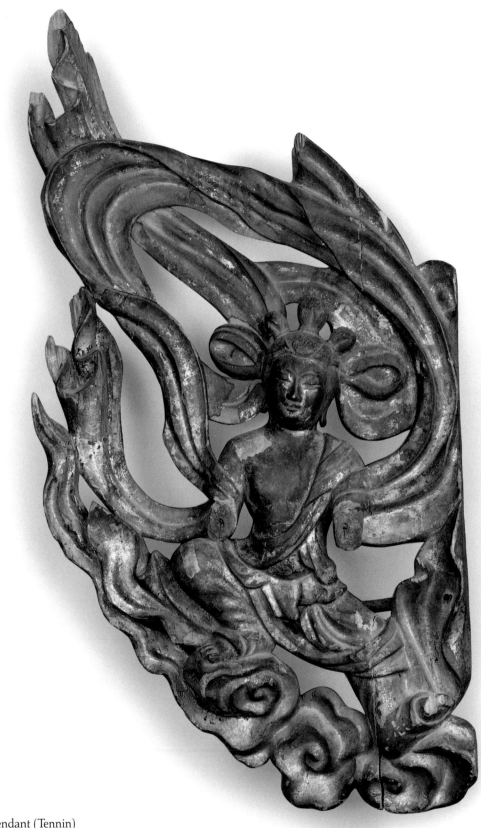

14.
Buddhist attendant (Tennin)
Heian period, 11th–12th century
Wood with gilt
H. 37″ (94 cm)
Eugene Fuller Memorial Collection 34.119

The origins of the many heavenly attendants found in the Buddhist arts of the Far East can be traced back to the *putti* of the classical West. This type of attendant figure entered Buddhist arts in Gandhara and related areas where Greek or Greek-trained artisans, members of enclaves that had existed since the conquests of Alexander the Great, influenced the formation of early Buddhist iconic art. The concept of heavenly attendants and their basic forms traveled with Buddhism across Central Asia to China along the silk routes; from China they were transmitted, in a somewhat altered form, to Japan. The earliest extant examples in Japan are found at the late seventh–early eighth century complex at Hōryū-ji. Above the two main icons, a Shaka Triad and a Yakushi, in the *kondō* (main hall) of this complex are elaborate canopies decorated with heavenly attendants, musicians, and other figures, all rather stiff and formal in the sculptural style prevalent in that period. The painted examples on the four walls of the *kondō*, however, are developed in a flowing, linear style.

Heavenly attendants were most frequently depicted in representations of the paradises of the various Buddhas. Their numbers rose dramatically with the rise in popularity of Pure Land sects during the Heian and Kamakura periods. Commissioned by Pure Land adherents for accumulating merit, the principal theme of many paintings and Amida-dō (a hall devoted solely to an enshrined Amida image) was the Western Paradise of Amida, which was occupied by vast numbers of heavenly musicians, dancers, and other attendants. Relief sculptures of these attendants appear to float along the walls of the Amida-dō and are also incorporated into the mandorla which frames the central image of Amida.

During the mid-eleventh century, partially in response to the rise in demand for sculpture associated with Pure Land Buddhism, a new technique for producing wood sculpture was developed. In this technique, *yosegi-zukuri*, wood blocks were hollowed out and then joined to form the basic shape from which the sculpture was carved. This had several advantages: first, hollow pieces were lighter and less prone to surface checking than those made in the earlier single-block technique; second, the pieces could be produced in large numbers in workshops where the blocks were rapidly assembled; third, a far smaller amount of material was needed to create the piece; and fourth, freer and more flowing styles could be created. Jōchō, the eleventh-century sculptor responsible for much of the work at the Byōdō-in, is credited with perfecting this technique; however, the earliest example in Japan is the thousand-armed Kannon at Hōryū-ji, dated 1012, and it appears that the technique evolved from continental sources over a period of time.

The heavenly attendant illustrated here is a superb example of Heian-period sculpture in which the characteristics of *yosegi-zukuri* have been exploited to their full advantage. The attractive youthful figure strikes an active pose, his feet wide apart, as if climbing on clouds. Billows of ribbon-like drapery flow behind and beside the figure, as if blown by the wind. Such freedom of detailing, very difficult to achieve in the single-block technique, demonstrates the new creative freedom made possible by *yosegi-zukuri*. The high quality of workmanship apparent in this piece suggests that it came from one of the major Amida-dō of the Heian period, and that it was produced under the direct influence of the Heian court.

MK

Buddhism did not receive immediate or over-whelming approval when it first came to Japan, and religious and political strife between families supporting Buddhism and those supporting Shinto broke into open conflict in 587. The Soga family, under the leadership of Soga no Umako, won this conflict. Umako manipulated the position of emperor, first putting his relative emperor Sushun (r. 587–592) on the throne and then having him assassinated and replaced by Umako's niece, empress Suiko. At this time Umako appointed prince Umayado (573–628), better known by his Buddhist name Shōtoku Taishi, as regent. Umako seems to have supported Buddhism mainly out of political ambition. Shōtoku Taishi, on the other hand, was a devout believer and student as well as a promoter of the religion. Several major early temples, including Hōryū-ji, were reputedly built under his patronage, and he contributed important commentaries on several Buddhist texts. Through his efforts the position of Buddhism in Japan was guaranteed.

Perhaps for these reasons, Shōtoku Taishi was among the first native-born Japanese to be portrayed in the country's Buddhist arts. Despite the fact that he remained a layman throughout his life and was perhaps as influential in political reform as in his religious activities, a Buddhist-inspired cult developed around him almost immediately after his death. The earliest legends surrounding his life appear in the seventh-century fragments of the Tenjukoku embroidery now at the Chūgū-ji nunnery of Hōryū-ji. These legends continued to expand and develop during the Asuka, Nara, and Heian periods; by the early tenth century a compendium, the *Shōtoku Taishi denryaku*, had begun to serve as the source for many of the representations of this figure.

During the Kamakura period, the cult of Shōtoku Taishi gained in popularity. He was given a prominent position in the religious hierarchy of such diverse sects of Buddhism as Shingon Ritsu, Jōdo Shu and Jōdo Shin Shu, (Pure Land and True Pure Land), and Zen; he also was recognized as the protector of the arts and crafts. By this period, representations of Shōtoku Taishi at the various stages of his life had been codified into three main categories: the mantra-chanting (*namu butsu*) form, based on the legend that Shōtoku Taishi at the age of two had faced eastward and chanted a mantra; the filial piety (*kōyō*) form, deriving from when Shōtoku, at sixteen years of age, prayed for the recovery of his father from an illness; and the prince regent (*sesshō*) form.

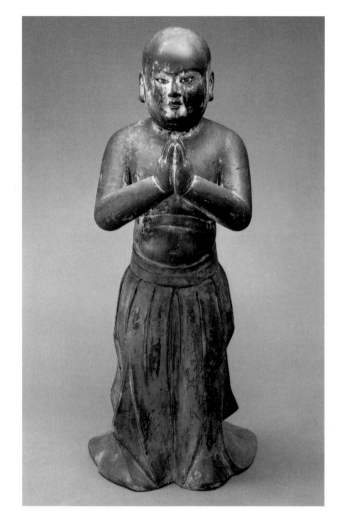

15.
The infant Shōtoku Taishi in mantra-chanting form
 (*namu butsu Shōtoku Taishi*)
Kamakura period, c. 1300
Wood with polychrome
H. 26¾" (68 cm)
Eugene Fuller Memorial Collection 36.22
Plate on p. 29

The sculpture illustrated, the *namu butsu* form, depicts a youthful Shōtoku Taishi dressed in the formal red *hakama*, a type of split skirt or loose trousers, which covers his feet but leaves his upper body bare. Rather than the complex construction of *yosegi-zukuri*, this sculpture of Shōtoku Taishi is created in a simpler manner, in which hollowed wood halves have been joined to create the body. This construction, quite suitable for the closed form of this sculpture, minimized weight and allowed the inlay of crystal for the eyes. Several dated sculptures of the *namu butsu* Shōtoku Taishi support a date of around 1300 for this piece.

MK

Esoteric Buddhism (*mikkyō*) rose rapidly in popularity in Japan during the early Heian period. It emphasized the magical and mystical aspects of Buddhism and tended to be practiced in remote settings away from the distractions of court and daily life. *Mikkyō* temples were frequently small, dark, and filled with the smoke of burning incense, which enhanced the practice of elaborate and highly formalized mystic rituals. By the late Heian period, *mikkyō* had become particularly popular at court. Although in later periods it was largely replaced by more populist sects, an exception was found among the remains of the Heian aristocracy in Kyoto.

The practice of *mikkyō* rituals required very specialized paraphernalia. During the rituals, elaborate altars (*dan*) were set up before the principal image of the temple; from these *dan* the *mikkyō* priest would perform incantations and practice magic. In order to assure success, his ritual paraphernalia had to be arranged on the *dan* in a manner determined by set formulas. These objects included incense burners, censers, vases for flowers, special cups and saucers, and a number of other specialized ritual implements. Despite the decline of *mikkyō* during the Kamakura period such objects continued to be made, with the greatest number intended for the aristocracy, who continued to practice the *mikkyō* rites in the temples around Kyoto. Owing to sophisticated patronage, the bronze objects for *mikkyō* rites created during the Kamakura period are often superb examples of bronze casting.

The major ritual implements of *mikkyō* Buddhism, like much Buddhist material, originated in the Hindu religion of India. The several types of vajra and bells, and even the form of the altars, can be traced to Hindu sources. Prominently positioned on *mikkyō* altars was a group of objects consisting of a bell, and a five-, a three-, and a single-pronged vajra arranged on a tray. Among typical decorations on these implements are lion heads, heads of the Four Directional Guardians (Shitennō), lotus in various forms, lightning bolts, the three precious jewels, and vajra patterns, all attributes indicating some aspect of the Buddha. The handles of both the three-pronged vajra (No. 17) and the bell (No. 16) illustrated here are decorated with the heads of the Four Directional Guardians and lotus patterns; their prongs issue from the mouths of lions. Below the handle, the body of the bell is divided into three bands. The upper band is decorated with single-pronged vajra patterns; the

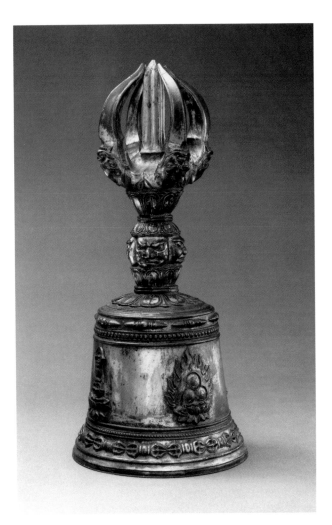

16.
Bell (*goko rei*)
Kamakura period, 14th century
Gilt bronze
H. 9¼" (23.5 cm)
Eugene Fuller Memorial Collection 49.237
Plate on p. 34

bottom band with three-pronged vajra; the wide central band is decorated with representations of a crossed vajra, a three-pronged vajra, and the three precious jewels surrounded by flame. The attributes in the central band are displayed on lotus plinths. The center of the single-pronged vajra (No. 18) is decorated with four patterns called "ghost's eyes," flanked above and below by lotus. The crisp casting of these pieces makes them fine examples of Kamakura Buddhist bronzes.

The censer (No. 19) also played a major role in esoteric ritual. The *mikkyō* priest carried a censer filled with materials that produced an aromatic smoke as he approached the altar; the censer was

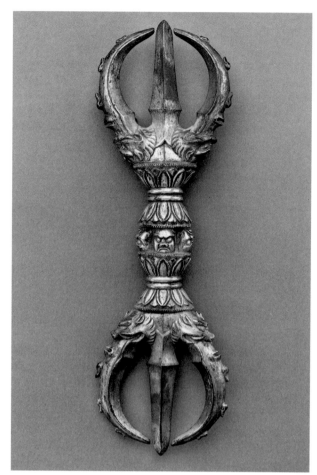

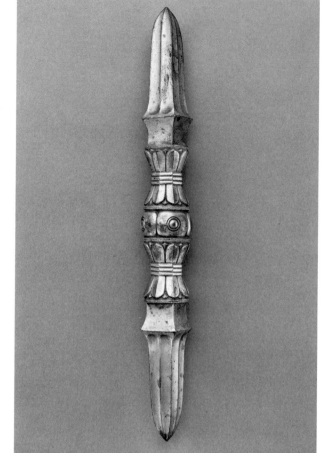

17.
Three-pronged vajra (*sanko sho*)
Kamakura period, 14th century
Gilt bronze
L. 9¼″ (23.5 cm)
Eugene Fuller Memorial Collection 62.100

18.
Single-pronged vajra (*tokko sho*)
Late Heian – early Kamakura period,
 12th – early 13th century
Gilt bronze
L. 9⅜″ (23.8 cm)
Eugene Fuller Memorial Collection 56.137

then strategically placed as the ceremony pro-
ceeded. Its smoke symbolically purified the air and
also added to the sense of mystery that accompanied
the ritual. The Seattle example lacks the vigor of
ritual implements of the Kamakura period; its deco-
ration is highly refined and reveals the courtly taste
of the Muromachi period.

The ritual gong (No. 20) did not originate in
India, but derived from the ritual stone chimes of
ancient China and evolved to play a role in the rites
of *mikkyō* and other forms of Buddhism. By the
eighth century, it was commonly used in Japanese
temples. The Chinese stone chime was triangular,
with painted decoration; during the Six Dynasties
period (420–589), under the influence of Bud-
dhism, these chimes began to be made in bronze
and their shape to evolve. This evolution continued

after their introduction to Japan, and by the late
Heian and Kamakura periods the so-called moun-
tain shape, which had a much more curvilinear
profile, had become the most popular. This type
of gong was hung from a wooden stand by a pair
of cast loops; the earliest example with an extant
wooden stand dates from the late Heian period
and is now at Chūson-ji. The Seattle gong is of the
mountain shape. Its more elaborate profile and
robust but somewhat crude style of decoration indi-
cate a Kamakura-period date or perhaps slightly
later, and possibly a provincial origin. Similar to
many gongs of the mountain shape, this one is
decorated on the front with a boss circled by a
lotus and flanked by a pair of peacocks. The boss
was the point of striking.

MK

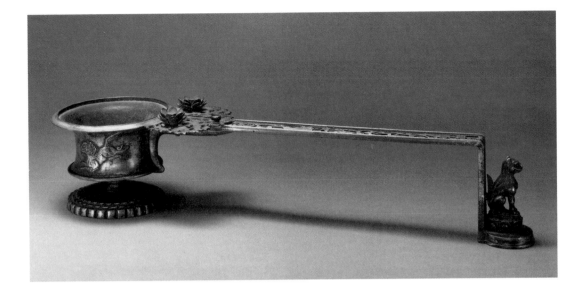

19.
Censer (*e-gōro* or *shuro*)
Muromachi period, 14th–15th century
Gilt bronze
L. 15″ (38.1 cm)
Eugene Fuller Memorial Collection 49.236

20.
Ritual gong (*kei*)
Kamakura period, 1185–1333
Gilt bronze
H. 3⅜″ (8.6 cm), W. 7⅛″ (18.1 cm)
Gift of J. Mayuyama in honor of the fortieth
 anniversary of the Seattle Art Museum 72.2

The interaction, conflict, and compromise between native Shinto and Buddhism reached a peak during the Heian period with the advent of esoteric Buddhism. The esoteric sects moved Buddhism into the mountains, the realm of the Shinto kami and the people who believed in them. This belief proved to be quite compatible with esoteric Buddhism, which sought enlightenment in natural settings. The compromise struck by these two religions, known as *honji-suijaku*, involved identifying the principal Shinto kami as incarnations of particular Buddhist deities; thus each deity had its *honji* (Buddhist) form and its *suijaku* (Shinto) form.

The *honji-suijaku* concept is clearly illustrated by votive plaques known as *kakebotoke*. Their origin can be traced back to mirrors that served as material embodiments of the kami in early Shinto shrines. With the influx of esoteric Buddhism during the Heian period, images of both Buddhist and Shinto divinities began to be incised into the mirror surfaces. The form of the *kakebotoke*, evolved from mirror shapes, consists of a circular metal votive plaque, which was suspended inside or outside shrines. The earliest *kakebotoke*, like the decorated mirrors, had incised designs; later, the images of deities were cast separately and attached, usually to a metal sheet which had been wrapped around a wood backing. These later *kakebotoke* were commissioned by devotees and offered at shrines; frequently the names of the donor and a prayer were inscribed on the back.

The *kakebotoke* illustrated here is decorated with a representation of the Thousand-armed Eleven-headed Kannon (Senju Jūichimen Kannon), frequently identified as the *honji*, or Buddhist form, of the kami of Nachi waterfall. The figure, which actually has only forty-two arms, is made up of several pieces attached through the metal plate to the wood backing. It sits on a high lotus pedestal and was once flanked by a pair of vases, attributes of Kannon. The points of attachment for these two vases can be seen just below the arms on each side of the figure. Much of the original gilding has survived but is hidden from view by thick coats of charcoal accumulated in the smoke-laden air of the shrine for which it was made. The high quality of workmanship and crisp casting of the figure indicate a date in the mid to late Kamakura period.

MK

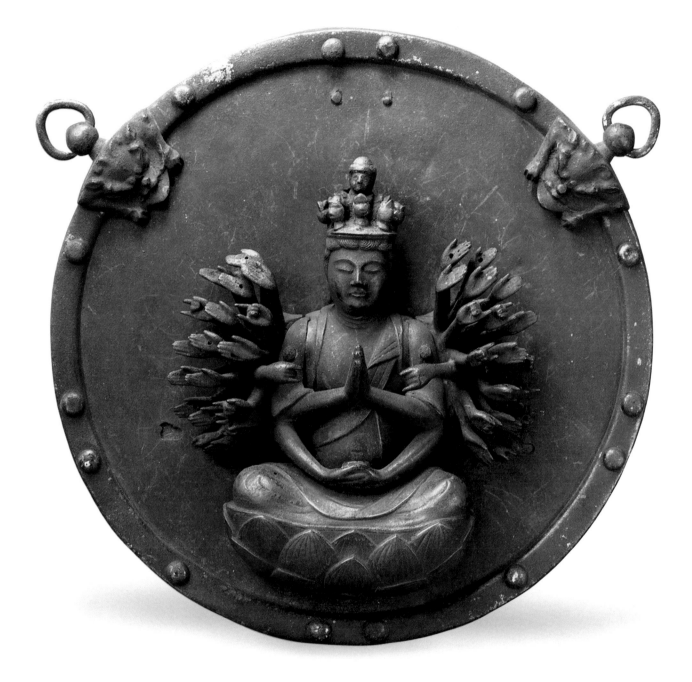

21.
Votive plaque (*kakebotoke*)
Kamakura period, late 13th century
Gilt copper with wood back
Dia. 9⅞″ (24.8 cm)
Eugene Fuller Memorial Collection 50.123

Ritual dance and procession are among the most enduring and popular expressions in Japan and have influenced a variety of arts. As with most major Japanese art forms, many traditional ritual performances originated on the continent: in Korea, China, or even as far away as India. Many such performances are highly formalized and involve the use of elaborate costumes and masks with shapes established by long tradition. Both the masks and the costumes often reflect the height of technical achievement in sculpture and textile design.

Among the most ancient ritual performances still practiced in Japan today is Gyōdō, a Buddhist procession. It takes several forms; one of the more common is an enactment of the *raigō*, or descent of Amida Buddha to receive a follower at the time of death. This procession was especially popular during the Heian and Kamakura periods when Pure Land Buddhism was at its height of influence (see No. 12). In the ritual, as in depictions of the *raigō* in painting and sculpture, Amida is usually accompanied by an entourage of bodhisattvas and other divine beings, each represented by an elaborately garbed dancer wearing an appropriate mask. The first mask illustrated here (No. 22) was worn by a participant who represented a bodhisattva. The mask, with its serene countenance, is carved with restraint and elegance in a method that relates it to Heian-period sculpture, a similarity indicating a close relationship between Heian-period sculptors and mask-carvers.

A second type of Gyōdō ritual entered Japan from China during the Nara period (710–794); in it a sacred image or person is presented to the populace on a richly decorated palanquin carried by a number of monks and accompanied by elaborately garbed and masked attendants. These attendants most frequently represent guardians of Buddha, such as the Eight Guardians of Buddha (Hachibushū, see No. 9) or the Twelve Deva Kings. The mask with the fierce visage (No. 23) represents Sagara, one of the Twelve Deva Kings. It has been identified as one of a series of masks carved for use in the Gyōdō procession in the Hōtō-kuyō-e ceremony at Kyōō-gokoku-ji (Tō-ji) in Kyoto, a ceremony which has been performed at that temple since the tenth century. Priests in masks of the Twelve Deva Kings and the Hachibushū attend the main priest of Tō-ji, who is carried in a palanquin supported by ten unmasked priests. Seven of the Twelve Deva Kings' masks created in the tenth

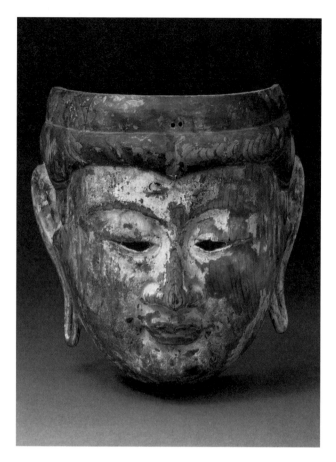

22.
Gyōdō mask in bodhisattva form
Heian period, 12th century; inscription dated 1158
Wood with gesso and polychrome traces
H. 8½″ (21.6 cm)
Eugene Fuller Memorial Collection 51.131
Plate on p. 44

century for the Ai ceremony at Tō-ji remain in the Kyoto National Museum; the Seattle mask can be dated to the end of the thirteenth or early fourteenth century. Comparison of the Sagara and the bodhisattva mask reveals the contrasts between the participants in these two rituals and also between the arts of the Heian and the Kamakura periods. The restraint and elegance of the bodhisattva mask contrasts with the elaborately carved and brightly painted features of Sagara. The dynamic approach and emphasis on an exaggerated naturalism found in the Sagara mask is also found in Kamakura-period sculpture.

MK

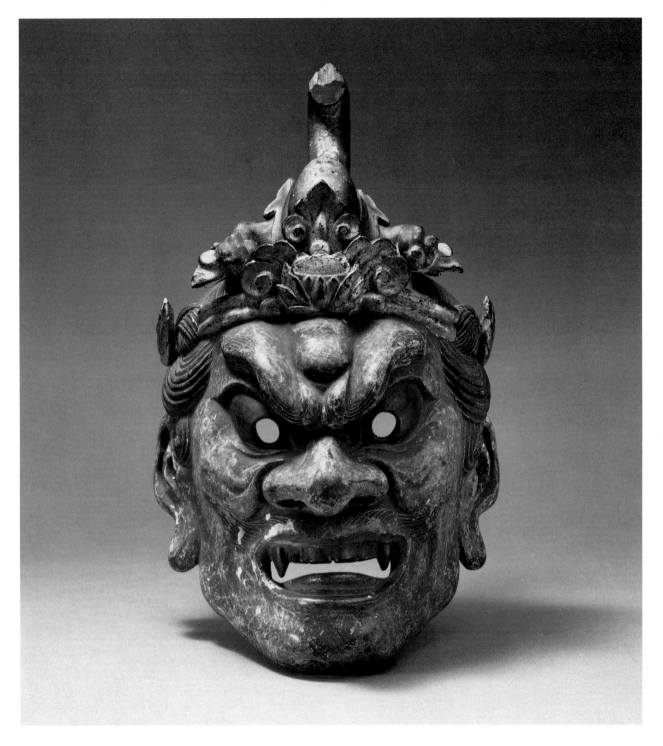

23.
Gyōdō mask in the form of Sagara
Kamakura period, late 13th–early 14th century;
 from Kyōō-gokoku-ji (Tō-ji), Kyoto
Wood covered with cloth, gesso, and polychrome
H. 15½″ (39.5 cm)
Eugene Fuller Memorial Collection 68.110

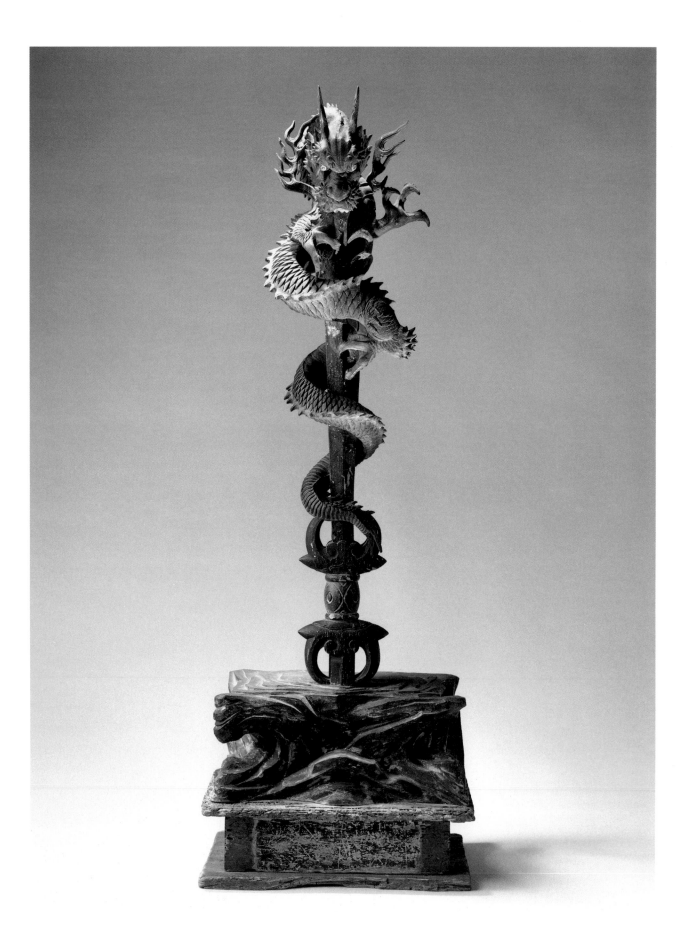

An inscription attached to this sword identifies it as having come from Haguro-san, a noted retreat of the Shugendō cult in Yamagata prefecture in the north. Shugendō, a religious order unique to Japan, combines elements of esoteric Buddhism and Shinto into a syncretic system of beliefs and is perhaps the ultimate distillation of the *honji-suijaku* concept (see No. 21). The *yamabushi*, practitioners of Shugendō, believe beneficial magical powers can be obtained through the practice of ascetic disciplines in remote mountain settings. The most important of their practices is the *nyūbu* or *minori* (entering the mountain), and entails climbing holy mountains during each of the four seasons. To the *yamabushi* this climb represents an ascent from the profane world to a condition of religious purity, as well as a rebirth into a more holy state. Although the highly secret nature and strict asceticism of Shugendō kept the number of its adherents comparatively few, the broad appeal of its magical and mystical practices prevented it from suffering the periods of decline witnessed in many other Buddhist sects. During the Muromachi period, when Zen Buddhism was most powerful, Shugendō continued to thrive in its secluded monasteries; it also survived proscription during the Meiji era. Mount Haguro is one of the mountains sacred to the *yamabushi* and was the site of a strong Shugendō movement.

Because Shugendō was practiced in small mountain temples and often required moving about, objects produced for this sect tended to be small and portable. Many esoteric traditions and motifs were continued in Shugendō arts long after they had lost their vitality in more traditional sects. This dragon-entwined sword is a striking example of both the comparatively small scale and the continued strength of Shugendō's esoteric arts. The writhing body of the dragon fully entwines the length of the sword. All but one of his three-toed claws grip it, while the fourth and uppermost claw stretches out as if to grab the viewer; his gaping jaws are poised just above the tip of the sword and flame spouts behind him. The sword itself is represented as firmly embedded in rock and has a vajra-type handle.

This entire assemblage is the *sammaya* form of Fudō Myōō, the principal of the Five Devas and in Japan believed to be a manifestation of the Vairocana Buddha. Fudo's main attributes are the lasso with which he binds the wicked and the sword with which he smites them. He is frequently depicted seated on a rock, a symbol of his unmovable faith. His *sammaya* form combines the attribute of the rock and the sword with a black dragon; as here, the dragon is almost invariably twined around the sword, about to bite its tip.

The exact origin of this form is somewhat of a mystery. There are no known examples of the dragon-entwined sword in India, and not one of the three extant versions of Fudō Myōō in China holds this attribute. The earliest known version of this figure is at Koya-san and was reportedly brought from Tang China to Japan by Kūkai (also known as Kōbō Daishi). If true, it can be dated to the late eighth or early ninth century. This sculpture consists of a wooden sword and dragon in a bamboo case. The earliest extant Japanese example is a painting of the "Blue" Fudō in the Shōren-in, Kyoto, a Heian painting dated to the late tenth century, depicting the seated Fudō holding a sword entwined by a black dragon. Depictions of Fudō holding the dragon-entwined sword, as well as the the Kurika Ryū-ō alone, are found in the late Heian and Kamakura periods in handscroll paintings and iconographic drawings, some dating into the thirteenth century. The sculpture of Kurika illustrated here is striking considering its relatively late date and its rarity as a repesentation of Kurika in three-dimensional form.

MK

24.
Dragon-entwined sword, Kurika Ryū-ō
Muromachi period, 16th century
Wood with polychrome and gilt
H. 37¼" (94.6 cm)
Eugene Fuller Memorial Collection 69.65

25.
Poems of Ki no Tsurayuki
From the *Ishiyama-gire*
Calligraphy attributed to Fujiwara no Sadanobu
 (1088–1156)
Heian period, 12th century
Page from bound book mounted as hanging scroll;
 ink, mica, and silver on paper
H. 7⅞" (20.1 cm), W. 6¼" (15.9 cm)
Eugene Fuller Memorial Collection 51.210
Plate on p. 47

Poetry and calligraphy, perhaps more than any other of the arts, represented the esthetics of the classical Heian court taste. Games based on competitions in poetry and painting were among the most popular pastimes enjoyed by Heian courtiers. All members of this elite society were able to construct verses extemporaneously, and while some clearly excelled, all were expected to participate actively. The emperor was the supreme personage in the aristocrats' world, and his taste — or the taste set for him by his councillors — established the course of the arts; this was especially true in poetry. Over a period of some three hundred years, eight imperial anthologies of poetry were commissioned. They helped establish standard thematic patterns and have served as reservoirs of poetic allusion sounded by countless poets in countless poems over the intervening centuries.

The earliest anthology and the one that set the standard was the *Kokin wakashū* (Anthology of Ancient and Modern Verse), commissioned in 905 by emperor Daigo (r. 897–930). Two of the four poets responsible for assembling the *Kokin wakashū* are represented here by calligraphies transcribing their poems. The poems of these Heian courtiers, Ki no Tsurayuki (868?–c. 946) and Mibu no Tadamine (867–965) were among the most renowned. These two poets were eventually included in the great eleventh-century anthology of works by the most significant poets of the Nara and Heian periods, the *Sanjū rokunin-sen* (A Selection of Thirty-six Master Poets).

In 1112, about a century after the *Sanjū rokunin-sen* was compiled, a large transcription of the poems of the poets named in it was created for the sixtieth birthday of emperor Toba (r. 1107–1123). This transcription, the *Sanjū rokunin-shū* (Anthology of Poems of the Thirty-six Master Poets), ran to thirty-nine volumes and brought together twenty master calligraphers of the day. The massive set remained in the imperial family until the sixteenth century, when it was dedicated to the Hongan-ji, a major Buddhist temple then located at Ishiyama in Osaka. When the temple was moved to Kyoto and divided — east and west — into the Higashi Hongan-ji and Nishi Hongan-ji, these important books became part of the Nishi Hongan-ji treasures. But the name Ishiyama remained associated with them, and when in 1929, two volumes of the original set were sold and the pages dispersed, the fragmented portions became known as the *Ishiyama-gire*. The two books that were sold included one of two volumes devoted to the poems of Ki no Tsurayuki; a page (No. 25) of that book is now in the Seattle Art Museum.

Probably created as an imperial gift, these books constitute works of art in themselves. Every care was taken in their preparation, and no expense spared to find appropriately elegant and refined materials. Decorated papers for calligraphic inscriptions and letters had become a highly developed craft in Kyoto, and these pages are fine examples of that tradition. The paper was first given a smooth, white sizing, masking its imperfections or modulations. On this unmarred surface, designs were block printed and highlighted with mica. A pattern of diamond shapes enclosing stylized blossoms and entwined by a scrolling floral-vine motif has overtones of the Buddhist *hōsōge* floral pattern and recalls the strong relationship among all the arts in the Heian period and the interconnection of court and religion. Over this ground pattern, tiny blossoms, pine branches, and bird motifs were added by hand in silver ink, which has darkened. The intent was to create an ethereal setting for Ki no Tsurayuki's poems and the elegant calligraphy transcribing it.

The pages of the books were bound edge-to-edge in accordion fashion, permitting two pages to fold out side-by-side. The light impression along the left edge shows that this page originally was the right half of a pair. Some pages were additionally decorated with a collage of colored papers, a technique highly developed at that time. Here, at the lower left, are traces of a triangular piece of colored paper that extended from collage decoration on the left-hand page.

A great deal has been written about the place of calligraphy in Japanese art. The distinctive grass writing (*sōsho*) has become so closely associated by the Western public with Japanese art and culture that it is probably recognizable even to the most casual museum visitor. It might therefore seem strange to realize there was a time when the Japanese had no writing system. Yet even after the Japanese borrowed the Chinese system, the calligraphy forms with which we are familiar today evolved only after considerable experimentation and generations of development. Subsequent to abandoning contact with China at the end of the ninth century, a period of intense assimilation ensued, during which the Japanese absorbed and transformed those foreign elements, such as calligraphy, that had recently enriched their lives. In the search for a written script that would answer the needs of the Japanese language, an important development was the syllabary, or *kana*, a script of assigned and associated sounds for transcribing the oral traditions of Japanese literature.

Court ladies contributed to the advancement of the *kana* scripts. Not required to deal with matters of government, they were free to turn their energies to literature. Out of their interests emerged the romantic novel, its exemplar the *Genji monogatari* (The Tale of Genji) of about 1000. Having no need to learn Chinese, the language of documents and government business, they used the *kana* scripts for their correspondence and compositions. In time, men, too, began using the efficient and esthetically appealing *kana* scripts. Formalization into stylistic schools or allegiances soon followed. A leading courtier, Fujiwara no Yukinari (972–1027), established a prevailing taste in calligraphy that became known as the Seson-ji lineage, after the temple where he often resided.

The fifth-generation head of the Seson-ji group was the calligrapher who brushed the poems on the Seattle page. He was Fujiwara no Sadanobu (1088–1156). His taste is reflected in this page by its greater variation in line width, its sense of spontaneity in the spacing, and the rhythmical cadence of brush movement. This unhesitating flow imparts an overall immediacy, uniting the writer's thoughts and the action of the brush in a single motion.

The true sense of Heian-period aristocratic taste is nowhere better exemplified than in this page of elegantly brushed poems of tender affection. The sheet of paper on which the poems are written seems as insubstantial as the dream of reality the courtiers believed this world to be, yet it glows with the beauty of the paradise they hoped to create. The trailing ink left by the moving brush sings the songs of love and parting that filled the hearts and thoughts of the courtiers in their perfumed progress through life. Two poems are written here: one in three columns begins at the right; this is followed by a three-line note to the second poem, which likewise is in three lines of uneven length. The mixture of cursive *kana* and cursively written Chinese characters is typical of the new *wayō*, or Japanese style of writing, which emerged during the mid-Heian period and from which modern everyday calligraphy eventually developed.

First poem, right:
A wind that will never fail
Though you
Were to fan forever —
Such is my deep respect
For you.

Headnote, second poem:
Poem added to a gift of clothes and paper offerings
for safety on journey for the daughter of Fujiwara
no Okikata.

Second poem:
These paper offerings
For the starting of your journey
May the gods accept,
And these my loving thoughts report to you,
At every shrine along the spear-straight way.

Mibu no Tadamine, another of the compilers of
the *Kokin wakashū*, is represented here by a frag-
ment of a later handscroll (No. 26) from the thir-
teenth century, at the end of the Kamakura period.
The courtly manners and pastimes established at
the palaces and the mansions of the Fujiwara and
exemplified in the *Ishiyama-gire* persisted for many
centuries. Some of the Heian-period traditions
proved viable, while others became lifeless anach-
ronisms; however, the pursuit of a poetic ideal
continued in undiminished force after the end of
the Fujiwara regime. Among the persisting courtly
traditions, the ones that best preserved for the
Kamakura-period courtiers the air of Heian court
taste included the transcribing of the poems of the
master poets, the *Sanjū rokunin-shū*. During the
Kamakura period, the popular Heian-period genre
of *kasen-e*, imaginary portraits of the master poets,
was adapted as a kind of poetry competition which
combined transcriptions of the poems of pairs of
poets with *kasen-e*-type portraits. These were imag-
inary competitions, *jidai fudō uta awase*, and fea-
tured the works of fifty pairs of poets, both ancient
and modern.

The retired emperor Go-Toba (1180–1239) is
credited with making the selection of the group of
fifty pairs of poets who were set in imaginary com-
petition. These fifty pairs were usually divided
between two handscrolls in a set, and many sets
were prepared over succeeding centuries. In this
section, Mibu no Tadamine is shown facing to our
left. In its position in the original handscroll, this
composition would have been followed at the left
with another poet, his competitor, facing right with
his poems above. This now-missing poet would
have been Minamoto no Shunrai (1057?–1129),
a poet Tadamine obviously could not have known.

Poems belonging to the poets matched in these
imaginary contests were inscribed above their por-
traits, and the pairs of poems were then judged.
Tadamine's three poems are from rounds 58, 59,
and 60.

Round 58, right:
Is it just because
They say that this is the day which marks
The coming of the spring
That the mountains of fair Yoshino
Are veiled this morning in a haze?

Round 59:
Even more fleeting
Than a dream
Is a parting
At the break of dawn
After a summer night.

Round 60:
Since that parting
When your indifference was as cold
As the fading moon at dawn,
I have known no kind of wretchedness
Like that brought by the break of day.

The calligrapher of this page is traditionally
identified as Fujiwara no Tameuji (1222–1286),
a major artist of his day and noted for his poetry
as well as his beautiful calligraphy. The attribution
seems justified from similarities to other works
attributed to him. There is a lively cadence to his
brush, which he further animates by moving the
columns of calligraphy slightly to one side and then
to the other of the imaginary center line of the
column, preventing the composition from becoming
stiff and making the reader conscious of the writer's
presence and of his creative role.

Often joint works between calligrapher and
painter, these portrait-types became standardized
very early. Tadamine, with a military rank at court,
is shown in the appropriate headgear (*oikake*) and
robes; he is shown similarly attired in scrolls both
earlier and later than the Seattle example. All the
artist's skill has been lavished on the face, and
though imaginary, the portrait has powerful model-
ing and individuality. The almost undifferentiated
costume, with its simple linear definition, contrasts
with the complex description of the face and head.
In *yamato-e* painting, this lack of color in the
costume classifies this depiction as *hakubyō*
(literally: white drawing); the only color used in
hakubyō is limited to a light touch of red at the
lips or on the cheeks. This posture with legs articu-
lated and at least one half-bent differed greatly from
depictions of other poets; this pose, with small
variations, was standardized very early for depic-
tions of Mibu no Tadamine.

WJR

26.
The Poet Mibu no Tadamine
From the handscroll *Jidai fudō uta awase* (Competition
 between Poets of Differing Eras)
Calligraphy attributed to Fujiwara no Tameuji (1222–1286)
Kamakura period, 13th century
Fragment of a handscroll, ink and light color on paper
H. 11¼″ (28.6 cm), W. 9⅛″ (23.2 cm)
Thomas D. Stimson Memorial Collection 48.170
Plate on p. 49

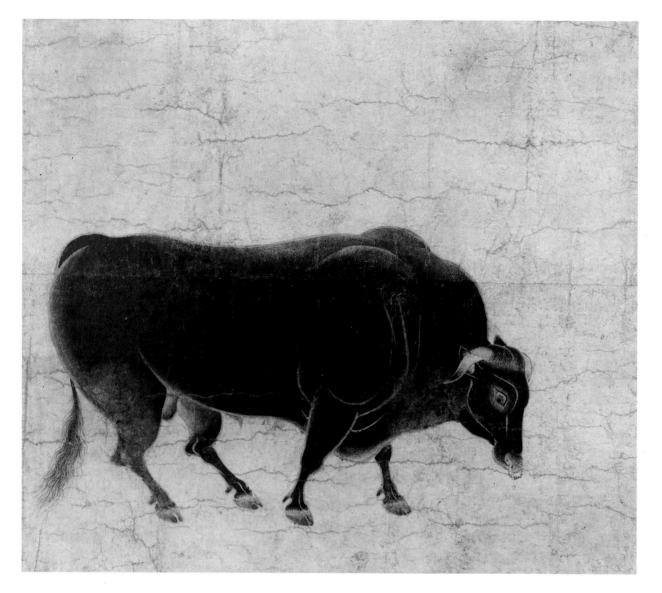

27.
One of the Ten Swift Bulls (Shungyū-zu)
Kamakura period, c. 1300
Fragment of a handscroll mounted as a hanging scroll,
 ink and slight color on paper
H. 10½″ (26.9 cm), W. 15⅝″ (39.8 cm)
Gift of Mrs. Donald E. Frederick 50.66

Realism as a faithful record of the visible world dominated in the esthetics of Kamakura-period art. In sculpture this took the form of muscular limbs, animated poses, and lifelike facial expressions enlivened with crystal eyes. In painting, depictions of everyday life abounded. Long narrative handscrolls of the biographies of religious leaders or detailed scrolls of historic battles characterize much of the mainstream of Kamakura-period art. As a part of this capturing of the visible, portraiture was highly developed. In sculpture and painting, depictions sometimes reached almost unbelievable exactitude. Likenesses of famous priests had been a recognized type from earlier times, but now portraiture in painting became the rage as a major art form and extended beyond humans to animals of exceptional beauty and power. In particular, the magnificent bulls and horses used to pull carriages were given special attention.

During the Heian and Kamakura periods, the fashionable carriage was a heavy, two-wheeled cart pulled by bullocks. These were the *gissha* or *goshoguruma* often seen in *yamato-e* paintings. It is not surprising that these beasts attracted attention; they must have been a very impressive sight, moving about the city or the countryside with their several trainers or handlers, as well as other attendants who carried steps for alighting and other equipment.

The fashion for painting portraits of these bulls seems to have been a Kamakura-period phenomenon. Several scrolls showing these treasured creatures are known to have existed from literary records, and a number of Edo-period copies of the scrolls remain. However, the Seattle painting belongs to a group in collections in the United States and Japan, all of them originally thought to come from the same Kamakura-period scroll. Scrolls recording the beautiful and admired beasts took several forms. One, known as the *Shungyū ekotoba* (Illustrated Tales of Bulls Past and Present), contained illustrated stories; another scroll type, presumably that from which this painting comes, the *Kokugyū jūzu* (Pictures of Ten Famous Bulls of the Nation), of circa 1310 (known in two Edo-period copies) listed ten champion animals from different provinces of the country. With each was a written description telling its place of origin and characteristics of appearance. Of the six bull paintings in Japanese collections and an example in the Cleveland Museum of Art which seem clearly related to the Seattle Art Museum painting, several correspond with illustrations from the *Kokugyū jūzu*. Among the examples in Japan, the Kitamura collection painting can be identified as the bull from Kawachi (near modern Osaka) and the Setsu collection painting can be identified as the bull from Tsukushi, in Kyushu. The Seattle bull (though the pose in the *Kokugyū jūzu* differs slightly) closely resembles the illustration of the bull identified as coming from the Imperial Enclave in Hizen, Kyushu.

The artist has captured the characteristic glossy coat and massive, muscled frame of these pampered beasts through a series of techniques developed for portraying human figures in the *yamato-e* tradition. In a technique termed *hori-nuri*, a lightly inked outline was first laid down; within it, the artist added several layers of ink wash until he had built up a great density. From the heavy neck and shoulder to the long swing of the powerful back, the layers of ink are modulated to define the rippling musculature. The lighter lines over the eye, along the jaw and at the shoulder are actually underlayers of lighter ink left exposed as the dark layer was added. The highlighting at places like the top of the shoulder, the rump, and the chest are important touches for visual confirmation of the three-dimensionality of the animal. The eye with its brown iris imparts vitality to the impassive pose. A very light brown wash suggests the texture of the horns. The sureness and descriptive detail in these areas contrast effectively with the broadly washed hulk of the beast.

The known paintings of these swift bulls no doubt have all undergone repainting and restoration in varying degrees. The Seattle painting seems to have had the entire area along the upper part of the back refreshed at some time in the distant past, and the back leg at the left has been completely repainted. Another damaged area covers the lower portion of the neck and the lower jaw. The other three legs, the tail, the head with its sensitive muzzle and obstinate horns, and the bulk of the massive form still show undisturbed the Kamakura-period artist's intention and record faithfully the absolute power of his brushwork.

WJR

The *yamato-e* handscroll tradition, which had arisen in the Heian period, found its full esthetic expression as a unique Japanese art form during the Kamakura period. The Heian themes, notable for their secular, seemingly nonmoralistic nature, or emphasis on more popular aspects of religious thought, were epitomized by the *Genji monogatari* illustrations and the *Shigisan engi*, the history of the founding of the temple of Mount Shigi. This tradition was expanded considerably by Kamakura-period artists and included scrolls illustrating competition between poets of differing eras (No. 26); in addition, purely documentary scrolls of historic events were produced, including thumbnail portraits of those involved, or the bull portraits (No. 27), and formed another characteristically Kamakura-period application, both in handscroll format and as portraiture. The new uses of handscrolls included depictions of the lives of the saintly religious leaders of the era and documentations of religious establishments called *engi*.

This expansion in part resulted from a broadening of the social base which, in religion, was reflected in the newly created exoteric sects, and in the rise of popular literature written in the vernacular. This popular storytelling is best represented by the warrior novels, but evolved in its extreme form into the sometimes vulgar tastes of the *otogi-zoshi* (medieval short stories), or the *setsuwa-bungaku* (legendary tales).

The two handscroll examples included here represent the religious *engi* and the popular warrior novel illustrations. The *Kitano tenjin engi* is the story of the events leading up to the deification of the wrongly accused courtier Sugawara no Michizane (845–903) and the subsequent founding of the shrine in Kyoto in 947 to placate his angry spirit. Michizane had been exiled to a part of Kyushu known as Tsukushi, which meant ignominious disgrace, dishonor, and isolation at what must have seemed the ends of the earth. Unjustly accused by a jealous rival, Michizane died of frustration and humiliation; soon after his death, terrible mishaps occurred in the capital, and his accuser also died unexpectedly. Michizane's wrathful spirit was believed responsible for these disasters. To placate it, he was posthumously reinstated with honors at court and deified as a Shinto Tenjin, or god of heaven. This Tenjin cult received imperial attention; it soon spread widely and remains today one of the most important in Japan.

This scene (No. 28) depicts the boat that carried Michizane into exile at Tsukushi. The tragic hero, unseen, sits within the roofed shelter at the stern; before the shelter, two men in the robes of courtiers, perhaps his jailers, sit with a priest, while a woman and several children, perhaps dependents of a man in the group, sit forward in the well of the boat. A somber mood pervades the scene, reflecting the ponderous sorrow that must have engulfed Michizane at that moment. The starkness of the setting forcefully informs the viewer of Michizane's fall from favor and the lost glories of his days in power at court, providing dramatic contrasts with the happy theme of boating on the lakes and ponds of the imperial capital for moon-viewing parties or other holiday outings popular with the court. Here the glum looks of the banished are reflected in the tone of all the other passengers and crew. Only the dog, sniffing at some unseen quarry below deck, goes about life oblivious of the sad journey underway. The tone of the inks, too, is subdued: a soft blue for the waves, a sober yellow, and a thin, almost invisible line of black ink for outlines. In contrast, the line describing the expanse of the Inland Sea is brilliantly brushed of seemingly endless concentric undulations, indicating the strength and incessant movement of the water.

Typical of the thoroughgoing observation of a real-life setting in Kamakura-period handscrolls, the deck shows tubs and ropes, anchors, and the furled sail lashed to the mast stowed along the deck. The ties of the *sudare* at the windows of the shelter, the clothing, most noticably in the black caps, are all clearly described and differentiated. An attendant carries a tray with a dish of food, his stately movement contrasting with the straining bodies of the crewmen poling the boat. Even as our attention is focused on one of the central moments of this story, three of the crew are watching something in the distance ahead. One shades his eyes with his hand, in a movement anticipating the next scene to be revealed as the scroll is unrolled.

The earliest known illustrated narrative of the *Kitano tenjin engi* is dated 1219, the *Jōkyū-bon* (Version of the Jōkyū Era). The great popularity of the Tenjin cult called for many scrolls, and even today various versions dating over many centuries are known. The portion illustrated here is from a set of scrolls originally commissioned for the main shrine in Kyoto and is dated to 1278. Parts of this set are now found in a number of collections. One in the Tokyo National Museum shows a boat pulled up on a beach, with a shore scene of a house, a woman doing laundry, and some scattered lumber from shipbuilding activities. The boat is different from the one depicted in the Seattle scene, but is clearly related to it; both its brushwork and wave

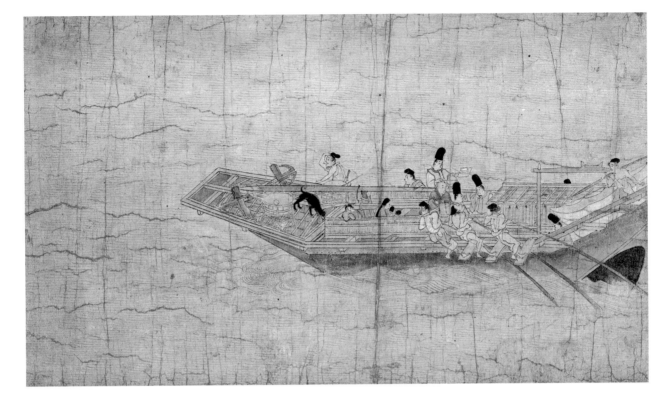

28.
Voyage to Tsukushi
From the *Kitano tenjin engi, Kōan-bon*
Kamakura period, 1278
Section of a handscroll mounted as a hanging scroll,
 ink and slight color on paper
H. 12″ (30 cm), W. 26″ (66 cm)
Eugene Fuller Memorial Collection 48.169

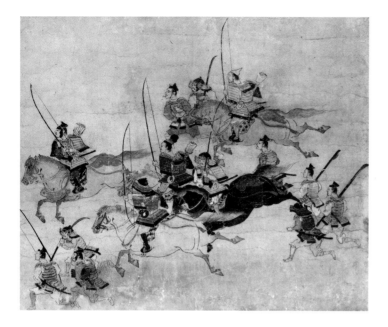

29.
Battle Scene
Kamakura period, 14th century
Section of a handscroll mounted as a hanging scroll;
 ink, color, and touches of gold paint on paper
H. 14″ (35.5 cm), W. 17¼″ (43.8 cm)
Eugene Fuller Memorial Collection 48.173
Plate on p. 61

treatment are continued in an identical manner. The Kitano shrine still possesses the major portion of this set of scrolls, which are known as the *Kōan-bon* (Version of the Kōan Era) after the reign era mentioned in the text.

The battle scene (No. 29) represents the Kamakura-period taste for tales of heroic warrior deeds. Heroism amid bloody tragedy marked the end of the Heian period when the warrior families, the Taira and the Minamoto, were fighting in support of differing alliances in a struggle to control the court after the death of the retired emperor Toba in 1156. The stories, based on the events of the Hōgen and the Heiji reign eras, are known as the *Hōgen monogatari* and the *Heiji monogatari*. Only the *Heiji monogatari* is known today in a series of handscroll illustrations (a painting in screen format in the Metropolitan Museum of Art is a rare example). These scrolls are only a small part of the original number in the set. One of the most brilliantly designed and executed is *Burning of the Sanjō Palace*, a scroll now in the Museum of Fine Arts, Boston. The thrilling sense of physical danger, the heat and choking smoke of the fire, the confusion

and terrifying noise are so clearly portrayed that the scroll stands as a classic example of Kamakura-period taste and artistic skill.

Typical of this sort of narrative, the group of horsemen and warriors on foot in the Seattle battle scene press forward with great energy, the stallions in flying leaps to indicate their speed. As in the well-known Heiji scrolls, the armor is detailed, the horse trappings accurately described. The artist has used a series of images in sequential motion to emphasize the movement and flow of action, and has systematically fanned the verticals of the halberds and bows from the right, through the upright positions in the center, to the tipped positions at the left.

In a comparison with existing warrior *emaki*, the treatment of the horses, armor, and faces in the Seattle painting seems closest to the Boston scroll; however, many distinctions between them also exist: the dimensions of the paper, the scope of the scene, the coloration, especially the use of gold on the Seattle piece. The greater complexity of composition and psychological insight of the Boston scroll, however, distinguishes it from this one as a completely unrelated work. Moreover, the scene depicted in the Seattle fragment is not found in any part of existing Heiji scrolls. Based on the distinctions between this scene and the standard of the Boston scroll, it would perhaps be more appropriate to see this one as a portion of a painting dating to the fourteenth century or later.

WJR

The latter half of the Heian period, frequently called the Fujiwara period, was a time of cultural introspection and development of national styles in Japan. This owed in part to disillusionment with China, leading to a break in official contact in 894, and also to an increase in national awareness and confidence. During this period, much of Japan's wealth was controlled by two large clans, the Fujiwara and the Taira, who competed for political control by manipulating the imperial family and, late in the period, through armed conflict. The aristocratic Fujiwara, as the period epithet suggests, remained the most influential until the late twelfth century. Their immense wealth and sophistication allowed them to patronize and greatly influence the arts and are reflected in the vast Buddhist temple building projects they commissioned, as well as the enormous numbers of sutras and other works of art they dedicated to these temples (No. 14). This sutra is thought to be from a set of the Sutra of the Lotus of the True Law that was dedicated around 1175 to the Chūson-ji, a temple founded by a family of the Fujiwara clan near the town of Hiraizumi, in what was then a very isolated part of northeast Honshu. From the time of the founding of the temple to the destruction of Fujiwara power in 1185, this family dedicated three major sets of sutras to the temple; their total number approached ten thousand scrolls.

The Lotus Sutra was perhaps the most influential of the nonesoteric Buddhist texts and its influence permeated much of the culture of Fujiwara aristocracy. It promised salvation through simply invoking the name of a particular Buddha or bodhisattva; however, doing good deeds, such as constructing temples and dedicating art objects to them, influenced one's status when reborn into paradise. This partly explains the great building projects undertaken during the Fujiwara period and the vast numbers of sutras dedicated to various temples. Many messages in the Lotus Sutra were transmitted through narrative, which also appealed to the Japanese of this period.

This frontispiece illustrates Chapter 10 of the Lotus Sutra, in which Shaka admonishes his followers to erect stupas wherever the Lotus Sutra is written or preached; he also likens those who have not understood it to thirsty men digging for water in a high place. The back of the sutra is densely decorated with flower motifs; the frontispiece shows Shaka Buddha on a lotus throne

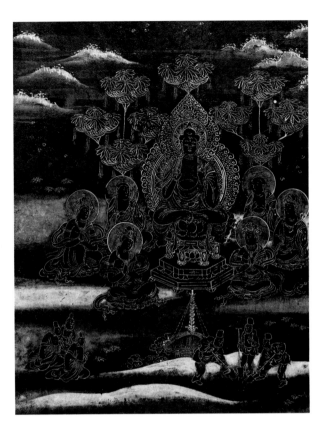

30.
Shaka Giving Sermon
Mounted as frontispiece to the Buddhist sutra Myōhō
 Renge-kyō (Sutra of the Lotus of the True Law)
Heian period, late 12th century
Silver and gold ink on indigo paper
H. 9⅞" (24.9 cm), W. of painting 7" (17.8 cm),
 L. of scroll 394" (1000.1 cm)
Eugene Fuller Memorial Collection 48.171
Plate on p. 30

surrounded by four bodhisattvas and two lohans. As is to be expected in paintings that were created by the thousands, the execution is somewhat cursory, with emphasis on the figures. The element of narrative found in many arts of the Fujiwara period is present in the two groups of men in the lower third of this work. Dressed in short coats and trousers, one group digs with shovels; the second, dressed in long robes and holding what appear to be badges of rank, intently observes the digging. This illustrates the theme Shaka is preaching. The text to which this frontispiece is attached, Book 5, Chapter 10 of the Lotus Sutra, does not correspond to the frontispiece.

MK

31.
Hell of Shrieking Sounds
From the *Jigoku zōshi*
Early Kamakura period, c. 1200
Section of a handscroll, ink and color on paper
H. 10¼" (26 cm), L. of painting 10¾" (27.3 cm),
 L. of calligraphy 13" (33 cm)
Eugene Fuller Memorial Collection 48.172
Plate on p. 56

During the mid-Heian period when the salvationist sects first gained popularity in Japan, the emphasis of art produced under their influence was on the positive, in particular the delights of the Western Paradise of Amida Buddha. But the writings of these sects also contained detailed descriptions of the sufferings undergone by those who did not follow their teachings. A major concept in these writings, the Six Realms of Existence (*rokudō*), divided the birth of sentient beings, depending upon their previous actions, into the realms of the heavenly beings (*ten*), humans (*nin*), beasts (*chikusho*), bellicose demons (*ashura*), hungry ghosts (*gaki*), and hells (*jigoku*). During the end of the Heian period and the early Kamakura, times of economic decline, war, and pestilence in Japan, a sense of pessimism entered religious arts, and depictions of the lower realms of existence became common. The Japanese interest in narrative detail and exposure to a multitude of sufferings during this period led to particularly graphic depictions of these realms. The evolution of the illustrated narrative in a handscroll format (*emakimono*) provided the Japanese artist with the perfect vehicle for expressing the horrors of these realms. The most gruesome were the multitude of hells, each dedicated to the perpetrators of a particular crime against Buddhist teachings.

The scroll illustrated here is one of seven fragments of a longer scroll depicting the Hell of Shrieking Sounds, the one to which Buddhist monks who torture animals on earth are condemned. The accompanying text describes this particular hell:

> Many monks for such cause arrive at the Western gate of this hell, where the horse-headed demons with iron rods in their hands bash the heads of the monks, whereupon the monks flee shrieking through the gate into hell. There, inside, is a great fire raging fiercely, creating smoke and flames, and thus the bodies of the sinners become raw from burns and their agony is unbearable.
>
> (Trans. by Kojiro Tomita)

This particular hell does not appear in the standard salvationist texts, but rather seems to be based on a sutra written in Tang-dynasty China; it first appeared in Japan during the late Heian period. The representation of fire in this scroll and in many contemporary scrolls is powerful, no doubt owing to the frequent fires witnessed by a people living in a time of martial strife in a country where the building materials were almost entirely wood and thatch. Although somewhat like caricature, the figures in this scroll are depicted in manners appropriate to their roles. Thus the massive and muscular demons are developed in strong ink outlines and bold colors and present a dynamic sense of movement, while the agony of the nude monks is well expressed through their twisting forms and the thin, wavy brushstrokes with which they are outlined. The sharp red lines that seem to appear randomly in the painting depict blood spurting from the monks as they are struck by the demons. The convincing depiction of flame, the strength of the brushwork, and use of color relate this work to the other narrative and Buddhist scrolls of the late Heian and early Kamakura periods.

MK

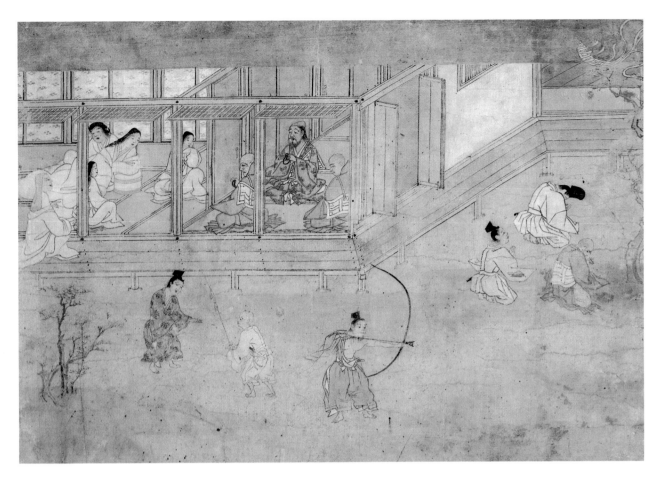

32.
Birth of Hōnen
Kamakura period, c. 1300
Section of handscroll, ink and color on paper
H. 16" (40.6 cm), W. 23½" (59.7 cm)
Eugene Fuller Memorial Collection 48.174

Throughout much of its history, Japan's cultural development has reflected a mix of continental and native elements. During periods of strong foreign influence, the Japanese selected largely those elements that fit their tastes or needs, while during periods of relative isolation, these foreign influences were retained and developed into a Japanese vocabulary. In painting, the dominant foreign influences came from China, and works executed in Chinese styles came to be known as *kara-e* (Chinese painting); the term *yamato-e* designated paintings in which Japanese content dominated in theme or in style. These terms were first employed during the Heian period when the refined and nationalistic Japanese aristocracy recognized the contrasts between their own esthetic and that of the Chinese.

In Japan, Buddhism and its accompanying arts evolved together from a strongly foreign to a more national character, an evolution that closely parallels that of *yamato-e*. As in *yamato-e*, an interest in narrative and in secular life most distinguishes Japanese Buddhist painting from that of China and Korea; this distinction is frequently found in paintings of the Jōdo (Pure Land) sects. The most influential Jōdo thinker of the early Kamakura was

Hōnen (1133–1212), who was concerned that the common people of Japan were offered no opportunity for salvation by contemporary Buddhism. He eventually disagreed with the Tendai doctrines in which he had been trained and wrote a major theoretical work, the *Senchaku hongan nembutsu-shū* (Treatise on the Selected Nembutsu of the Original Vow), which guaranteed that anyone could be reborn into the Western Paradise of Amida simply by reciting with firm belief from his deathbed the name of Amida (*senju nembutsu*).

The popularization of Buddhism initiated by Hōnen paralleled and was influenced by political, cultural, and artistic developments in Japan. The collapse of the Heian aristocracy before the military leaders of the Kamakura led to a change in artistic emphasis from the refined esthetic of the aristocracy to the emphasis on expressive forms and realism of the military. Among the *yamato-e* of the Heian period were a group of paintings that focused on themes drawn from contemporary novels and reflected the day-to-day life of people in the court. Under the influence of the greater interest in realism of the very late Heian and the Kamakura, this type of painting, known as *fūzoku-ga*, expanded to include the customs and manners of the Japanese people of all levels. This pervasive interest influenced content in Buddhist paintings, particularly those of the Jōdo sects.

One major category of Jōdo painting, the depiction of the Six Realms of Existence, or *rokudō* (see No. 31), was particularly popular during the chaotic times of the late Heian and early Kamakura. Although the *rokudō* concept has continental origins, an emphasis on dynamic activity, narrative, and an often morbid realism distinguishes Japanese illustrations of this theme and relates many of them to *yamato-e*. Other Jōdo paintings that may also be described as *yamato-e* include illustrated narratives of the lives of Japanese priests and saints, and works in which Buddhist themes are combined with depictions of places, events, and activities unique to Japan. The two works illustrated here fall into this category.

The handscroll (No. 32) illustrating the birth of Hōnen was once a part of a much longer scroll that would have depicted the major events in his life. The scene is identified as his birth by the presence of a Buddhist banner (*ban*) in the upper right corner. According to Hōnen's biography, two of these *ban* appeared just prior to his birth and remained for seven days. Although only one *ban* is depicted in this scroll, its divine nature is clearly illustrated by the priest and two aristocratic men kneeling

below it. Inside the entry to the elaborate building, three men await the birth. Two are Buddhist monks, evident from their shaved heads, priestly garments, and strings of beads. The third, a mountain ascetic, or *yamabushi* wears a different style of robe, and has a beard and a full head of hair partially covered by a soft hat. In the next room, Hōnen's mother and three female attendants appear unconcerned about the imminent birth. The mother, leaning against a pillow, seems particularly calm. Outside, an archer is about to shoot an arrow, a scene frequently described as an allusion to the impending birth, which will be as quick and easy as the release of an arrow from a bow. A small boy hands a decorated twig to a man who may well be Hōnen's father. The figures are sensitively executed in fine, even ink lines and a careful application of color. However, a slight stiffness in the architectural drawing and in the cloud pattern bordering the painting at the top suggest a date around 1300 or slightly later.

The second work (No. 33) is also a narrative, but is arranged in a hanging scroll format rather than the more common handscroll. Its stylistic development points to a Nambokuchō-period date (mid to late fourteenth century). The painting is divided into two registers by a band of blue across the middle; this band serves as a body of water in the top scene and as clouds for the bottom. This painting has been identified as one of a pair depicting the life of the Jōdo Shinshū priest Gensei Shōnin (d. 1360). The other painting, now in the collection of the Tokyo Fine Arts University, depicts the early life of this monk; the Seattle painting depicts his later life. According to the *Itoku hōrin shū* of 1712 and other eighteenth-century sources, a pair of paintings of these subjects was in the collection of Mampuku-ji, a temple Gensei founded in 1321; this painting and the one in Tokyo have been identified as that pair. The setting of the Seattle scroll is the Yakushi-dō at Ōba, Sagami no Kumi, near Tokyo; the monk depicted in various parts of the painting is Gensei.

The Japanese interest in genre scenes is clearly shown in this entire work. Below, before the entry to the temple, is a gathering of merchants, beggars, aristocracy, and monks of a broad range of ages and types of dress; many wear particularly high *geta*, a type of sandal. Numerous blossoming trees indicate the season is spring. Just inside, a masked dancer moves about a green square to the sound of drums and an elaborate flute. Watching the performance are a number of aristocrats and Buddhist monks, some seated on the ground near the dancer, others screened by walls of fabric, and still others

seated in a tall viewing platform. Two spectators have climbed into the topmost branches of a tree in order to get a better view. Farther up the scroll, a number of monks, aristocrats, and samurai are involved in various activities. The large building to the left of this scene has a cartouche in the roof center; its characters, missing, may have identified the temple portrayed here. More likely, the content was similar to other cartouches identifying individual buildings in the painting. Outside the upper, and therefore northern, wall of this temple is a building identified as a tomb or memorial hall to Shinran. Around it are a number of tomb markers; several monks and others have gathered in it, perhaps to participate in memorial services for the occupant. Above the blue band separating the two registers is a mountain temple with a large gateway guarded by two *niō* (gate guardians). In the building to the right of the gate, a man is having his head shaved by a group of monks. This is part of the ritual involved with taking religious vows and must represent an event in the life of Gensei Shōnin. Farther up are a number of other buildings, one identified as a Yakushi-dō, a hall dedicated to Yakushi Buddha; to its right is a three-storied pagoda; behind the pagoda is a red building, which can be identified as a Shinto shrine. A small group of men enjoy the mountain scenery and a waterfall in the left section of this register, where autumn is indicated by the presence of bare-limbed trees, and others with a few red leaves.

MK

33.
Scenes from the Life of Gensei Shōnin
Nambokuchō period, c. 1360
Hanging scroll, ink and color on silk
H. 60" (152.4 cm), W. 31⅞" (81 cm)
Eugene Fuller Memorial Collection 49.92
Plate on p. 39

B ecause many of the converts to the Pure Land sect were of the less educated lower classes, paintings illustrating Amidist precepts either through narrative or parable were created to edify them. Using these paintings, traveling monks spread the word to the masses. Although the practice of using paintings in this manner was brought to Japan with Buddhism, the native Japanese interest in narrative raised the art form to new levels, as seen in long scrolls of Buddhist topics such as the *Jigoku zōshi* (No. 31), in paintings such as the *Scenes from the Life of Gensei Shōnin* (No. 33), and in works such as this hanging scroll, which illustrates the parable of the White Path between Two Rivers.

The parable was written by Shandao (613 – 681), the third patriarch of Pure Land Buddhism in China, and is found in the fourth chapter of his commentaries on the *Kammuryōju-kyō*. It was frequently quoted by Hōnen (1133 – 1212), who founded the Jōdo sect in Japan. It concerns a man who traveled west on an extremely long journey, during which he encountered many dangers in desolate places. Midway through his journey he encountered two rivers entirely blocking his path: a river of fire to the south and one of water to the north; between the two rivers and crossing them was a long and very narrow white path. Although to turn back would mean certain death, the man hesitated to attempt to cross the white path, but ultimately decided to do so. Just then he heard the voice of Shaka Buddha from the near side of the river warning him of the dangers of the place he was in and urging him on, and the voice of Amida Buddha from the far side promising to aid and protect him in the crossing. The man proceeded over the bridge, despite the pleading of thieves who pursued him and promised to cause him no harm, and beyond the rivers he found the Western Paradise of Amida Buddha. This parable illustrates the difficulties encountered while following the path to

salvation in the Western Paradise. The wild beasts and thieves are worldly dangers; the rivers represent two of the great pitfalls on the path — anger (fire) and greed (water). The appearance of both Amida and Shaka displayed their willingness to assist, once one made the decision to follow the path to Amida's Western Paradise. The theme was particularly prevalent in paintings of the Kamakura and the Nambokuchō periods when Jōdo was at its peak in Japan.

This painting follows very closely the plot of the story. It is divided into halves by a diagonal line; the bottom half represents the secular world, the upper half the Western Paradise. In the lower part are two houses in which obviously upper-class men and women read and play music. Between the two houses a peasant is dragged by a bucking horse. Just below the diagonal line, a band of fully armed thieves pursues the fleeing man. Around him are snakes, dogs, and other wild beasts. The man appears again on the white path where he is portrayed hurrying with arms outstretched to a waiting Amida Buddha. On one side of the path a couple and their possessions are washed away by the river of water; on the other, a man beats a woman in the river of fire. But once the man enters the Western Paradise, he encounters musicians and dancers, Amida and his attendants Kannon and Seishi, and a beautiful pavilion in a lotus pond. The artist emphasized the contrasts between the two realms by making extensive use of cut gold leaf (*kirikane*) in the scene of the Western Paradise, while dark and somber colors and no *kirikane* are used in the lower, earthly section. Earlier depictions of this theme are divided horizontally and usually include a depiction of Shaka Buddha on the near side of the river. The diagonal division of this painting, the fact that Shaka is not portrayed, and other stylistic factors indicate a date in the Nambokuchō period.

MK

34.
White Path between Two Rivers (Niga byakudō)
Nambokuchō period, late 14th century
Hanging scroll; ink, color, and cut gold leaf on silk
H. 32¼" (81.9 cm), W. 15½" (39.4 cm)
Margaret E. Fuller Purchase Fund 56.182

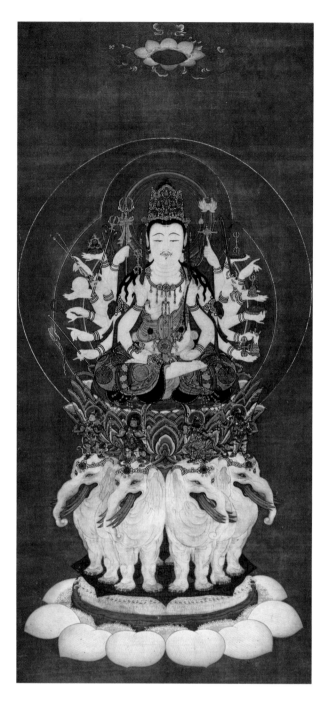

35.
Fugen Emmei Bosatsu
Nambokuchō–Muromachi period, 14th–15th century
Hanging scroll; color and cut gold leaf on silk
H. 36" (91.4 cm), W. 16¾" (42.6 cm)
Eugene Fuller Memorial Collection 69.17

During the early Kamakura period, the vigor of the military rulers and their desire for a greater degree of realism in art were powerful creative forces that contributed greatly to artistic and religious developments. However, by the mid and late Kamakura period, the familiar forms of Buddhism had lost much of this vigor, a development clearly reflected in the arts. The introduction of Zen from China and the funneling of much creative energy to that sect was at least partially responsible for this decline. In sculpture the emphasis on realism led to secularization, and, following the last creative efforts of the Kei school, much of the power of this art form was lost. A similar development can be seen in the traditional styles of colored Buddhist painting such as the hanging scroll of Fugen Emmei Bosatsu illustrated here. This painting lacks the expressive power of earlier esoteric works, replacing it with delicacy, refinement, and an overriding interest in minute detail.

Depending upon the sect of Buddhism, the particular ceremony or ritual, and a number of other factors, each bodhisattva in the Buddhist pantheon can play several roles. The bodhisattva Fugen is at once one of the two attendants of Shaka Buddha, where he represents the dynamic aspect of Shaka, the defender of those who believe in and recite the Lotus Sutra, a special protector of women, and, in his esoteric form, one who prolongs life and brings prosperity and wisdom. Like many deities of Indian origin, Fugen is associated with a particular vehicle, the six-tusked white elephant. Its color and the six tusks symbolize purity, each tusk representing purity of one of the six organs — eyes, ears, nose, tongue, body, and mind. This iconography derives from two sources, the Lotus Sutra (Hoke-kyō) and the Kan Fugen-kyō. This figure depicts the esoteric "life-prolonging" (Emmei) form of Fugen. Its iconography is developed in great detail: over his head is a floating lotus, behind his back are three halos, on his head a complex crown contains representations of the five Dhyani (Wisdom) Buddhas; his twenty arms hold a variety of ritual implements including different forms of vajra, bells, jewels, lotus, and related objects. His complex and brightly colored lotus throne is supported on the backs of four elephants. On the head of each elephant appears a small representation of one of the Four Directional Guardians; the elephants stand on a large wheel of the Buddhist law which, in turn, is supported by over five thousand small elephants; the entire ensemble is supported by a lotus.

MK

The influence of the Fujiwara, perhaps the most powerful of the nonimperial aristocratic families of Japan's early history, goes back to several sources. The Fujiwara traced the origins of their clan back to the kami Ame no Koyane no Mikoto, who played a primary role in the legend of Amaterasu, the Sun Goddess and supposed ancestress of Japan's imperial family. The story involves rivalry between Amaterasu and her sibling deities. Disgusted with the actions of her brothers, Amaterasu withdrew into a cave, plunging the world into darkness. The various kami were unable to convince her to emerge and finally resorted to trickery: while one was performing a somewhat bawdy dance to music, Ame no Koyane no Mikoto and others hung a mirror, sword, and jewel from a *sakaki* tree (*cleyera ochnai*) near the cave. The beauty of the dance and curiosity lured Amaterasu from her cave, and a straw rope was strung across the entrance to prevent her re-entering. Thus Ame no Koyane no Mikoto became associated with the *sakaki* tree and the mirror, an association passed on to his descendants, the Fujiwara family. The mirror hung from the *sakaki* tree is a frequent element of paintings that deal with this family. Because of their historical and legendary background, the Fujiwara (which in earlier times, as the Nakatomi clan, had adhered to Shinto) were in charge of important Shinto rites and were able to exert strong influence from that position.

A second legend dealing with the Fujiwara dates to when the Japanese capital was established at Nara (c. 710). According to this legend, two members of the clan (which had not yet been granted the title Fujiwara) effected the transferral of two tutelary clan deities from their homes at Kashima and Katori in northeast Japan to Mount Mikasa and the Kasuga shrine near Nara. According to legend these two men, Takemikazuchi no Mikoto and Futsunushi no Kami, made the trip from the north riding white deer. The deer is still sacred to Shinto and is a symbol of the Fujiwara family; herds wander freely about their family shrine at Kasuga. *The Departure from Kashima* depicts Takemikazuchi no Mikoto mounted on a white stag and attended by two of his descendants, Nakatomi no Tokikaze and Nakatomi no Hideyuki. The depiction of these legendary ancestors of the Fujiwara family and the *sakaki* tree with the mirror and *gohei* (white strips of paper containing prayers) combines these two legends in a single work.

The box for this painting bears the date 1428, which seems consistent with the style of the work itself. The clouds, in a typical Muromachi-period

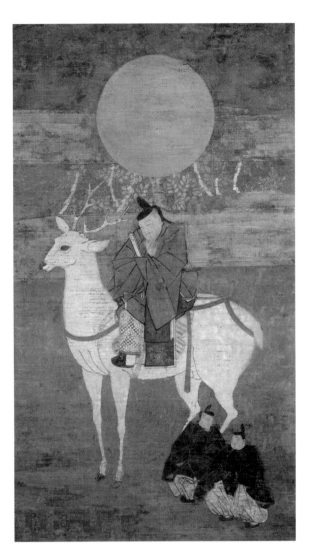

36.
The Departure from Kashima
Muromachi period, 14th–15th century;
 reputedly from the Kasuga shrine, Nara
Hanging scroll; ink, color, and gold on silk
H. 55½" (141 cm), W. 31½" (80 cm)
Lent by the estate of Mrs. Donald E. Frederick L 61.1

manner, are depicted with bands of gold color but retain a sense of mist and space not seen in later paintings. Although Takemikazuchi no Mikoto's white stag and the three human figures are executed somewhat stiffly, the close observation of details of the men's faces relates this painting to portraits of the Kamakura, Nambokuchō, and early Muromachi periods. The sharp, angular folds in the drapery are also reminiscent of paintings of these periods. Although the large mirror appears to float like a moon on the *gohei*-festooned branches, the suggestion of a ground line and a limited spatial development also supports a Muromachi-period date.

MK

The end of the Heian period was marked by violent warfare between the Taira and the Minamoto clans, a conflict eventually won by the Minamoto, samurai from northeast Japan. Their victory initiated not only a change in political power in Japan, but also a series of changes in taste and cultural values that deeply influenced later Japanese arts. During the Kamakura period, for the first time in Japanese history, the political center was moved to a site separate from the imperial capital. The military leaders of the Minamoto clan, although perhaps considered rough provincials by their contemporaries in Kyoto, were people of action and decision; freed from the influence of the court, their tastes allowed for the development of art styles far more direct and expressive than the sophistication of the Heian court arts.

The military rulers of the Kamakura period found other sects of Buddhism more suited to their outlook than either the Jōdo or the *mikkyō* of earlier periods. Of particular appeal was Zen, which entered Japan in the late twelfth and early thirteenth centuries with the reopening of relations with China. Rather than the magic and mysticism of the esoteric sects or the constant accumulation of merit of Pure Land, Zen emphasized concentration, discipline, and an acceptance of the unexpected to overcome self and attain enlightenment. This direct approach was well suited to the military minds of the Kamakura rulers; Zen esthetics also held great appeal for them. Rather than the scenes of salvation or hell of the Jōdo sects or the mandalas and fierce guardians of *mikkyō*, Zen arts focused on deeds of patriarchs or the historical Buddha, and on depictions of nature. Sculpture had no real place in these arts, and paintings were most frequently done quickly and spontaneously in ink.

The first traces of this new esthetic in Japan are found in a series of sketchlike ink paintings from Kōzan-ji, a temple of the Kegon sect; among these is the Seattle Shussan no Shaka. Although it was not a Zen temple, arts reflecting Zen taste appeared at Kōzan-ji through the wide-ranging interests of its founder, Myō-e Shōnin (1173–1232). Myō-e was a friend of Myōan Eisai, the man credited with establishing the first Zen temple in Japan. Myōan Eisai made several trips to China to study Zen; in 1168 he traveled with Shunjōbō Chōgen, a Pure Land priest, and it is in the record of the treasures brought back from China by Chōgen that the first reference to the Shussan no Shaka theme, in the form of a Song painting, appears in Japan. On Myō-e Shōnin's directives, sketchlike copies were made of many of the works in the Kōzan-ji collection by a workshop of artists he gathered there, and it has been suggested that the Song painting may have served as the model for the work illustrated here. This painting thus is derived from two quite different traditions. Its origins in late twelfth-century Chinese Zen painting can be seen in the diagonal composition, the minimal landscape setting, and the strong, spontaneous brush with which the garments and setting are depicted. The thin, even lines used to depict the details of the face, however, clearly relate to other sketches done by the Kōzan-ji workshop. As in other works, the two Kōzan-ji seals on this painting are randomly placed to the right of the figure. Dates ranging from the early thirteenth century to around 1300 have been suggested for this piece. If the earlier date is accepted, the painting was completed during Myō-e's lifetime and is more than a century earlier than the first real flowering of Zen arts in Japan.

The exact iconography of the motif of Shaka descending appears to have been a topic of debate from its first representation in Northern Song China. According to standard Buddhist texts, Shaka spent six years practicing austerities before realizing that was not the path to enlightenment. The event of his descent from the mountains after this period of austerity does not exist in Indian Buddhist sources and does not appear to have become prevalent until the Northern Song dynasty in China. In China, native Daoist practices suggested that enlightenment was best achieved by the hermit in a wilderness setting. The theme of Shaka descending may thus reflect the influence of Daoist principles on Zen Buddhism in China. Its first representation is often attributed to the Northern Song literati artist Li Gonglin (c. 1049–1106); soon afterward the debate began whether this figure represents the enlightened Shaka, or his discouragement after realizing the error of austerity. Representations of this theme show Shaka with the attributes of enlightenment, the knowledge bump (*usnisa*) on his head and the divine eye (*urna*) on his forehead, but standard texts state that Shaka reached enlightenment while meditating under a bodhi tree, well after his period of austerity. Since the theme does not appear in scripture, there seems to be no real resolution to the debate. The secularization of Shaka, typical of Zen, is apparent in this emaciated, bearded figure, a quality that made this theme and Zen in general popular with the military leaders of Kamakura Japan.

MK

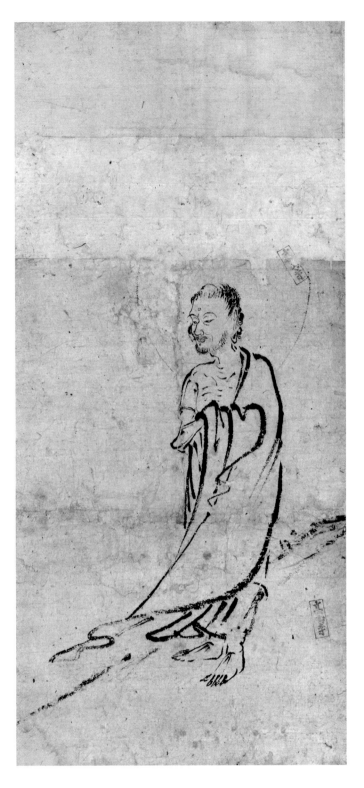

37.
Shaka Coming Down from the Mountain
 (Shussan no Shaka)
Kamakura period, 13th century
Hanging scroll, ink on paper
H. 35¾" (90.8 cm), W. 16½" (41.9 cm)
Eugene Fuller Memorial Collection 50.124

Lacquer has been used to decorate and protect objects made of wood and other materials in China and Japan for many centuries. Methods of using lacquer were developed in Japan to a high degree of technical and artistic perfection, placing Japanese lacquer work in a class of unsurpassed excellence of workmanship and beauty of design.

Lacquer is prepared from the sap of the tree *Rhus verniciflua*, known in Japan as *urushi no ki*. Raw lacquer (*urushi*) is collected annually during the warmer months by cutting the bark and collecting small amounts of sap. Excess moisture is then slowly evaporated from the sap, while at the same time impurities are filtered out in order to prepare it for use.

Lacquer ware varies greatly in quality, fineness of finish, and detailing of the object, normally constructed of wood, to which the lacquer is applied. Because of its toxic nature and its time-consuming preparation and application, lacquer has always been a costly and precious material. High-quality lacquer was required for *maki-e*, the technique most favored during the Heian period.

Maki-e decoration is applied by first drawing a preliminary design in lacquer on a lacquer ground, then, while it is still damp, sprinkling the surface with gold or silver dust. The result is a surface of metallic brilliance tempered by subtle textures of gold and silver particles. *Maki-e* originated in the Nara period (710–794), when the first examples of *makkinru*, its early predecessor, appeared.

This *tebako* is thought to be a Japanese-adapted form of an earlier Chinese cosmetic box. In the Heian period, such luxury items were often presented to temples and shrines; they were used to store precious possessions and became objects of veneration. This custom of donation was continued in the ensuing Kamakura period.

On the underside of the lid is depicted an ancient tale told in the *Manyoshu* (Collection of Ten Thousand Leaves), an eighth-century compilation of poems and other literature going back to the fourth century. The story is essentially of Japanese origin and has come to represent the theme of longevity, which ultimately derives from the Daoist legend of the Island of the Immortals in the Eastern Sea. The scene is taken from the legend of a fisherman, Urashima, who came to the aid of a tortoise dying on the seashore. The tortoise was really the daughter of the Dragon King. Urashima and the fairy princess went together to the land of immortality beneath the sea, where they lived in idyllic bliss. Urashima, however, longed to visit his family once more. The princess consented to his leaving, but on his departure gave him a box he was never to open. Once in the upper world, he found no one who knew or recognized him. Urashima, forgetting his instructions, then opened the box and suddenly became a white-haired old man, for what had seemed three years in the undersea world had actually been three hundred years on earth.

On the underside of the Seattle *tebako* lid, Urashima is seen beside a pine tree on a small island in the foreground. On the right is the island of the blessed, carried on a tortoise. The pine trees and flight of cranes are symbolic allusions to long life and immortality.

The exterior of the box is decorated with a gold diaper pattern of tortoise shell (*kikko*) design. A flower is centered inside each hexagon; the rims of the lid and box are reinforced with pewter. It is decorated in gold *maki-e*, one indication of its date, for silver had become scarce during the Kamakura period. Recent studies also suggest that this *tebako* dates in the Kamakura period in the thirteenth century, when powerful military rulers replaced the effete aristocracy — a change of artistic patronage reflected in the art of the period. Kamakura *maki-e* tends to exhibit bolder designs and a greater clarity of shape and contours, characteristics appearing in the Seattle box.

HT

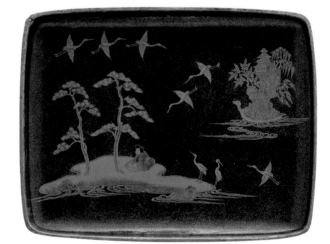

38. Lid interior

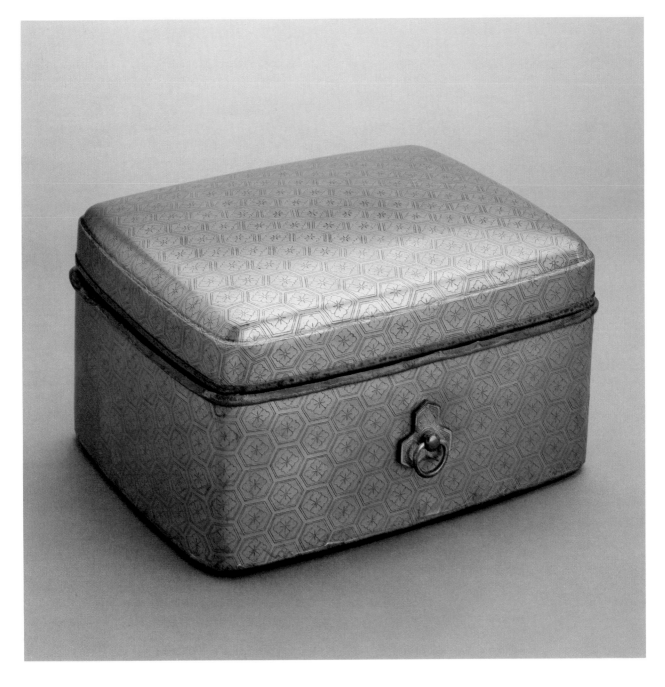

38.
Cosmetic box (*tebako*)
Kamakura period, 13th century
Maki-e lacquer on wood
H. 6¼" (15.9 cm), L. 11½" (29.2 cm)
Gift of Mrs. Donald E. Frederick 51.78

This large lobed tray with foliate rim is perhaps the most important example of fifteenth-century Negoro lacquer outside Japan. Of large size, it is in an unusually fine state of preservation, with no relacquering of any of its surfaces and only minor small areas of repair.

The term *negoro-nuri* (Negoro ware) derives from the name of the Buddhist temple Negoro-ji, Wakayama prefecture, where, it is believed, it was produced in large numbers by temple priests for their daily use as early as the late thirteenth century. Production flourished in the years between the temple's founding in 1288 and its burning in 1585 by Hideyoshi's armies. Because of the temple's destruction and lack of documentation to support the theory that it was exclusively produced there, *negoro-nuri* is now used to designate this type of lacquer ware, which was probably made in several localities.

A narrow definition of *negoro-nuri* designates lacquer ware with a red surface over a layer of black lacquer. The wood core was either turned on a lathe or carved and shaped into attractive and elegant forms, then primed with raw lacquer before the black lacquer was applied.

Negoro ware must also be strong and resilient, consistent with its utilitarian rather than decorative use. In their simple beauty and emphasis on smooth, undecorated surfaces, Negoro wares may have been inspired by the monochrome lacquer of Song (960–1279) and Yuan (1279–1368) China, brought to Japan during the Kamakura period (1185–1333).

Early Negoro ware was primarily for daily use in Buddhist temples; the most common shapes are tables, trays, wine bottles, containers for food service, and objects used in the preparation or serving of tea in Zen temples. It is believed that this tray and two similar but smaller examples in Japan were used to carry Chinese-style *temmoku* tea bowls, the black iron-glazed bowls first used by Chinese Zen Buddhist monks for the tea ceremony; they were later imitated in Japan by potters in the Seto kilns, who produced them for similar purposes.

With frequent usage, the red lacquer surface gradually wore off in spots, exposing the black underneath and producing a subtle interplay of color, an effect that also suggests a natural aging process. These distinctive qualities, together with simple but strong forms, have made Negoro lacquer ware greatly appreciated, especially in Japan, for its understated beauty and plain undecorated surfaces.

Negoro-type lacquer ware was surely produced earlier than the founding of Negoro-ji, for it can be seen in paintings from the Heian through the Muromachi periods (twelfth through fifteenth centuries). Arakawa cites a red-lacquered table dated to 1164, and thus would put its beginnings in the second half of the twelfth century. Although its use is well documented in Heian- through Muromachi-period paintings, the majority of extant Negoro ware pieces, and certainly the most beautiful, were made only after the fall of the Kamakura shogunate, during the Muromachi (1392–1568) and beginning of the Momoyama periods (1568–1615).

The lobed outline of this tray suggests an open flower or blossom. It is supported on a low lobed base, its contours following those of the tray and forming five "feet." The base is lacquered black and is reinforced by two wooden slats. As Negoro ware is undecorated, its style is determined by shape alone, and often reflects Chinese influence; such large pieces with lobed outlines often clearly show Song-dynasty influences. This is not surprising, as Chinese lacquers strongly appealed to Zen Buddhist monks as well as to the country's military rulers during the late Kamakura and Muromachi periods.

This tray can be rather accurately dated in the middle of the fifteenth century on the basis of its close similarity to a pair of trays in Japan that bear identical inscriptions on their bases, including the date of dedication to Saidai-ji, an important temple west of Nara, in the fourth year of Kyōtoku (1455); one of them is still there. The second tray now belongs to the Tokiwayama Bunka Foundation, in Kanagawa, and includes in the inscription, in the third line, the characters for 'one of a pair.' The same characters, forming part of the inscription on the Saidai-ji piece, have been scratched out, presumably when the two pieces were separated. The Seattle tray has no inscription.

Arakawa describes both trays as *rinka temmoku bon* (lobed tray to carry *temmoku* bowls). A detail from the *Fukutomi zōshi* (Story of Fukutomi) handscroll, which shows *temmoku* or lacquer bowls on a footed tray, lends this point further credence. There is little doubt that the Seattle tray was similarly used to carry *temmoku* bowls to serve tea in a Buddhist temple or monastery.

HT

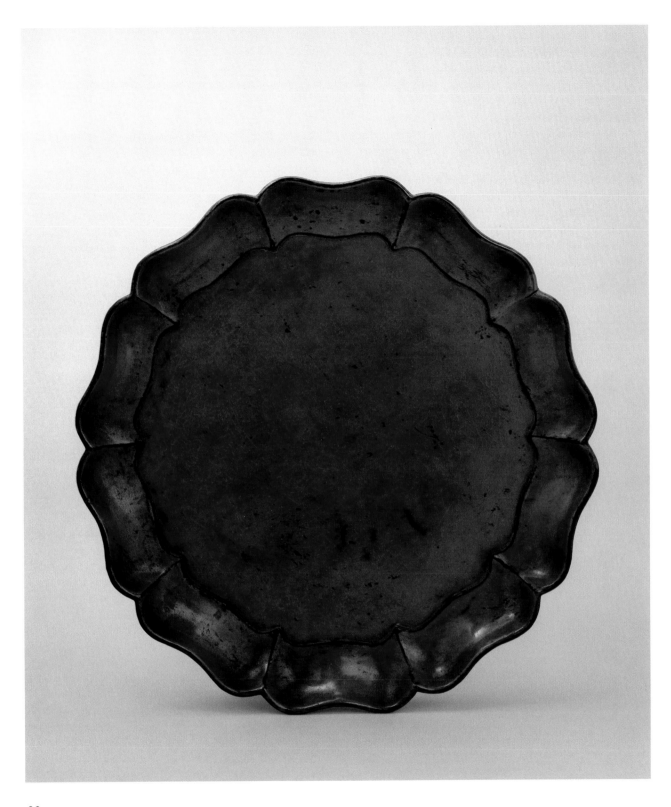

39.
Lobed tray (*rinka bon*)
Muromachi period, mid-15th century
Negoro ware, red and black lacquer on wood
Dia. 20¼" (51.5 cm)
Eugene Fuller Memorial Fund by Exchange 81.22

The *oi* is closely associated with the *shugenja*, followers of the austere form of religion known as Shugendō, which required its adherents to engage in rigorous and frequent mountain climbing as part of their training. A blending of Shinto, Daoism, and folk religion with the rituals and doctrine of esoteric Buddhism, Shugendō focused on a group of sacred mountains and the deities and spirits inhabiting them in the area around Kyoto and Nara. The religion was started by En no Gyoja (En the Ascetic, 634–?). It is believed that En and his followers traveled about the countryside establishing shrines and sanctuaries in remote mountain areas, dedicating various peaks to the Buddha and other deities. Subsequently the practice developed of performing certain rituals thought to produce magical and spiritual powers. Mountain climbing in turn became symbolic of the path toward enlightenment, and the life of the *yamabushi* (mountain priests), as Shugendō adherents were called, found widespread popular acceptance.

The *oi* was designed to carry the itinerant monk's sutras, utensils, food, and personal effects. It originated in China, where the earliest recorded examples, from about the tenth century, can be seen in paintings and drawings recovered from the Buddhist cave temples at Dunhuang in the northwestern part of the country. These early predecessors of the Japanese *oi* were of much simpler form, consisting of a single wooden board with two vertical supports at the sides.

Literary references to the *oi* go back to the first half of the tenth century; its introduction in Japan must have occurred prior to this time. The *oi* is mentioned in the oldest Chinese-Japanese dictionary in Japan, the *Wamyō ruijū shō*, edited between 931 and 938. The *oi* subsequently became associated with Buddhist monks and their paraphernalia, but its use was not exclusively reserved for them. Various types of *oi*, including a simple board-and-support type (*ita-oi*) and a more complete box type (*hako-oi*) were developed in the course of the thirteenth and fourteenth centuries and can be identified in some of the narrative scrolls of this period.

A special type of *hako-oi*, a box supported by four legs, one at each corner, seems to have been developed especially for use by the *shugenja*. When carried on the back, it displayed an outer surface completely covered with bronze plate ornamented in relief. Another type of *hako-oi*, represented by this example, has only three legs, two in front and one centered in the back. Its outward-facing surface is decorated with designs carved directly into the wood. This type of *oi* was closely but not exclusively associated with the *shugenja*.

The Seattle *oi* was probably made in the late Muromachi period and most likely comes from the northeastern area of Japan. Its sides and back are of woven bamboo. The front is divided horizontally into two sections, with two sets of doors below. The doors are held closed by a vertical slat, carved to resemble a Buddhist vajra, which fits into a slot at the top and bottom of the cabinet. Inside, a wooden shelf (originally there may have been more) divides the interior into compartments in which various Buddhist paraphernalia and statuettes could be arranged; the *oi* could then serve as a portable altar.

The doors and side panels are decorated with designs of camellias (*tsubaki*) and chrysanthemums (*kiku*) carved and lacquered in red, green, and black in the *kamakura-bori* technique and highlighted with washes of gold. The red camellia has long been regarded as a symbol of longevity and was also considered a powerful protector against evil spirits. It is seen on almost all *oi* with carved designs.

It is believed that the popular *kamakura-bori* technique developed in Japan as a substitute for the more complex and time-consuming technique of lacquer carving prevalent in China during the Ming dynasty and known in Japan as *chōshitsu*. In this technique, the lacquer was built up in many layers; very fine and detailed designs were then carved into its surface. *Kamakura-bori* greatly simplified this process, substituting carving the wood itself in relief; the carved designs were then covered with coats of polychrome lacquer, as illustrated by the Seattle *oi*.

Examples of sculpture, furniture, and various types of decoration in temples are often the work of anonymous Buddhist monks. There are no literary references to *kamakura-bori* earlier than the late fifteenth century. The term describing the technique derives from the city of Kamakura, but we do not know how the city came to be associated with this particular method of lacquer carving, which has been popular in Japan since the late Muromachi period.

HT

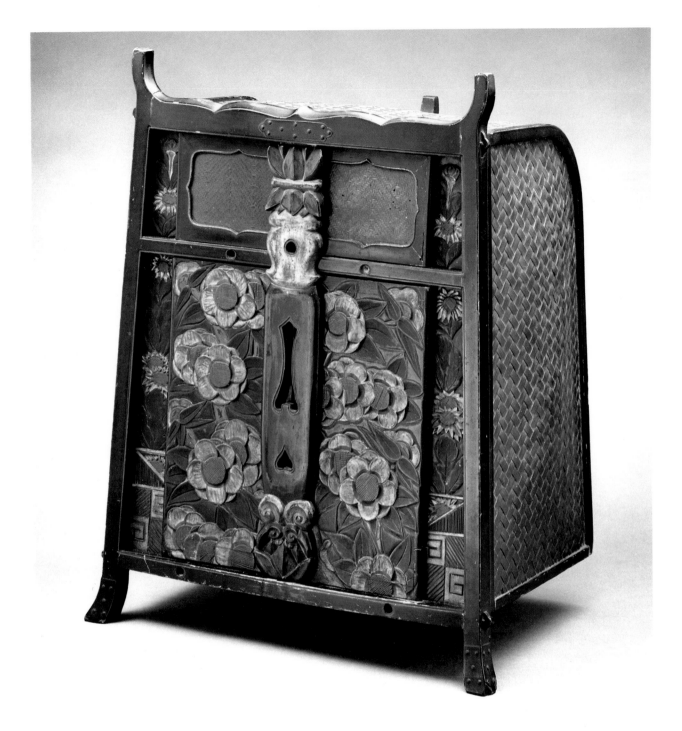

40.
Monk's portable shrine (*oi*)
Muromachi period, 16th century
Kamakura-bori lacquer on carved and decorated wood
H. 25¼" (64.1 cm), W. 20½" (52.1 cm)
Eugene Fuller Memorial Collection 72.15

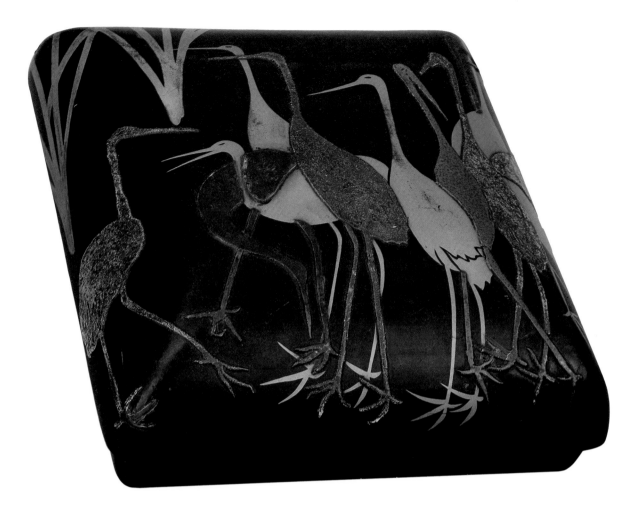

A *suzuri-bako* attributed to Kōetsu and a slightly earlier *sage-dansu* are important examples of Momoyama – early Edo period lacquer work inlaid in lead, pewter, or mother-of-pearl. Some of the designs were applied in gold or silver lacquer, providing rich decorative effects characteristic of the art of this period. The *suzuri-bako* (No. 41) in particular has long been regarded as being among the foremost examples of Rimpa-style lacquer associated with the name of Honami Kōetsu. It has also been attributed to Ogata Kōrin (1658–1716), but for the reasons discussed below, it should properly be attributed to Kōetsu or his workshop.

On the exterior, interior, and underside of the cover, the box is decorated with groups of cranes and reeds executed in lead and pewter inlays, and with washes of gold lacquer against a black lacquer ground. The cranes take a variety of poses, some bending or with their necks pulled in, some pointing their beaks to the right, in opposition to the general leftward movement of the groups of birds — an animated counterpoint which relieves an otherwise static arrangement. Vertical accents are provided by

41.
Writing box (*suzuri-bako*)
Attributed to Honami Kōetsu (1558–1637)
Edo period, first half 17th century
Black lacquer on wood with lead and pewter inlays and gold lacquer decoration
Lid: L. 9⅛" (23.2 cm), W. 8⅝" (21.8 cm)
Box: L. 8⅜" (21.3 cm), W. 7⅞" (19.8 cm)
H. incl. lid: 3¼" (8.3 cm)
Gift of Mrs. Donald E. Frederick 50.67

the cranes' long necks and legs, diagonals by their bodies, and horizontal and diagonal accents by their beaks. The carefully planned compositions, ingenious in their design and decorative effects, could only have been planned by a great artist and master craftsman.

The box complements the famous scroll (No. 58) with calligraphy by Honami Kōetsu and painting of deer traditionally attributed to Tawaraya Sōtatsu (act. c. 1600–1640). The cranes and reeds motif of the writing box and that of the handscroll have a close stylistic relationship and represent the decorative Rimpa style in its most accomplished form.

Kōetsu was one of the most skilled and versatile artists of the Momoyama–early Edo period. He was born into the wealthy Honami family, whose members were the foremost sword connoisseurs of their time. Kōetsu became famous not only as a calligrapher and potter, but also as a creative genius. In 1615, given some land by the Tokugawa shogun Ieyasu at the village of Takagamine, he gathered a following of artists and artisans whose work had a profound influence upon the art of the period. No single piece of lacquer may with certainty be attributed to Kōetsu's own hand, but a number of works show the influence of his ideas and concepts and may have been made under his guidance and supervision; this writing box falls into that category.

Kōetsu introduced a new arrangement for the interior of writing boxes. Up to his time, the inkstone had usually been placed in the center of the box, flanked on either side by small brush trays. Kōetsu divided the box into two halves, moving the inkstone and water container to the left half and freeing the right for the brushes. During writing, the box was placed to the right of the paper; thus, Kōetsu's arrangement made the box more functional by shortening the distance between the ink-loaded brush and the paper. After Kōetsu, this interior division frequently prevailed in writing boxes.

Perhaps the most dramatic demonstration of Kōetsu's genius is in the way he changed the shape

of writing box covers by sharply ballooning the center of the lid, which would rise like a dome over the rectangular box. This feature, not seen before Kōetsu, is found in the Seattle box.

Kōetsu was also a master in the creation of decorative designs. Here the cranes generally move toward the left, but counterthrusts are provided on the lid by the crane on the left turning in the opposite direction, and by the two cranes with heads and beaks pointing right; their bodies and legs also break up the leftward movement. The composition is based on a series of diagonals, horizontals, and counterthrusts employed deliberately but with considerable constraint, in order to adapt the crane motif to the shape of the box lid and its interior divisions.

On the strength of the design, decorative motifs, highly skilled use of gold lacquer, and lead and pewter inlays, the writing box is attributed to Kōetsu and his workshop. Kōetsu's concepts and ideas often influenced the later artist Ogata Kōrin, who became famous as a painter and lacquer ware designer during the middle Edo period. Kōrin came from a wealthy merchant family in Kyoto, and his grandfather had lived for a time at Takagamine with Kōetsu. It is therefore not surprising that Kōrin was influenced by the work of Kōetsu. Compared with Kōetsu's work, Kōrin's designs are more abstract and stylized, as well as more purely decorative and less pictorial.

The portable cabinet (*sage-dansu*) (No. 42) dates somewhat earlier than the *suzuri-bako*. It is a fine example of the magnificent decorative lacquers produced during the Momoyama period (1568–1615) and was probably made during the latter part of the sixteenth century. The cabinet interior originally had two drawers and was intended for use as a storage box housing small items, which could be carefully arranged and organized. The cabinet door is fitted with metal hinges and a lock, and a handle is mounted on top.

The exterior of the box is lavishly decorated with designs of trailing grapevines, grape bunches, and squirrels at play. The designs are executed in gold and silver lacquer, as well as mother-of-pearl inlay used for parts of the grape bunches. The effect is one of rich beauty reflecting the magnificent splendor characteristic of paintings and screens of the period. The popular motif of squirrels and scrolling grapevine must have derived from China, and similar designs of grape tendrils, inlaid in mother-of-pearl, are also found in Korean lacquer work of the sixteenth and seventeenth centuries, as well as in later examples.

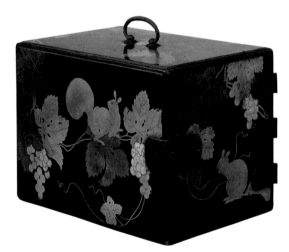

42.
Portable cabinet (*sage-dansu*)
Momoyama period, late 16th–early 17th century
Black lacquer on wood with mother-of-pearl inlay and gold and silver lacquer decoration
H. 10⅛" (25.7 cm), W. 9⅛" (22.2 cm), L. 14⅞" (37.8 cm)
Eugene Fuller Memorial Collection 72.16
Plate on p. 72

HT

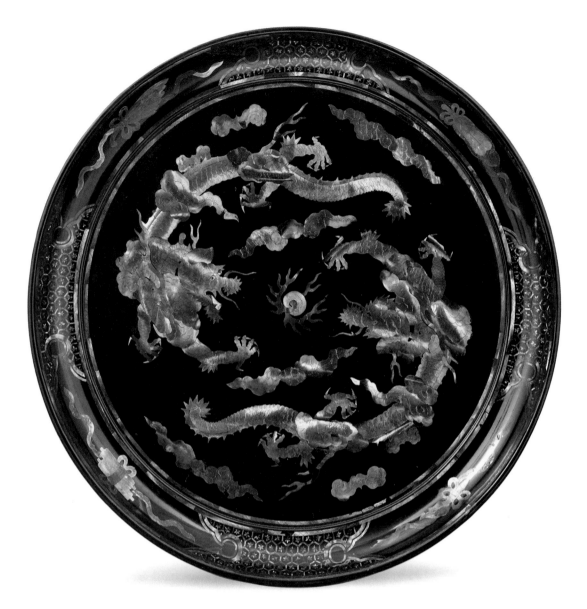

43.
Large circular tray
Ryukyu Islands, late 18th century
Black lacquer on wood with mother-of-pearl inlay
Dia. 13¾″ (35 cm)
Gift of the Asian Art Council 81.50

This tray, with its inlaid design of a pair of dragons chasing a flaming pearl, is a superb example of a type of inlaid lacquer ware known as Ryukyu lacquer, made in Okinawa and in the Ryukyu Islands in the eighteenth and nineteenth centuries.

The cavetto, or outer border of the tray, decorated with inlaid designs in mother-of-pearl (*raden*), is divided into eight sections in which four felicitous Buddhist emblems alternate with four segments of hexagonal diaper patterns. Brightly colored iridescent wafers of mother-of-pearl cut into small

and very thin slivers have been inlaid in a technique characteristic of Ryukyu designs.

There is evidence that lacquer of fine quality was made in Okinawa from the fifteenth century onward, and judging by extant examples in the Shuri Museum and elsewhere, the lacquer industry flourished there during the eighteenth and nineteenth centuries. Various types of Chinese lacquers must have been sent to the Ryukyu Islands as early as the fifteenth, if not the late fourteenth century. The technique of mother-of-pearl inlay was undoubtedly imported from the Chinese mainland.

Until recent times, Ryukyu lacquer has usually been identified as either from China or Japan. During the period when lacquer was manufactured in Okinawa, the Ryukyus were under strong cultural influences from these countries and to a lesser extent from Korea and Southeast Asia. The Ryukyu Islands, skirted by coral reefs and crowned by inhospitable mountain peaks, made it difficult for inhabitants to subsist solely upon their natural resources. As a result, a flourishing and wide-ranging trade of crafts, goods, and foodstuffs developed, primarily with China and Japan, but also including East and Southeast Asia.

Two events occurred that were to have a negative effect upon Okinawa's prosperity during the early part of the seventeenth century. The first of these was the capture of Malacca by the Portuguese in 1511, followed by the incursion of Europeans into East and subsequently Southeast Asia. The second event was the annexation of the Ryukyus by the Japanese in 1608, who politically dominated the islands and increasingly influenced their arts and crafts. Whereas Chinese cultural influence had been dominant from the fourteenth to the sixteenth century, the influence of Japan became an important factor by the beginning of the seventeenth century. Okinawan lacquer therefore shows strong Chinese influence during the fifteenth and sixteenth centuries, balanced by qualities based on the common cultural background shared by the islands and Japan.

The history of the manufacture of lacquer in Okinawa from the seventeenth century on is discussed at length in a compilation of 1889, *Ryūkyū shikki-kō* (Study of Ryukyu Lacquer Wares) by Hyōgo Ishizawa, a member of the Okinawa governor's staff; he was assigned the task of drafting a report on Okinawa's arts and crafts, with special reference to lacquer. The survey not only gives a fairly accurate summary of the history of lacquer ware in Okinawa back to the seventeenth century, but also includes family records, descriptions and specifications, and, most important, large numbers of drawings of pieces. These drawings, as well as the sheets providing detailed information regarding construction materials and their cost, reveal much about the nature and quality of Okinawa lacquer during the eighteenth and nineteenth centuries.

The manufacture of lacquer in Okinawa had undoubtedly attained a high degree of perfection and sophistication by the late eighteenth century, qualities evident in the large Seattle tray. The mother-of-pearl decorated lacquers were particularly elaborate. Ishizawa's specifications, for instance, in describing a black lacquer table with mother-of-pearl inlay, mention the presence of five different types of shell, in addition to seven layers of undercoating, including fabric, paper, and leather.

This splendid tray attests this technical achievement. The black lacquer surface and colorful mother-of-pearl inlay are of the highest quality and show the artisan's great skill and dexterity. The infinitely detailed workmanship evident in the hexagonal border patterns, in the Buddhist emblems, and in the twisting dragons demonstrates that the tray is the work of highly accomplished craftsmen with talents in every way comparable to those of their counterparts in China, Japan, and Korea. Each of the hexagons of the border pattern, for example, is individually inlaid line-for-line, and each is filled with tiny blossoms, their petals made up of minute pieces of mother-of-pearl. The inlaid designs, including the dragons, clouds, flaming pearl, and borders, also all feature very finely incised lines and stipling to render individual details, such as the scaling of the dragons. The two narrow bands separating the dragons from the design of hexagons and Buddhist emblems are inlaid by means of a series of tiny triangular pieces of mother-of-pearl joined together and set in alternation to form a continuous band.

The inlaid designs reflect an amazing degree of refinement and precision. There is no doubt that the development of Okinawan lacquer at the beginning of the eighteenth century had entered upon a new period of florescence and technological success, which continued into the nineteenth century.

HT

Ink painting (*suiboku-ga*) developed slowly in
Japan between the thirteenth and fifteenth cen-
turies. During this time ink painting was largely
under the influence of the Buddhist clergy, partic-
ularly Zen priests — first through travelers from
China, or Japanese priests returning from visits
to temples in China, then by the painting studios
established at the monasteries, such as that at the
Shōkoku-ji. In the earliest stages of development,
suiboku-ga was dominated by paintings of figures,
both fabled and historical, who were central to Zen
beliefs, and it was only early in the fifteenth cen-
tury that landscape emerged as a primary subject
in ink painting.

Landscape as a theme grew out of the practice
among Zen priests, in the late fourteenth and early
fifteenth centuries, of depicting an idyllic imaginary
retreat, a hermitage, sited in a mountain fastness.
This practice originated among priests in Song-
dynasty China; over the centuries, as Japanese
priests traveled increasingly to China and stayed for
longer periods, they became well acquainted with
these traditions and introduced them to Japan upon
their return. In China, the practice was at its height
during the Yuan period (1279–1368) and was re-
flected in contemporary Japanese priestly behavior.
While the Japanese interpretation of the imaginary
retreat differs somewhat from its Chinese artistic
antecedents, the point is that in both China and
Japan such paintings were made for the pleasure
of fellow-priests and friends.

These paintings of hermitages in exotic settings
represented an idealized escape from the turmoil
and distractions of life. Friends and associates were
invited to inscribe poems or observations on these
scrolls; consequently these *shiga-jiku* (literally:
poem-picture-scroll) reserved large areas for inscrip-
tions, and the painting, essentially an ink landscape,
was restricted to the lower portion. As a result, the
landscape in these early works fills perhaps the
lower quarter of the entire scroll, with the balance
devoted to inscriptions.

Josetsu (fl. early fifteenth century) is among
the earliest artists to be linked directly with the
development of landscape as a theme in *suiboku-ga*.

44.
Landscape
Attributed to Tenshō Shūbun (act. 1423–1460)
Muromachi period, late 15th century
Hanging scroll, ink and light colors on paper
H. 35½" (90.1 cm), W. 13¼" (33.6 cm)
Eugene Fuller Memorial Collection 49.90
Plate on p. 63

His role was crucial by virtue of his close personal relationship with the fourth Ashikaga shogun Yoshimochi (1386–1428; see No. 46). Josetsu is best known for the painting, based on a Zen koan, of a fisherman with a gourd pursuing a catfish, in which the background setting is in essence a *suiboku* landscape. Song-dynasty artists, deeply attached to the concept of ink landscape painting, had established standards for unity of composition and proportion that balanced qualities of breadth with depth and height. The early *suiboku-ga* painters, like Josetsu, did not meet these criteria fully, and it was not until a generation after Josetsu, with such artists as Tenshō Shūbun (fl. 1423–1460), that Japanese *suiboku-ga* painters began to reflect this esthetic in their work.

The Seattle painting (No. 44) shows in the upper portion two places where inscriptions have been removed and replaced by plain paper closely matching that in the rest of the painting. It was probably taken from the upper portion, so that originally this landscape painting would have had not only inscriptions, but also a decidedly taller proportion, in the manner typical of *shiga-jiku*. The seal reading *Shūbun*, like all such seals, is not original and was probably added at the time the inscriptions were removed.

The composition follows the style usually associated with Shūbun, in which the landscape is disposed vertically in a proportion rather narrow for the width, with prominent rocky mountain forms and lakeside pavilions amid craggy, rugged trees. The huge boulders and mountain faces are marked by "axe-cut" strokes faceting and modeling surfaces dotted with verdure. The zigzag of ancient pines, paired in the foreground, is a recurrent motif. A waterfall dropping from a great height and ending in the mist-laden distance is often an important element in these atmospheric imaginary scenes. The scholar's retreat might be perched in a high clearing or nestled at the water's edge, and while the earliest *shiga-jiku* featured unassuming thatched huts or simple pavilions, by the latter part of the fifteenth century it was more common to find elaborate architecture, sometimes incorporating large complexes.

45.
Moonlit Landscape
Bokkei Saiyo (fl. late 15th century)
Muromachi period, late 15th century
Hanging scroll, ink and slight color on paper
H. 22¼" (56.4 cm), W. 8½" (21.6 cm)
Eugene Fuller Memorial Collection 55.55

Shūbun and his immediate circle of followers operated on principles generated from Song- and Yuan-dynasty artists, which featured such characteristics as strongly asymmetrical composition, atmospheric space with enveloping mists, and sharply rendered axe-cut strokes defining rock faces. This is the so-called Ma-Xia style, named after qualities found in the art of Ma Yuan (fl. c. 1190–1244) and Xia Gui (act. first half thirteenth century), artists who were part of the Song-dynasty imperial painting academy, and some of whose paintings were known in Japan through temple and the Ashikaga shogunal collections.

Artists influenced by Shūbun, such as Gakuō Zokyū (fl. late fifteenth to early sixteenth century) and Shōkei Tenyū (fl. 1440–1460), carried forward the style of atmospheric space, and while Gakuō and Shōkei are without direct connection, the art of these painters, along with the Seattle painting, shares traits of the Shūbun discipline. Interestingly, several paintings by these artists also show close compositional parallels with the Seattle painting. Further, the parallels between it and the landscape sometimes attributed to Shūbun in the Yamamoto collection (datable by inscription to 1455) demonstrate the two paintings were very probably following some common model, a Song-dynasty Chinese painting which had been imported to Japan. The Seattle painting, therefore, belongs to the group of works by artists of the Shūbun school of the late fifteenth century, which represents a furthering of the Shūbun tradition, leaving intact the evocative illusion of space that so strongly characterized the Shūbun style and stopping short of the rationalization of space that Shūbun's student Sesshū Tōyō (1420–1506) subsequently introduced after a period of first-hand exposure in China to contemporary Ming-dynasty painting.

Ma Yuan and Xia Gui, whose art formed the dominant influence in the formation of the Shūbun tradition, were but two Song-dynasty artists whose works were influential in the development of Japanese *suiboku-ga*. Two others who have become legendary masters are Mu Qi and Yujian (both active about the mid-thirteenth century). The paintings remaining in Japan by these artists are found in museum, temple, and private collections; however, Mu Qi's most famous paintings are preserved at the Daitoku-ji in Kyoto, the great monastery with which the art of these two painters is often associated. These artists worked in rather less linear styles than the Ma-Xia tradition, and the Seattle landscape by Saiyo (No. 45) is an example of the *haboku*, or broken ink, style associated with Yujian. The *haboku* technique seen here eschews the Ma-Xia approach in favor of layering ink in successive washes, some intensely black, and contrasting suffused and blurred shapes (as in the tree trunks in the foreground and the distant peaks) with the raspy punctuations of the upper branches and the touches of intense ink on the peaks. The number of extant paintings by Yujian is small; however, two very important examples remain that display effects and techniques reflected in this landscape. These are the painting *Mount Lu* (Yoshikawa collection, Tokyo) and the painting *Mountain Village in Clearing Mist* (formerly Yoshikawa collection; now Idemitsu Museum of Arts, Tokyo). The distinct horizontality apparent in these paintings results from these works' original handscroll format, while the Saiyo landscape was composed for a vertical hanging scroll; however, the gentle manipulation of the ink washes, alternating with the contrasting touches of detail, shows the type of model that inspired Saiyo.

The Seattle painting is one of two remaining landscapes known to be by Saiyo and, as a *haboku* landscape by a late fifteenth-century Zen priest-painter, represents the major contending style to the long-dominant linear Shūbun tradition.

WJR

46.
Du Fu on His Donkey
Calligraphy, dated 1575, by Ashikaga Yoshiaki (1537–1597)
Painting by an unknown artist, c. 1450
Muromachi period (1392–1568)
Hanging scroll, ink on paper
H. 39¾" (101 cm), W. 12¾" (32.4 cm)
Purchased from the bequest of Archibald Stewart and
 Emma Collins Downey 53.82

These paintings illustrate themes taken from Chinese literature, religion, and art that were popular in Japanese ink painting during the fifteenth and sixteenth centuries. The first (No. 46) is thought to represent the eighth-century Chinese poet Du Fu, a literati theme popular among Zen priests; it shows a scholar astride a donkey and attended by a youth. Across the top of the painting is a long poetic inscription. The author and calligrapher of the inscription, Ashikaga Yoshiaki (1537–1597), is well known as the last of the long line of Ashikaga shoguns. His was a shaky tenure racked by disorders and warfare across the country.

From the inscription, it is clear that Yoshiaki added his poem and inscription to this unsigned painting in the belief it had been painted by his ancestor Ashikaga Yoshimochi (1368–1428), shogun over 150 years earlier. On the basis of the poem and dated inscription, the painting has long been misattributed to Yoshimochi and dated to the early fifteenth century. Yoshimochi had lived lavishly, in contrast to Yoshiaki's plight, and in the poem Yoshiaki seems to hint at the sadness of his own fate:

> The tired horse hesitates on the road around
> Mount Hua;
> The urchin steadies the rider, who, oblivious,
> is slipping off.
> A gallon of wine after long poems;
> Fast asleep under the pine tree, and never
> again awake.

Unlike Yoshiaki, burned out of Kyoto and here brooding in exile, Yoshimochi, the fourth Ashikaga shogun, had ruled during a time of great wealth and secure power when Kyoto was a lively center of art and culture, spurred by the great Zen monasteries, direct contact with China, and close ties between the shogun and the Zen sect. Yoshimochi was deeply involved with the circle of artist-monks of the Zen temples of Kyoto and a moving force in promoting the new Zen-inspired ink painting. He held poetry parties in his sprawling mansion and commissioned works by the painters at the Shōkoku-ji, the temple traditionally favored by Ashikaga shoguns. It was Yoshimochi who, in about 1413, commissioned from the artist-monk Josetsu (fl. early 15th century) the famous *Hyōnen-zu*, which takes a Zen koan for its theme and depicts an improbable scene of a fisherman trying to master a catfish with a gourd. Josetsu played a pivotal role in the formulation of ink painting in Japan and was associated with the Shōkoku-ji, which became home to some of Japan's greatest ink painters.

With these kinds of associations, it is natural that Yoshimochi made ink paintings. Moreover,

although all Ashikaga shoguns were closely asso-
ciated with the Zen monks, Yoshimochi became
a devout Zen adherent, and his paintings can best
be understood as a form of Zen discipline, the well-
intended efforts of a dedicated disciple. His known
paintings all depict typical Zen subjects, such as
Kannon or Daruma, or are based on Chinese
themes popular among the literati priests.

In contrast to the characteristic paintings by
Yoshimochi, this painting shows skillfully modeled
and graded ink washes. The convincing donkey is
carefully rendered, and the slumped, drowsing
figure of the poet is quickly but adroitly suggested
by strongly worked brushstrokes. The pine branch,
though seemingly sketchy, is a lively maneuvering
of the brush in capturing a natural form, and judg-
ing from the skill of the rendering, was brushed by
a painter of far greater experience and training
than seen in any painting definitely attributable to
Yoshimochi's hand. The absolute sureness of tech-
nique in generating texture and modeling displayed
by the sharp dark lines of ink for the harness, the
bushier lines for the mane, and the crisp outlines
of the rump, tail, and head carries through to the
incisive lines of the pine needles and marks the
piece as the work of a thorough professional, not
a devoted amateur artist.

How the unsigned painting of a poet on a
donkey came into Yoshiaki's hands is not know-
able at this distance. It is entirely possible that
the name of its real author was forgotten, and the
situation was confused by the tradition that Yoshi-
mochi had painted this theme or possibly compli-
cated by knowledge of an existing example (such as
the one in the collection of the Nishi Hongan-ji).
In any case, it seems that an uncritical Yoshiaki,
perhaps eager to associate himself with an illus-
trious ancestor and the glories of a former time,
made a natural mistake and brushed his misleading
inscription. Ironically, in separating this scroll from
the amateur artist Yoshimochi, the handsome paint-
ing gains in art historical importance as a tribute to
a fifteenth-century artist-monk whose identity, like
that of many others, will perhaps forever remain
unknown.

The six-panel screen of Daoist Immortals in a
landscape setting (No. 47) represents another type
of ink painting theme from China. This category,
in Japanese dōshaku-ga, featured subjects from
Daoist and Buddhist traditions. Dōshaku-ga
included images of Bodhidharma (Daruma), the
Indian priest who brought Zen Buddhism to China,
and Avalokitesvara, the bodhisattva known in
Japan as Kannon. Of Daoist traditions, the Immor-

tals were a favorite subject and one of the most
popular was the Immortal Qingao (Kinkō), who
is shown riding through the sky on a giant carp.

This screen was painted by an artist from Kantō,
the region far to the east of Kyoto where modern
Tokyo is situated. In this region an important school
of ink painting developed with a history as old as
that of the better-known Kyoto Zen painting centers.
Emigré Chinese priests, escaping the effects of the
Mongol invasions, arrived in Japan in the thirteenth
century and settled in the Kamakura region, where
they were welcomed by the shogunate established
by Minamoto no Yoritomo (1147–1199). Trained in
poetry and painting, the priests brought intriguing
aspects of contemporary Chinese culture into the
Japanese mainstream. In art these contacts intro-
duced the Japanese artist-monks of Kamakura to
a new ink-painting tradition, which they were to
develop independently during the latter years of
the thirteenth century. This painting tradition
remained strong at the Kamakura monasteries even
after shogunal support was lost in 1333 with the
collapse of the Kamakura government and the
establishment of the Ashikaga shogunate in Kyoto.

Zen monasteries rose to prominence in Kyoto
once the Ashikaga shogunate was established, and
some, such as the Shōkoku-ji where Josetsu worked,
were under the direct protection and support of
the shoguns. The Ashikaga shoguns did not aban-
don the older Kamakura temples entirely (perhaps
because of their involvement with the trading ships
to China), and the painting ateliers in the Zen mon-
asteries at Kamakura maintained a strong regional
presence throughout the Muromachi period. Con-
tact between the two Zen centers grew, and the art
of Chuan Shinkō (fl. mid-fifteenth century), a lead-
ing priest-painter at the Kenchō-ji in Kamakura,
reflected influences from contemporary painting at
the Tōfuku-ji in Kyoto. The primacy of the paint-
ing centers of the Kyoto monasteries, moreover,
attracted provincials who traveled to Kyoto for
study, and Chuan Shinkō's student, Kei Shoki, also
known as Kenkō Shōkei, traveled to Kyoto in 1478,
to study directly. After his return to the Kenchō-ji,
Kei Shoki gained prominence as an artist and
attracted a number of followers.

The Kei Shoki school heritage of this painting
lies in the jagged, almost sawtooth profiles of the
rocks and the strongly accented lateral "axe-cut"
brushstrokes defining the rock faces and textures,
especially the occasional heavily inked strokes that
seem almost a short "nail head and rat tail" stroke.
The C-shaped arcs of the openings in the rocks and
of overhangs, which in Kei Shoki's compositions
seem often to alternate in a bracketing manner, and

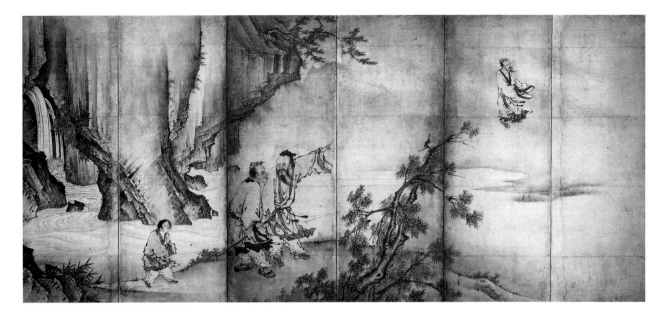

47.
Daoist Immortals
School of Kei Shoki
Muromachi period, first half 16th century
Six-panel folding screen, ink and color on paper
H. 58¼" (147.9 cm), W. 130¾" (332.4 cm)
Margaret E. Fuller Purchase Fund 74.18

the use of disconnected dotting along the water's
edge and the vertical faces of the cliff are character-
istic elements of his art. The interesting incorpora-
tion of blue and very pale ochre washes on the rock
surfaces further relates this screen to the traditions
of the Kantō artists. The treatment of the trees is
remarkably reminiscent of trees seen in Kei Shoki
paintings, and the use of a dry brush to stroke
individual leaves is quite similar, although clearly
revealing a different hand.

While emulating techniques and motifs found
in Kei Shoki's work, certain qualities in this work
suggest a time some distance after Kei Shoki. In
particular, the profound vagueness of the spatial
relationship between foreground, middle ground,
and far distance is a new element distinguishing
this screen from the works of Kei Shoki and those
attributed to Shikibu Terutada, his best-known fol-
lower of the sixteenth century. The Kei Shoki style,
based on traditions learned at Kyoto, contained
already in the latter part of the fifteenth century
(when Kyoto was rebuilt after the devastation of the
Ōnin War, 1467–1477) a tinge of the secularism
that was invading the arts, particularly painting.
The Seattle screen reflects the reemergence of the
secular and essentially decorative origins of screen
painting in Japan that in the Kanō school would

triumph completely. The landscape elements are
given secondary consideration, and while cling-
ing to a *dōshaku-ga* theme, the painter has empha-
sized the bizarre image of a levitating figure whose
behavior seems to amuse or mystify even his com-
panions. The wind-whipped robes and emphatic
gestures of the figures reflect a baroque taste for
startling effects, a tone heightened by the gratuitous
dramatics of the waterfall hidden within a grotto.
All these distinctions point toward someone other
than Kei Shoki or Shikibu Terutada as the artist; yet
the indications of the Kei Shoki tradition are suffi-
ciently strong to suggest this unknown follower was
perhaps a contemporary of the renowned Shikibu.

A pair of landscape screens (No. 48) illustrates
a third very important theme borrowed from Chin-
ese sources, the Eight Views of the Xiao and Xiang
Rivers. The eight views celebrate the misty scenery
around Lake Dongting in humid southern China
where these two great rivers converge. This sub-
ject was popular in Song-dynasty poetry and paint-
ing, and at the beginning of the Muromachi period
was adopted in Japan, where it is called Shōshō
Hakkei.

The immediate prototypes for the Shōshō
Hakkei theme in Japan were available through the

collection of Chinese paintings of the Ashikaga shoguns, which contained several examples by Song-dynasty artists. These paintings were all in handscroll format. By the mid-fifteenth century Japanese artists had adapted the theme to the screen format, arranging the scenes in a continuous composition; as a second level of interest, compositions reflected the four seasons, moving, on the right-hand screen, from spring at the right to summer, and, on the left-hand screen, from autumn to winter at the extreme left. Likewise, time of day passed from early morning at the right to evening at the left. The earliest examples were disjointed in their organization, perhaps, but soon the typical landscapes were laid out to incorporate motifs near and far, high in the composition and low.

The origins of folding screens as part of interior decoration dominated the development of screen painting as the sixteenth century progressed. The use of such screens, and the theme of the Eight Views in particular, became popular throughout Japanese warrior society. Unkoku Tōgan (1547–1618), a prolific Momoyama-period painter, sometimes omitted one or more elements of the prescribed number in an otherwise recognizable Eight Views composition. The landscape compositions of the Seattle screens continue this practice.

These screens, however, incorporate a number of the eight standard motifs of the series of views.

These are (on the right-hand screen) Mountain Village after a Storm, Wild Geese descending to a Sandbar, and possibly, along the left side, Night Rain over the Xiao and the Xiang. On the left-hand screen are the scenes Returning Sail off Distant Shore, and possibly in the foreground rooftop and trees, Fishing Village in Sunset Glow, and clearly at the back, Autumn Moon over Lake Donting. Missing are specific references to Evening Bell from a Distant Temple, which is usually shown by a tiny pagoda or diminutive temple in the distance, and River and Sky in Evening Snow.

The screens (once attributed to Unkoku Tōgan) share certain characteristics revealed in paintings by Tōgan in their general compositional aspect: major elements at either end, with distant peaks occupying approximately half the space. Also, the well-structured buildings, shown nestled in clearings or half-hidden in a mountain dale, recall Tōgan's screens, as does the pairing of trees or groups of trees, with darker, accented tree forms fronting shadowy, less distinct ones. The full moon, emerging out of a pale wash of ink, low over a rounded mountain in the distance, is a regular feature of the Unkoku repertoire, along with the characteristic clustering of tiny distant trees and other accented areas of detail.

These screens are set apart from typical Tōgan landscape composition and brushwork by the small

48.
Landscape
School of Unkoku Tōgan
Edo period, early 17th century
Pair of six-panel folding screens, ink and gold on paper
H. 59" (149.9 cm), W. Each screen: 138¼" (351.2 cm)
Eugene Fuller Memorial Collection 70.27

scale of the elements and the soft, rounded quality of the land-mass forms, featuring a Mi-dot stroke in the distant hills. The mellifluous brushwork is at almost the opposite pole from Tōgan's brittle and angular rocky forms. Occasional passages of softer profile and muted ink tones appear within Tōgan compositions, but in contrast to the Seattle screens' gentle reverie, the overall impression of Tōgan's work is one of assertive samurai-like energy and assurance.

In addition to the bold presentation of his ink paintings, Tōgan also produced screens in a softer mode; these include scenes of people frolicking in the countryside, warriors on a hunt, blossoming cherry trees and misty summer groves done in a decorative manner of color on gold ground, and a set of dramatic *fusuma* paintings of crows on tree branches in ink on a vast gold ground. Thus Tōgan's style, while usually described as crystalline, brittle, and assertive, carried a strong subcurrent of fluidity. The artist of the Seattle screens has chosen to fulfill that potential for fluid grace and decorative charm contained within the Unkoku style.

WJR

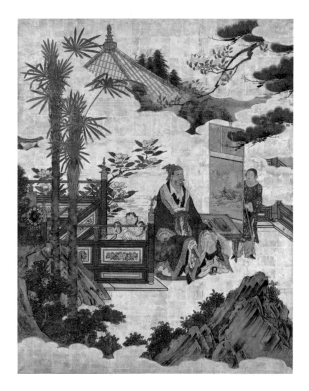
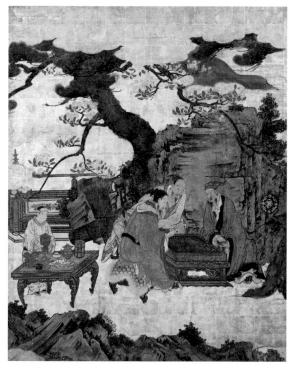
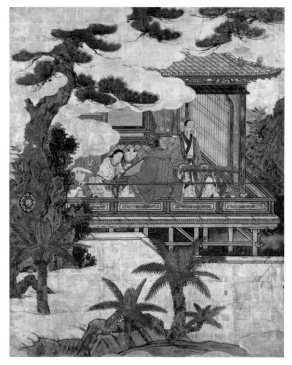
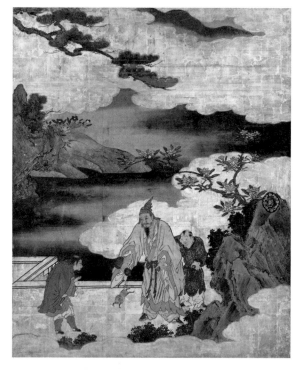

49.
The Four Accomplishments (Kinki shoga-zu)
Kanō Takanobu (1571–1618)
Momoyama period, early 17th century
Four sliding panels, ink and color on gold-covered paper
Each panel: H. 68½″ (174 cm), W. 55″ (139.7 cm)
Eugene Fuller Memorial Collection 51.37
Plate on p. 65

These three sets of panels and screens are typical of the Kanō school of painters and reflect developments in that school between the late sixteenth and early eighteenth centuries.

Building on the artistic foundation laid by his grandfather Kanō Motonobu (1476–1559), Eitoku (1543–1590) created a dynamic new style, becoming the outstanding painter of the Momoyama period. Eitoku studied with Motonobu until age sixteen or seventeen and collaborated with his father, Shōei (1519–1592), on commissions in and around Kyoto. He developed a monumental style which filled the broad spaces of sliding screens and wall panels with close-up views in continuous, unified compositions, employing simplified elements in shallow depth. This new style brought him great fame and rewards. His art supplied inspiration and creative energy for generations of artists to come and, coupled with the family-centered organization of the studio, assured a prominent role for the Kanō school during the next three centuries.

Mitsunobu and Takanobu, the sons of the preeminent artist of the age, were also trained to become painters. Mitsunobu (1565–1608), six years Takanobu's senior, no doubt was old enough to assist his father in important commissions for Oda Nobunaga (1534–1582), such as the key project at Azuchi castle (1576) that established Eitoku's reputation. Later their patron was Nobunaga's successor Toyotomi Hideyoshi (1537–1598), for whose many grand building projects they also painted panels and screens. The few paintings known to be by Mitsunobu, or safely attributed to him, show Mitsunobu's approach differed markedly from his father's powerful compositions. Eitoku had enlarged on the fusion made by his grandfather of the *kanga* tradition of landscape with the color and seasonal reference of the native *yamato-e*, and Mitsunobu carried the blending further and, in doing so, emphasized the more intimate character inherent in *yamato-e* painting style. He modified the drama and exaggerated stylization of his father's work into a gentle flow of an almost dreamlike quality, characterized by delicate features in his figures, more natural description of trees and shrubs, and a subdued color range.

Mitsunobu's affiliation with the leading military figures of the age was balanced by his younger brother's associations with the imperial household. Much of the acknowledged work by Takanobu is related to the imperial palace, or was commissioned for dedication at a temple or shrine. The Seattle panels (*fusuma*) (No. 49) are believed to have come from the Danzan shrine at Tonomine, Nara prefecture. Like his brother, Takanobu's style differed considerably from that of their father; however, that is not to say the two brothers worked in similar styles. Takanobu emphasized the more decorative qualities of compositions through meticulously detailed renderings, using rich shadings and brilliant color; moreover, to the extent he enjoyed using bold composition, as exemplified in the Seattle panels, Takanobu relied more directly on the influences of his father's style than what appears in Mitsunobu's art. The figures of Takanobu's paintings, in particular their distinctive noses, ears, and hands, show greater affinity with the figures in compositions of Chinese themes of remaining works attributed to Eitoku.

These four panels show a group of Chinese worthies idling away their lives in some enchanted place where time has been forgotten. They lounge amid a splendid setting that evokes the impression of a Chinese palace garden. The continuous composition is bound together by the centrally placed pines which reach left and right, the branches partially obscured by the conventionalized clouds of gold leaf that blend with the gold-leaf background. A low barrier of rocks rises across the immediate foreground, and more rocks with exotic palms at the left and blossoming camellias at the right bracket the scene. The tiled roof of a nearby building appears through the clouds at the left beyond the Chinese-style stone terrace with its brightly lacquered and gilded railing; a waterside pavilion overlooks a small lake.

The richly attired worthies are shown enjoying the four elegant pastimes approved for cultured gentlemen (*kinki shoga*). The theme, dating from ancient times in China, was introduced into Japanese painting as part of the Chinese-inspired *kanga* painting during the middle ages. It is soberly Confucian, emphasizing music (*kin*), the game of go (*ki*), calligraphy (*sho*), and painting (*ga*). Through a sumptuous setting, replete with elegant lacquer furniture and a generous supply of helpers to fetch and tote, Takanobu has contrived to minimize the moralizing tone.

Moreover, as in earlier depictions, the sages no longer commune with nature while wending their lonely way through primeval forests. At the left, a sage admiring an ink landscape scroll held aloft by a young attendant represents painting; two figures play go in the next panel; the figure in the pavilion strums a *koto* (Chinese: *qin*), which rests across his knees, representing music. The *sho*, or calligraphy, of the term *kinki shoga* is less specifically illustrated; however, it might be imagined that the young boys in the pavilion who gesture with their fingers at a paper with writing on it are

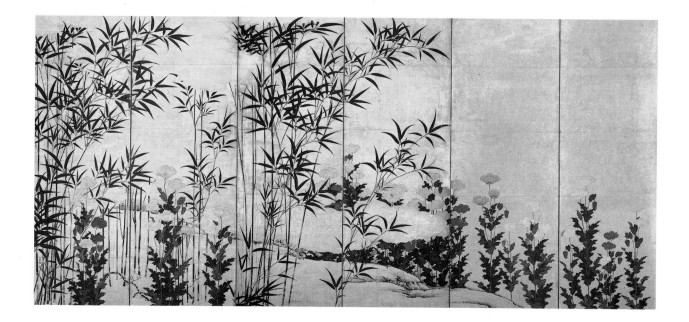

admiring, or more probably, trying to read something just written by the sage who relaxes against the railing, his back to the viewer.

The presence of figures whose actions are not directly related to the theme of *kinki shoga* suggests that these screens were part of a larger composition that included additional panels depicting other figures from Chinese history and legend. Shown here at the right is Chōkarō (Zhang Guolao), a Daoist Immortal who lived in the seventh century. He possessed a magic mule (here a horse) which he kept in a gourd. The animal in its miniature state returned to normal size when Chōkarō sprayed water on it with his mouth, and could whisk Chōkarō across thousands of miles. Another figure not directly related to the *kinki shoga* theme sits watching the *go* players. This is Ōshitsu (Wang Zhi), a legendary woodcutter, who one day wandered into a grotto in the Ku Zhou mountains where he found some old men playing *go*. Putting down his axe and his bundles of wood, he sat down to watch. One of the players gave him a date stone to chew, whereupon he fell into a deep sleep that lasted several centuries.

Takanobu has captured the sweep of sensuous luxury and sophistication of the Momoyama period through the golden setting with elegant figures, foreign architecture, and rich furnishings; moreover, his informal handling of these exalted figures and their environment, as though an extension of the viewer's own time and space, emphasizes the popularization of once-noble themes and the growing dominance of the decorative aspect in Momoyama-period screen painting and painting in general. This resulted directly from the taste of the parvenu class of warrior rulers, such as Nobunaga and Hideyoshi, who found pleasure in projecting their success through opulent display and grandiose associations. The influence eventually reached the decorations of shrines and temples and the homes of the aristocracy through the art of the Kanō painters.

During the early decades of the seventeenth century, a strong demand for the services of Kanō painters meant there were many opportunities for commissions for any number of artists. Kyoto was being rebuilt as the great imperial capital it had been before the devastations of the civil wars, and construction of the new capital for the Tokugawa shogun at Edo generated its own special needs. Before the end of the century, there were four major Kanō studios in Edo and an even larger number

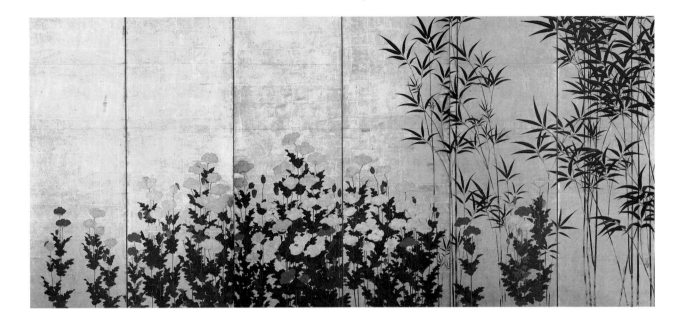

50.
Bamboo and Poppies
Kanō Shigenobu (act. 1620s and 1630s)
Edo period, c. 1625
Pair of six-panel folding screens, ink and color on
 gold-covered paper
Each screen: H. 62⅛" (157.8 cm), W. 140¼" (356.2 cm)
Margaret E. Fuller Purchase Fund 61.79
Plate on pp. 86, 87

of satellite groups. The tradition of ink painting
of the Muromachi period out of which the Kanō
school had sprung became central to the newly
established Kanō painters in the shogunal capital;
however, as in the screens of *Bamboo and Poppies*
(No. 50), the *kimpeki* style of gold-ground screens
painted with opaque mineral pigments remained
popular among the Kyoto Kanō school painters.

The artist of the Seattle screen, Kanō Shigenobu,
was active in Kyoto during the Genna and Kanei
eras (1615–1644). He was initially a student of
Kanō Sōshū (1551–1601), a younger brother of
Eitoku. Surviving examples of Sōshū's work show
similarities with these screens, but the refinement
of Shigenobu's work suggests that upon Sōshū's
death he turned to Mitsunobu, whose approach was
more inclined to promote the elegant delicacy of
Shigenobu's style with its almost obsessive con-
cern for authentic detail.

This pair of screens has a purely decorative
theme devoid of any didactic or allusive content.
Shigenobu exploited the potential for coloristic
effects afforded by the massing of the large blos-
soms. Arranging a strongly vertical composition in
a shallow space, he brought the plants close to the
viewer. The plants are observed in detail, down to

the minutest veins in the leaves. To carry the realism
even further, parts of the composition have been
built up with an application of a powder of ground
seashells with glue, creating raised designs on the
painting surface. Certain petals are built up, and
an occasional dewdrop rests on some leaves. The
astonishingly accurate depiction of the bamboo
continues from the slender culms with their drying
and discarded sheaths to the crinkly rhizomes that
reach horizontally, as though to creep forward in
the characteristic drive of bamboo to spread.

The wealth of botanical detail notwithstanding,
stylizations typical of the Edo-period Kanō school
appear in the balancing of the composition through
the arcing movements of the lithe bamboo and the
interweaving of the gold clouds on the gold back-
ground. The poppies, so exhaustively realistic in
almost every other respect, are shown rising straight
out of the ground with no allowance for their natu-
ral connection to the soil. Shigenobu demonstrates
his skill at ink painting in the brief description of
the edge of a low bank on the left-hand screen. Few
works by Shigenobu have been identified to date,
and these screens are among the most affecting in
terms of composition and state of preservation. On
each of the screens are two seals, the upper seal

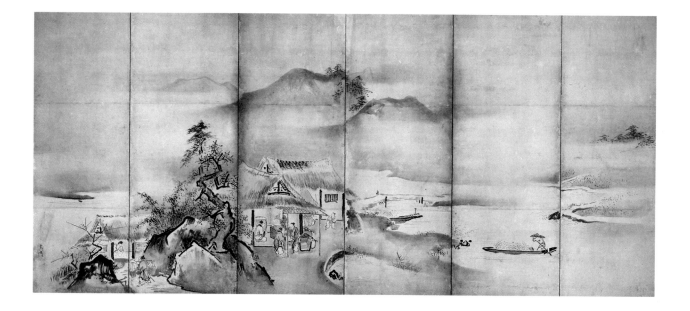

reading *go* and the lower *ji*. In an idiosyncrasy
as personal as his intensely realistic depictions,
Shigenobu seems always to have impressed the
upper seal upside down.

Takanobu had three sons, Tanyū, Naonobu,
and Yasunobu. Early in the Edo period, Tanyū
(1602–1674) and Naonobu (1606–1650) trans-
ferred to Edo to serve as *goyō-eshi*, official artists
to the shogun. Yasunobu (1613–1685) stayed in
Kyoto as head of the family until the Kanei era
(1624–1644) when he, too, moved to Edo to estab-
lish a studio. Later, a fourth branch was established
in Edo by Kanō Minenobu (1662–1708), so that by
the latter part of the seventeenth century there were
four main studios working directly for the shogun.
These were the *oku-eshi* (inner painters), artists
who were permitted direct audience with the sho-
gun, received hereditary stipends, and were allowed
to wear swords. Their counterparts, the *omote-eshi*
(outer painters), were allowed to assist the *oku-eshi*
on commissions, but their perquisites were con-
siderably limited in comparison.

Tanyū and Naonobu were largely responsible
for charting the academic, conservative course on
which the Kanō school now embarked in concert
with the Confucian conservativism of the sho-
gunate. Tanyū is well known as a connoisseur of
ancient paintings, and his certificates of authen-
ticity are found to this day attached to paintings
of earlier centuries. It is not surprising that this
doctrinal conservatism and the Kanō insistence
on the origins of the school in Chinese Song-
dynasty ink painting led to an absorbing interest
with older styles. The ink paintings of Naonobu
and his son Tsunenobu (1636–1713), for instance,
frequently pay homage to the broken ink style of
the Song-dynasty artist Mu Qi, whose paintings
were included in the Ashikaga shogunal art
collection.

Tsunenobu's ink painting style, characterized
by energetic line, skillful contrasts of light and dark
ink tone, and spacious compositions using large
unpainted areas, is well represented in these screens
(No. 51). As is often the case with pairs of screens,
one side is active and the other quiet. The right-
hand screen shows a thrashing dragon blasting
heavenward out of the river and sending showers
of water over the heads of the young Chinese boys
who run for cover. The rice paddies depict the new
crop at the left, and a foot-powered irrigation pump

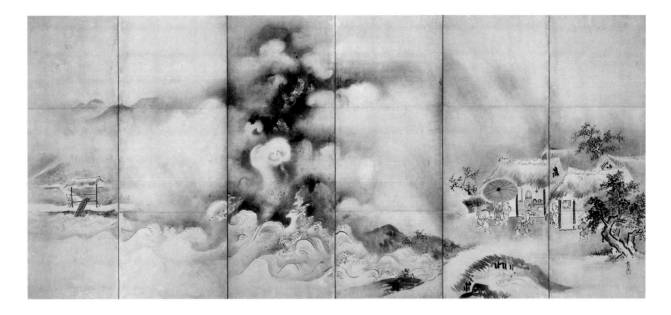

51.
Scenes of Farming
Kanō Tsunenobu (1636–1713)
Edo period, early 18th century
Pair of six-panel folding screens, ink and slight color
 on paper
Each screen: H. 60¼" (153 cm), W. 136¼" (346.1 cm)
Margaret E. Fuller Purchase Fund 71.4

sits on the bank of the river. The dragon, with its
long slender snout and feelerlike whiskers, is remi-
niscent of Mu Qi's dragon in a pair of scrolls in the
Daitoku-ji. The swirling clouds and crashing waves
with spattered ink demonstrate the careful control
of modulated ink and the bravado of Tsunenobu's
brushwork.

The left-hand screen conveys the quiet mood
of harvesting in the autumn. Boats transport grain
to the men who husk and clean it in preparation
for winter storage. The foreground detail of cottages
and men at work melts away into a romantic haze
of distant hills. Rich ink accents in the rock forms
and the outlines of the tree contrast with the mellow
tone of the distant hills and sky. Tsunenobu has
used color in very small amounts and in very pale
tones. A light greenish blue represents the bamboo
and pines at the left, the young rice plants and
tree leaves at the right. A pale greenish color is
used for the clothing of some of the men and boys,
and a spot of red colors a box on the table in the
cottage in the right-hand screen. On each screen the
signature reads simply *Tsunenobu hitsu* (from the
brush of Tsunenobu), and the seal reads *Ukon*.

Religious or philosophical themes like the
Confucian *kinki shoga*, once given weighty dignity,
became by the late sixteenth century opportunities
for elaborate decoration, and purely decorative
painting increasingly absorbed artists' energies
throughout the Edo period. Almost as though to
counter the prevalent mood for decorative works,
and in an apparent effort to return spiritual content
to painting, there is a moralizing tone — simple as
it is — in these screens, which no doubt was designed
to explain and indeed bolster the position of the
shogunate. The subject of these screens is a didac-
tic tale of the power of the beneficent water deity
to bring the joys of a good and plentiful harvest
to carry the happy peasants through the winter, yet
Tsunenobu has tried to tell his story with playful
boys and dignified peasant farmers who live quaint
lives amid bountiful nature. The composition is
typically disposed in a pleasant manner, the activ-
ities of topical interest are suitably well depicted,
and a Kanō school artist like Tsunenobu was able
still, in the early eighteenth century, to project a
sense of vitality through a visually exciting com-
position and adroit brushwork.

WJR

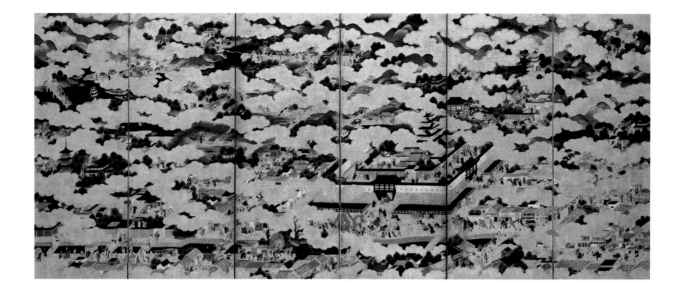

In the sixteenth and seventeenth centuries, Kyoto emerged as a great urban center. The imperial capital since 794, Kyoto embodied an ambience of art and culture which, though affected by the political and consequently the economic power of the emperor and his nobles, in many ways remained a force unto itself, propelled by the momentum of almost a thousand years of its own history. Contributing to this force were, of course, both courtiers and the Buddhist clergy; another element was the newly identifiable class of townspeople arising from the *machi-shū* of the Muromachi period.

This group was composed largely of the money-lenders and merchants whose fortunes had been tied to those of the Ashikaga shogunate and the ordinary craftsmen and laborers who kept the city functioning. The *machi-shū* also eventually included impoverished nobles whose land-based wealth had disappeared after the collapse of the Ashikaga shogunate in the sixteenth century. Each element brought a different strength to this unique amalgam, creating an urban spirit at once energetic, ambitious, and talented. In the seventeenth century, under the feudal stratification of the Tokugawa shogunal government, this group became the *chōnin* (townsman) class of the Edo period. Osaka, Edo,

and others eventually were to share this urban culture, but it was in Kyoto that the spirit of the new urban age developed first.

This new group or social stratum generated an unprecedented demand for material culture in the Edo period, to which the art world responded with alacrity. Novelty (*ukiyo*) and the fashionable (*fūryū*) were the enthusiasms of the day. In painting, new schools such as the *ukiyo-e* emerged; moreover there appeared out of the established ateliers a new type of artist who became a professional painter, the *machi-eshi*, or town painters, who were often graduates of the Kanō academy or possessed strong classical training in Tosa style. Trained in traditional studios but dissociating themselves from the lineage, they chose to work independently. Further, the diverse nature of the *chōnin* in levels of taste and purchasing power created great opportunity for professional painters to succeed. Three pairs of screens in the Seattle collection represent the *chōnin* spirit characteristic of early Edo-period Kyoto — the urban pride, reverence for traditional beauty, and delight in luxurious novelty that helped inspire the *machi-eshi*.

The first set of screens, the *Rakuchū rakugai-zu* (No. 52), shows a view of Kyoto. During this time,

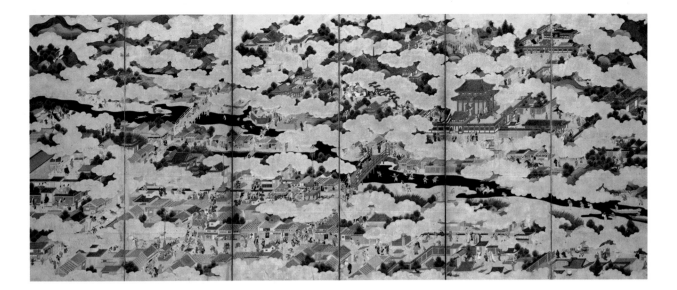

52.
Scenes of Life in and around the Capital
 (Rakuchū rakugai-zu)
Edo period, second half 17th century
Pair of folding screens, ink and color on gold-covered paper
Each screen: H. 67⅞" (172.4 cm), W. 149¾" (380.4 cm)
Purchased with funds donated by Mildred and Bryant
 Dunn and by the Floyd A. Naramore Memorial
 Purchase Fund 75.38
Plate on p. 83

as never before, art forms began to reflect the every-day life of the city dweller. Depictions of seasonal outings and religious festivals in settings of important and famous architectural sites or places of scenic beauty were especially popular. The citizens of Kyoto were fond, too, of seeing portrayed in their art the beautiful and powerful city that the *machi-shū* had been so instrumental in bringing back to life after the disastrous Ōnin War (1467–1477). Especially eager for such views of exciting city life and imperial splendor were provincial merchants and certain of the feudal lords, some of whom sought so assiduously to capture the sense of the capital in their own domains that some are still known as "little Kyotos."

Important architectural monuments, recreations centering on the four seasons, and the city's most important festival, the Gion Matsuri, are featured in these screens. A pair of screens with this theme painted by Kanō Eitoku in about 1570 for the Uesugi daimyo can be considered the immediate prototype for all such screens. The screens by Eitoku were commissioned by Oda Nobunaga (1534–1582) as a gift to the head of the Uesugi family, and clearly established in the august Kanō school the viability of the screen format for the genre scene.

In the Seattle screen, each panel depicts various aspects of life in the great city. Often presented with a touch of humor, their almost festive mood suggests a general sense of well-being shared by a prosperous nation at peace. Well-to-do and socially secure, although lacking any political power, the merchant class of the early Edo period seem never to have tired of portrayals of their life, and the wide expanses of the screen format afforded artists ample opportunity to please their patrons. The depictions could hardly be called *cinema verité*, for the stylized action and the idealized representations smooth out discomforts and irritations that must have beset daily life then no less than today.

In this configuration, the city is disposed along a north-to-south orientation showing its east and west sides. North is located at the center of the two screens; the city view reads in opposite directions from the center. The scene on the right-hand screen encompasses the eastern side of the city looking south and east from the imperial palace, located in the lower left corner. In the middle ground is the area along the Kamo River centering on the important Sanjō and Gojō bridges, today still the heart of downtown Kyoto. Other areas with their distinctive buildings are easily recognizable and include the

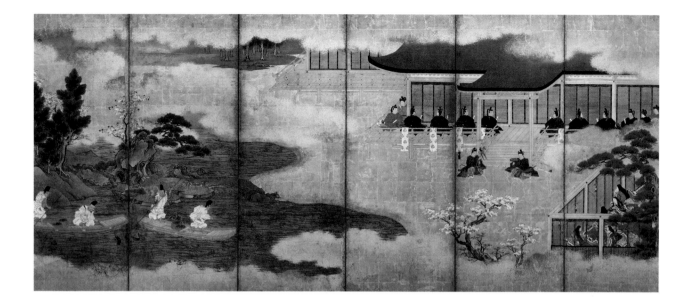

Sanjū-sangen-dō, across from which today stands
the Kyoto National Museum, and the Kiyomizu-
dera perched on its unique high stilts at the crest
of the hill.

The view on the left-hand screen is dominated
by Nijō castle, the symbol of Tokugawa authority
in Kyoto. Other famous shrines and temples found
along the western side of the city are included,
ranging in the north from Takao, a location in
the western hills noted for maple-leaf viewing in
autumn, and the Golden Pavilion (Kinkaku-ji),
to the pagoda of Tō-ji in the south.

Seasonal festivals with their attendant proces-
sions and activities also are given great attention.
The most prominent is the Gion Matsuri. This great
Shinto festival still occurs during the month of July,
and visitors travel from all over Japan to enjoy the
sights and merrymaking. In the right-hand screen,
the procession with its elaborate floats and palan-
quins for shrine deities winds its way along the
Kamo River, turning at the end of the Gojō bridge
to disappear from view at the bottom of the screen.

The painting style is a combination of older,
established traditions with newer perceptions that
mirror the eclectic influences at work in the shaping
of merchant class culture. There are allusions to the

courtly *yamato-e* and Tosa schools of painting,
and the particularized antics of the urban populace
indicates a familiarity with the emerging *ukiyo-e*
spirit. The brilliant gold background with embossed
cloud forms is an obvious borrowing from the elite
Kanō school of screen painting (see Nos. 49, 50)
and is indicative of the urban merchant-class aspira-
tion to emulate the lifestyles of powerful art patrons
such as the daimyo and the clergy.

Themes such as *rakuchū rakugai* represented
the relatively new interests of the urban dweller;
however, themes with a long history as major ele-
ments in painting, or as decorative and poetic
motifs, were also popular. Since the time it was
written in the Heian period, the *Genji monogatari*
had supplied inspiration for painting motifs, and
during the early Edo period a fresh burst of interest
in native literary sources brought particular atten-
tion to this story as a source of painting themes.

Traditional Genji-theme iconography has called
for one illustration for each of the fifty-four chap-
ters. In album or handscroll form, this presents no
real problem. However, in terms of six-panel folding
screens, such an arrangement offers special diffi-
culties. A pair of screens in the Mary and Jackson

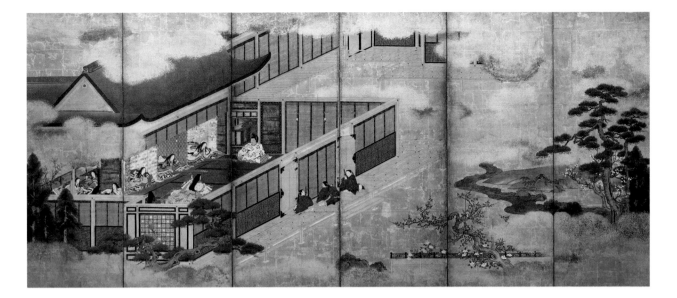

53.
Scenes from the Tale of Genji
Edo period, second half 17th century
Pair of folding screens; ink, color, and gold on paper
Each screen: H. 66" (167.6 cm), W. 146¼" (370.8 cm)
Gift of Friends of the Seattle Art Museum in
 honor of the 75th birthday of Dr. Richard E. Fuller 72.1
Plate on pp. 52, 53

Burke collection, New York, ingeniously distributes a complete set of scenes across the face of the screens, but such tour de force examples must have been rare even in the Edo period. A simpler and presumably more frequently adopted solution was to select an independent and self-contained scene for each screen. The Seattle screens (No. 53) are of this type, and bear scenes from Chapters 33 and 35.

The scene from Chapter 33 refers to a visit to Genji's palace by the emperor Reizei and the retired emperor Suzaku. The emperor, retired emperor, and Genji are out of sight inside the palace while large numbers of courtiers line the veranda. In a room at the right, ladies of the house peer through the blinds at the assembled guests; one courtier turns to look in their direction. Cormorant fishing is under way in a small lake at the left. At the foot of the steps are lieutenants of the inner guard, who present fish from the pond and pheasants taken nearby for a banquet. The season is autumn and maple leaves in their fall colors are shown prominently in the foreground and scattered among the pines surrounding the pond.

On the other screen, bearing Scene 5 of Chapter 35, appears a group of ladies playing music before Genji, who keeps time. The ladies are separated by screening curtains. Present are Murasaki, the Crown Princess, the Akashi lady, and the Third Princess. The ladies play a Japanese and a Chinese *koto*, a lute, and a smaller *koto* for the Third Princess. On the veranda are Yūgiri (Genji's son) and two young boys; one is Genji's grandson (Yūgiri's son), the other is Genji's niece's son. The boys play *shō* pipes and a flute. The season is spring, and two types of blossoming plum trees, the red and the white, appear along with camellias blooming at the garden fence.

Yamato-e painters throughout the centuries had specialized in such courtly scenes as the Genji theme, establishing certain characteristic compositional techniques and descriptive formulas for figures and faces. These screens incorporate elements long associated with the *yamato-e* artists, such as the Heian-style court dress and the open-roof scene shown from bird's-eye view, the *fukinuki yatai* technique (literally: blown-off roof). The softly rounded topography and gentle seasonal displays of colored leaves or blossoms are reminiscent of *yamato-e* taste. The painter of these screens has utilized such elements only superficially. He reveals his thorough schooling in the Kanō style through the strongly linear treatment

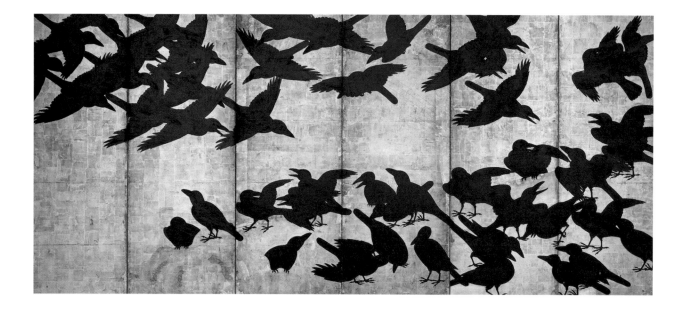

of the architecture, thoroughly detailed and convincingly portrayed, the angularity of the brocade robes, the emphatic use of ink along the outlines of the tree trunks, and the typical rock formations. The *suyari*, or drifting bands of gold clouds, used to separate action and divide spaces, originally a *yamato-e* motif, had long since been adopted by the Kanō school painters. Further, the detailed and individualized representations of the faces are distinctly unlike the *yamato-e* approach.

A third pair of screens (No. 54) represents still another facet of the *machi-eshi* painters of the early Edo period. These screens show a large flock of crows squawking and yelling in their typically raucous way. The unloved crow is an unlikely choice of subject to fill the space of a pair of six-panel folding screens, yet the dramatic contrast of the silhouette-like motifs, repeated in myriad multiple images, generates a highly memorable decorative device. Almost universally crows are scorned and disparaged as tricksters or mischievous provocateurs, and among urban populations they can be disruptive neighbors. It is perhaps their size, large for a bird that lives closely with humans, that makes them seem somehow threatening; certainly

they have a profound curiosity and are aggressive territorialists, given to continual wrangling among themselves and menacing other birds. These characteristics are found equally among humans, and perhaps it is his own traits man sees mirrored in its actions, which makes him shun the crow.

As unpleasant as crows might make themselves, they remain fascinating creatures. The symbolism of the crow in Japanese art is not clear, even though it has appeared with some frequency in poetry, painting, and woodblock prints; yet for all its unattractive habits, the crow as a motif was sufficiently benign — or suggestive — to appear as a textile design on kimono of courtesans in Genroku-era (1688–1703) woodblock prints.

As independent artists who painted secular themes for popular consumption, the *machi-eshi* are usually described as combining Kanō and Tosa school techniques in producing a freer, decorative kind of painting. By about the mid-seventeenth century, however, it is quite probable the success of the Sōtatsu (act. c. 1630) and Kōetsu (1558–1637) taste (No. 58) was already spilling over into popular painting done by these *machi-eshi*. It is this blending of various stylistic modes with the excellence of the artist's masterful portrayal and composition

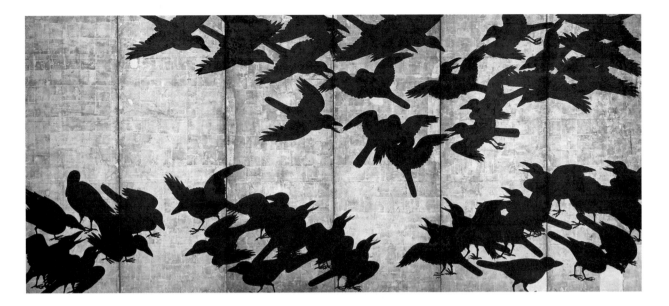

54.
Crows
Edo period, c. 1650
Pair of six-panel screens, ink and gold on paper
Each screen: H. 61¾" (156.9 cm), W. 139" (353.1 cm)
Eugene Fuller Memorial Collection 36.21
Plate on p. 68

that, on the one hand, takes these screens of crows out of a specific school, but at the same time assigns them to a skilled and talented painter.

The bold shape of the birds is, upon close inspection, carefully detailed within the strong outline of the form. The birds have been very fully observed in nature, and their characteristic features are here well represented: the beaks; the feet with their scaly skin, joints, and claws; the tongues. The eyes are built up with *gofun* and circled with perhaps a touch of silver pigment, which has since darkened. The in-flight appearance with feet pulled up, the groupings and individual poses and actions, all demonstrate the artist's close examination of crow behavior. Further, the feathers are delineated in a method of black-on-black painting in which an admixture of some ingredient, sometimes glue, renders a slightly different surface to the ink, making possible visual and textural distinctions between two superimposed black elements.

In contrast to this careful observation and representation, the screens are not compositionally continuous; the little ground space given any definition appears on only one screen as a diagonal line beginning midway on the right end of the screen and moving down to the left, ending in the suggestion

of a rocky form where several crows perch. This line is differentiated mainly by a change in gold texture which results from a very light build-up of *gofun* under the gold. The other screen shows no ground line, even though the birds gathered along the lower portion are clearly seen as being on the ground. The sweeping aerial battles taking place in the upper portions are discontinuous and seem unrelated. The significance of these seeming discrepancies is not easily explained, but might be the result of the experimental nature of the theme.

WJR

The tradition of painting that depicted the pleasure quarter and its activities emerged in the early Edo period from the broader *fūzoku-ga* of the middle ages (see No. 33). *Fūzoku-ga* (pictures of manners and customs) were eventually standardized as a set of specific themes, such as views of Kyoto (see No. 52) or scenes of seasonal events. They are best known in the screen paintings of the late sixteenth and seventeenth centuries. *Ukiyo-e* paintings focus more narrowly on the pleasure quarter, and are termed *nikuhitsu*. The term indicates that the painting (or calligraphy) in question is actually by the artist's own hand, i.e., not a woodblock print. This type of painting greatly appealed to the urban merchant and artisan class; however, the popularity of *ukiyo-e* art was greatly compounded when it was combined with woodblock printing. Producing multiple images not only reduced their cost, but more important, made possible images of greater variety and constant novelty — qualities that immediately endeared the prints to the townsman class. Their wide availability and low cost helped create among the townspeople an even greater sense of their mutual interests.

Ukiyo-e art also featured prominent actors of the recently formed Kabuki theater, depicting them in roles for which they were famous, and revealed other aspects of urban society, eventually broadening in the nineteenth century to include views of nature and famous places throughout the country. However, from the outset, the courtesan and entertainer remained the essential symbol of the *uki-yo* — the "floating world," as the pleasure world was popularly termed — and appeared as the central figures of *ukiyo-e*. Painters of the *ukiyo-e* genre also began creating illustrations for popular woodblock texts, and Hishikawa Moronobu (1618–1694) became the first commercially successful woodblock *ukiyo-e* artist when he added his signature to woodblock designs sometime late in the Kambun era (1661–1673). The participation of such artists joined woodblock technology with *ukiyo-e* art in book printing, the medium in which *ukiyo-e* artists ultimately gained their greatest renown.

Woodblock printing had its own traditions, and its processes were divided among several specialists. The blocks were carved and printed by craftsmen, not by the artist, who functioned essentially as a designer. Eventually *ukiyo-e* artists became almost exclusively associated with woodblock prints, but, especially in the early period, not all *ukiyo-e* painters designed for prints — Miyagawa Chōshun, for instance, did not — and as the painting here by Hokusai demonstrates, print-designing artists also continued to paint *nikuhitsu ukiyo-e*.

The artists Ryūho, Chōshun, and Hokusai represent three distinct periods in the development of *ukiyo-e* painting. Nonoguchi Ryūho (1595–1669) worked in the early period when *ukiyo-e* art was largely a phenomenon of Kyoto. A painter, calligrapher, and poet, he has created a painting (No. 55) incorporating all these arts. He followed the *kambun bijin-e* format, established in the Kambun era to depict entertainers and popular beauties. The figure is placed in a mild contrapposto pose characteristic of these paintings, here with turned head and hands and one foot extended as if describing a dance movement. The sense of motion is heightened by the flow of the kimono and the swing of the ends of the obi. For all its suggestion of graceful movement, the figure remains essentially two-dimensional, a flat color pattern within a strong if rhythmical outline. These *kambun bijin-e* also portrayed the figure wearing fashionable costumes that displayed complex and expensive tie-dye techniques on silk kimono, often incorporating costly embroidery decoration. Throughout the Edo period, these entertainers exerted a commanding influence on clothing and hairstyle fashions for the townsman culture in general.

The young lady in this scroll by Ryūho wears a brilliantly dyed kimono of red with a band of blue along the lower part of the sleeves and along the hem. The trailing length of the kimono is the newest fashion, as are the wider sleeves, a style that would grow eventually into the *furisode* of the eighteenth century (see No. 70). The kimono surface has been marked off with gold lines into squares like those on the popular board game *shōgi* (still widely played, mainly by men). Its appearance here as a decorative motif reflects the free access of *ukiyo-e* to popular subjects or current themes. The game pieces lie scattered across the kimono, their identifying marks written in gold and colored inks. (A word of the same sound, 'shōgi,' is a term for a licensed prostitute, and Ryuhō's punning design on the entertainer's kimono would have delighted the *chōnin*, for whose taste the painting was made.)

The fanciful hairstyle also was very new at the time, and originated among the *wakashū* (beautiful young men) who assumed female roles in Kabuki after women were prohibited from the stage in 1629. Ryuhō's version of it, circa 1665, is considerably exaggerated; however, it shows the basic divisions of the hair as it was separated, piled, and tied in place. The long bun (*mage*) down the back of the neck was a chief characteristic of the *wakashū-mage* from which developed the basic style current into the eighteenth century. The use of simple crisp

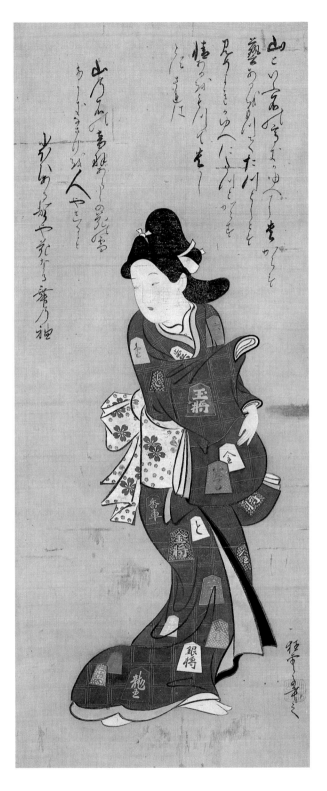

55.
Kambun Bijin
Nonoguchi Ryūho (1595–1669)
Edo period, 17th century
Hanging scroll, ink and color on silk
H. 31¼" (79.4 cm), W. 12⅝" (31.1 cm)
Eugene Fuller Memorial Collection 60.80

white paper ties and the absence of any decorative combs or pins marks its earliest phases. (It is similar to hairstyles of the Chōshun-style screens, No. 56, but dramatically different from those of the Hokusai painting of the nineteenth century, No. 57.)

Ryūho's paintings follow a variety of schools; he is said to have studied the Kanō, Tosa, and even Sōtatsu schools. Living in Kyoto, however, Ryūho was part of the early *ukiyo-e* tradition that focused on the hurly-burly of the new entertainment districts along the Kamo riverbanks and the Shijō area, a social and artistic phenomenon that no one in Kyoto could ignore. This painting is a result of the impression it left on him.

Ryūho was also an acknowledged poet and calligrapher. By combining his own poem with a painting elucidating it, Ryūho was indulging in a type of painting resembling the *haiga*, which Yosa Buson brought to its full artistic statement a century later (see No. 61).

Ryūho's inscriptions here contain, at the right, an introductory passage cleverly composed and artistically calligraphed in columns of irregular length, and at the left, a type of linked verse poem (*haikai no renga* or *haikai*). The poetry has been paraphrased thus:

> At Mount Otoba, petals fall like snow.
> Can man know the beauties and feeling of these?
> Her dancing figure is like flowers and her voice
> like perfume.

Ryūho's seal, *Shō-ō* (Venerable Pine Tree), is well known on his works. The signature *Kyōun-shi* (The Crazy Cloud One) is apparently little known, and its presence gives this painting a special place in his oeuvre.

In terms of popular culture, Kyoto could not long compete with the new shogunal capital of Edo. After Edo was rebuilt subsequent to a disastrous fire in 1657, the amenities of the massive new Yoshiwara licensed quarter and the affluence of the merchant class shifted the artistic focus of *ukiyo-e* culture to that city, where, during the Genroku era (1688–1703), the *ukiyo-e* style grew to maturity.

Miyagawa Chōshun (1683–1753), a prominent *ukiyo-e* painter of the first half of the eighteenth century, represents a very different time from Ryūho in the development of *ukiyo-e* art. His quiet paintings, contrasting with earlier *ukiyo-e* works, no doubt reflect his taste, but might also reflect greater government supervision of public morals, in an effort to suppress what was considered lewd and licentious behavior among the lower classes. Chōshun had arrived in Edo as a young man fresh

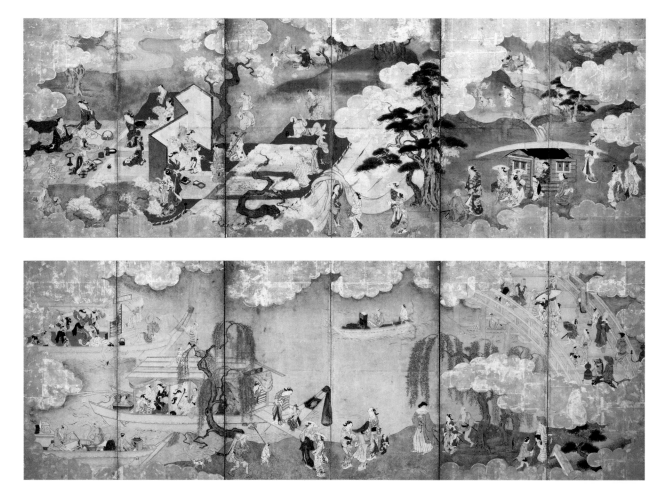

56.
Ukiyo-e screens
Style of Miyagawa Chōshun (1683–1753)
Edo period, mid-18th century
Pair of folding screens, ink and color on paper
Each screen: H. 40¼″ (102.2 cm), W. 112½″ (285.8 cm)
Margaret E. Fuller Purchase Fund 62.133

from the Owari district (modern western Aichi prefecture) during the opulent and heady Genroku era, a time noted for extravagance among all classes of society in the shogunal capital. Its momentum carried over into the succeeding decades when Chōshun was emerging as an important artist.

The interest among patrons and admirers of courtesans and entertainers in paintings depicting their lives was sufficient to sustain several major groups of artists. Chōshun and his followers were able to compete successfully with already established artists. Chōshun, like other *ukiyo-e* artists, also studied Tosa and Kanō school painting, but his skill at fusing influences from different styles to capture the romance of the pleasure quarter soon

made him a recognized artist of *ukiyo-e*. In painting beauties of the Yoshiwara, he followed the stylistic lead established by Hishikawa Moronobu, and also worked with confidence in the well-known style of the Kaigetsudō group. Chōshun's work, however, reflected his own unique passion for sumptuous furnishings and dazzling costumes and attests his eye for authentic detail which, with his exquisite taste in color harmony, brought him acclaim.

Chōshun brought to *ukiyo-e* painting a view of the world of pleasure at its ease. Perhaps partly because of changing taste, partly a reflection of shogunal censorship, or perhaps basic to his own more temperate views (he did not design for print books, which were often sexually explicit),

Chōshun's acknowledged works are uniformly tame. The active performer of the *kambun bijin-e* became, in Chōshun's paintings, a stereotyped beauty symbol, neither seeing, nor hearing, nor joining in unseemly acts.

This pair of six-panel screens (No. 56) is typical of much of what is considered characteristic of Chōshun's mature style. Certain discrepancies preclude assigning these screens to Chōshun's brush, but the anonymous painter must have been well trained in the *ukiyo-e* school and close to Chōshun in time and in style. The scenes depict the escapist romanticism of *ukiyo-e*, portraying the courtesans of the Yoshiwara at play outside the confines of their world of endless pleasures and constant delights. On the right, a boating scene represents the summer retreat to the cool breezes of the Sumida River. The bridge at the right side shows the bustling city life with a great variety of passersby, including a scowling *yamabushi* (mountain priest) and a courtesan (her high rank indicated by an elaborate umbrella) glancing over the railing to evaluate a departing boatload of revelers. There are also men and women of the merchant class, a street entertainer with a trained monkey, and a mounted samurai. A bookseller crosses from the top of the bridge, seeming to eye closely an approaching itinerant priest. Below at the riverside, two samurai, their paired swords indicating their rank, pause — the one seeming to hide his face — as a covey of courtesans approaches. On the gangplank a courtesan leads her apprentice aboard the departing pleasure barge, while aboard, others entertain their customers with music played on the *shamisen*, a three-stringed instrument imported from Okinawa in the mid-sixteenth century, which became the particular instrument of popular culture. The willow trees, though a reference to summer and growing naturally at waterside, also allude to the pliant mistresses of the Yoshiwara. On a boat in midstream, dancing suggests the Obon festival of midsummer. A patron washes out a sake cup, while another signals a food vendor's boat alongside; a third man smokes a tobacco pipe — a mark of an up-to-date dandy. In the foreground, a fish vendor selects a specimen for slicing into *sashimi*, while one helper stirs a pot and another puffs at the fire in a brazier. Many of these characters are standard types that appear regularly in *ukiyo-e* paintings.

On the left, the scene is of a cherry blossom viewing party. The location is probably meant to suggest Ueno, famous for its cherry blossoms and today a major Tokyo park where viewing parties still come every spring. In imitation of the behavior of courtiers and the ruling military class, a private enclosure has been created by the long curtain (*mammaku*) bearing crests strung on twisted black-and-white rope. The ground is covered with colorful *mōsen* (felt carpet) and what appear to be Chinese rugs, a touch suggesting great luxury. A palanquin appears at the right, curiously without bearers but surrounded by a group of ladies and apprentices. A courtesan, obviously of high rank, is greeted by a kneeling man with a gesture motioning her to enter through the opening where the curtain has been thrown back. The two swords and elaborately dressed white hair of the attendant indicate he is an elderly samurai, probably a retainer for the dandy inside. This gentleman, seen at the far left lying on his stomach in a wanton breach of decorum, leisurely smoking a pipe, is both the chief guest and host for this party. Beside him is the *oiran*, the star of the event, her rank indicated by her position at the innermost part of this hidden garden, where she poses regally, like a Song-dynasty goddess, basking in the glow of ardent admiration and obedient attention. The *oiran* (called *tayū* in the Kyoto-Osaka area) were of the highest rank among the courtesans. Their lives in the Yoshiwara quarter, called the city of endless night, were circumscribed by ceremonious behavior, and the cost of their favors was enormous. The scene is replete with dancers maneuvering to the sounds of music, *maki-e* lacquer food boxes overflowing with delicacies, and ladies and gentlemen alike enjoying the sake.

The appearance here of *oiran* records a fashion that, not long after these screens were painted, went into decline. Prints of beautiful women and fashionable actors reached their zenith in the late eighteenth century with artists such as Utamarō (1753–1806), Kiyonaga (1752–1815), Eishi (1765–1815), and the enigmatic Sharaku (act. 1794–1795). As print designers struggled to find ever more ingenious ways to present time-honored themes and imagery, the print-buying public seemed to weary of the traditional format. Perhaps inspired by a vogue for travel books and exotic tales, print artists began experimenting with scenic landscape motifs. Katsushika Hokusai (1760–1849) emerged in the nineteenth century as the brilliant pioneer talent in this new type of print, and as early as 1799 was designing prints featuring scenes of contemporary life in local landscape settings. In 1804 he designed a series featuring scenes along the Tōkaidō, the road connecting Kyoto and Edo (a theme his contemporary Andō Hiroshige, 1797–1858, used with great success

some years later). Over the next decades Hokusai did many popular series of prints including waterfalls of the various provinces, views of Okinawa, and famous bridges around the country.

Hokusai had a full and active artistic life. His career began when, barely eighteen, he entered the studio of the important print artist Katsukawa Shunshō (1726-1792). His very great talent was early recognized, and after a short time Shunshō accorded him the honor of sharing his own art pseudonym by giving him the name Shunro. Upon Shunshō's death, Hokusai turned his back on studio affiliation and struck out on his own (some reports say he was expelled).

By the time Hokusai launched into the landscape series in the early nineteenth century, he was in his fifties. These prints are probably his best-known work among Western audiences, particularly his design showing Mount Fuji in the distance framed by a cresting wave. He is credited with tens of thousands of designs during his lifetime; his book illustrations and the *Manga*, or sketchbooks, alone would represent a prodigious production for a single artist. In addition to his print designs, Hokusai painted many *nikuhitsu ukiyo-e* scrolls on paper or silk; his folding screens further testify to his versatility and wide interest as an artist.

The period between his leaving Shunshō's studio in 1792 and before beginning the landscape designs in earnest found Hokusai searching into the furthest corners of technique and influences, meeting and mastering challenges of style. He studied both Kanō and Rimpa school painting; his investigations took him into Chinese history and literature, and he did many book illustrations. He also worked to master Western techniques of perspective and shading. All this contributed to the formation of his highly individual, often unorthodox style. More than any of the other *ukiyo-e* artists who at the time were intrigued by Western exoticisms, Hokusai absorbed the experience of Western techniques to the benefit of his art.

This painting of five beautiful women (No. 57) relates to several other Hokusai paintings of beauties which, though undated in inscription, all seem to have been produced about the same time. The handling of forms and the naturalistic sense of volume and mass, and the individualized psychological identity of the figures in these works, all point to a radical shift in Hokusai's artistic vision that leads away from the insubstantial figures characterizing his work during his years with the

Shunshō studio and the early independent years up to about 1805. The new figures are plumper, considerably more solid not only in physical form but in emotional intensity. The paintings are far richer in color, the pigments more opaque, the detail more profuse, and the impact often heightened by unexpected or unconventional compositions.

Distinguishing the Seattle painting are the complete lack of any setting for the figures or any apparent common relationship (other than that they are all women) and the exceedingly high point of view. The setting of a shallow room interior with varying amounts of description has been discarded; the figures are left to generate space through their physical forms. Further, while the overlapping figures partially obscure one another, they seem not to touch. The strange grouping combines contradictory types, as if to emphasize further their separateness, such as the unlikely proximity of the shrine pilgrim (previously mistakenly identified as a bride), shown wearing the typical *tsunokakushi* headdress, with the haughty though presumably accomplished courtesan facing her. The rather soberly attired figure above, tending her flower arrangement, bends her head sharply, exposing the nape of her neck in a provocative manner; this contrasts with the elegant lady at the top who pauses, apparently deep in thought, in composing a poem. The reclining figure in the foreground reading a book seems completely unrelated to any of the others, even in terms of contrast. Given Hokusai's considerable experience illustrating books, it is not inconceivable he saw this figure as imagining the others as she reads.

Groupings of beauties in the guise of famous figures of history or of fable, or parodies of serious themes, called *mitate*, were popular in Hokusai's day and reflect the scurrying of print designers to find new ways to present traditional *ukiyo-e* themes. It might be possible to understand this painting in terms of a *mitate*; however, the disparate nature of the ladies seems to leave the group without a common reference. More probably a patron's whim inspired this unusual grouping, and surely the challenge of a request for an unconventional group composition would have appealed to the adventuresome spirit of the artist.

Hokusai has lavished on his gathering a lush display of technique and color in their clothing, stressing its tactile qualities and the special characteristics of fabrics from heavy brocade obis to gauzelike summer kimonos. This bravura style

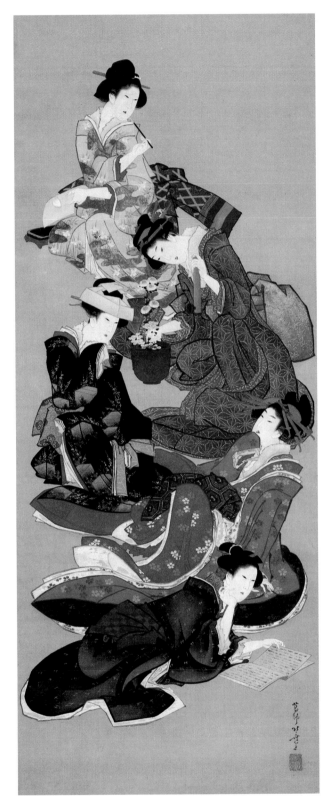

transcends the question of logical association and generates a visually absorbing work of art all the more intriguing for its troubling air of seemingly purposeful ambiguity.

The painting bears no inscription other than the signature, *Katsushika Hokusai-hitsu* (from the brush of Katsushika Hokusai), using the name by which he is best known today. The seal, one of his well-known seals, reads *Ki-mō da-soku*. The signature is at least a partial clue to the date of the painting, for he used it, along with several other names, from 1796 until 1820 when he abruptly dropped the name Hokusai, bestowing it on a student. Stylistically the painting is accepted as coming during the Bunka era (1804–1817), along with the other related paintings of beauties. The *Ki-mō da-soku* seal on this painting supports a date of 1811 or 1812, because Hokusai bestowed this seal on his pupil Hokumei (act. c. 1804–1830) in 1813.

Over the course of his long career Hokusai used many different art names. In later life he used one name appropriate for an artist of such great energy and genius: *Gakyō rōjin*, Old Man Mad about Painting.

WJR

57.
Five Beautiful Women
Katsushika Hokusai (1760–1849)
Edo period, early 19th century
Hanging scroll, ink and color on paper
H. 34″ (86.4 cm), W. 13½″ (31.8 cm)
Margaret E. Fuller Purchase Fund 56.246
Plate on p. 76

Art and esthetics no less than the institutions of society, politics, and commerce reflected the tumult of change and experimentation that was the hallmark of the Momoyama period. Extravagant masses of gold and silver in painting and in palace and temple decoration coexisted with the austere tea rooms and restrained tea wares of *wabi-cha*. In tune with the expansionist overseas trade and politics of Nobunaga and Hideyoshi, the exotic arts of foreign countries were more popular than ever, yet the demand for native arts led to the development of new ceramic wares for the tea ceremony, and new styles appeared in lacquer and textile arts. Fascination with the new and the exotic was equaled by an interest in the revival of arts of earlier times in Japan. The Zen-inspired ink painting that dominated the preceding Muromachi period had been superseded by the colorful and energetic style of Kanō Eitoku, yet Muromachi ink painting was revisited by artists of newly established schools such as the Unkoku and Hasegawa, whose founders both claimed to be the new Sesshū. Literature of the past, too, became more readily available through creative printing techniques, which included an exploration of movable wood-carved type introduced from Korea. This accessibility of earlier literature helped kindle a further interest in the twin arts of *waka* (Japanese poetry) and the cursive calligraphy traditionally used to transcribe it. It was an interest that extended beyond the narrow circle of the court, traditional guardian of these arts, to the emergent bourgeoisie of the townsman class.

Near the end of the sixteenth century, a new artistic expression began to take form out of the profound esthetic sensibilities of two men of this commoner class, Honami Kōetsu and Tawaraya Sōtatsu. Their style, derived directly from their passion for the court arts of the Heian and Kamakura periods, captured the essence of bygone days, combining the intellectualism of the poet and literateur with the sensual elegance of gold and silver. Important to the success of this art in Kōetsu's hands was the perfume of a poignant recognition of lost imperial grandeur, the *mono no aware* of Heian esthetics. Sōtatsu's work, more than Kōetsu's, drew inspiration from the *yamato-e* handscroll tradition (see No. 29), and it was the *yamato-e* sense of color and rhythmical composition he stressed. Sōtatsu also projected the *yamato-e* style of small-scale images devoid of nonessential detail into new large formats appropriate to Momoyama-period taste. It was a fresh expression of well-known traditions, which in its latter-day manifestation became available to an increased market

of affluent commoners; it became a middle ground, like the tea ceremony, where aristocrat and commoner could meet.

Kōetsu (1558–1637) was the son of a noted and well-to-do sword connoisseur who polished and judged blades for the nobility and for both Oda Nobunaga and Toyotomi Hideyoshi. It was a highly respected position in an age of military rulers, and it is possible his contacts with members of the nobility later provided Kōetsu an entrée into court society. Little is known of Kōetsu's life before his father died in 1603; however, within a short time it was apparent that he had developed into a cultural esthete with broad artistic interests. A superior calligrapher, Kōetsu collected antique specimens of calligraphy and incorporated their influences into a unique style that was to establish a new standard. He was later honored as one of the three great calligraphers of the Kanei era (1624–1643). He was also a tea master and is said to have studied with the great Furuta Oribe (1544–1615). Kōetsu's interest in tea led him to study with the Raku family of potters; his tea bowls are among those most treasured today.

In 1615 Kōetsu moved to a tract of land north of Kyoto at Takagamine. There he assembled a group of relatives and cherished artisans who supplied his art needs, and among whom the community tie seems to have been primarily religious. Viewed in the context of his art, the group appears to have been uniquely devoted to the joy of producing beauty.

Kōetsu's earliest known works, predating his move to Takagamine, already show the combination of subtlety and richness that characterizes his oeuvre. Small books done in luxury editions were designed by Kōetsu and published by a wealthy associate, Suminokura Soan (1571–1632), who had studied calligraphy with Kōetsu. Together they designed and produced texts, which were then transferred to carved wooden type and printed on pages of colored paper already printed with designs of powdered mica and gold and silver. These delightful books and a number of other texts of classical literature were produced up to about 1610 and are known as the *Saga-bon*, after the Saga area of Kyoto where Suminokura's private press was located. The stamped mica and gold and silver designs of the *Saga-bon*, along with the concept of albums of calligraphy on decorated papers, were clearly inspired by the Heian-period album pages on which the poems of the imperial anthologies were transcribed by the great calligraphers of the day (see No. 25).

58.
Section of the *Deer Scroll*
Calligraphy by Honami Kōetsu (1558–1637)
Painting by Tawaraya Sōtatsu (act. 1600–1640)
Momoyama period, early 17th century
Handscroll, ink and gold and silver paint on paper
H. 13⅜″ (34 cm), L. 363¾″ (939 cm)
Gift of Mrs. Donald E. Frederick 51.127
Plate on p. 73

Kōetsu also provided calligraphy, transcribing poems to be printed on sheets and fashioned into handscrolls. Numerous remaining examples show that the imperial anthology *Shin kokin wakashū* (Anthology of Ancient and Modern Poems), created in the thirteenth century by the retired emperor Go-Toba, was the collection he loved most. The woodblock-printed books and scrolls involved the talents of many other artists, since production required carving Kōetsu's calligraphy as wooden type, after which blocks were printed on specially made paper decorated with woodblock designs. No doubt master craftsmen executed each stage of the work.

Sōtatsu (act. c. 1600–1640), who in his early career sometimes joined Kōetsu in collaborative works, was the proprietor of Tawaraya, the successful art studio known for its fans and also for creating decorated papers, *shikishi* and *tanzaku*, for calligraphic inscription, as well as elaborate panels and screens for interior decor. The clientele included the imperial court and the fashionable of Kyoto; the shop apparently supplied Kōetsu with decorated *shikishi* squares and paper sheets for handscrolls or screens. Sōtatsu himself seems to have worked at the studio along with his associates, and they used a round seal reading *I-nen* as a sort of trademark. Later in his career, as he rose to prominence and received the Buddhist honorary

rank of *hokkyō*, Sōtatsu began signing works and using a distinctive seal, apparently relinquishing the *I-nen* seal for studio use. It is thought Sōtatsu received the *hokkyō* rank soon after 1621, in recognition of his paintings at the Yōgen-in, Kyoto. Interestingly, this commission came through the wife of shogun Tokugawa Hidetada, demonstrating the wide-ranging acceptance and relative importance of Sōtatsu as a painter.

Sōtatsu's intimate acquaintance with monuments of Kamakura- and Muromachi-period handscroll painting is manifested in many still-existing paintings from the span of his career. Of particular interest in terms of the Seattle handscroll are a group of Sōtatsu's earliest known works, which date from 1602. Invited to help with the restoration of the covers and frontispieces of sutra scrolls dedicated by the Taira family in about 1160 to the Itsukushima shrine at Miyajima and known as the Heike Nōkyō, Sōtatsu created several landscapes and a painting of a single deer, working in gold and silver pigments. The deer, depicted grazing, its muzzle almost to the ground and eyeing the grasses that rise about it, is almost identical to one that appears in the Seattle scroll.

Sōtatsu's experience with medieval scrolls resulted in his adapting themes from them, as he did in a pair of screens in the Freer Gallery of Art. Fans pasted across the surface show motifs lifted

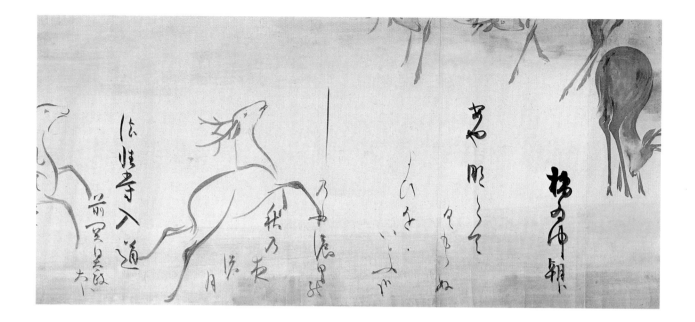

from the thirteenth-century handscrolls of the *Heiji monogatari* and *Hōgen monogatari*. The motifs are faithful within the context of translation from the rectangular handscroll format to the curving shape of the fan. Clearly, Sōtatsu's access to important works of *yamato-e* art from earlier centuries was fundamental to the successful development of his own art and brought the necessary note of assurance through familiarity that made his interpretations of the themes from classical literature and history so compelling.

Kōetsu and Sōtatsu collaborated on several poem handscrolls and sets of *shikishi* of the classical poets during the years prior to Kōetsu's move to Takagamine. In them, some of Sōtatsu's underdecoration (*shita-e*) was done in woodblock-printed form, as in the handscroll in the Freer Gallery of Art with designs principally of ivy, bamboo, and flying cranes. The scroll in the Daitōkyū Kinen Bunko, Tokyo, has Sōtatsu's block-printed designs with Kōetsu's calligraphy also block printed in a technique reminiscent of the *Saga-bon*. Other examples have under-designs painted directly by Sōtatsu with Kōetsu's calligraphy. The two paramount examples of this type are the *Lotus Scroll* and the *Deer Scroll*. Both are painted on paper in gold and silver ink (*kingindei-e*), the paper specially finished in a technique called *gofun-biki* to give it a brilliant and flawless white surface. Against it the gold and silver decorations and the lush black ink of Kōetsu's calligraphy resonate.

The *Deer Scroll*, like the *Lotus Scroll*, was broken from its original length into a number of sections. The Seattle portion of the *Deer Scroll*, the largest at over 30 feet long, was taken from the last half of the original. It contains the signature of Kōetsu (reading *Tokuyū-sai*), his personal cipher, and the red circular *I-nen* seal used by Sōtatsu and his studio.

Sōtatsu's design begins, in the Seattle section, with bands of silver which change to gold and back again as they pass the length of the scroll, in a technique reminiscent of the *suyari* clouds that drift across medieval handscrolls. The deer images are disposed in groups numbering from a single stag to a herd. They move about, prancing and playing or quietly grazing. At one point three young stags leaping with joy seem to be racing. Placed along the length of the whole scroll are twenty-eight poems from Kōetsu's favorite anthology, the *Shin kokin wakashū*; the Seattle portion contains twelve of them. In poetry, deer are a seasonal motif for autumn. Kōetsu responded to Sōtatsu's choice with poems appropriate to the imagery. The calligraphy is scattered in lines of irregular length in a relaxed and highly decorative *chirashi-gaki* style, one highly favored by Heian-period calligraphers and at which Kōetsu excelled. It is characteristic of the years of his peak powers, full of rhythmic grace and without any trace of the tremor that appears in the calligraphy of his later life. The flow and balance marking his mature style are evident throughout the length of the scroll.

It is tempting to see a story line in the scroll, much as the *Lotus Scroll* is thought to show the life cycle of the lotus from bud through blossom to

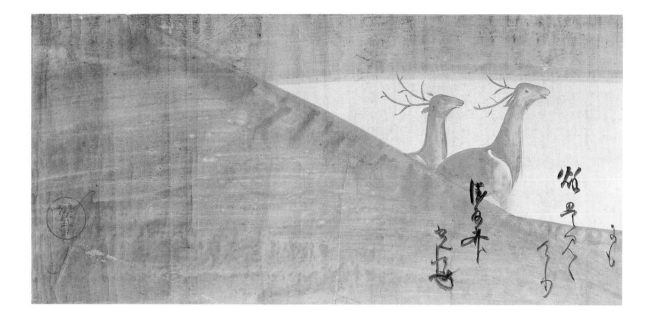

58. Seal and signature

its end. It has been suggested by some that the deer were shown in continuous narration with the same stag appearing variously in the pursuit of a doe, protecting his herd, and posing in triumph with his mate and their fawn.

Unlike other examples of early Kōetsu and Sōtatsu poem squares and handscrolls, where the calligraphy flows gently across the under-decoration, Kōetsu has contrived in the *Deer Scroll* almost completely to avoid writing on any of the deer. He has lengthened *kana* strokes boldly and varied the columns of characters in a playful dance among the images. For instance, in the opening passage of the Seattle scroll, his brush has extended a *kana* in a manner mimicking Sōtatsu's stroke defining the foreleg of the stag at the right. The two lines stop short of meeting, and across the tiny space between them an electric spark flashes to highlight the majestic stance of the stag. The mellifluous harmony of interaction of these artists in the *Deer Scroll* epitomizes Kōetsu's art of blending talents of others with his own to create transcendent works and to generate anew a traditional calligraphic beauty and poetic mood.

WJR

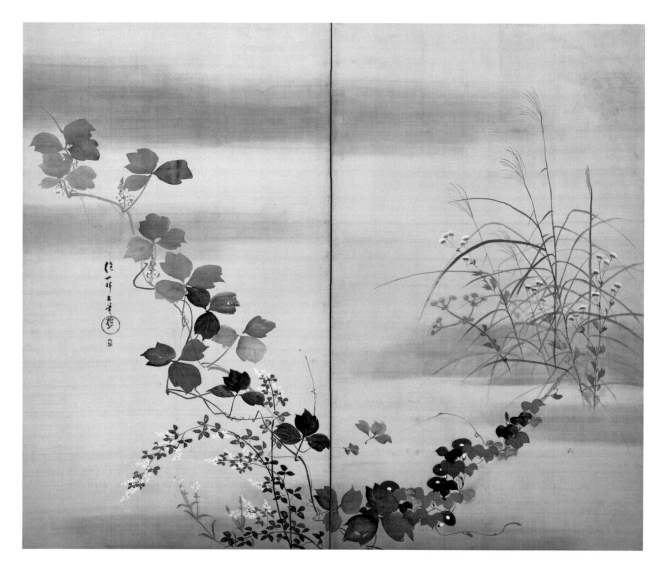

59.
Autumn Grasses (Aki no Nanakusa)
Sakai Hōitsu (1761–1828)
Edo period, early 19th century
Two-panel screen; ink, colors, and gold on silk
H. 56½″ (143.5 cm), W. 68½″ (174 cm)
Eugene Fuller Memorial Collection 72.17

Plants and flowers of the seasons play an important role in Japanese art. The most familiar are blossoming plum or cherry trees, indicating springtime, and chrysanthemums, indicating autumn. This two-panel folding screen (No. 59) shows a group of plants traditionally known as the seven grasses of autumn (*aki no nanakusa*). Dominating the composition are two of the most familiar — the Japanese pampas grass (*susuki*) at the right and the trailing arrowroot vine (*kuzu*) at the left. Others are (left) bush clover (*hagi*) and fringed pink (*nadeshiko*) and (right) agrimony (*fujibakama*) and patrinia (*ominaeshi*). Hōitsu was particularly attracted to flower and plant compositions, and often painted the autumn grasses theme. This alternate group, including the morning glory (*asa-gao*) rather than the more frequently encountered bell flower (*kikyō*), has a long tradition and allowed Hōitsu to vary the composition while not deviating from a recognized standard, and also offered opportunities to accommodate widely differing formats. Here the trailing vine of the morning glory is skillfully worked to tie together the foreground elements at the left and the more distant group at the right. Both the morning glory and the bell flower are a bright blue; therefore Hōitsu's decided interest in color could be satisfied by either plant.

Iris represent summer in depictions of the seasons; however, in this fan (No. 60), the reference is not so much seasonal as literary. The *Ise monogatari* (Tale of Ise) is a mid-tenth-century compilation of prose and poetry, much of it composed at an earlier date; the hero of many of the episodes and author of much of the poetry is the courtier Ariwara no Narihira (825–880). In one episode, as they travel in the province of Mikawa (modern eastern Aichi prefecture), Narihira and his group come upon a river famous for a profusion of *kakitsubata*, a native Japanese iris, blooming in the shallow waters beside a unique eight-part plank bridge. Awed by the sight of the masses of blooming iris, someone suggests the group prepare a poem on the theme "thoughts of a traveler" (*tabi no kokoro*), beginning each line with a syllable from the name of the iris, *ka-ki-tsu-ba-ta*. The resulting poem has been translated as follows:

I have a beloved wife
Familiar as the skirt
Of a well-worn robe,
And so this distant journeying
Fills my heart with grief.

The incident and the poem represent the Heian-period sense of poignant melancholy at parting. The journey symbolized the separation of lovers and loved ones, and had become so familiar to educated Japanese that it was not considered necessary to detail the depiction with figures; merely by describing the riverside with a plank bridge and iris, Hōitsu has called up the incident and the poem that it occasioned. The *yatsuhashi*, the eight-part bridge spanning the river, has given the name to this episode in the *Ise monogatari*.

Hōitsu was born the second son of the powerful Himeji clan, which ruled the area west of modern Kobe on the Inland Sea. Under the regulations of the Tokugawa shogunate, daimyo were obliged to keep large establishments in Edo, the capital, and it was there that Hōitsu was born. He grew up in a household frequented by artistic and cultured guests, taking advantage of the educational opportunities in the metropolis and thoroughly enjoying the cosmopolitan spirit of life in the capital. Education and artistic and cultural accomplishments, such as the tea ceremony and poetry, were important to the training of young men of Hōitsu's social class. Further, as a son of a daimyo family, Hōitsu naturally received training in the arts of the warrior. In addition, Hōitsu is specifically described as studying Nō theater, dance, and music. He studied with an eminent haiku teacher and also with the master of the *kyōka* comic verse, Ōta Nampo (1749–1823). Hōitsu was a friend and comrade of the renowned Confucianist and calligrapher Kameda Bōsai (1752–1826) and the preeminent artist Tani Bunchō (1763–1840), who like Hōitsu was born a samurai.

Initially Hōitsu took training in the Kanō school of painting, the artists formally endorsed by the shogunate and the appropriate school for a member of a daimyo family to study. Later he studied with the *ukiyo-e* artist Utagawa Toyoharu (1735–1814), a *nikuhitsu* artist of great skill who was noted as a colorist. Strong color in painting was also a major characteristic of the Nagasaki school artist Sō Shiseki (1712–1826) and his son, Shizan (1733–1805), whom Hōitsu also knew and studied with. A painting in the *ukiyo-e* manner dated 1785 is a rare early work which, even in its mixed character of elements of the Nagasaki school and of *ukiyo-e*, clearly indicates Hōitsu's penchant for precision and detail. Out of this welter of cosmopolitan influences, Hōitsu eventually selected as his model the modish and sophisticated Rimpa style perfected by Ogata Kōrin (1658–1716) a century earlier. It is suggested by some that the Sakai family

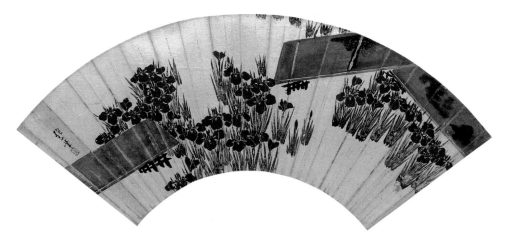

60.
Yatsuhashi
Sakai Hōitsu (1761–1828)
Edo period, early 19th century
Fan painting, color on gold-ground paper
H. 7" (17.8 cm), Chord 21⅝" (55 cm)
Eugene Fuller Memorial Collection 59.132

possessed works by Kōrin, resulting from his visit to Edo in 1707–1708, and that it was from his association with these paintings that Hōitsu grew fond of Kōrin's style and sought to bring attention to Kōrin's art. More certain is the record that Kōrin received a stipend from the Sakai household; it is not certain he ever received a commission. Whatever the source of his inspiration, Hōitsu formed a profound attachment to the style of Kōrin and turned away from all other styles in the pursuit of his own art. In 1797 Hōitsu became a priest of the Jōdo Shinshū sect, not out of any pious devotion, but out of a desire to escape the tedious formality and absorbing routine of life in the daimyo rank. By becoming a priest, he was free to engage in his personal interests without bringing undue attention to his activities or reproof from the shogunal authorities, who closely monitored the behavior of the daimyo.

Enamored of Kōrin's art, Hōitsu sought out existing sketches and preparatory drawings and conducted an exhibition of Kōrin's works. On the hundredth anniversary of Kōrin's death (1816), Hōitsu arranged publication of the seals and signatures of Kōrin and other artists of the school, and a book of one hundred of Kōrin's designs. Illustrated in the book of designs is a pair of screens with the *yatsuhashi* motif. A set of screens now in the collection of the Metropolitan Museum of Art, New York, is thought to be the same pair. The Seattle fan is related to this Kōrin composition not only in the orientation of the planks of the bridge and the clusters of iris in the usual iconography for this theme, but specifically in the use of an ink outline for each

iris petal. Hōitsu in his own compositions of iris usually preferred the "boneless" method, in which pigment is laid on without the aid of outlines. The unceremonious cutting of the leaves as they enter the undifferentiated water line also follows the decorative character of the Metropolitan screens. In relation to a pair of six-panel screens, the tiny format of the fan with its curving shape imposes distinct limitations, and the discontinuous line of the bridge in the fan suggests it was done to accommodate a wider display of iris in the smaller format. Hōitsu seems to have been reflecting Kōrin's manner very closely in this fan; the strong reliance on Kōrin's compositions and Hōitsu's rather tentative expression in works of the early part of his career, as Chizawa notes, might point to a time early in Hōitsu's career, soon after 1800.

The screen of autumn grasses shows Hōitsu's adaption of Rimpa techniques into his own style. Hōitsu, like Kōrin, featured in his designs the *tarashikomi* technique of dropping pigment or ink into damp areas to create texture and modeling. The freedom of composition and fluidity of expression possible through the boneless method contrasts with the rather stiff quality of the abbreviated iris stalks and leaves in the *yatsuhashi* theme with their repetitive blue blossoms. The shimmer of the silk, too, is characteristic of Hōitsu's use of high quality materials; as a man of wealth, he had no difficulty in procuring the best materials for his paintings. The brushed gold, which blends across the background, adds a modulated vibrancy characteristic of his mature works and contrasts with the opaque gold ground of the paper-fan face.

WJR

The art world of the Edo period witnessed the emergence of a number of new painting groups. From the popular *ukiyo-e* school, with its broad narrative often tinged with erotic associations, to the elegant and refined Rimpa there ranged a highly diverse spectrum of taste and expression in painting. Some artists, such as Ōkyo and Shijō painters, formed identifiable groups based on distinct artistic, sometimes family, lineages and master-pupil relationships. The art of the literati or scholar-painters, however, was more nearly a lifestyle pervading the artist's entire being, and the concept of individual expression central to their esthetic viewpoints makes it impossible to describe these painters as members of any coherent school. The earliest literati artists scarcely attracted followers, at least in any numbers, let alone close pupils, and it was not until the mid-eighteenth century that the style began to take definable form. One of the most important artists whose work contributed greatly to the identification of the literati style as a Japanese art form was Yosa Buson (1719–1784), born in Kema, a village on the Yodo River near Osaka. Little is written of his early life until, at about age twenty-two, he appeared in Edo as a student of a major haiku poet of the day, Hayano Hajin (1677–1742). After Hajin's death, Buson wandered the northern provinces for almost a decade, visiting with haiku enthusiasts and Hajin's former students. At one point, he retraced part of the route described in the poetic journal *Oku no hosomichi* (The Narrow Road to the Far North) by Matsuo Bashō (1644–1694), the supreme haiku master whose poetry Buson revered. Buson's poems appeared in publications during this ten-year pilgrimage; in 1744 he first used the Buson signature.

Buson seemed also to be experimenting with painting as an expressive medium during these years in the north, and a number of paintings of rather indifferent quality survive as a reminder of his visits and a testimony to his struggles as a fledgling painter. Settling temporarily in Kyoto in 1751, Buson continued publishing but in 1754 withdrew to Yosa in the west, an area said to be his mother's native home, where he worked at his painting studies. In 1757, he returned permanently to Kyoto.

As an artistic genius, Buson is honored equally as a painter and as a haiku poet. His poetry skills emerged first; during the decade of self-imposed exile in the north, he produced one of his earliest innovative poetry works, "Elegy to Hokujū Rosen." His skills in painting developed fully only relatively late in life. Scrolls and screens from the time in the north and during his years in Yosa show a welter of stylistic influences, including Chinese painting, often derived from Japanese adaptations, and literary and historical themes. He shared this particular influence with other painters of his age, for a knowledge of Chinese painting had become a matter of cultural importance during the early Edo period, in large part as a result of the Tokugawa government-fostered pursuit of Confucian studies.

In the past, Chinese painting had been adapted into various hereditary painting schools in Japan, but by the early eighteenth century a new emphasis on Chinese art and culture produced a fresh interest in continental painting, including more or less contemporary work, particularly in the tradition of the scholar-painter. This tradition, known in China as *wenren hua* and in Japan as *bunjin-ga* (literally: scholar's painting), was generally defined as the work of the amateur artist. In terms of Chinese art criticism of the late Ming dynasty, the *wenren hua* belonged to the Southern school of painting, or *nan zong hua* (Japanese: *nanga*). In theory, it had descended from the art of the Tang-dynasty painter Wang Wei, through the art of the Yuan-dynasty Four Great Masters (Huang Gongwang, Wu Zhen, Ni Can, and Wang Meng), to the Wu district painters of the Ming dynasty (Shen Zhou and Wen Zhengming), and continued into Buson's own time through the orthodox literati painters of the Qing dynasty. Ultimately, it was the latter-day Wu district artists of Suzhou whose work, through firsthand study or through woodblock illustrations, most affected the course of Buson's development as a painter.

In China, the Southern school was theoretically set in opposition to a Northern school, stereotyped as academic and typified by the Song-dynasty academy and followers in the Ming dynasty. These artists of the Ming dynasty were called the Zhe school after the Zhejiang area where many had lived, and their art was much in favor at the Chinese imperial court. A parallel existed in Edo-period Japan, where the officially favored Kanō school had developed since the fifteenth century from these very Northern school influences, and perhaps young artists, repelled or disappointed with contemporary Kanō school art, turned to the Chinese antithesis of academic painting—the amateur scholar-painter's art. The literati style, with its theoretical emphasis on individual expression, must have presented a very special appeal to young artists trapped in a segregated feudal society, and it was ultimately through the less strict practices and less

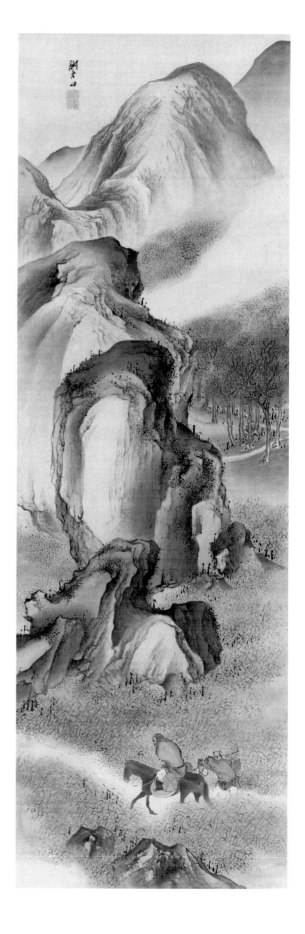

61.
Travelers in a Winter Landscape
Yosa Buson (1719–1784)
Edo period, c. 1778
Hanging scroll, ink and color on silk
H. 45⅜″ (115.3 cm), W. 17⅜″ (44 cm)
Purchased with funds from the estate of
 Mary Arrington Small 84.9
Plate on p. 80

nearly orthodox interpretations found in *nanga* — especially the art of the Suzhou artists — that Japanese artists like Buson found an avenue to reach esthetic respectability outside the tyranny of the Kanō school.

Two of the best-known pioneer practitioners of scholar-painting, Gion Nankai (1677–1751) and Yanagizawa Kien (1706–1758), were from samurai families. Other artists arose from among merchants and artisans, and a third early scholar-painter of note, Sakaki Hyakusen (1697–1752), came from the merchant or townsman class (*chōnin*). Born in Nagoya and probably of Chinese descent, Hyakusen moved as a young man to Kyoto where he studied painting and worked professionally, gaining special notice for his copying of Chinese paintings of the Ming and Qing dynasties. He also published lists of Chinese artists and their works, and otherwise made familiar the histories of Chinese painters.

A respected haiku poet, Hyakusen helped popularize the *haiga* — a haiku painting which in a summary gesture describes the essence of the brief poems. As an established older artist, Hyakusen considerably influenced Buson, already a trained and talented haiku poet who, newly arrived in Kyoto in 1751, was eager to find the appropriate mode for his painting. Direct contact between the two artists would have been brief because Hyakusen died in 1752. Buson in later years brought Hyaku-sen's *haiga* form into a perfected union of Japanese poetry, calligraphy, and pictorial image. Buson's poetic career, in fact, rivaled his stature as an influential and successful painter, and he was eventually acclaimed one of Japan's preeminent haiku poets, second only to Matsuo Bashō.

Inspiration for the scholar-painter derived from a variety of sources. Appreciation of Chinese paintings was a matter of course in the cultivation of the warrior-scholar; the educated among the merchant or professional classes with leisure time and disposable income sought cultural respectability through acquaintance with Chinese art. It was also thought important to view or possess Chinese paintings; while the number of available Chinese paintings increased during the early decades of the eighteenth century, people like Hyakusen found no shortage of admirers of their copies. A few Chinese artists who came to Japan were lionized in a manner well beyond what their talents would have evoked among a sophisticated audience at home. These artists were essentially restricted to Nagasaki, in an exception to the otherwise strictly enforced exclusionary policy of the Tokugawa government. Their presence eventually made Nagasaki a sort of artistic

mecca among literati artists, and a Nagasaki school grew up, comprising these artists and their students and amplified by priests of the Ōbaku sect.

Of more widespread inspiration were the series of woodblock-printed books on painting, which entered Japan from China during the late seventeenth and early eighteenth centuries. The *Bazhong huapu* (Eight Styles of Painting), published in the 1620s during the late Ming dynasty, reached Japan in the 1670s. The volumes that make up the book, known in Japan as *Hasshu gafu*, contained much information regarding Tang-dynasty poetry and painting, illustrations of works combining images and poetry, and depictions of flowers and plants, along with illustrations of landscape paintings from ancient to recent times. For the *bunjin*, the traditional themes of plum blossoms, bamboo, orchid, and chrysanthemum painting were of special interest. The mainstay of the scholar-painter since antiquity, these subjects combined the discipline of the brush in a pictorial rendering with what was considered a calligraphic statement revealing the writer's spiritual attainment.

The most important of these woodblock-printed books was the *Jieziyan huachuan* (Mustard Seed Garden Painting Manual; Japanese: *Kaishien gaden*). First published in China in 1679, it appeared in Japan only in the early eighteenth century. Certainly people like Gion Nankai and Yanagizawa Kien knew these books and derived much of their historical information from discussions in them. In addition to painting history and theory, the greatest impact of these books no doubt came from the carefully prepared sections on how to create Chinese-style paintings. A reprint produced in Japan in 1748 would have been available to artists like Buson. Other painters also made use of these manuals; their popularity remained strong well into the nineteenth century.

Literati painting in Japan was not just a transported copy of Chinese art, and the Japanese approach to it was somewhat at variance with the Chinese ideal. One fundamental difference was the cavalier attitude the Japanese took toward selling their art, something their Chinese colleagues would have roundly denounced. This radical departure from literati-painting protocols owed to the economic circumstances in which Japanese artists lived and worked; they often found themselves outside the strictures and support of the established social system, which left them no alternative. A younger contemporary of Buson, Ike Taiga (1723–1776), who like Buson rose to prominence among *bunjin* artists, established a fan shop while still in his teens

and painted fans himself. Commercially the shop was not a success, but Taiga did not hesitate to present himself as an artist purveying his art as a commercial product.

An analogue to the government-supported bureaucracy which comprised much of the scholar-painter class in China was potentially present in the Japanese feudal *han* or clan system, but in practice the feudal establishment regarded the *bunjin* lifestyle with little sympathy. The samurai scholar-painters Nankai and Kien both suffered mysterious periods of banishment and disfavor. Later conflicts between *han* authorities and artists among the feudal retainers provoked serious incidents in the lives of men like Uragami Gyokudō (1745–1820), Tanomura Chikuden (1777–1835) (No. 67), and Watanabe Kazan (1793–1841). The suggestion is strong that for many aspiring artists the life of the scholar-painter offered an unofficial compromise affording escape and a chance at upward mobility within the stratified Edo-period society. Some, perhaps many, led what might be termed today a counter-culture existence.

Japanese artists also were far more adventurous than their Chinese antecedents in choice of subject matter and models. Coming to literati traditions through diverse contacts, and removed from their sources at great distances of space and time, the Japanese could only imperfectly duplicate Chinese ideals; artists of the mid-eighteenth century found no trouble in adopting a highly eclectic approach, even accepting Japanese painting as inspiration. The willingness of these painters to break or bend rules and standards clearly set forth in any Chinese discussion of painting came, in part, because their interest was spurred as much by a desire to escape the tedium and superficial nature of the academic Kanō school as by any devotion to a specific foreign art style.

Chinese sources, however, remained the most important impetus in their training. Buson had clearly taken Chinese landscape and figure painting as a challenge in shaping a style and point of view in the mastering of techniques. During the years following his return to Kyoto in 1757, his studies brought him ever closer to that mastery. A cycle of paintings during the 1760s and 1770s chronicles his increasing control and power to manipulate at will the Chinese mode. The depth of this inspiration and preoccupation is exemplified in the pair of albums of paintings created jointly in 1771 by Buson and Taiga and based on a poem by the Qing scholar Li Yu (1611–1680?). (Li Yu owned the villa named "The Mustard Seed Garden"

that gave the painting manual volumes their title, and for which he supplied a scholarly foreword.) An imaginative interpretation, the Buson-Taiga work is entitled *Jūben jūgi* (The Ten Conveniences and the Ten Pleasures); Buson painted the ten pleasures. The albums brought together the two eighteenth-century artists credited with assimilating the *nanga* movement into a uniquely Japanese expression; moreover the albums symbolize a culmination in the initial stages of *bunjin-ga* development, in which the adopted esthetic had been sufficiently absorbed so that Japanese artists could confidently make independent interpretations and achieve them with accomplished mastery.

The Seattle landscape by Buson belongs to this cycle of paintings. In them he sought to capture the monumental landscape style with its built-up forms and multiplicity of textures and atmospheric effects. The painting represents, in a way, a diploma piece demonstrating Buson's mastery of techniques, ranging from the description in brush and ink of massive, solid rock cliffs that rise convincingly to meet the bands of wraithlike mist or fog which enfold them. His skill with the brush is evident in the grove of trees and the ground cover, which are built up of myriad individual, precise brushstrokes and dots. In the low rock grouping in the foreground, Buson revels in ink play, presenting a smooth but firm texture and depicting the surrounding grasses with incisive clarity.

The handling of the figures is highly representative of Buson's style of the late 1770s. The hunched rider and his attendant echo the shapes of which the landscape itself is constructed. The horse plodding along the pathway lulls the rider into a half-doze; the attendant engages the viewer directly in an almost comically irreverent gesture much used by Buson.

Buson's early mature style, already suggested in the pages he did for the *Jūben jūgi*, reflected the romantic lyricism of his poetry, and his paintings often show intimate glimpses of nature rendered in a lighthearted way. It does not seem exceptional to find in poetry references to the scent of blossoms and scattered petals, the cry of birds or deer; Buson used them all with superb skill. Moreover, he was able to mold into masterful haiku form such unlikely themes as a pan brought to a boil, a man washing his feet, or even bird droppings. He speaks sensitively of the quivering summer atmosphere against a shoji, and the halo around the moon; all manifestations of light fascinated Buson. His poetry indicates his interest in sound, in such references as the distinctive cracking of bamboo under the

61. Seal and signature

weight of snow, and other aural effects. Buson's paintings similarly reflect this ability to express the ordinary in extraordinary ways. As in many of his paintings, he has abandoned here the standard motif of a scholar posed amid the vastness of nature in favor of anonymous, classless travelers, possibly Japanese, set against the exotic monumental Chinese landscape. This conscious manipulation suggests his recognition, or perhaps unconscious desire, to escape the tutelage of a foreign style. He later rejected the grand style in his perfecting of it and, while accepting the discipline, transmuted it in his last years into a tool through which he expressed a truly native sensibility.

The Seattle scroll is not dated; however, a relative dating emerges from stylistic similarities and the appearance of the same seals on a number of dated scrolls and albums from the 1770s. A close parallel exists in Buson's scroll dated 1779, *Solitary Deer in a Deserted Winter Forest*, in the Idemitsu Museum of Arts, Tokyo. This was the time in Buson's development when he had reached the artistic equilibrium of his mature period, that state of grace when the artist had control at all levels, and art flowed seemingly without cognitive deliberation. For Buson this time is marked by a new art name (*gō*), Sha-in. He assumed this name in 1778, and with it he signed the Idemitsu scroll. The Seattle painting seems poised on the brink of the Sha-in phase, and his use in the Seattle scroll of another new signature, Sharō-zan — known only on a few paintings and probably not used later — suggests a transitional period in which he sought a new name to reflect this new phase in his art. The upper seal reads *Sha-chō-kō*, and the lower seal reads *Shun-sei (no) in*.

WJR

62.
Landscape Scene of Mountains and Lake
Ki Baitei (1734–1810)
Edo period, 1780s
Pair of two-panel screens, ink and slight color on paper
Each screen: H. 67¾″ (172.1 cm), W. 72″ (182.9 cm)
Gift of Cheney Cowles in memory of his mother,
 Sarah Ferris Fuller 76.17

Many young men were attracted to the study of poetry and painting under Buson's tutelage. Perhaps the most important of them, in terms of carrying forward the *nanga* painting tradition Buson helped establish, was Ki Baitei (1734–1810). The two examples of his paintings included here represent opposite ends of the wide range of his oeuvre. The *fusuma* (No. 62), now mounted as a pair of folding screens, strongly reflect some aspects of Buson's work, while the handling of the plum branch painting (No. 63) reveals Baitei's personal energy.

Baitei's life and the chronology of his artistic development will perhaps always be somewhat clouded. His exact place of birth is not recorded in reliable biographies, and no records exist to establish even the approximate date he joined the group surrounding Buson, but his earliest known dated painting is from 1778. The exact date and circumstances surrounding Baitei's departure from Kyoto are just as unclear as so many other details of this prolific artist's history. What is clear is that he left Kyoto to reside in Ōtsu on Lake Biwa, and it is believed he was already living there when, in 1783, he was summoned to be with Buson during his final illness. Baitei and another Buson pupil, Matsumura Goshun (1752–1811), agreed to look after Buson's affairs upon his death; they assembled scraps of his calligraphy and poem drafts into salable works in an effort to improve the financial situation of Buson's widow and divorced daughter, who was living at home.

The Seattle screens by Baitei bear themes easy to associate with Buson's work, especially those of the earlier period. They contain suggestions of a set of *fusuma* stylistically dated to about 1770 at Jishō-ji, the Kyoto temple better known as the Ginkaku-ji (Silver Pavilion). The three rooms of *fusuma* paintings by Buson at the temple represent perhaps the single largest commission of his career, and as other rooms at Jishō-ji have paintings by Ike Taiga, his collaborator on the celebrated *Jūben jūgi* albums of 1771, it can be safely assumed these Jishō-ji paintings were well known. This traditional literati style of sober landscape rendered in ink tones with little color and almost no action was a theme not often undertaken by Buson, but the individual elements of brushstroke delineating mountain forms, the underbrush, and distant trees, along with the figure gazing at the viewer, are all elements frequently encountered in Buson's more varied compositions.

Baitei's ropey, languid brushstrokes defining the texture and structure of the rock faces and the soft tonality of the ink resemble works by Buson, and the tranquil setting clearly suggests Buson's artistic vision. The solitary boatman quietly propels his craft into calm waters; the passenger has turned to engage the viewer directly, and an idyllic mood pervades the scene. In the accompanying screen, a traveler on foot, perhaps a wood-gatherer, is equally self-absorbed; he seems to pause to straighten his back, as if searching out likely caches of firewood. These are all typical of Buson's own view of traditional Chinese literati landscapes, and also suggest his strong interest in the familiar and easily identified imagery of his own poetry and painting.

More personally Baitei-like, and one of his favorite landscape conventions, is the placement of a figure at center foreground within a cell of space generated by overhanging forms; this composition sometimes is combined with a tree behind which the subject is partially obscured. In some paintings the overhanging form takes on a sinister appearance, suggesting a potential for danger. The *fusuma* format, seldom undertaken by literati painters, was first attempted by Hyakusen in 1748; however, with few exceptions, *bunjin* artists seemed more intrigued by other, more intimate formats. *Fusuma* decorative schemes represent the most expensive format for commissions, and without the regular patronage of Buddhist temples or the ruling class, it might owe simply to economics that few literati *fusuma* are known.

The Seattle screens are undated; however, a seal impressed at the lower right of the right-hand screen reads *Baitei*, in the same characters as a seal found on a hanging scroll dated 1788. The screens probably date from Baitei's years in Ōtsu, and he might well have been consciously recalling the Jishō-ji *fusuma* executed by Buson. He was well known as a student of Buson, and commissions such as these *fusuma* surely would have helped build the reputation that led to his gaining the sobriquet "Ōmi Buson."

In contrast to the low-key solitude of Baitei's screens is his painting of a branch of plum blossoms. This scroll represents the less restrained side of his personality — the Baitei whose dynamic brushwork shifts the world on its axis, shattering all clichés, emphasizing energy and expressiveness. His power of brush is nowhere better expressed than in the branch that rises abruptly, almost lunging into the cold night sky. In dramatic works such as these there is at times more than a hint of peril; here, the boldly modulated, lowering sky seems to threaten. The jagged forms of the branch dominate the composition, which is thrust flat against the painting surface — the plum blossoms, presumably the thematic subject, almost lost in their tight bud forms.

In a reflection of Buson's interest in the effects of light, Baitei, too, shows the branch laden with snow, which seems to shine against the black of the branch and under the pulsing washes of the sky. Reversing the method of a sculptor who reveals form by removing surrounding mass, Baitei has modeled his snow by filling in and surrounding the whiteness of the paper with ink tones of deep black to grey. Buson frequently used a similar method of modeling to create positive images out of negative spaces with washes and revealed paper or silk. The heavy snow tells the viewer it is still the depth of winter; yet the assurance of renewal and growth, symbolized by the ancient theme of a blossoming plum branch, is here given new interpretation and a stinging visual impact.

A second artist often connected by tradition to Buson was Yokoi Kinkoku (1761–1832). In contrast to Baitei's close relationship with Buson, no evidence exists that Buson and the much younger Kinkoku ever met. Rather, Buson's influence reached Kinkoku through their common interests in literati painting, haiku, and *haiga*.

Kinkoku's boisterously personal painting could not be confused with Buson's lyrical romanticism, yet a tinge of Buson's style and compositional phrasing rises from Kinkoku's works. His absorbing appreciation of Buson was manifested through direct and faithful copies of Buson's work, some of which survive. These are not necessarily literal imitations, but studies or exercises in composition and brushwork; even the closest version reveals Kinkoku's inimitable surging brush, charged with an urgency suggesting a passion born of religious fervor. Further, reports of his autobiography suggest that, aside from his appreciation of Buson, Kinkoku's personality, exceptional intelligence, and natural inquisitiveness propelled him into spheres of activity too varied to permit a single artistic stereotype.

A child of devout parents, Kinkoku was strongly influenced by his religious training. At age nine he had already been sent to prepare for the Buddhist priesthood; however, he was later expelled. After a rambunctious few years of mischievous adventures, he returned to the clerical life and eventually became the chief priest at a temple on Mount Kinkoku near Kyoto, a place-name from which he took his most familiar art pseudonym. Not entirely satisfied with the life of a conventional priest, he later entered the esoteric and mystical Shugendō sect.

63.
Plum Branch in Snow
Ki Baitei (1734–1810)
Edo period, c. 1800
Hanging scroll, ink on paper
H. 50¾" (129 cm), W. 20¾" (53 cm)
Margaret E. Fuller Purchase Fund 74.19

Kinkoku, given to wide swings of behavior ranging from hedonistic abandon to solitary ascetic austerities, perhaps found the degree of commitment demanded by Shugendō and the fervor of the initiated sympathetic to his paradoxical nature.

In Shugendō belief, magical powers accrue through the ritual ascent of high peaks, a feature in keeping with Kinkoku's restless spirit. It combined with his love of landscape painting to create a unique painting style. Kinkoku was an exhaustively prolific painter, and like his extremes of personality, his style could vary from meticulously constructed depictions of the mountain journey of the Tang-dynasty emperor Minghuang to explosive renderings of rain or snow storms.

The Seattle landscape (No. 64) exhibits much of the solidity and poised balance Kinkoku was capable of achieving, but certain elements also relate to his more dynamic mode. Compositionally, high mountains form a solid backdrop sheltering and enclosing the lakeshore setting of the scholar's retreat. A logical recession of landforms moves from the foreground cottage to the distant mountains. The large projecting rock and tree, lower left, like the mountain masses behind, still hold together as identifiable forms. The forms are only mildly agitated; yet the furred and fringed bristling foliage ascending the branches suggests strongly the trees of later paintings, which burst in a spontaneous combustion of frenzied brushwork. In extreme instances, Kinkoku's trees seem almost to shatter into bits and pieces. The partially concentric and overlapping double and triple outlines of rock and land forms blur the integrity of the form in a manner suggesting a design to animate the solid forms they describe. This technique was used by Buson, Baitei, and others, and it became a major element in Kinkoku's style.

Like Buson and to some extent Baitei, Kinkoku pursued the effects of light in his painting, frequently featuring a moonlit scene or spattering white pigment to capture the bright purity of falling snow. In this painting, the rosy glow would suggest a sunrise scene, but one very different from Buson's warm and affectionate version in the *Jūben jūgi*. Buson had purposely replaced the hermit-scholar of Chinese literati painting with peasant figures frequently at work or in motion, and it is perhaps indicative of the renewed awareness of Chinese painting in the late eighteenth century that Kinkoku has re-introduced the isolated, perhaps alienated, scholar into his landscape.

WJR

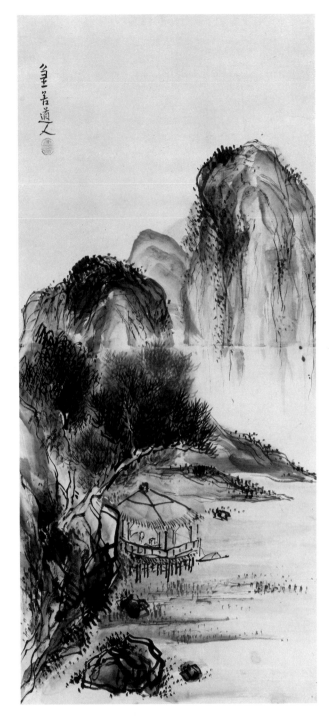

64.
Sage in a Rose Pavilion
Yokoi Kinkoku (1761–1832)
Edo period, c. 1825–1830
Hanging scroll, ink and color on paper
H. 49⅝″ (126 cm), W. 22¼″ (56.5 cm)
Floyd A. Naramore Memorial Purchase Fund 75.37

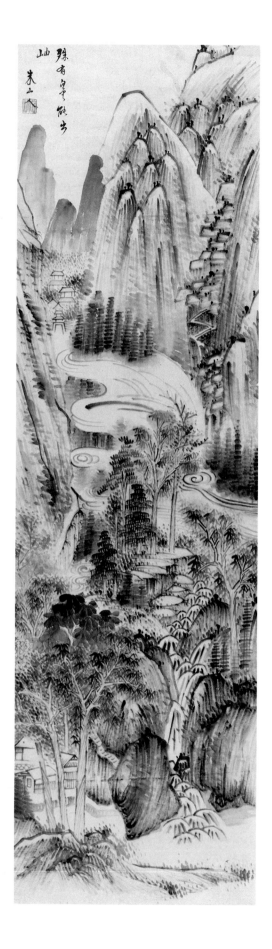

65.
Mountain Landscape
Okada Beisanjin (1744–1820)
Edo period, early 19th century
Hanging scroll, ink and light color on paper
H. 52″ (132.1 cm), W. 15⅛″ (38.4 cm)
Eugene Fuller Memorial Collection 65.21

A major *nanga* artist somewhat younger than Taiga and Buson, Okada Beisanjin (1744–1820) belonged to the self-taught, independent townsman class of artists. Accounts vary as to Beisanjin's place of birth and family history, especially concerning his relationship to the Tōdō clan and their rice warehouses. Some sources list Beisanjin as the son of a rice merchant family, and judging from what is known of Beisanjin's adult life, it seems very possibly correct.

All accounts seem to agree that Beisanjin grew up with a fondness for scholarly study and eventually served the daimyo of Tsu, a powerful lord of the Tōdō clan. He resided in the *han* (clan) establishment in Osaka, probably as overseer for the rice warehouses, and seems eventually to have established himself as an independent rice dealer. In the late eighteenth century, Osaka was the principal rice exchange of the country, an economically prosperous and artistically bustling metropolis; rice, the source of daimyo wealth, was a critical commodity in feudal economics. Further, daimyo were prohibited from residing within Osaka by order of the *bakufu*, the military government; therefore, Beisanjin's position might have been as a trusted overseer for the Tōdō *han* rather than in direct connection with the sale or preparation of rice.

Kimura Kenkadō (1736–1802), son of a wealthy sake-brewing family, set the tone for literati society in Osaka. A scholar and amateur artist, he opened an art goods shop that he operated as a literati salon, and traveling *bunjin* artists always found a warm welcome there. Beisanjin, too, apparently opened his home to these literary and scholarly men. Perhaps this experience and contact led him, at approximately age fifty, to abandon active life and take up the quiet existence of scholar-painter and poet.

Kyoto had been the main center of *nanga* painting during the lifetimes of Taiga and Buson. By late in the eighteenth century, the literati movement had spread more widely, and cities like Osaka, Nagoya, Edo, and Nagasaki began to figure prominently in the biographies of *bunjin* artists, who moved about the country with an ease surprising in a feudal society. The fact that the monied merchant class essentially ruled daily life in Osaka might have moderated the intellectual climate and improved the social ambience for these literati, in contrast to other cities. Certainly the hospitality of people like Kenkadō and Beisanjin helped to keep Osaka on every artist's itinerary. Tanomura

Chikuden (No. 67) often visited with them on his frequent trips to the Kyoto-Osaka area, and Uragami Gyokudō and Shunkin, his son, were also distinguished guests.

In the late eighteenth century, new influences guided development of *bunjin-ga*. Knowledge of Chinese painting had progressed well beyond the stage of woodblock-printed painting manuals and handpainted copies, which had influenced earlier Japanese artists so strongly. Now painters traveled frequently to Nagasaki to visit Chinese residents there, to see paintings firsthand and to discuss with others the special character of Chinese painting. The wealthy Kenkadō and other *bunjin* patrons built collections of Chinese paintings, and Japanese artists became increasingly conversant with Chinese painting styles and traditions. Beisanjin was even able to indulge in a rather sophisticated pun in creating his art name. "Beisanjin" can be interpreted as referring to the "rice-mountain-man" or "rice hermit," and at the same time alludes to the Song-dynasty painter Mi Fu (1051–1107), whose style Beisanjin admired and often adapted; the so-called Mi-dot of horizontal brushstroking creates landscape in a rather pointillistic manner.

The Seattle landscape (No. 65) is typical of Beisanjin's thoroughly conscientious restatement of recognizable Chinese painters' styles of the Song and Yuan dynasties. Here, rather than the Mi Fu style, he has adapted elements suggesting Huang Gongwong, whose style he is also reported to have studied. It is possible to view the style as a fanciful version of the earlier painter Juran. The paintings of these early artists are very rare today, and were probably no less rare nor any more available in the early nineteenth century in Japan; however, the traditions were still viable among Chinese painters and were available through Chinese versions of varying date and, of course, through reproductions. In this work, the long "hemp-fiber" stroke for mountain forms, the barren geometric spaces defining series of rock ledges and eroded plateaus, and the clusters of enfolded hilltops crowding around the major peaks are elements derived from Chinese sources.

Beisanjin's well-thought-out landscapes, executed with bold and distinct brushwork, seem, in light of later developments, a bit naive or provincial in their subjectivity. While landscapes were his primary interest in painting, he presented humorous versions of famous literary and historical persons and themes. He was no less candidly witty

when painting his own likeness—drunken, with a silly grin, slowly disappearing beneath his writing table.

In the manner of mainstream Chinese scholar painting, Beisanjin was preoccupied technically with brushwork and ink play. He concentrated on generating a linear splendor which, as in the Seattle scroll, often nearly filled the entire painting surface and receded only slightly from it. The differentiation of landscape forms seemed of less importance than the flowing rhythm of the brush. Where artists like Buson fussed to express atmospherically the evanescent enveloping mists, Beisanjin's penchant for linearity led him to reveal the mists or fogs outlined in ink on uncolored paper, the flow set forth as brushstrokes coursing across the painting and threading from middle ground into the distance disappear into a canyon. Further, a series of cascades rising in the middle foreground and ending near the bottom of the painting are only slightly differentiated from the enfolded hilltops.

The inscription describes the scene of a misty mountain fastness. The signature is very similar to one on a painting dated 1793; however, stylistically this painting comes from a somewhat later date. The seal reads simply *Beisan*. A duplicate painting, probably a copy, is dated in inscription to 1812, a date consistent with the stylistic evidence, and it might be assumed this is a probable date for this painting.

The lives and art of Beisanjin and Okada Hankō (1782–1846), his son and pupil, bridge a crucial period in the development of *nanga* painting in Japan. They link the era of the self-taught, individualistic scholar-artist with a new age of sophisticated taste in Chinese art. This new age of literati painting occurred during the Bunka and Bunsei eras (1808–1830), a time that witnessed the final profound artistic outpouring of the Edo period.

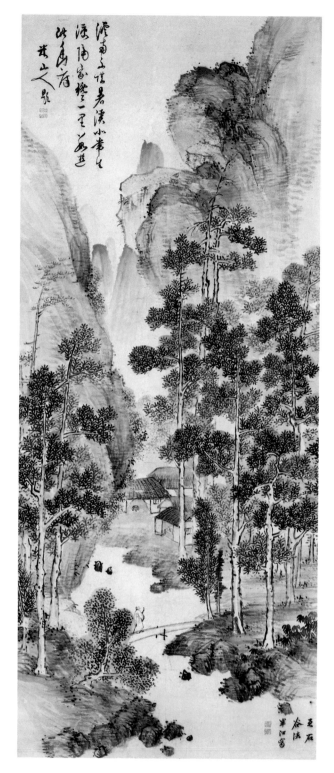

66.
Landscape with Solitary Scholar
Okada Hankō (1782–1846)
Edo period, c. 1810
Hanging scroll, ink and light color on paper
H. 50⅞" (129.1 cm), W. 21¼" (54 cm)
Floyd A. Naramore Memorial Purchase Fund 74.72

At the end of the eighteenth century, Beisanjin still felt free to amuse himself with paintings, as his friend Gyokudō and earlier artists such as Taiga and Buson had done, and to develop a highly personal style, bending the traditions to his convenience and pleasure. But even then, Beisanjin possessed an understanding of Chinese painting that prompted him to adopt masters of the Chinese *nanga* tradition as avowed models and create a style evoking those artists' styles. He willingly accepted the landscape genre of the past and focused on the beauties of brush and ink rather more than on form.

Beisanjin's son Hankō, and his contemporaries such as Tanomura Chikuden (No. 67), Nakabayashi Chikutō (No. 68), and Yamamoto Baiitsu (1783–1856), surpassed earlier generations in accurately absorbing Chinese art and philosophy. After Beisanjin's day, an orthodoxy appeared among the sophisticated crowd surrounding the renowned Confucian scholar and historian in Kyoto, Rai Sanyō (1780–1832), which Hankō aspired to join. A new generation of artistic conservatives, these artists of the new knowledge sought to capture in their own art the pure and essential spirit of lofty idealism that had guided the ancients. The emphasis was on authenticity in brushwork and form. This new understanding proved a mixed blessing, and in the hands of an artist such as Hankō, whose training at his father's side no doubt tempered his outlook, or geniuses like Chikuden or Watanabe Kazan (1793–1841), the effects were probably marginally inhibiting.

Hankō was born in Osaka and grew up surrounded by the world of the literati, his father's friends. Well versed in Confucian studies, like his father he served Lord Tōdō as a Confucian teacher. He retired in 1822 and made his home on the outskirts of Osaka. His poetry and calligraphy gained him a fine reputation, but he perhaps is best known for his towering, humid landscapes that breathe a moist luxuriance. The inscriptions he added to his paintings were suitably erudite. In the painting here, at lower right, he wrote that he was following the style of Wang Hui (1623–1717). The impact of the painting seems more like Cha Shibiao (1615–1698) or some other seventeenth-century artist; nevertheless, Hankō consciously strived to choose a later literati model and perhaps only coincidentally named one of the most versatile of the Qing-dynasty orthodox literati painters.

The present painting (No. 66) lies outside the moisture-laden landscapes often associated with Hankō's later style. Here the air is light and breezy, the brushwork springy and crisp, suggesting this is a work from the time before Hankō had established his mature style. The painting, however, is thoroughly accomplished, and the handsome composition is equaled by the superb brushwork and delicately balanced coloring. Hankō's skill in generating the rocky textures along the water's edge in the foreground is neatly expanded in a complementing space at the top of the scroll, while a series of masterfully structured trees rises almost the full height of the picture. A rock and cliff extend from the left, partially blocking the view of a group of cottages in the middle ground, the probable destination of the solitary traveler crossing the footbridge. Hankō has made use of the horizontal Mi-dot stroke to create a patterned texture appropriate to the prominent massing of the leaf forms of the trees. He gently balances the composition with strategic open areas in the stream, the mountain form, and the sky.

The long inscription in the upper left is by Beisanjin. It is a Tang-style poem of five-character lines of Beisanjin's composing. Hankō's seals read *Shuku (no) in* and *Hankō.*

WJR

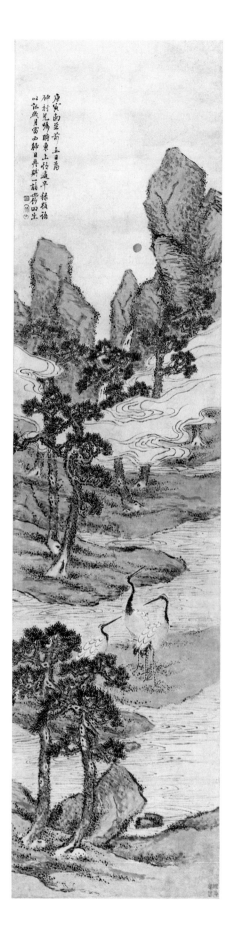

67.
Cranes at Play under Pines
Tanomura Chikuden (1777–1835)
Edo period, dated 1830
Hanging scroll, ink and color on paper
H. 49½″ (125.7 cm), W. 12⅛″ (31 cm)
Margaret E. Fuller Purchase Fund 74.20

One of the most important artists in all of Japanese literati painting, Tanomura Chikuden adopted the life of a scholar, poet, and painter only in his middle years, somewhat as had his elder contemporary Beisanjin. Unlike Beisanjin's personal history, events in Chikuden's life are well known, in part because he was a member of the bureaucratic feudal administration of a fief in northern Kyushu. His family had for many years served as physicians to the lords Nakagawa of the Oka *han* (clan), who ruled in what is modern Ōita prefecture. Further, Chikuden was a prolific writer and left many essays and works of art criticism. An academic prodigy, he seemed destined to succeed his father as clan physician; however, he was allowed at age twenty-two to abandon medicine in favor of a broader scholarly role teaching Confucian studies. One of his first duties in his new position was to assemble a massive record of events in the province.

The fashion for *bunjin* taste was spreading increasingly as Chikuden was growing up, and the proximity of his home in northern Kyushu to Nagasaki, with its long association with Chinese visitors, particularly the artists and their Japanese students, no doubt quickened his interest in the arts. Even as a young man, he worked to emulate Chinese painting styles with his local teachers. As evidence of this currency in literati thought, at least two poetry and painting groups are recorded in Chikuden's home area, and he was a member of both.

The year 1811 saw peasant uprisings to protest wretched conditions in the fief. In that year, Chikuden encountered an unresolvable conflict with feudal authorities over his plan for *han* reform and relief for the peasants. After his plan was rejected a second time during an outbreak of disturbances in 1812, Chikuden requested and was granted permission to retire from *han* service.

Travel was a constant element in the lives of many literati. There was surprisingly rapid communication, considering the nature of feudal society and notwithstanding the fact that transport was for the most part on foot or by boat. The frequent boats and well-traveled footpaths between Osaka and Kyoto made it possible to know of events in one city almost immediately in the other. The Inland Sea, much like the Mediterranean in Western culture, provided a commercial and communication link between urban centers like Osaka and the provincial areas; moreover, a regular shipping service connected Chikuden's home area with Osaka, and he soon became a regular visitor there and in Kyoto.

One of Chikuden's most renowned works of his later life is a small album, entitled *Views from a Ship's Window* (1829), of paintings of scenes along this route.

Before his withdrawal from *han* administration, Chikuden already had taken opportunities to travel to Kyoto for study with prominent scholars. In 1801, on the occasion of a trip to Edo, he chose to visit Kimura Kenkadō in Osaka, where he examined Ming-dynasty paintings in Kenkadō's private collection. Chikuden later visited Ki Baitei at Ōtsu in Ōmi province, and in Edo he saw Tani Bunchō, one of the preeminent painters of the time. In 1811 on a trip to Kyoto, he first met Rai Sanyō, the doyen of Confucian studies and chief guardian of literati painting orthodoxy. The two became lifelong friends, and it is possible their meeting influenced Chikuden's decision to retire in 1812 and seek his own place in literati circles. By this time, Chikuden already counted among his friends people such as the painters Aoki Mokubei (1768–1833), Uragami Gyokudō and his son Shunkin, Okada Beisanjin and his son Hankō (Nos. 65, 66), and the historian, poet, and author Ueda Akinari (1734–1809).

Chikuden had absorbed a profound understanding of Chinese painting. His earliest works already indicated his awareness of Chinese artists such as Shen Zhou (1427–1509) or their latter-day imitators; however, Chikuden went to Nagasaki in 1826, where he spent most of the year examining Chinese paintings and discussing theories and techniques with Chinese artists and their sinified students. This experience confirmed in Chikuden's painting a new element that derived from the strong color and detailed compositions of the Chinese painter Shen Nanpin (Shen Chuan, act. c. 1725–1780; Japanese: Chin Nampin), who had lived in Nagasaki from 1731 to 1733, and whose influence remained strong through his students. Nanpin's own colorful style derived from realistic Ming-dynasty bird and flower paintings, and he attracted students and imitators, who collectively became known as the Nagasaki school. Out of this tradition, Chikuden adapted the realistic detail and rendering in bright colors into a mode of massive works that technically are bird and flower compositions, but whose power and sheer overwhelming size move them out of the ordinary realm of this genre.

To some extent, Chikuden worked in traditional literati ink landscape modes with "hemp-fiber" strokes in the manner of Huang Gongwang (1269–1354), but he seemed to prefer more delicate

brushwork and soft, cool colors for his landscape paintings, whether album or large hanging-scroll formats. The grand-scale format of folding screen and sliding doors seems to have been of only limited interest to him. Specific Chinese models are difficult to identify for Chikuden's mature landscape style, which blended many elements to perfect his expression. Cahill notes possible Yangzhou school influences; others closer to home, in addition to the Shen Nanpin techniques, included touches of the school of painting associated with the Chinese monks of the Ōbaku sect.

This sect had arrived from Fujian, southern China, in the early Edo period and constituted an officially sanctioned Chinese cultural enclave amid an otherwise thoroughly xenophobic feudal system. Major Ōbaku temples were built first at Nagasaki and then at Uji, not far from Kyoto; therefore, from the time of the earliest *nanga* pioneers, the Japanese literati artists had opportunities for exposure to influences which, though artistically rather meager, were exotically inspiring. The Ōbaku priests introduced various cultural influences, including the pervasive fashion for *sencha*, a ritual tea ceremony using very strong steeped tea, the tea the ancients drink in Chinese paintings. By the early nineteenth century *sencha* was solidly identified as the *bunjin* tea ceremony. With it, of course, came a need for all the necessary equipment and dishes. Chikuden's literati friend and noted painter, Aoki Mokubei, was first renowned for his ceramic art, much of it designed for this *bunjin* tea ceremony.

In another departure from traditional literati painting, Chikuden was given to recording contemporary scenes, populating them with appealing Japanese figures. These sympathetic observations of nature and daily life are an intimate view of life outside the scholar's idealized world. Perhaps even Chikuden, in many ways a paradigm of literati lifestyle, wearied of a constant diet of communing with the ancients and felt an urge to bring into his art something more relevant to his actual life. To be sure, the glimpses into daily life were suitably idealized to remove any unsightly elements.

Chikuden's large-scale hanging-scroll landscapes represent the mainstream of his late painting. These paintings, from the years subsequent to the artist's visit to Nagasaki, reach a level of artistic skill and esthetic expression that, in many respects,

perfectly reveal the scholarly and poetic ideals of the literati tradition. Many of these late paintings focus on the theme of scholars in idyllic landscapes. Both the crane and the pine are ancient and potent symbols long associated with the scholar. They represent a lofty spirit and personal integrity, a wish for longevity and enduring truth. The Seattle scroll of cranes under a group of pine trees belongs to this series of late paintings.

Compositionally the painting recedes in a manner typical of Chikuden's landscapes, with a tall, rather narrow format borrowed from contemporary Chinese taste, the rising ground plane merging into high, distant peaks. The series of pine trees serves several functions, a technique Chikuden favored. They mark the distances of foreground and middle ground and surround and shape the space the birds inhabit. Further, the motif of clustered pine needles generates repeated patterns which move across the picture plane, carrying the viewer's eye upward, ultimately to the sun bracketed by the distant peaks. The presence of the red sun, not usually a part of Japanese landscape painting of any school, suggests an intentional iconographic reference that points most strongly to the theme of fabled Mount Hōrai (see No. 69). This was the island of immortality located off the coast of China and inhabited by Immortals, those transcendent beings who shared their world with cranes, tortoises, and stags, the symbols of longevity. Many auspicious plants flourished there, including the pine. A specific theme is not established in the inscription, but the presence of these other elements, particularly the sun, suggests it was intended at least to evoke that association in the viewer. Chikuden wrote that he was rushing to leave for a trip and had no time to add an appropriate inscription. He intended, he said, to add one after returning, or at least at some time in the future. He reserved a large open space to accommodate it; however, he obviously never fulfilled his friend's request for a poem. The painting is dated by inscription to the year 1830.

The calligraphy is brushed in the wiry, precisely formed style Chikuden often used. The signature reads simply *Chikuden-sei*. The seals *Ken-in* and *Chikuden* are among those he most frequently used in the late part of his life. In the lower right corner is a seal which reads *Shin-sen Fū-do*.

WJR

Okada Beisanjin's career as a *bunjin* artist can be seen as marking the end of the phase of *nanga* painting begun with Ike Taiga and Yosa Buson in the mid-eighteenth century. It may also be considered as marking the opening of a second *bunjin-ga* phase characterized by increased contact with actual Chinese paintings and an accurate knowledge of both history and technique. Tanomura Chikuden (No. 67), one of the principal artists working within the esthetic of this second major phase and a younger friend of Okada Beisanjin, represents the generation that built brilliantly on the increased contact yet were not fully willing, merely for the sake of orthodoxy, to reject new inspiration from among artists outside literati painting. Another important artist of the same time, though he lived much longer than Chikuden and was temperamentally very different from him, was Nakabayashi Chikutō (1776–1853).

Reflecting the new wave of intellectualism in *bunjin* painting, Chikuden and Chikutō were accomplished at art historical criticism, and, along with their many paintings, both left publications that were important monuments of Edo-period art criticism and scholarship. More than Chikuden, however, Chikutō seemed preoccupied with concepts of orthodoxy and accuracy in translating literati art from the past to the present. He seemed to dismiss the art of Taiga and Buson. Beisanjin's imaginative renderings and Gyokudō's fantasies, too, were beneath consideration to this new generation of literati painters, whose superior knowledge bred a zeal that, taken at face value, approached a condescending smugness.

Convinced of his correctness, Chikutō painted purposely subdued, repetitive ink landscapes — sometimes with washes of blue and pale ochre color — in the belief he was expressing the ancient literati ideal of lofty spiritualism in an appropriately restrained and dignified manner. The styles of ancient Chinese masters such as Huang Gongwong and Mi Fu were standardized and repeated endlessly by Chikutō, who reduced these artistic conventions to patterned devices. Where Huang Gongwong's landscapes had bouldered and sinewy mountains with characteristic blocky forms describing rocky outcroppings, Chikutō's approach was almost literally to pile the stereotyped elements high enough to build a mountain. When Chikutō was at his best, however, his landscapes could transcend this seemingly willful banality. He was capable of infusing the innumerable layers of ink with shimmering patterns that scintillate and flow rhythmically across the face of the painting.

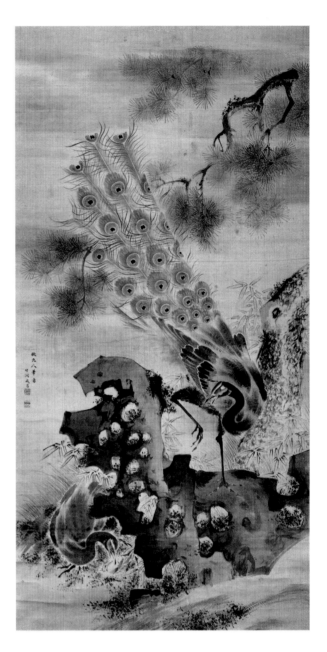

68.
Pair of Peafowl
Nakabayashi Chikutō (1776–1853)
Edo period, c. 1845
Hanging scroll, ink and color with touches of gold on silk
H. 61" (154.9 cm), W. 31" (78.7 cm)
Eugene Fuller Memorial Collection 66.100

Born in Nagoya into a professional household, Chikutō grew up predisposed to scholarship and art. While still young, he trained with a professional painter named Yamada Kyūjō (1747–1793), student of a Nagasaki school painter who followed Chinese taste in painting. Another figure whose influence greatly affected the course of Chikutō's career was Kamiya Tenyū, in whose company

Chikutō spent much time absorbing Chinese lore and studying and copying Chinese paintings. This experience molded Chikutō's interest in art into a conviction of the rightness of the conservative literati traditions. Yamamoto Baiitsu (1783–1856), also a Nagoya painter and friend of Chikutō, was similarly befriended by Tenyū. Chikutō and Baiitsu are almost always mentioned together as artists; however, their styles were not closely related. Although Baiitsu's work demonstrates a dedication to uniformity equally as strong as Chikutō's, he seems to have been content to create a style without becoming tendentious. Chikutō is primarily associated with ink landscapes, as opposed to Baiitsu's colorful bird and flower compositions; however, each painted in the other genre. It is something of an irony that today Chikutō's most imaginative works are considered to be among his bird and flower scrolls.

Essentially a sumi ink painting, the Seattle scroll of peafowl shows a sense of calculated stylishness in the handling of theme and composition which, in Chikutō's landscapes, is spectacularly restrained, if not absent. Uncharacteristic of his ink landscapes, Chikutō has here added some points of bright color. The "eyes" of the tail feathers originally had centers of intense bright blue, laid on over black ink in a heavy impasto that has all but disappeared today. These centers were circled with a pigment of suspended gold dust of which only a trace now remains. In the use of color, particularly in the use of gold, Chikutō revealed a heightened feeling which, in relation to other of his ink paintings, reaches almost emotional intensity.

Compositionally, he has created a tension in the complex combination of two- and three-dimensional elements. The fantastic rock of Lake Tai on which the peacock stands shows considerable mass and density; the tree trunk, too, has been modeled to suggest roundness. However, the remainder of the composition is essentially a two-dimensional pattern which tries to adhere to the picture plane. This constantly reversing tendency, moving from objects perceived in space to ink pattern on the surface, generates a visual uneasiness absent from Chikutō's unruffled landscape style. His exhibition of technical mastery of the brush treats the viewer to a multitude of textural juxtapositions: bony feet and sharp claws strike the dense rock, dry and crisp bamboo leaves rustle against rough bark, and smooth, webby feathers rise before prickly pine needles. There is a great deal more compositional movement than in the landscapes, with the major upward thrust of the diagonal tail countered by the

downward motion of the bough. A series of points link to create a parallel diagonal from the knot in the tree trunk to the turned head of the male bird, his foot raised in a watchful prancing gesture, to the large hole through the rock and finally to the head of the female poised over her prey. This line also brings the viewer's eye to the terror-filled moment of death for the frog.

The uneasiness of the spatial ambiguity is emphasized by the exotic rock form, which has the disconcerting appearance of solid rock mysteriously rotted or worn out. The mystery is further deepened because the rock is not set squarely into the earth, but projects rather precariously, seemingly unsupported. The painting of peafowl is a perfect example of the differences between Chikutō's and Baiitsu's visions in art. The same subject appears as part of a larger composition in a pair of screens by Baiitsu in the collection of the Idemitsu Museum of Arts, Tokyo. Executed with considerable color, the screens show a great number of birds gracefully posed amid wild but tranquil settings. Though peafowl are colorful by nature, Baiitsu has rendered his primarily in black ink with only touches of color. The lack of color notwithstanding, Baiitsu brings to his birds their characteristic languid grace and a textured modeling, in sharp contrast to Chikutō's brittle angularity and flat patterning.

Chikutō has not dated his painting in his short inscription; however, Baiitsu's screens are carefully dated to the year 1845, when both artists were living in Kyoto having successful careers. Familiarity with one another's work would have been highly possible. The signature reads *Chikutō Seishō*, and the two seals read *Seishō* and *Chikutō*. Chikutō writes in his inscription that he was following the ideas of Yuan-dynasty artists in creating this painting; but such paintings, if indeed he were following a literal model, would date much later and certainly were not in the tradition of the literati painters. If the 1845 date can be accepted for Chikutō's painting, it would indicate that he was less rigid in his interpretations in genre outside landscape, and that as he matured he became more willing to experiment with themes and styles. The movement toward the ultimate conservatism in interpretation and the codification of techniques had been set into motion, propelled in part by Chikutō's own writings and embodied in his own landscape painting. It was this codification that eventually drained all meaningful interpretation from late *nanga* painting in Japan.

WJR

After Rai Sanyō's death in 1832, the role of guardian of orthodoxy in Kyoto *bunjin-ga* was filled by the Confucian scholar Nukina Kaioku (1778–1863). A splendidly gifted calligrapher, he is known as one of the great calligraphers of the late Edo period. He also painted classically restrained landscapes in the conservative literati style. But in painting he was overshadowed by one of his students, Hine Taizan, who became perhaps the outstanding exponent of literati art during the last years of the Edo period, bringing to *nanga* painting a vigor of brush and ink and clarity of expression.

Little is written about Taizan's origins or upbringing. It is believed he came from a farming family in the village of Hine near Osaka. He studied calligraphy with Kaioku, who apparently acquainted him with literati painting traditions; however, Taizan's painting, even at its most reserved, far surpasses any of Kaioku's for grandeur, scale, and drama. It is not certain whether Taizan studied directly with the Zen priest Tetsuō (1791–1871), as Kaioku had, but sources often link them, and it is conceivable, with Tetsuō's prominence among Nagasaki painters, that Taizan knew and admired his work.

This hanging scroll reveals Taizan's reliance on Chinese styles and subject matter as the source of his inspiration. The theme is the fabled Mount Hōrai (Chinese: Penglai), the island mountain of immortality which, according to Chinese legend, lies somewhere off China's eastern coast. This legendary theme was popular in China at least as early as the third century B.C., and was a source of inspiration for numerous Chinese and Japanese works of art. In this landscape, the topic is identified by the artist in several ways. The craggy mountain, surrounded by crashing waves and partially blanketed in clouds, clearly indicates an idealized location, as do the scholars tucked among the hills and dales. A pair of cranes bearing Daoist Immortals on their backs identify this scene as the Daoist paradise, for in Chinese legend cranes are said to carry the spirits of Immortals to Mount Penglai.

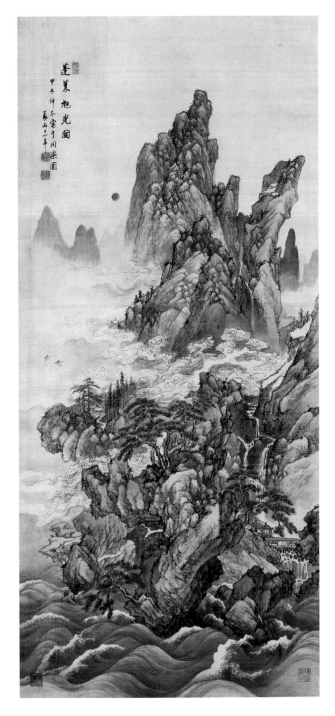

69.
Mount Hōrai, Island of Immortality
Hine Taizan (1814–1869)
Edo period, dated winter 1864
Hanging scroll, ink and light color on silk
H. 74⅜" (188.9 cm), W. 34⅝" (87.9 cm)
Gift of Drs. R. Joseph and Elaine Monsen, Jr. 75.59

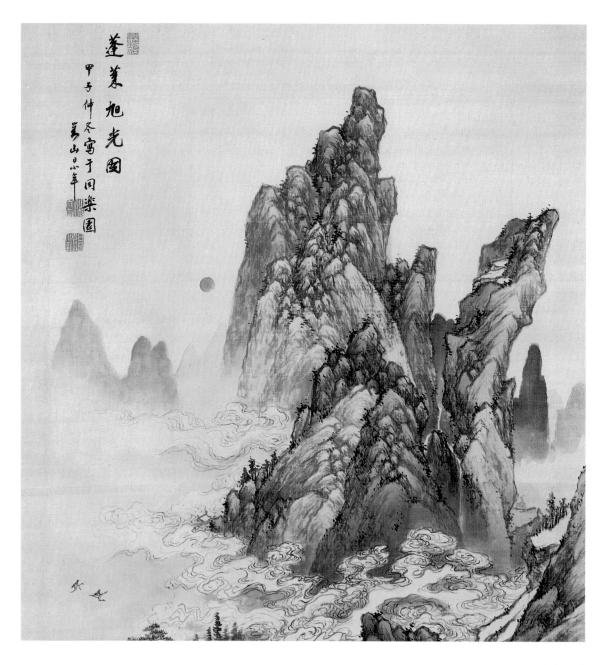

69. Detail

Stylistically this landscape is closely related to Chinese literati painting, indicating Taizan's probable direct access to Chinese works. The many small round boulders repeated over the surface of the mountain are known as alum clump boulders, a stylistic device attributed to the Five Dynasties painter Juran (act. c. 960–980). These were a commonly used motif in literati painting, and Taizan has closely captured the authentic Chinese taste in brushwork.

The long brushstrokes in relatively dry ink, repeated over and over to build up the sides of the mountain, are "hemp-fiber" strokes, a device employed by Chinese literati artists, which also formed a basic motif of Japanese *bunjin* artists. The composition, with a tall central mountain built up in a number of layers, is based on paintings by literati masters of the late Yuan and Ming dynasties, but this painting has a dramatic flair and dynamism not usually found in Chinese examples. The crashing waves, swirling clouds, and unstable rock forms, although created in a manner influenced by Chinese painting, reveal an individual artistic temperament that in its essence is purely Japanese.

WJR

Textiles were among the most highly developed Edo-period arts. These two striking garments are examples from opposite ends of the social spectrum. They reveal the pervasive influence of the weavers' and dyers' art during the Edo period, which touched not only those in socially high places but reached even the humblest peasants. Edo weavers and dyers generated a great variety of techniques by which textiles could be interestingly decorated, and methods for colorful dyeing were particularly favored. Some of these techniques were relatively new, like the paste-resist *yūzen* dyeing. More ancient techniques, such as tie-dyeing, witnessed new developments designed to meet the increased demands for novelty and fashion. This silk kimono (No. 70) is a stylish lady's robe decorated with a persimmon tree motif.

Furisode originally were worn by young unmarried women of high station, and the type has been popular since the middle of the Edo period. Its most characteristic feature is the swinging sleeve (*furisode*) that has given the garment its name. The sleeve is actually very wide; its width is the same measure as that from shoulder to wrist. A light padding of silk floss in the bottom of the sleeve insured that as the young lady walked, the sleeves would swing slightly, a feature subtly calculated to concentrate attention on the wearer. The hem of the robe also has a light padding of silk floss, its weight causing the kimono to trail lightly. This elegant movement not only emphasized the grace of the wearer, but brought the design of the persimmon tree into clear view. The flowing sleeves were arranged on the tatami beside or before the wearer when seated, complementing her pose and emphasizing the choice materials, skillful dyer's art, and the rich designs of her kimono.

The silk fabric is a loose twill weave, a rather exceptional choice, for this popular type of tie-dyeing for kimono was more frequently done on damask-weave fabric (*rinzu*). The branches of the persimmon tree bear fruit (*kaki*), the tawny russet of the dye emulating the color of the ripe fruit in a charming conceit. The trunk of the stylized tree rises, curving from hem to shoulder at the center of both front and back. The branches spread outward to fill the shoulders and sleeves. The areas surrounding the tree and all the spaces within the parts of the tree are filled with myriad tiny squares, each with a dot at the center (*hon hitta kanoko*). They are created by hand-tying tiny knots in the fabric to create lines of resisted squares that run on the bias, in diagonal lines. The design would have been drawn lightly on the silk before dyeing, yet

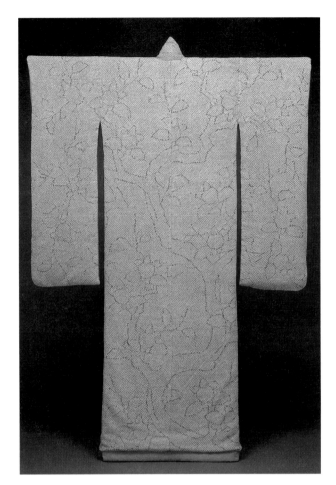

70.
Kimono (*furisode*)
Edo period, c. 1800
Silk twill fabric with *sōhitta* tie-dye decoration
L. 63⅛″ (160.2 cm)
Eugene Fuller Memorial Collection 56.133

it was the responsibility of the person tying the resisted areas to lay out the patterns of the resists to fill the design spaces properly. This would have been done by eye, relying on the tier's experience and training. Thus the continuous design, crossing both the front and the back, makes a dizzying display of the dyer's talent and discipline.

Garments with designs using small areas of tie-dyed dots were worn during the Muromachi, Momoyama, and Edo periods; however, beginning in the middle Edo, garments like this *furisode*, in which the design covers the entire garment and is filled with *hon hitta kanoko*, became popular. This special technique is termed *sōhitta*. The narrow spaces left to take up the dye create a negative linear design. The effect is called *ji-ochi*, or omitted ground. This luxurious decoration on kimono

required many thousands of resisting knots, each one made with up to eight turns of silk thread. This demanding and difficult method of binding has apparently disappeared completely. Since the late Edo period, the older method has been replaced by the use of stenciled patterns to indicate the location of the required resisting ties. Not unexpectedly, this creates a stiff, mechanical appearance in the design, in contrast to the gently irregular flow of the diagonal rows of dotted squares which, on this kimono, clearly reveals the hand of the skilled tier working without a printed pattern.

The *shifu* (No. 71) jacket exemplifies how new technology in the Edo period benefitted even the lowest social classes. Clothing in pre-modern Japan was for the most part made from silk, cotton, or *asa*, a hemplike bast fiber. In the West, linen from flax resembles the *asa* fiber; however, paper, an important material often employed for weaving and making clothing in Japan, is far less familiar to Westerners. Even if the common people had aspired to possess silk in the Edo period, it was out of reach economically, and although the merchant class might have afforded its cost, the government enacted sumptuary laws to restrict silk for the use of samurai and nobility. Therefore, the availability of cotton textiles on a wide scale in the mid-eighteenth century brought to peasants and commoners a welcome material for clothing that was at once comfortable, warm, and took easily to dyeing and decoration.

The most widely used material for weaving, even after the appearance of cotton goods, remained *asa*, a thread made from the inner fiber of the *asa* plant. *Asa* fabric had disadvantages as a year-round material; when newly woven, with few exceptions, it can be uncomfortably crisp against the flesh, a condition ameliorated only through continued wearing and repeated washing. The weave, rather open by the nature of the thread, best suits the fabric to warm-weather wearing.

Paper, however, provided many advantages over *asa* in terms of clothing and cloth, and *washi* (literally: Japanese paper) was the unique source for these fabrics. *Washi* is prepared from the inner bark of a number of different plants or small trees, and that made from *kōzo*, the paper-fiber mulberry, is tough and resilient, yet gently soothing to the touch. In general, the physical properties of such paper, most important its thermal insulating nature and soft touch, were well understood through the traditional means of house construction. The lightweight and durable yet soft finish of paper combined with its relatively low cost and easy availability to provide an alternative to the traditional *asa* fabrics.

The two principal forms of paper fabrics are *kamiko* and *shifu*. *Kamiko* is made of sheets of mulberry paper treated to render them supple. Traditionally these were used either in a white state or sometimes strengthened and waterproofed by applying persimmon juice, which turned them a tawny brown color. More decorative types of *kamiko* were hand painted or stencil decorated in imitation of colorful silks and cottons.

Shifu, the other paper form of clothing, is woven on a loom using threads twisted from shredded *washi*. The strips are compacted and rolled on a hard surface, then united into long strands. The long strands are wound onto bobbins to make thread. Depending on the thickness of the paper sheets and the width of the strips, different thread weights are obtained, which will vary the type of fabric. *Shifu* can be woven entirely of paper thread, but often the vertical or warp threads are made from cotton. This coat was woven using cotton warps and paper wefts. A type of *shifu* using silk warps is called *kinujifu*; this luxurious form was popular as a gift item among the wealthy, even into modern times, and was said to be superbly comfortable for summer wear.

Shifu and *kamiko* provided advantages for both summer and winter wear, and over time were used by all classes in various ways. Garments made of such material shed water surprisingly well. *Shifu* garments, like the wide-shouldered jackets and divided skirts of formal samurai dress (*kamishimo*), were considerably cooler in summer than those made of silk, while in winter *kamiko* coats retained body heat and shielded the wearer from cold winds, yet were lightweight and not bulky. In summer, *shifu* fabrics absorbed perspiration without sticking to the skin, and in winter, the breathing characteristics of cotton in the warp and the insulating qualities of paper in the weft combined to make an indispensable outer garment like the Seattle coat.

Similar garments were reinforced along the edges of openings with either cotton or softened *asa* fabric, and these additions, when combined with indigo-dyed cotton threads among the paper wefts in this coat, added another decorative feature. With a needle, the maker of the coat sewed across the sleeves and along the hem extra blue threads which, in combination with the blue wefts, form a chain pattern. This is perhaps not merely decorative, for the additional threads would add somewhat to the strength of the fabric.

WJR

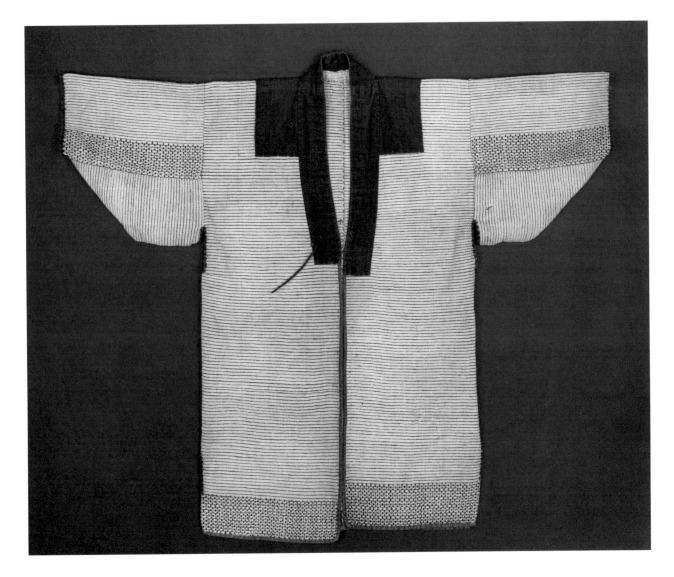

71.
Peasant coat (*nora-gi*)
Meiji era, c. 1900
Shifu weaving with embroidery and cotton appliqués
L. 37″ (94 cm)
Purchased with funds from the Sue M. Naef estate
 in memory of her husband, Aubrey A. Naef,
 by exchange 85.290

This Ko Seto vase (No. 72) was produced at one
of the numerous kilns in the area near Seto City
in ancient Owari, present-day Aichi prefecture. Pro-
duction of Seto ware began in the late thirteenth
century and continued through the Muromachi
period. Wares from the Ko Seto (Old Seto) kilns,
as distinguished from later wares produced there,
are included among the traditional Six Old Kilns,
a customary grouping of ancient kilns which have
been among the major centers of production since
before the Kamakura period. Recent research and
excavations of increasing numbers of medieval kiln
sites indicate that many other kilns were also in
operation at that time, giving medieval Japanese
society broad access to ceramics ranging from sim-
ple earthenware imports from China to indigenous
stoneware jars and mortars.

The traditional Six Old Kilns also included
Tokoname, Echizen, Shigaraki, Tamba, and Bizen,
but Ko Seto ware stands in a class apart. The fine
high-fired clay of great plasticity found in the area
around Seto City allowed potters to produce rela-
tively thin-walled wares of complex shape using
both the potter's wheel as well as the ancient coil-
ing method. What chiefly distinguishes Ko Seto
from products of other medieval kilns is the inten-
tional application of celadon-type glazes, which
are found in various shades of green, yellow, and
brown, resulting from mixing wood ash and min-
erals with a high iron content. When fired in an
oxidizing kiln, the glaze color would be green
to yellowish green or yellow-brown, whereas a
reducing fire would produce a dark brown glaze.

Many of the shapes and decorative motifs of
Ko Seto ware show a clear relationship to Chinese
prototypes of the Southern Song period (1127–
1279) and Korean wares of the Koryo period
(918–1392). This is not surprising, inasmuch as
trade with China and Korea was flourishing at the
time. The bottle-shaped vase (heishi) illustrates
this point — not only is the shape based on the
Chinese meiping of Southern Song and its Korean
equivalent, but the transparent green glaze also
recalls the celadons of Southern Song. But the
stamped designs of chrysanthemum flowers (kiku)
around the shoulder and incised, freely drawn
patterns of pampas grass (susuki) on the body are
clearly of Japanese inspiration. The vase is distin-
guished by rather broad shoulders and rounded
sides tapering toward the bottom, and has a short
straight neck with a horizontal flange around the
middle.

Another major Japanese medieval ceramic
center is represented by the fifteenth-century stor-
age jar (No. 73) from Shigaraki. In contrast to the

72.
Bottle-shaped vase (heishi)
Kamakura period, 14th century
Ko Seto ware, stoneware with green wood-ash glaze
H. 9½" (24.2 cm)
Gift of the Asian Art Council in honor of its tenth year
 and the museum's fiftieth year 84.11

73.
Tea jar
Muromachi period, 15th century
Shigaraki ware, stoneware with ash glaze
H. 18⅞″ (47.9 cm)
Gift of Drs. R. Joseph and Elaine Monsen, Jr. 75.60

Chinese-inspired Ko Seto wares, the jar reflects the bold forms and sturdy serviceability characteristic of the native wares that emerged in response to the needs of the peasant and commercial life of medieval Japan.

The Shigaraki kilns, named after the town and valley of this name, were located in the mountains at the southern edge of Shiga prefecture southeast of Kyoto. The stonewares produced there are distinguished by an unsophisticated roughness, resulting in part from coil construction and in part from the somewhat lower fire resistance of the clay, with its high gravel and sand content. Like other medieval stonewares, the clay, high in iron content, often fired to a rich red-orange or reddish brown color. A special balance of sand, feldspar, and trace metals contributed to the gritty texture and golden red or red-brown color of the well-fired bodies.

Three basic shapes of medieval stoneware were produced at the Shigaraki kilns: the wide-mouthed vat (*kame*), the narrow-necked jar (*tsubo*), and a mortar or grating dish (*suribachi*). Like other medieval kilns, the Shigaraki kilns mainly produced only these basic shapes until the early sixteenth century, when a number of smaller shapes were added. Large jars such as this one served as long-term storage vessels in the storeroom and kitchen; both the wide-mouthed vat and narrow-necked jar had already been produced in Sue-type earthenware before these types were produced in stoneware. The mortar, however, was first introduced from China in the Kamakura period, where it had proved indispensable in Zen cuisine. *Suribachi* often served as lids for *kame* and *tsubo* and are often found in association with them.

The majority of Shigaraki *tsubo* come from graveyards and temple sites. In the temples of ancient Ōmi, which included the Shigaraki area, and in neighboring provinces, Shigaraki wares served three basic functions: as vessels for storeroom and kitchen, as ritual vessels, and as burial urns.

The Seattle *tsubo* was made for use as a tea jar. Its body was built in sections, and it has an everted neck with a narrow rim. Natural glaze, the result of wood ash settling on the body during the firing and vitrifying in the heat, runs in long drips and covers the neck and shoulder. Scorch marks (*koge*) are visible where kiln flames came in contact with the surface of the vessel; the glaze is a warm red-brown. These distinctive features all suggest a fifteenth-century date for the jar.

HT

74.
Bowl
Momoyama period, 1568–1615
Karatsu ware, E Garatsu (Painted Karatsu) type;
 stoneware with underglaze iron brown decoration
Dia. 13″ (33 cm)
Eugene Fuller Memorial Collection 51.207

This bowl is decorated with a simple design of water reeds freely painted in iron oxide on a rough, sandy body under a transparent greenish yellow glaze. In its unpretentious simplicity, it is characteristic of the Korean-style Karatsu wares produced at kiln sites near the ancient port city of Karatsu during the late sixteenth and early seventeenth century.

The beginnings of Korean-style Karatsu wares can be put in the Muromachi and early Momoyama periods. Among the earliest known documentary evidence is a Karatsu jar with an incised date of the twentieth year of Tenshō, corresponding to 1592. Excavation of the earlier Azakura palace at Ichijōgatani, in Echizen, destroyed by Nobunaga in 1573, has also yielded Karatsu plates. It seems reasonable, therefore, to assume that Karatsu ware was already in production at least as early as the third quarter of the sixteenth century.

A major impetus to the rising importance of Karatsu wares was provided by the large influx of Korean potters brought to Japan by Toyotomi Hideyoshi's generals in the wake of the two military campaigns against Korea at the end of the sixteenth century. It was at Karatsu that Hideyoshi assembled his military forces for the first Korean campaign in 1592, and it was here that his second expeditionary forces landed upon their return from Korea in 1597. The two Korean campaigns, militarily unsuccessful, are often referred to as the Pottery Wars, for the various feudal lords from western Honshu and Kyushu who took part in these military expeditions brought back with them large numbers of Korean potters and subsequently established kilns within their fiefs to produce Korean-style pottery.

Karatsu ware, produced over a wide area in ancient Hizen in northern Kyushu (present Saga prefecture, including the cities of Karatsu, Imari, Arita, Takeo, Taku, and part of Nagasaki prefecture), and Satsuma ware, made at kilns in Naeshirogawa, near Kagoshima in southern Kyushu, were two of the principal ceramic products resulting from the import of Korean potters by Hideyoshi's generals. The powerful Hata clan controlled the area that included the city of Karatsu, whereas the Shimazu family was in command of Satsuma province and the area surrounding Kagoshima. In addition to the Korean potters brought over by Hideyoshi's feudal lords and generals, many Korean artisans

came of their own volition across the straits of Tsushima to settle and open kilns in many places in Kyushu.

The term 'Karatsu ware' has been applied in a general sense to the products of some two hundred kilns in ancient Hizen and centered primarily in the city of Karatsu. The Nabeshima, Hirado, and Hata clans all extended their patronage and protection to the immigrant Korean potters, who introduced Korean-style sloping kilns and the foot-powered kick wheel.

The earliest Karatsu kilns were those centered in the Kishidake range of mountains, five miles to the south of Karatsu. This group of kilns, which included the Handogame, Hobashira, Saraya, and Michinaya kilns, was at that time under the protection of the powerful Hata clan, whose castle of Kishidake can still be seen lying in ruins some twelve miles south of Karatsu.

The Karatsu kilns produced pottery made of sandy, rather coarse clay with a high iron content. There are many different types of Karatsu ware, but all are distinguished by great simplicity and refined taste, following the example of their Korean prototypes. One of the most attractive and most popular types of Karatsu is the E Garatsu (Painted Karatsu) group, decorated with simple designs in underglaze iron. The designs of grasses and reeds, pine trees, bamboo, persimmon, or floral motifs such as the popular iris were all taken from nature and were invariably drawn with great freedom and spontaneity. The Seattle bowl illustrates fully the simple beauty and free spirit of E Garatsu ware.

Other varieties of Karatsu include Madara Garatsu (Mottled Karatsu), characterized by the use of devitrified white glazes applied to a feldspathic clay body; and Chōsen Karatsu, or Korean-type Karatsu, distinguished by the application of a white glaze over an iron brown glaze, or vice versa. Numerous other types include Muji Karatsu (Plain Karatsu), without design and with plain ash glaze, and *temmoku* Karatsu. Originally a simple peasant ware, Karatsu was later adapted to the tea ceremony.

The Karatsu stonewares represent one of the most important groups of Kyushu ceramics produced from the end of the sixteenth century and continuing to the present. They form a link to the next major development in Japanese ceramics, which came with the introduction of true porcelain production early in the seventeenth century.

HT

The development of Japanese ceramics flourished from the late Muromachi through the beginning of the Edo period (sixteenth to early seventeenth century). Much of the new activity had to do with the rise of the tea ceremony (*chanoyū*), which had been introduced from China in 1191 by the Zen priest Eisai (1141–1215). In the course of time, the wealthy citizens of Kyoto and other large towns, as well as the samurai, had come to accept the tea ceremony and its basic tenets as their way of life. As the tea ceremony came to occupy a place of intense importance, a demand arose for appropriate ceramics to be used in the ritual.

Whereas Karatsu (No. 74) was originally made as a simple peasant ware and only later adapted to the tea ceremony, Shino ware as well as Oribe (Nos. 77, 78) were from the beginning intended for use in the *chanoyū* and the accompanying *kaiseki-ryōri* (before the tea ceremony food service). It has traditionally been suggested that the noted tea master Furuta Oribe (1544–1615) played a major role in the designs of Shino. This cannot be proven, and it may be that he only placed orders at the Shino kilns, which were operating under the protection of the powerful Toki clan, of which he was a descendant.

The Toki family was in control of eastern Mino. To this area, some fifteen miles north of Seto, many Seto potters had migrated toward the end of the Muromachi period, when it had become increasingly difficult for them to continue their work in Owari province owing to the unsettled conditions caused by the civil wars then raging. As a result of the movement of potters away from Seto, new kilns were set up in eastern Mino, leading to the production of new wares — Ki (Yellow) Seto, Shino, Seto-guro (Black Seto), and Oribe — which flourished in the Momoyama period.

It was once thought that both Shino and Oribe were produced at Seto kilns in Owari province. But in 1930, Toyozō Arakawa excavated the site of the Mutahora kiln in the Ōkaya group in Mino, where the finest Shino ware had been made. His investigation established once and for all that Mino was the center of production for Shino and Oribe. Besides the Ōkaya group, some white Shino pieces were also made at the Ōhira kilns in Kukuri, one mile southwest of Ōkaya. Large quantities of Shino were fired here at the Yuemon kiln, also famous for the outstanding quality of its E Shino.

The Shino wares were normally made in a single round-chamber kiln half above and half below the ground, a type best suited to obtain the slow increase in temperature and proper firing conditions

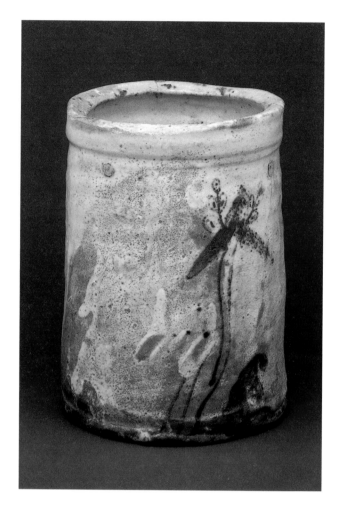

75.
Water jar (*mizusashi*)
Momoyama period, late 16th century
Mino ware, E Shino type; stoneware with feldspathic
 glaze over painted iron oxide decoration
H. 7" (17.8 cm)
Eugene Fuller Memorial Collection 51.208

to achieve the desired glaze effects. The Mutahora kiln had five chambers; here the finest Shino wares were made. The Shino kilns were different from the multiple-chamber climbing kiln introduced by Korean potters at Karatsu and by the Oribe potters at the Motoyashiki kiln, at Kujiri, where a thirteen-chamber Korean-style climbing kiln (*noborigama*) was found. Although some Shino ware of lesser quality may have been made in sloping kilns when they were first introduced to the area, the small single-chamber kiln was ideal for Shino ware and would normally have been used. Because of its size and shape, it could not take more than five hundred pieces at one firing. The pieces were therefore closely packed in the kiln and many were underfired.

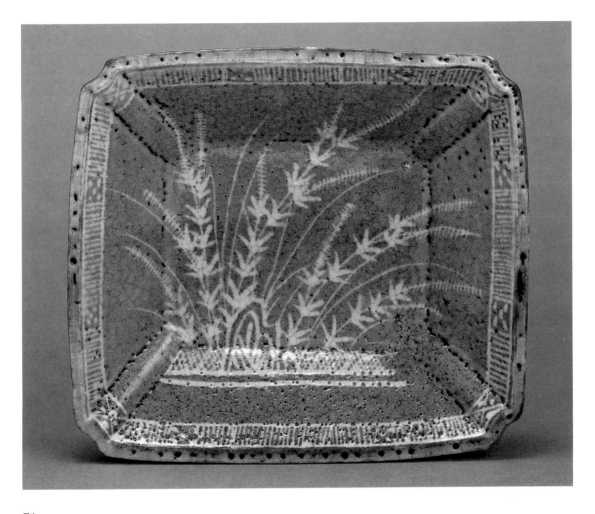

76.
Plate
Momoyama period, late 16th–early 17th century
Mino ware, Nezumi Shino type; stoneware with transparent
 feldspathic glaze over iron rich slip and incised decoration
L. 9¼″ (23.3 cm), W. 7⅞″ (20.2 cm)
Gift of Mrs. John C. Atwood, Jr. 51.205

The clay dug at the Mino kiln sites, primarily in the Ōkaya and Ōhira areas, was of high quality and usually of reddish color. Characteristic pieces had heavily pitted bodies and were covered with a thick milky-white, usually uneven, feldspathic glaze. The Shino potters were the first to use such a white glaze, in a sharp departure from the monochromes and natural ash glazes of medieval wares. As for E Shino, the painted designs were drawn in iron oxide directly on the body before application of the feldspathic glaze; the Seattle water jar (No. 75) illustrates this technique and glaze. The body is heavily pitted and its reddish color shows a high iron content. With its irregular form and spon-taneous, uninhibited decoration of freely painted grasses, such a piece would appeal strongly to tea ceremony tastes.

A second important category of Shino is Nezumi (mouse-grey) Shino. The Seattle plate (*mukōzuke*) (No. 76) with design of grasses was intended for use in the dinner course preceding the tea ceremony.

Nezumi Shino was made by covering the body with an iron rich slip through which designs were cut. A thick feldspathic white glaze was then applied. As a result of firing the piece in a combined oxidizing and reducing atmosphere, the iron slip turned a warm grey color while the designs appeared white. On the lip of this piece, where the glaze is thinner, and on the base the iron in the slip has produced rich red-brown colorations.

Nezumi Shino, much less common than painted Shino, is highly prized in Japan today, and both Seattle examples of Shino reflect the simple, refined taste of the tea masters during the late Momoyama period.

HT

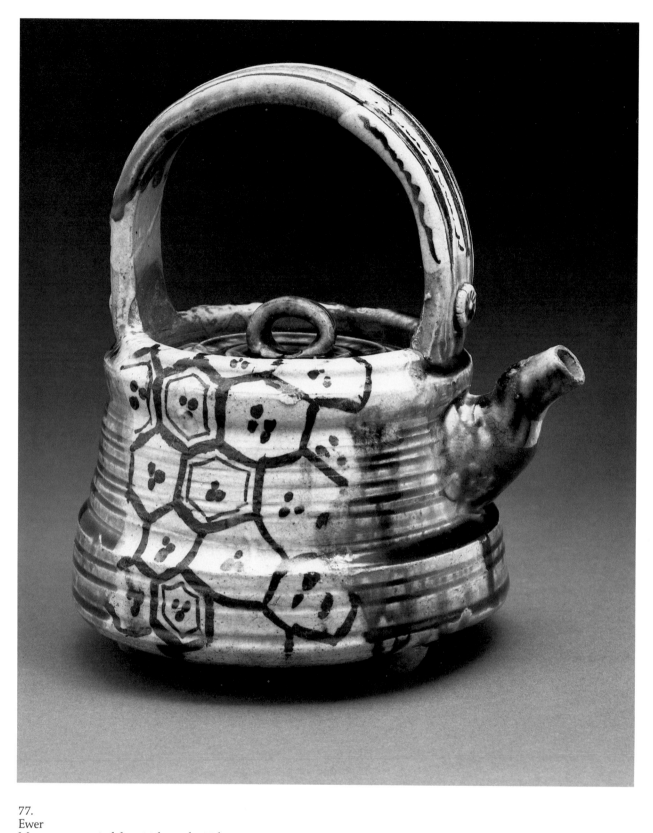

77.
Ewer
Momoyama period, late 16th–early 17th century
Mino ware, Oribe type; stoneware with green and
 transparent glazes over painted decoration in iron oxide
H. 8¼″ (21 cm), W. 6½″ (16.5 cm)
Eugene Fuller Memorial Collection 58.12

The shapes of Oribe ware are most commonly rectangular or faceted and are formed by molds. Most popular are dishes with loop handles, lozenge-shaped trays, boxes, ewers, pricket candlesticks, and incense burners. The bold and imaginative forms represented a new spirit in the history of Japanese ceramics, as did the introduction of a distinctive copper green glaze used in combination with innovative, abstract designs painted in iron oxide. Glazes and designs were used in a variety of combinations to form contrasting, asymmetrical patterns which in turn enhanced the irregular shape of the pieces.

Oribe takes its name from that of the famous tea master Furuta Oribe (1544–1615), who came from an old and well-established family in Mino. He was a pupil of the famous tea master Sen no Rikyū and served in turn the powerful Momoyama military rulers Oda Nobunaga, Toyotomi Hideyoshi, and Tokugawa Ieyasu. Although the ware bears his name, it is uncertain how much influence Furuta Oribe actually exerted over its design and manufacture. However, the best Oribe was produced when Furuta Oribe was at the height of his power and influence late in life, at the end of the sixteenth and beginning of the seventeenth century.

Oribe ware introduced a bold and dynamic style of tea ceremony wares, quite distinct from the elegant but subdued nature of Shino and other Mino wares. The finest Oribe was produced at the Motoyashiki kiln, which was of the *noborigama* (multiple-chamber step-kiln) type. Introduced from Korea, this type of kiln permitted a natural updraft from the fire box and more efficient, even firing.

The Seattle ewer and tray, both made for use in the tea ceremony, admirably illustrate the innovative features of Oribe. The irregular shape of the ewer (No. 77), probably derived from a cast-iron tea kettle, is complemented by the bold style of decoration painted in underglaze iron oxides. One side is decorated with a tortoise-shell pattern derived from similar motifs found on textiles of the Momoyama period, especially fabrics of *nui-haku* type (silk with embroidery and gold leaf appliqué). The opposite side features an abstract design of vertical stripes topped by floral bands. Horizontal ridges and grooves formed by the potter's wheel encircle the body and provide a sense of balance to the rich decorative patterns. Copper green and transparent glazes, irregularly distributed, further enhance the imaginative new designs.

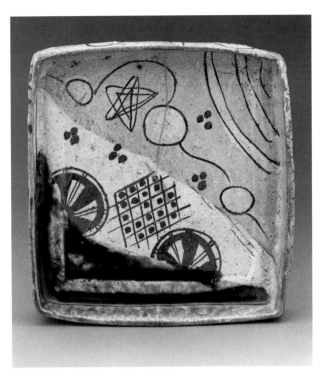

78.
Tray
Momoyama period, early 17th century
Mino ware, Oribe type; stoneware with green and
 transparent glazes over painted decoration in iron oxide
L. 8″ (20.2 cm), W. 7¾″ (19.7 cm)
Eugene Fuller Memorial Collection 56.130
Plate on p. 71

The mold-made tray (No. 78), a slightly irregular square form probably intended to serve as a dish in the tea ceremony, is also distinguished by bold abstract patterns of decoration. This example employs a combination of red and white clays divided diagonally. A subdued copper green glaze, applied over the lower portion of the white clay section, suggests water. On the remaining portions, designs were painted in iron oxides and white slip under a transparent glaze. There is a prominent design of half-submerged wheels, a decorative motif popular since the Heian and Kamakura periods, when it was frequently used on lacquer ware. It also occurs on Momoyama and early Edo-period screens, notably the various sets of screens depicting the famous bridge at Uji, while the checkerboard motif suggests the popular game of *go*.

HT

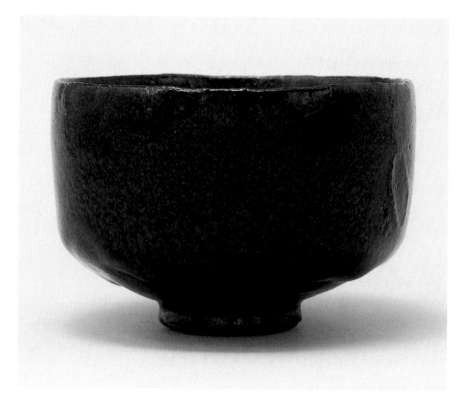

79.
Tea bowl, named Tamamushi (Golden Beetle)
Edo period, early 17th century
Black Raku ware, earthenware with black lead glaze
H. 3⅜″ (8.5 cm), Dia. 5″ (12.6 cm)
Gift of Dr. Masatoshi Okochi 52.68

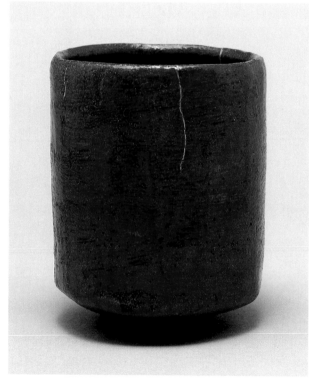

80.
Tea bowl, named Kan-kōbai (Winter Blossoming Red Plum)
Seal of Dōnyū (1599–1656)
Edo period, early 17th century
Red Raku ware, earthenware with red lead glaze
H. 4⅛″ (10.5 cm), Dia. 3⅜″ (8.6 cm)
Gift of Dr. Masatoshi Okochi 52.67

Two tea bowls, one with thick black glaze, the other with a soft, salmon red glaze, are examples of early Edo-period black and red Raku ware. The red bowl bears the seal of Dōnyū (1599–1656), also known as Nonkō, the third-generation potter of the Raku line, and the black bowl is attributed to him on stylistic grounds.

Raku, a ware made exclusively for the tea ceremony, originated in Kyoto, which had no prior ceramic tradition despite the fact that for centuries it had been at the center of Japanese civilization and artistic heritage. It is believed that Raku ware was introduced during the Tenshō era, about 1579–1580, under the influence of the tea master Sen no Rikyū (1522–1591). He patronized Chōjirō (1516–1592), first potter of the Raku line and son of a Korean tile maker who had settled in Kyoto. Under Rikyū's influence, Chōjirō began to turn out tea utensils, primarily bowls, which were of an entirely new type made especially for the *wabi-cha* tea ceremony. Murata Jukō (1423–1502), sometimes called the father of the tea ceremony, originally established the concept of *wabi-cha* (*wabi*, literally: quiet, solitary, unassuming). As tea master to the Ashikaga shogun Yoshimasa, he was responsible for formalizing tea drinking as an elaborate ritual performed according to strict rules. This ceremony was further developed and its essential tenets codified by Sen no Rikyū. The latter's patrons included the powerful Momoyama military rulers Oda Nobunaga (1534–1582) and his successor Toyotomi Hideyoshi (1537–1598).

Raku tea bowls are light in weight and were molded by hand. Each tea bowl therefore reflects the individual character and personality of its creator. Raku ware kilns were simple single-chamber kilns small enough to be set up in a garden or backyard. The simple techniques encouraged amateurs to try their hand at making Raku-type pots, which became a fashionable pastime. The glazes, primarily black, white, transparent, or red, were suspended in a lead solution, and the pieces were fired at a low temperature, about 1000 degrees centigrade. The resulting simple, unassuming tea bowls and utensils corresponded to the ideals of the *wabi-cha* advocated by Sen no Rikyū.

The black tea bowl has a thin body, but its thick, lustrous glaze has been manipulated to flow smoothly over the surface. The deep glossy black was obtained by applying three or four glaze layers, a technique known as *maku* (curtain glaze). The glaze is noticeably thicker at the base, where it gathered as it flowed downward in melting.

The red bowl is distinguished by its soft, salmon red glaze intended to complement the greenish color of tea. This particular matte sand-glaze is obtained from powdered *hinu-oka*, a kind of acidic rock. The glaze was applied over a body of fine pinkish clay molded by hand and shaped with a bamboo spatula. The bowl's rim line, intentionally irregular, was considered agreeable to the lips. The shape of this red tea bowl is notable; it is taller and narrower than the more usual form seen in the black bowl.

Individual tea pieces were sometimes named in appreciation of the color of their glaze, their shape, or a particular historical or literary allusion they evoked. Such names were never bestowed capriciously or without special connotation. The black Raku bowl is named after the iridescence of its glaze, which recalls the shining wings of the *tamamushi* beetle. The red bowl's name derives from the color suggested by the blossoms of the winter-flowering red plum (*kan-kōbai*).

Dōnyū's works show considerable advances in technical refinement and experimentation with glazes, which tend to be more lustrous and free-flowing but always well controlled in comparison with the earlier Raku products of Chōjirō and his immediate followers. It is said that Dōnyū also fired his glazes at higher temperatures than his predecessors.

Dōnyū was a close friend and teacher of Kōetsu (1558–1637), and it seems that he worked with Kōetsu from time to time at Takagamine. We know today from Kōetsu's letters to various Raku ware potters that Dōnyū and others fired pots and applied glazes for him. Some of these tea bowls are today attributed to Kōetsu.

These two tea bowls may well be by Dōnyū's hand, especially the black Raku bowl, which exhibits great skill and imagination in both form and glazing technique.

HT

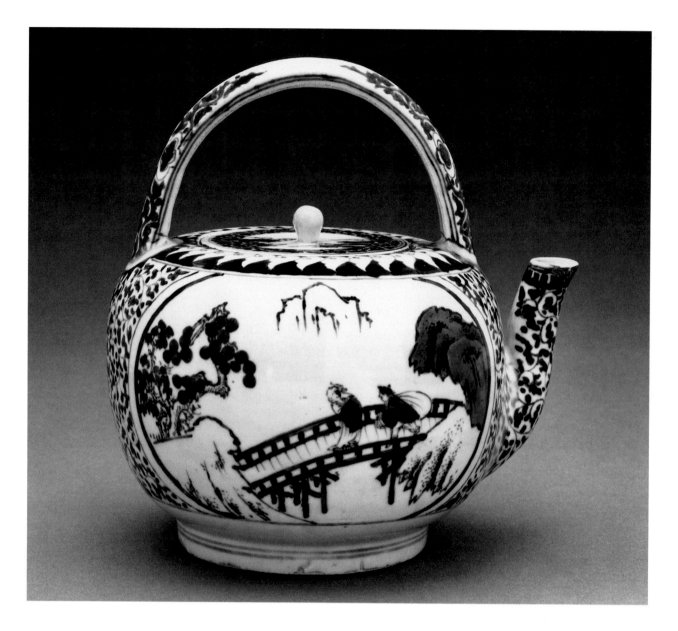

81.
Ewer with bail handle
Edo period, first half 17th century
Arita ware, early Hizen type; porcelain
 decorated in underglaze blue
H. 8⅞" (22.4 cm)
Eugene Fuller Memorial Collection 70.11

Korean-inspired decoration characterized the first phase of Japanese porcelain production. It was followed by blue and white porcelain showing Chinese influences of the late Ming dynasty in their decorative motifs and shapes.

The sturdy ewer (No. 81) is decorated on both sides with oval reserve panels of Chinese-style landscapes and figures. One side depicts a landscape with rocky cliffs and two figures, one with a large bag slung over his shoulders, crossing a bridge. The opposite side depicts a moonlit winter landscape with two scholars in a pavilion on a lake. Two other figures beyond the rocks on the right have just set out from the pavilion in the snow. The scenes are skillfully executed in deep blue underglaze painting, as are the decorative motifs covering

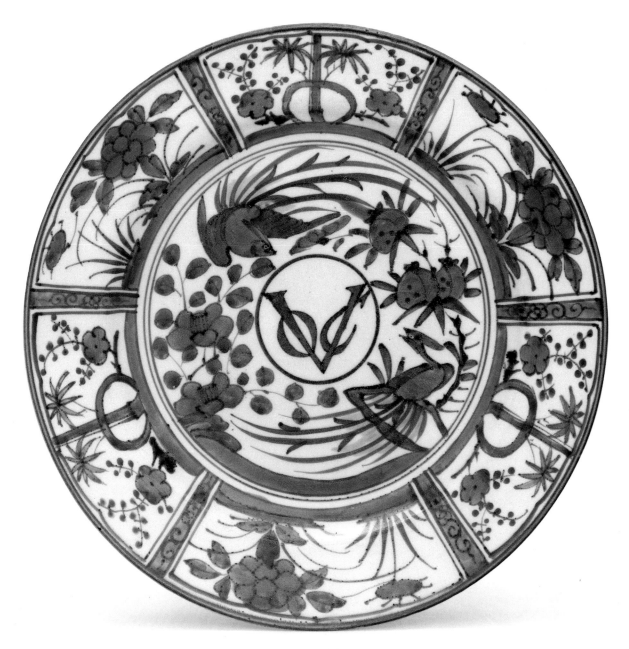

the rest of the vessel. Densely painted foliate scrolls on the sides, spout, handle, and rim and decoration on the lid contrast with the openness of the landscapes. The arch of the bail handle enhances the feeling of lightness of the essentially heavy, squat form of the pot. The ewer probably comes from the Hyakken group of kilns or a related kiln; Chinese-style blue and white fragments have been unearthed at the Hyakken site, located at Itanokawachi, near Arita.

The initials "V.O.C." in the center of the large plate (No. 82) refer to the Dutch East India Company (Vereenigde Oostindische Companie). A number of such plates with the V.O.C. initials are known, all made for the Dutch trade; this we know from the Dagh registers of the company, kept at

82.
Plate with "V.O.C." design
Edo period, second half 17th century
Arita ware, Ko Imari type; porcelain
 decorated in underglaze blue
Dia. 15⅜" (38.9 cm)
Floyd A. Naramore Memorial Purchase Fund 75.78

Batavia. According to these registers, the export of fine Chinese porcelain ended altogether between the years 1658 and 1682, although coarse provincial ware continued to be exported in large quantities, mostly via Amoy. During those years, the gap was filled by Japanese exports of both coarse and fine porcelain. The first considerable export of Japanese porcelain for the Asian and European markets occurred in 1658–1659.

The Seattle V.O.C. plate belongs to the period when Japanese porcelain replaced Chinese exports as a trading commodity. Some of the plates found their way to other parts of Asia, to Europe, and even to South Africa. The manufacture of these plates can now be traced to the Sarugawa kiln, south of Arita, where fragments of the V.O.C. plate type have been excavated.

All V.O.C. plates follow, in a debased form, similar designs found in late Ming export wares of the so-called Kraak type, but vary greatly in quality and size; some are decorated with rather perfunctorily painted designs. This large plate with its carefully drawn designs may be ranked among the best extant examples.

The central monogram of this plate is surrounded by a design of two phoenixes, one perched on a rock, the other in flight. A branch of pomegranates and a branch of camellias separate the birds. The wide, flaring rim features six reserve panels separated by narrow scrolling bands. Three panels of stylized bamboo and plum alternate with three panels of peonylike flowers and grasses. The underside is undecorated, and has five spur marks within the foot ring.

The immigrant Korean potter Ri Sampei fired the first examples of true porcelain in Japan at the Tengudani (Valley of the Long-Nosed Goblins) kiln in Arita in 1616, or perhaps earlier. This event led to the rapid rise of porcelain production, which soon rivaled and subsequently overcame the traditional Japanese preference for stonewares.

Until 1967, Ri Sampei had only been a legend; various theories as to his life and activities existed, but no clear proof that he ever lived. In 1966, Tsugio Mikami, then professor at Tokyo University, began the scientific excavation of the Tengudani site. In the following year, while these excavations were still going on, Chū-ichi Ikeda, a designer for the Iwao Porcelain Company in Arita, was going through the archives of a small Buddhist temple called Ryūsen-ji in Nishi (west) Arita when he came upon a document clearly identifying Ri Sampei and recording his death on the eleventh day of the eighth month of the Meireki era, corresponding

to September 20th, 1655. With this discovery, Ri Sampei moved from legend into history. If he had in fact come as a well-established potter from Korea to Japan in 1598, as legend has it, he would have led a long, active, and productive life during the first half of the seventeenth century.

At the close of the Kanei era, about 1643, Sakaida Kakiemon, an Arita potter, reportedly introduced the technique of overglaze enameling, which he supposedly learned from a Chinese refugee ceramist at Nagasaki. Overglaze enameling became an important and popular technique of porcelain decoration and was practiced not only by the Kakiemon family of potters, but by many artisans specializing in this new technique. As early as the 1660s, these artisans came to be housed in a special section of Arita set aside for them, known as the *aka-e machi*, or red painting quarter. Enameling added another dimension to the porcelain industry.

Ri Sampei's achievement, which radically changed the future course of Japanese ceramics, would have been impossible had he not earlier discovered the rich supply of kaolin (porcelain) clay at Izumiyama, just outside of Arita. Centuries of use have not yet exhausted this huge clay deposit. Arita was, in fact, ideally located to become the center of Japan's rising porcelain industry, with unlimited supplies of kaolin, wood for kiln fuel in the surrounding mountains, and water for washing the porcelain stone always available from the streams that run through the valley occupied by the town.

Blue and white porcelain fragments recovered from Arita kiln sites can be divided into four groups. Two early groups show first Korean and then Chinese Tianqi-period (1621–1627) influence in their decoration; a third shows Chinese Wanli (1573–1619) influence; and the fourth shows decorative motifs of essentially indigenous Japanese or Japanese-assimilated Chinese motifs.

Specific dating is difficult, as the groups blend and overlap. The Seattle ewer clearly shows the influence of Tianqi, especially in the landscape and figure motifs, and must have been produced soon after the introduction of blue and white porcelain. Its decoration displays none of the Korean influence found on the bottles and flat-bottomed dishes of the very earliest period, with simple foliate and floral motifs. The ewer is probably contemporary with the well-known Tianqi-style dishes decorated with heron and bamboo or hare and moon motifs and associated with the Hiekoba kiln; they are usually dated in the Kanei era (1624–1644).

HT

These five pieces represent some of the finest of the Arita wares produced during the second half of the seventeenth and beginning of the eighteenth century. They all belong to the large family of Arita wares decorated in overglaze enamels, or a combination of underglaze blue and overglaze enamels, sometimes with the addition of gold. Some are in the tradition of the Kakiemon family of potters (Nos. 83, 84), while others conform more closely to the style and decorative patterns of Imari ware (Nos. 85–87). All these pieces come from kilns in the Arita area of Kyushu, but what constitutes Imari and Kakiemon porcelain respectively is more complex.

Polychrome enameled porcelain, produced in China since early Ming times (fifteenth century), was unknown in Japan until its introduction by the Kakiemon family in the early Edo period. According to tradition, in about 1643 Sakaida Kizaemon (Kakiemon I) succeeded in making the first enameled porcelain in Japan. Helping behind the scenes was a certain Higashijima Tokuzaemon, a potter. He was greatly attracted by late Ming enameled ware (*aka-e*), and with his close friend Tokuzaemon, established the *aka-e* technique in Arita. The Kakiemon workshop and kiln, now established at Nangawara, appears to have been managed jointly by the Sakaida family and its relatives. It was not owned by Kizaemon, who was simply running the workshop in cooperation with his father.

The Kakiemon workshop and kiln, now established at Nangawara, appears to have been managed jointly by the Sakaida family and its relatives. It was not owned by Kizaemon, who was simply running the workshop in cooperation with his father.

In recent years, the traditional "Kakiemon theory" has been seriously questioned, some scholars even suggesting that enameled porcelain from the Kakiemon kiln was not made earlier than the middle Edo period. A letter to Sakaida Kakiemon, dated November 8, 1685, and signed by a Saga clan official (thus it may be considered a semi-official document), confirms the fact that the Kakiemon workshop was at that time already well established and was producing polychrome enameled porcelain (*aka-e nishiki-de*). The document also confirms that the kiln had been officially sanctioned to operate by the Nabeshima clan, which controlled Hizen province and the Arita area.

The history and genealogy of the Kakiemon family is confused, and questions have arisen that cast doubt on earlier attributions, lineage, and relationships of the early Kakiemons. Attributions

83.
Headrest
Edo period, c. 1680
Arita ware, Kakiemon style; porcelain decorated in
 overglaze enamels
H. 5¾" (14.5 cm), L. 3⅞" (9.8 cm), W. 2⅞" (7.5 cm)
Gift of an anonymous donor 76.100
Plate on p. 78

to Kakiemon I, II, or III, and notably to Shibuemon, uncle of Kakiemon VI, can no longer be sustained. Further complicating the process of identification and dating is the fact that by about 1672, the secret of enameling had become widely known and was not in any way restricted to the Kakiemon kiln.

It is difficult to draw clear lines of distinction between Arita wares of the second half of the seventeenth century decorated in the Kakiemon style and those decorated in the Imari style. Two separate styles did emerge in the Arita area after about 1670, displaying different forms, designs, and colors. To these two types may be added a third, the style of the official kiln operated by the Nabeshima fief (see No. 88). Further complicating the picture is the group of wares made at the Kutani kilns in

84.
Octagonal bowl
Edo period, late 17th century
Arita ware, Kakiemon style; porcelain decorated in
 overglaze enamels
Dia. 7⅛" (18.1 cm)
Eugene Fuller Memorial Collection 56.124

Ishikawa prefecture (see No. 90), many of which had been identified as old Ko Kutani ware, but now, in the light of recent scholarship, have been assigned to the Arita kilns.

The developed Kakiemon style is normally distinguished by great care in the manufacturing process, including refinement of the clay bodies for both blue and white (*sometsuke*) and color-decorated (*iro-e*) wares, as well as glazing and firing. Other characteristics include the use of delicate overglaze enamels painted over a sketchy black outline on a wheel-thrown or molded body of fine, often milky white, quality known as *nigoshi-de*.

By contrast, the Imari style can generally be recognized by the use of heavier, coarser bodies decorated with bolder, less delicate designs. The highly stylized and often complex decoration is

frequently overcrowded to the extent of almost concealing the white porcelain body. The underglaze blue, used in combination with overglaze enamels (principally opaque iron red and gold) has a murky quality and is often blurred, unlike the clear, luminous blue and pure overglaze enamels of the Kakiemon style.

According to tradition, the name 'Kakiemon' originated when the potter Sakaida Kizaemon made an ornament for an alcove (*okimono*) for Nabeshima Katsushige in the form of two persimmons (*kaki*). They so delighted him that he conferred the new name upon Kizaemon. Another theory is that it derived from the orange-red color of one of the overglaze enamels that resembled the color of the fruit. The validity of these two theories is manifestly doubtful. The term 'Imari' derives from the

85.
Sake pourer
Edo period, late 17th century
Arita ware, Imari style; porcelain decorated in underglaze
 blue and overglaze enamels and gold
H. 6¼" (15.9 cm), W. 5⅝" (14.3 cm)
Purchased with funds from the Sue M. Naef estate,
 in memory of her husband, Aubrey A. Naef 83.35

small seaport by that name from which the Arita
porcelains were shipped to Nagasaki for export; no
porcelain was actually made at Imari.

The Seattle headrest and bowl both date to
the end of the seventeenth century. They are both
distinguished by spareness and elegance of decora-
tion and the milky white quality of the clay bodies,
all in conformity with the Kakiemon style. The
unusual and rare headrest (No. 83) is decorated on
one side with a millet and quail design, a popular
autumnal theme associated with the Kakiemon
workshop, and on the opposite side with a bamboo
and floral design in clear, luminous enamels on
white ground of *nigoshi-de* type. By contrast, one
end panel is decorated with a lotus and scroll design
in green enamel within black outlines on yellow
glazed ground.

The octagonal bowl (No. 84) is decorated with
a "Three Friends" design of pine, plum, and bamboo
in typical Kakiemon-style enamels — green, blue,
yellow, and red, with some black outlines. The
design is sparsely arranged about the rounded sides
of the faceted body, drawing attention to the large
areas of the milky white body left undecorated.
A roundel with two phoenixes is centered on the
bottom inside, and around the rim, which projects
at an angle, is a border of eight prunus blossoms
linked by a formal scroll.

Hexagonal or octagonal bowls with faceted sides
are common in Arita ware. In the Genroku era
(1688–1704) and afterwards, during the middle
Edo period, the Kakiemon workshop apparently
joined with other potters in the Nangawara area to
fire their wares. As demand increased, both at home

86.
Large plate
Edo period, late 17th century
Arita ware, Imari style; porcelain decorated in underglaze
 blue and overglaze enamels and gold
Dia. 21¼″ (54 cm)
Floyd A. Naramore Memorial Purchase Fund 76.22
Plate on p. 79

and from abroad, the potters increased their output by making identical molded bisque wares. These were decorated with various designs in overglaze enamels, including the popular pine, bamboo, and plum design. The edge of the rim was usually given an iron oxide wash, following the painting of the floral border.

The three examples of Imari-style porcelain represent an interesting contrast with the two Kakiemon-style pieces. In date they are roughly contemporary, but they show a difference in decorative style as well as techniques. Moreover, underglaze blue is abundantly used in combination with

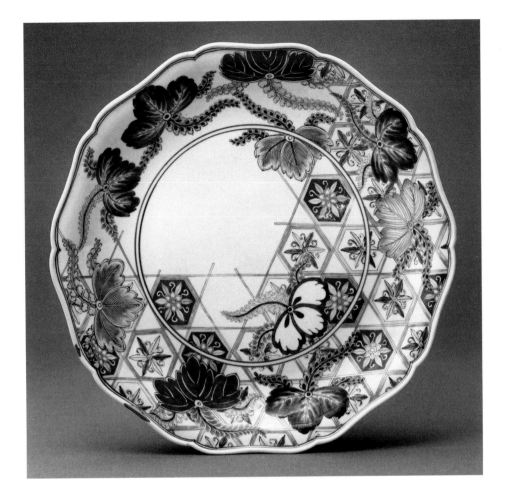

87.
Large plate with foliate rim
Edo period, late 17th–early 18th century
Arita ware, Imari style; porcelain decorated in underglaze
 blue and overglaze enamels and gold
Dia. 13½″ (34.2 cm)
Gift of Mrs. John C. Atwood, Jr. 60.42

polychrome overglaze enamels and gold, thus differing considerably from those porcelains decorated in the Kakiemon palette. Most of the enameling, with the exception of the Kakiemon wares produced at the Nangawara workshops, must have been carried out in Arita by artisans of the red painting quarter (*aka-e machi*), which is mentioned in records for the first time in 1662.

The sake pourer (No. 85) is of a shape found primarily in Arita wares, but it was also copied in Ko Kutani and was later copied from the Japanese in early Meissen of about 1730 to 1735. The shape was probably derived from a metal sake pot of similar form; porcelain ewers of this type were probably intended for export. Its arching handle distinguishes it from another type of ewer intended as a teapot, with a handle attached to one side of

the body rather than arching over the top. This type was produced in both Imari as well as Kakiemon-style porcelain. The Seattle sake pourer is decorated with an *ukiyo-e* design of women and children against a background of floral sprays and a terrace railing below, suggestive of an outdoor setting.

The two large Imari plates are both decorated in underglaze blue and overglaze enamels and gold. The plate with round rim (No. 86) has a central design of *shishi* (Chinese lion) on a rock among peonies. A border design repeated several times features a scrolling pattern with *shishi* among peonies and phoenixes among camellias in underglaze blue and overglaze red, pale pink, black, and purple-grey enamels, as well as gold. The underside is decorated in underglaze blue and overglaze red enamel and gold with sprays of peony, chrysanthemum, and

plum blossom. There are also four concentric circles in underglaze blue. The decoration is characteristic of the fully developed Imari style of the late seventeenth century. This type of plate was a favorite export commodity; examples found their way to Europe via the Dutch East India Company trade and were popular in Holland and England.

The large Imari plate with foliate rim (No. 87) is also decorated in underglaze blue and overglaze enamels and gold. Plates of this type are distinguished by a hexagonal trellis and paulownia design. Both in position within the design and in coloration, the paulownia (*kiri*) and flower groups inside the double circle hold the key to the overall design. The rim of the Seattle plate is decorated with a continuation of the formal trellis and floral pattern, probably derived from a textile design, and is dominated by eight deliberately placed paulownia leaves and blossoms in underglaze blue and overglaze iron red and green enamels. The central paulownia motif differs from the others by its prominent deep blue outline. The paulownia is often encountered as a *mon*, or family crest, sometimes used by the imperial family, among others. Here it serves purely decorative purposes.

The underside of the plate is decorated with a wave design in underglaze blue and plum blossoms in red and yellow enamels. The bottom is flat and has a central *daikon* (radish) mark within a broad circle, both in underglaze blue. There are eight spur marks.

This plate, one in the Freer Gallery of Art, and one in the W.W. Winkworth collection were formerly attributed to Shibuemon (d. 1716), the enigmatic uncle and guardian of Kakiemon VI (1690–1735). But the family's complex genealogy and the production of Kakiemon-style porcelains at other Arita kilns make attribution to specific persons impossible. Neither the Shibuemon theory nor attribution to him of certain types of porcelains, particularly those of superior quality and new shapes, often with indented edges in the case of plates, and with geometrically disposed designs showing the influence of textiles, can be sustained.

Future research might lead to a clearer identification of pieces once attributed to Shibuemon. In the use of underglaze blue and overglaze enamels and gold, the decoration of the Seattle plate conforms to Imari ware; the plate is therefore assigned to the Arita groups, decorated in the Imari style, a change from the former attribution. Its dating, on the basis of style and other attributes including the fine white porcelain and careful construction of the rounded sides with everted lip and short vertical beading, corresponds with the florescence of the fully developed Imari style. If, indeed, Shibuemon had anything to do with the plate, this is also the period when his best work is said to have been produced, namely between the years 1695 and 1699.

HT

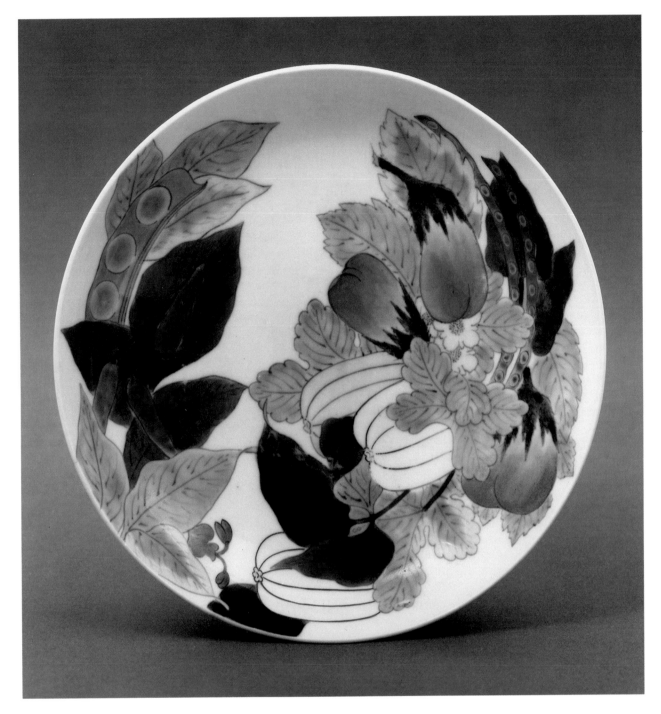

88.
Dish
Edo period, late 17th–early 18th century
Nabeshima ware, porcelain decorated in
 underglaze blue and overglaze enamels
Dia. 8⅛″ (20.4 cm)
Margaret E. Fuller Purchase Fund 68.176

During the height of its production, Nabeshima porcelains were the exclusive preserve of the Nabeshima clan and were produced to serve as presentation gifts to the Tokugawa shogunate, as well as to other feudal lords and nobility. The Nabeshima clan also presented the ware to household retainers in reward for services. Nabeshima porcelain, as illustrated by this example with vegetable design (No. 88), was a highly sophisticated ware of uniformly superior quality and flawless

texture created from the choicest and most refined clays.

Nabeshima ware was initiated by Naoshige, lord of the Nabeshima clan of Saga province and one of Hideyoshi's warlords. No precise historical record survives to trace the early development of Nabeshima porcelain, but its chronology generally follows three periods of development, identified by the location of its kilns: I, at Iwayakawachi (1628–1660); II, at Nangawara (1661–1674); and III, at Ōkawachi (1675–1871).

The earliest examples from Iwayakawachi consisted primarily of celadon and blue and white porcelain. It is recorded that the very first generation potter, Soeda Kizaemon, studied celadon production under Takahara Goroshichi and was eventually successful in producing a fine celadon. As a result, his kiln became the *ondōgu-yama* (a place producing "official utensils") and the title *teakiyari* was conferred upon him by the Nabeshima clan, whose official patronage he then enjoyed.

The reasons for moving the *ondōgu-yama* to Nangawara are not known; the event, unmentioned in the official Nabeshima record, is known only from a passing comment in the Soeda family record. One possible explanation may be that the potters and products of Nangawara, located nearer to Arita, were superior to those of Iwayakawachi.

The most important phase is the third, when the kiln was moved in about 1675 to Ōkawachi, a remote mountain village near the port town of Imari. Most wares identified today as Nabeshima come from this site, including the Seattle example.

Fine porcelain clay had been found at Ōkawachi, where the best Nabeshima ware was produced during the Genroku (1688–1704) and Kyōhō (1716–1736) eras. These superior clays were refined and aged, producing ceramic bodies distinguished by purity of color and uniformly delicate texture. During this time, when the kilns enjoyed a noncompetitive "official" status, the manufacture of Nabeshima was strictly controlled, and potters were required to adhere to the highest technical standards in order to produce only the finest porcelains.

According to the Soeda family record, a new title was conferred upon the family in the Kyōhō era, inferring the establishment at this time of the official clan kiln system. Their title was changed from *ondōgu-yama-yaku*, connoting responsibility for the clan kiln, to *tōkigata-yaku*, meaning responsibility for ceramic affairs (porcelain production) — or kiln governor. The official kiln now became known as the *goyōtōki* kiln, a term applied to the clan kiln and to the system accompanying this appellation, which remained in effect until 1871.

During the first and second periods of development, Nabeshima porcelain was produced in the clan kiln on a relatively small scale. The official system of supervising porcelain production had not yet been established. Only in the third period, when the kiln was at Ōkawachi and when the family title and responsiblity expanded, did the clan begin tight organizational control, demanding production of high quality pieces according to standardized specifications.

With the change of title and appointment of kiln governors, a number of related positions were simultaneously established, including thirty-one posts for artisans with specific duties, who were looked after by the Nabeshima lord and who received clothing, food, and housing. Records show that the artisans numbered eleven throwers, nine decorators in painting, four mold makers or perhaps modelers, and seven general workers.

Designs and patterns were controlled by the clan. Not only shapes but even the size of dishes, which were usually made in sets of ten or twenty for use at official gatherings, were standardized. The desire to produce porcelain of the highest quality meant that each piece demanded much handwork and individual attention; mass production on the order of the Arita kilns was impossible. Imperfect pieces were buried; because of attrition at each stage of production, the yield of successfully fired pieces must have been less than 50 percent.

The Seattle dish is an example of Iro-Nabeshima, or enameled Nabeshima. In this technique a combination of underglaze cobalt blue and overglaze enamels was used for the decoration. Characteristically, this technique was used only on the inside; the underside and exterior of the foot rim were decorated in a pure, luminous cobalt blue without use of enamels. Pieces like this dish were specially made to be presented to the shogun and other clan lords.

The dish is decorated on the inside with a vegetable design, rare compared to the more common floral and textile patterns. The design is disposed asymmetrically and includes a hot pepper plant, peapod, melon, eggplants, and two long beanpods with leaves. Underglaze blue outlines delineate the design, which was then completed in overglaze enamels. Like other dishes of this type, the distinctive form of the piece, with its high foot and relatively shallow interior with smoothly curving sides, was probably derived from lacquer prototypes.

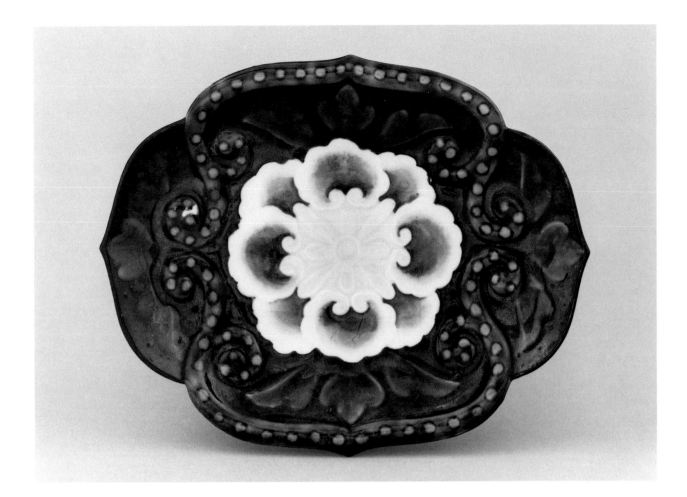

89.
Shallow dish with petal edges
Edo period, early 18th century
Arita ware, Matsugatani type; porcelain decorated
 in underglaze blue and overglaze enamels
L. 6⅜" (16.2 cm), W. 5" (12.2 cm)
Eugene Fuller Memorial Collection 65.112

The high foot rim with cobalt blue comb pattern design (*kushi-de*, or *kushi-kōdai*) is one of the most characteristic features of Nabeshima ware; however, "heart" patterns and lattice patterns are also found. The care and quality of workmanship of the design often indicate the date of the piece; later pieces tend to become more mechanical and careless in execution. The underside of the Seattle dish has a cobalt blue design of interlocking circles (*shippō*) and ribbons representing strings of Chinese coins, a pattern frequently encountered on Nabeshima ware dishes. Only three enamel colors — red, yellow, and green — were used for the vegetable designs inside the dish. These colors are almost exclusively used for Iro-Nabeshima, in combination with underglaze blue. The Nabeshima enamels are distinguished by brilliance of color, as well as by

elegance and subtle harmony of effects. The red, for example, was very subdued and usually more orange than pure red, and contrasts with the bright persimmon red of Kakiemon-type porcelain.

At 20.4 centimeters in diameter, the Seattle dish is close to the medium size of three standard sizes reserved for dishes of this type. During the two hundred years of Nabeshima production, only about seventy designs for dishes of this size were created. The uniformity of the designs, whether of the pictorial or patterned variety, was achieved by using stencils and paper transfers, techniques ordinarily associated with stencil pattern dyeing and *maki-e* lacquer. After the piece was formed, a paper with the desired design outlined in charcoal was placed over the surface to be decorated. The design was transferred to the porcelain surface by

rubbing the paper, and then outlined in cobalt blue. A clear glaze of flawless transparency was then applied, the piece fired, and the enamels subsequently added over the glaze. A second, lower temperature firing was required to fuse the enamels to the glaze surface.

It had been standard practice at Arita to divide the artisans involved in overglaze enameling work into two groups — those who operated the enamel kiln and those who painted the overglaze enamel designs. This was in accordance with the express orders of the Nabeshima clan, whose intent was to keep the two groups separate in order to preserve the secrecy of the production process. According to the records of the Taku clan, an offshoot of the Nabeshima clan, the Ōkawachi kiln produced celadons and underglaze cobalt blue decorated porcelains, but it seems that the overglaze enamel decoration was fired at Arita, which was also under the control of the Nabeshima family. The art of overglaze enamels was the sacred preserve of the artisans living in Arita, and any attempt to allow artisans to practice their profession outside Arita proved unsuccessful. As a result, the enamels were brought to Ōkawachi to be applied to the porcelain. The painted pieces were then carefully packed and transported to the red painting quarter in Arita, where they were fired in enamel kilns. After firing, the finished pieces were again returned to Ōkawachi, escorted and guarded en route by watchful clan officials.

This cumbersome and costly method undoubtedly slowed the output of enameled ware and helps account for the small number of surviving enamel-decorated pieces. And as enameled Nabeshima porcelains were made only on special order and on rare occasions, considerably fewer pieces were produced compared to the regular output of the Nabeshima kiln. According to Imaizumi, only about thirty dishes with this rare design of vegetables were made as gifts, and very few have survived.

The second dish (No. 89) is classified as Matsugatani type and represents a ware rather different from Nabeshima. Like the latter, it is decorated in underglaze blue and overglaze enamels, but here all similarity ends. The dish is of small foliate shape and has a molded floral motif in the center reserved in white, with petals shaded in underglaze blue. The remaining ground is painted black, with leaves in deep, soft green and scrolls of aubergine highlighted with yellow dots on the scrolling. The technique is that used for Ao Kutani (Green Kutani), but the emphasis and spirit are quite different. The back of the dish is undecorated but has a thin white glaze, which has turned somewhat matte in one of the firings. The piece is supported on a high, oval sturdy foot that shows the clay body to be very fine grained and white.

Matsugatani was an Arita kiln, but the history of the ware is uncertain, and the kiln site has not been excavated. The kiln belonged to the Ogi clan, an offshoot of the Nabeshima, and is believed to date from 1699. The kiln was most active during the period 1736 to 1743; activity seems to have come to an end in 1746. Matsugatani-type ware remains very rare; further attempts at identification and classification must await excavation of the kiln site. For the present, it may be concluded that Matsugatani is an Arita ware and that pieces so identified, usually small shallow dishes, are normally distinguished by their molded designs, as well as underglaze blue and overglaze enamel decoration with bold and unconventional designs.

HT

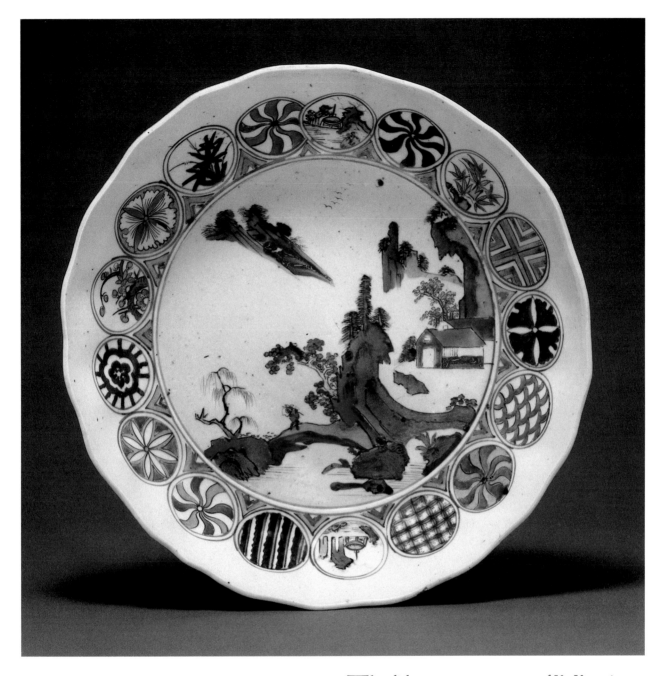

90.
Deep dish
Edo period, late 17th–early 18th century
Ko Kutani ware, porcelain decorated in
 underglaze blue and overglaze enamels
Dia. 12⅝″ (32.1 cm)
Eugene Fuller Memorial Collection 52.102

This dish represents a rare type of Ko Kutani ware decorated in the Shonzui style. This designation derives from the decoration of circular medallions (*marumon*) with geometric, floral, and landscape motifs, as well as the large landscape in the center, all typical of Chinese Transitional ware attributed to the legendary potter Shonzui and much admired by Japanese tea masters.

According to legend, Shonzui learned the secrets of porcelain making in China. Upon his return to Japan, he is said to have created the porcelains now associated with his name. These wares are distinguished by decoration in brilliant underglaze blue

and by superior white porcelain bodies that rival the best of the Chinese imperial porcelains.

The interior of the dish is decorated with a striking Chinese-style landscape in overglaze enamels of brilliant blue, turquoise, aubergine, dull yellow, a subdued matte red, and black. The landscape is contained within a large circle of double lines in underglaze blue. The *marumon* and the triangular motifs between them are painted in underglaze blue and enamels. The back of the dish is decorated with four rapidly executed sprays of plum painted mostly in underglaze blue and supplemented by a degraded red enamel almost maroon in hue, and a green enamel approximating the color of Kangxi apple green. On the base, within the unglazed foot ring is a stylized square *fuku* (happiness) mark in underglaze blue and centered within a double circle of underglaze blue. Formed of a heavy greyish white clay, the dish is well made with a rounded wavy lip rim and short, cut foot. The glaze is creamy white and uncrackled, but is rather uneven and flocculent, especially on the underside. The center is slightly crowned and the sides curve up rather steeply.

The history of Ko Kutani and its exact provenance is a matter of considerable controversy. Traditionally Ko Kutani porcelain, with its bold designs and colorful overglaze enamels, is believed to have been made under the patronage of the Maeda clan, lords of Kaga province (modern Ishikawa prefecture) in northwestern Japan, and among the wealthiest and most powerful feudal retainers under the Tokugawa shogunate. According to one legend, the lord of Kaga, Maeda Toshiharu, who wished to establish a porcelain industry in order to produce ceramics locally after the fashion of popular late Ming and Qing overglaze ceramics, sent Gotō Saijirō, a loyal vassal, to Arita to act as a spy to learn the secrets of overglaze enameling at the Kakiemon kilns. This is said to have occurred around the middle of the seventeenth century.

The process of overglaze enameling was carefully guarded by the Kakiemon family, and in order for Saijirō to gain access to it he married a Kakiemon daughter and became a servant in the household. Once in possession of the enameling secrets, Saijirō is said to have abandoned his family and returned to Kaga around 1655. Under the patronage of the Maeda clan, he subsequently established a kiln at the remote mountain village of Kutani. The products of this kiln are known as Ko Kutani, but for unknown reasons the manufacture of this ware is thought to have ceased by the end of the Genroku era (1688–1704).

The Saijirō legend, including the identity and provenance of Ko Kutani, has been seriously questioned by scholars in recent years, with no clear answers forthcoming. One difficulty is that despite a series of excavations in 1970 and 1971 at the kiln site, some twelve miles upstream from present-day Yamanaka Hot Springs on the Daishōji River in Ishikawa prefecture, as well as further intensive archaeological research by Japan's leading scholars and ceramics experts, none of the sherds excavated can clearly be identified as enameled ware of Ko Kutani type. Only sherds of white, blue and white, celadon, and iron-glazed ware were found. The painting on the blue and white sherds was, moreover, quite different from that associated with Ko Kutani and rather resembled the style of Arita wares. It is therefore not clear that enameled wares of Ko Kutani type were in fact produced at the site in Ishikawa prefecture. At the time Ko Kutani is supposed to have been produced, the area was controlled by the Daishō-ji fief, a subdivision of the Maeda domain.

A revival of Kutani porcelain production occurred with the opening of the Kasugayama kiln in 1806, and languished until the opening of the Yoshidaya kiln on the site of the old Kutani kiln in 1823. But the remote location was not conducive to commercial success, and in 1826 the kiln was relocated at the village of Yamashiro. These revival wares were aimed at commercial production featuring everyday wares. Yoshidaya and Wakasugi ware, as these later products are referred to after the names of the principal kiln sites, are quite distinct from earlier Ko Kutani in their decorative motifs as well as color of the enamels.

Some of the Ko Kutani wares suggest a stylistic relationship to the Arita products, especially to sherds from the Yamabeta kiln site, and this group of Ko Kutani wares has in recent years been reassigned and given an Arita provenance. It has also been suggested that some of the so-called Ko Kutani pieces were made at Arita and exported, undecorated, to Daishō-ji where they were then decorated in enamels. This theory has a few followers, but there is no real evidence to support it. In fact, the lack of any literary evidence makes a solution of the Ko Kutani problem all the more difficult. The question as to where the bulk of Ko Kutani wares was produced presently remains unanswered and must await the results of possible new excavations and future findings. Many pieces previously believed to have a Kaga provenance were in fact from kilns in the Arita area of northern Kyushu.

The fame of enameled Ko Kutani ware derives in large measure from the strong ceramic shapes, bold imaginative designs, and brilliant colors of the overglaze enamels, which introduce hues usually quite different from those normally encountered in Arita wares. Pieces identified as Ko Kutani are characterized by a virile roughness, in contrast with the elegance and sophistication of the Kakiemon and Nabeshima porcelains. Ko Kutani bodies often show kiln damage and usually have an impure, grey tone frequently described as having the appearance of *mochi* (rice cakes). The typical Ko Kutani glaze is unevenly applied and nonlustrous; moreover, it often shows cracks, pitting, or crazing. The majority of this ware consists of large plates and dishes, with a variety of smaller examples, as well as a few bowls, sake bottles, wine ewers, and vases.

The large Seattle dish may reasonably be given a date in the second half of the seventeenth century, the period when Ko Kutani is believed to have flourished. For the present, it may be assumed that some of the various types of Ko Kutani enameled porcelain, including the Seattle example, were produced in Kaga province under the patronage of the Maeda clan. And in the case of the Shonzui group represented by the Seattle example, the inspiration for the decorative motifs is clearly of Chinese derivation. Kaga province was a major market for the import of Chinese goods, including ceramics. The Maedas eagerly sought such goods, as did the daimyos bearing allegiance to them, for they were all quite prosperous as a result of the shipping trade then flourishing in the Japan Sea. Considerable quantities of Chinese ceramics were at the same time imported through Hirado and Nagasaki. Chinese Transitional-period motifs on Ko Kutani porcelains is therefore not surprising.

HT

NOTES AND LITERATURE

1.

LITERATURE: J. E. Kidder, Jr., *Japan Before Buddhism*, New York 1959, p. 70ff; idem, *The Birth of Japanese Art*, New York/Washington 1965, p. 45ff; idem, *Jōmon Pottery*, Tokyo/New York 1968, pp. 7, 225ff; Namio Egami, *The Beginnings of Japanese Art*, New York/Tokyo 1973, p. 159 and chart after p. 152; Richard Pearson, *Image and Life: 50,000 Years of Japanese Prehistory*, Vancouver, B.C. 1978, p. 10; Hiroyuki Kaneko, *Jōmon Jidai (III) (Kōki Banki), Nihon no Bijutsu* no. 191, Tokyo 1982, Fig. 9, and pp. 30–31.

2.

LITERATURE: J. E. Kidder, Jr., *Japan Before Buddhism*, New York 1959, p. 90ff; Richard Pearson, *Image and Life: 50,000 Years of Japanese Prehistory*, Vancouver, B.C. 1978, p. 12ff; Makoto Sawara, *Dōtaku, Nihon no Genshi Bijutsu* no. 7, Tokyo 1979, Nos. 25–26, 38–39, 45, 75, 91, and pp. 44, 47–49, 54–55, 58–59, 64; Masashi Kinoshita, *Yayoi Jidai, Nihon no Bijutsu* no. 192, Tokyo 1982, p. 17; Tokyo National Museum, *Ogura Korekushion Mokuroku*, Tokyo 1982, No. 27; Fumio Miki, *Dōtaku*, Tokyo 1983, p. 100.

3–5.

Carmen Blacker (1975) discusses the holy mountain concept and the ritual summoning of kami. She interprets the term *yorishiro* as "temporary vessels for the kami" and specifically mentions "mirrors, swords and ... *magatama*, found in profusion in the great tombs...." Her discussions of theories about the Tokoyo (or Tokoyo no kuni), an enchanted faraway land, are interesting; it is intriguing to ponder the possibility of a connection between the design of the tombs and the ideas, described in Blacker's text, of Ichiro Hori regarding a shift of focus among the Japanese from the sea to the mountains during the late prehistoric period.

LITERATURE: J. E. Kidder, Jr., *Japan Before Buddhism*, New York 1959, No. 78, and pp. 135, 146–47, 178; Fumio Miki, *Haniwa, Nihon no Bijutsu* no. 19, Tokyo 1967, Nos. 9–10; Carmen Blacker, *The Catalpa Bow: A Study of Shamanistic Practices in Japan*, London 1975, pp. 38ff, 79; Richard Pearson, *Image and Life: 50,000 Years of Japanese Prehistory*, Vancouver, B.C. 1978, ill. p. 18, Nos. 44, 87a, and pp. 19, 30; Kanekatsu Inokuma, *Haniwa, Nihon no Genshi Bijutsu* vol. 6, Tokyo 1979, ill. p. 44, Nos. 13, 124–25, and jacket ill., and pp. 13, 30, 46ff, 62; Shō Machida, *Sōshin-gu, Nihon no Genshi Bijutsu* vol. 9, Tokyo 1979, Nos. 45, 100, 117, 125, and p. 30; Bunji Kitamura, *Kodansha Encyclopedia of Japan* vol. 1, Tokyo/New York 1983, p. 167.

6–8.

Narasaki distinguishes green ash-glazed Shirashi types from late Sue ware both in purpose and technique; Shirashi, however, developed separately from Sue ware (Narasaki 1979; Cort 1979). A jar and cover nearly identical to the Seattle jar, in the Aichi Prefectural Ceramic Museum, comes from the Sanage area, pointing strongly to a Sanage provenance for the Seattle jar and further confirming Narasaki's opinion that it was made at a Sanage kiln. According to him, the glaze on its cover was applied with a brush, accounting for the slightly different glaze structure and color from that of the body.

The Tokyo National Museum holds two comparable examples of Shirashi ware: a jar and cover with ash glaze, early ninth century, described as Sue ware by Mayuyama (1976); and a smaller jar without lid dating in the tenth century (*Nihon Tōji Zenshū* 1976). The Tokyo covered jar is similar in shape and type to this piece; the smaller lidless jar is taller, more ovoid and elongated in shape, with higher shoulders (*Sekai Tōji Zenshū* 1979). A third example without lid is in the Fukuoka Art Museum (Narasaki 1979); registered as an Important Art Object, it is also designated as ninth-century Shirashi ware. A fourth jar without cover in the Idemitsu Museum of Arts is of the same type and ninth-century date; it was classified as Sue ware (Seattle 1981); a fifth, in the Suntory Museum of Art, also lidless and with running and streaked glaze effects, relates in general type to the Seattle example (Seattle 1972).

LITERATURE: *Ceramic Art of Japan: One Hundred Masterpieces from Japanese Collections*, Seattle 1972, No. 14, and p. 88; Junkichi Mayuyama, *Seventy Years* vol. 2, Tokyo 1976, No. 313, and p. 131; Shoichi Narasaki, *Japanese Ancient Period, Sekai Tōji Zenshū* vol. 2, Tokyo 1979, Nos. 92, 286–89, and pp. 112, 270; Louise Allison Cort, *Shigaraki, Potters' Valley*, Tokyo/San Francisco/New York 1979, p. 55; Henry Trubner and Tsugio Mikami, *Treasures of Asian Art from the Idemitsu Collection*, Seattle 1981, No. 40, and p. 97.

9.

LITERATURE: *Catalogue of Art Treasures of Ten Great Temples of Nara* vol. 1, *Hōryū-ji*, Pl. 39; and vol. 14, *Kōfuku-ji*, Tokyo 1932, Pls. 37–40; Miyeko Murase, *Japanese Art: Selections from the Mary and Jackson Burke Collection*, New York 1975, pp. 63–64; Jirō Sugiyama, *Classic Buddhist Sculpture: The Tempyō Period* (trans. Morse), Tokyo/New York 1982, Pls. 34–35.

10, 11.

LITERATURE: E. Dale Saunders, *Mudra: A Study of Symbolic Gestures in Japanese Buddhist Sculpture*, New York 1960, pp. 76–78; Takaaki Sawa, *Art in Esoteric Buddhism* (trans. R. L. Gage), New York/Tokyo 1972, pp. 9–15, 137; Akio Satō, ed., *Michinoku no Butsu-zō, Nihon no Bijutsu* no. 221, Tokyo 1984, pp. 32–59; Kyōtarō Nishikawa, *Ōmi no Butsu-zō, Nihon no Bijutsu* no. 224, Tokyo 1985, Figs. 95, 104.

12, 13.

The *natabori* technique was prevalent in the Kantō region and further north and appears to have originated in the late tenth and early eleventh centuries. Relatively few examples date from the Kamakura period; many early examples are provincial in nature, consisting of simple, harshly chiseled figures in stiff frontal poses. The sophisticated carving and careful and decorative use of the chisel on these two demons indicate a date at the very end of the Heian period or early Kamakura. Many of the chisel marks still contain traces of a gritty clay which must have served as gesso, and the figures were also entirely painted, contrasting with the earliest examples of this style and thus supporting a late Heian or early Kamakura date; see Satō (1984) and Tanaka (1984).

LITERATURE: Heinrich Zimmer, *The Art of Indian Asia* vol. 2, New York 1955, Pls. 34–35; Terukazu Akiyama and Saburō Matsubara, *Arts of China* vol. 2, Tokyo 1969, p. 174; Takaaki Sawa, *Art in Esoteric Buddhism* (trans. R. L. Gage), New York/Tokyo 1972, Pls. 123, 129, 145–46, and pp. 111, 115, 123; Miyeko Murase, *Japanese Art: Selections from the Mary and Jackson Burke Collection*, New York 1975, pp. 16–19; Bunsaku Kurata, ed., *Chōkoku, Zaigai Nihon no Shihō* vol. 8, Tokyo 1980, Fig. 56, and pp. 138–39; Akio Satō, *Michinoku no Butsu-zō, Nihon no Bijutsu* no. 221, Tokyo 1984, Figs. 83, 86–87; Yoshiyasu Tanaka, *Kamakura Chihō no Butsu-zō, Nihon no Bijutsu* no. 222, Tokyo 1984, Figs. 33–36.

14.
LITERATURE: Kyōtarō Nishikawa, ed., *Ichiboku-zukuri to Yosegi-zukuri, Nihon no Bijutsu* no. 202, Tokyo 1983, Fig. 91, and p. 71; Bunsaku Kurata, ed., *Hōryū-ji: Temple of the Exalted Law*, New York 1981, p. 27.

15.
Tanabe (1980) dates this piece to the Nambokuchō period (mid to late fourteenth century) on the basis of comparison with an example dated 1192 in the Harvard University Art Museums and a second, undated example in the Philadelphia Museum of Art. The body and the face of the Seattle Shōtoku appear softer and more fleshy than those of the other two; this seems stylistically more consistent with a date of around 1300.

LITERATURE: Saburosuke Tanabe, in Bunsaku Kurata, ed., *Chōkoku, Zaigai Nihon no Shihō* vol. 8, Tokyo 1980, Fig. 77, and pp. 146–47; Bunsaku Kurata, *Hōryū-ji: Temple of the Exalted Law*, New York 1981, p. 52.

16–20.
LITERATURE: Osamu Kurata, ed., *Butsugū, Nihon no Bijutsu* no. 16, Tokyo 1967, Figs. 50–57, 72, 74, 135, 142, and pp. 40, 45–47, 75–78.

21.
LITERATURE: Haruki Kageyama and Christine Guth Kanda, *Shinto Arts: Nature, Gods, and Man in Japan*, New York 1976, pp. 17–18, 25, 116.

22, 23.
There is some debate about the dating of the Sagara mask. Tanabe (1981) discusses the inscription on this piece and seems to accept it as belonging to a set of nine in Tōdai-ji and Tamukeyama shrine. The same author (1980) describes the mask as an early Kamakura replacement of the late twelfth century. There was a great deal of reconstruction and art activity at Tōdai-ji and the other great temples in Nara in the late twelfth century, at the very beginning of the Kamakura, and either date seems possible.

LITERATURE: Seiroku Noma, *Nihon Kamen Shi*, Tokyo 1943, pp. 221–25; Jōji Okazaki, *Pure Land Buddhist Painting* (trans. E. ten Grotenhuis), Tokyo/New York 1977, pp. 94–102; Kyōtarō Nishikawa, *Bugaku Masks* (trans. M. Bethe), Tokyo/New York 1978, pp. 19–31; Saburosuke Tanabe, in Bunsaku Kurata, ed., *Chōkoku, Zaigai Nihon no Shihō* vol. 8, Tokyo 1980, Fig. 100, and pp. 157–58; idem, *Gyodō-men to Shishi-gashi, Nihon no Bijutsu* no. 185, Tokyo 1981, Pls. 1–5, and pp. 1–22, 59–60; Kyōtarō Nishikawa, personal correspondence Dec. 1985.

24.
LITERATURE: *Kōya no reihō*, Tokyo, n.d., p. 40; Kyoto National Museum, *Iconography of Fudō Myōō*, Kyoto 1981, Pls. 1–8, 35 (color); 18, 22, 28, iconographic drawings Nos. 183, 186, and pp. 196–207; Carmen Blacker, *Kodansha Encyclopedia of Japan* s.v. Shugendō, Tokyo/New York 1983, p. 182; *Sangaku Shinkō Ihō*, Nara 1985; Genzō Nakano, *Fudō Myōō zō, Nihon no Bijutsu* no. 238, Tokyo 1985, pp. 44–45.

25, 26.
Poems by Ki no Tsurayuki and Mibu no Tadamine are quoted from Shimizu and Rosenfield (1985), pp. 46, 54, Edwin A. and Fumiko E. Cranston, translators.

Four more pages of the *Ishiyama-gire* are in collections in the United States: two in the Mary and Jackson Burke Collection, New York, and one each in the Philadelphia Museum of Art and the Freer Gallery of Art, Washington, D.C. They all show scattered floral and bird motifs over block-printed designs. The Freer page shows the collage decoration in addition to the other techniques, and along with one Burke page is also from the *Tsurayuki-shū*. All three pages show the same elegant brushwork from the hand of Fujiwara Sadanobu. The second Burke page is from the other book, the *Ise-shū*, written by a different calligrapher.

LITERATURE: Tōru Mori, ed., *Sanjū Rokkasen-e, Nihon Emakimono Zenshū* vol. 19, Tokyo 1967, Pls. 76, 94, and pp. 3, 68, 72; Yūzō Yamane, ed., *Rimpa Kaiga Zenshū, Sōtatsu-ha* part 1, Tokyo 1973, p. 263ff; *Nishihongan-ji bon, Sanjū Rokunin Kashū*, Osaka 1974; Yoshiaki Shimizu and John M. Rosenfield, *Masters of Japanese Calligraphy, 8th–19th Century*, New York 1985, Nos. 9, 36, and pp. 46–47, 54, 106; Tokyo National Museum, *A Selection of Japanese Art from the Mary and Jackson Burke Collection*, Nagoya 1985, Nos. 69–70.

27.
LITERATURE: Deitrich Seckel, *Emakimono*, New York 1959, Pl. 30a, and p. 140; Tōru Mori, *Kamakura Jidai no Shozō Ga*, Tokyo 1971, ill. pp. 233–36; Terukazu Akiyama in *Yamato-e*, Miyabi VIII, Tokyo 1985, No. 11.

28, 29.
LITERATURE: Kadokawa Shoten, ed., *Heiji Monogatari, Mōkō Shurai Ekotoba, Nihon Emakimono Zenshū* vol. 9, Tokyo 1964, ill. opp. p. 8; Miyeko Murase, "Japanese Screen Paintings of the Hōgen and Heiji Insurrections," *Artibus Asiae* 29:2/3 (1967), p. 198n14; Shujirō Shimada, ed., *Shōheki-ga, Rimpa, Bunjin-ga, Zaigai Hihō* vol. 1, Tokyo 1969, No. 18; Shigemi Komatsu, ed., *Heiji Monogatari Ekotoba, Nihon Emaki Taisei* vol. 13, Tokyo 1977, pp. 2–20; idem, *Kitano Tenjin Engi, Nihon Kaiga Taisei* vol. 21, Tokyo 1978, ill. pp. 80–82, and p. 101ff; *Emakimono, Zaigai Nihon no Shihō* vol. 2, Tokyo 1980, No. 10, and p. 130.

30.
LITERATURE: Miyeko Murase, *Japanese Art: Selections from the Mary and Jackson Burke Collection*, New York 1975, pp. 47–51; Toshio Fukuyama, *Heian Temples: Byōdō-in and Chūson-ji* (trans. R. K. Jones), Tokyo/New York 1976, pp. 46–79; John M. Rosenfield and Elizabeth ten Grotenhuis, *Journey of the Three Jewels: Japanese Buddhist Art in Western Collections*, New York 1979, pp. 61–62.

31.
LITERATURE: Jōji Okazaki, *Pure Land Buddhist Painting* (trans. E. ten Grotenhuis), Tokyo/New York/San Francisco 1969, pp. 174–79; Shujirō Shimada, ed., *Bukkyō Kaiga, Yamato-e, Suiboku-ga, Zaigai Hihō* vol. 2, Tokyo 1969, Pl. 49, and p. 69; John M. Rosenfield and Elizabeth ten Grotenhuis, *Journey of the Three Jewels: Japanese Buddhist Art in Western Collections*, New York 1979, No. 45, and p. 153.

32, 33.
LITERATURE: Richard E. Fuller, *Japanese Art in the Seattle Art Museum*, Seattle 1960, No. 59; Jōji Okazaki, *Pure Land Buddhist Painting* (trans. E. ten Grotenhuis), Tokyo/New York/San Francisco 1969, pp. 13–27; Shujirō Shimada, ed., *Bukkyō Kaiga, Yamato-e, Suiboku-ga, Zaigai Hihō* vol. 2, Tokyo 1969, p. 88; Saburō Ienaga, *Painting in the Yamato Style* (trans. J. M. Shields), Tokyo/New York 1973, pp. 9–36; Yoshitaka Ariga, in Taka Yanagizawa, ed., "Kannon-dō Zu," *Bukkyō Kaiga, Zaigai Nihon no Shihō* vol. 1, Tokyo 1980, No. 95, and pp. 156–58.

34.
LITERATURE: John M. Rosenfield and Elizabeth ten Grotenhuis, *Journey of the Three Jewels: Japanese Buddhist Art in Western Collections*, New York 1979, pp. 133–36; Taka Yanagizawa, ed., *Bukkyō Kaiga, Zaigai Nihon no Shihō* vol. 1, Tokyo 1980, Fig. 35, and p. 130.

35.
LITERATURE: Shujirō Shimada, ed., *Bukkyō Kaiga, Yamato-e, Suiboku-ga, Zaigai Hihō* vol. 2, Tokyo 1969, No. 9, and supplement p. 24; John M. Rosenfield and Elizabeth ten Grotenhuis, *Journey of the Three Jewels: Japanese Buddhist Art in Western Collections*, New York 1979, pp. 57–59.

36.
LITERATURE: Shujirō Shimada, ed., *Bukkyō Kaiga, Yamato-e, Suiboku-ga, Zaigai Hihō* vol. 2, Tokyo 1969, No. 40, and supplement pp. 61–62; Haruki Kageyama and Christine Guth Kanda, *Shinto Arts: Nature, Gods, and Man in Japan*, New York 1976, pp. 15–17; Terakazu Akiyama, *Bukkyō Kaiga, Zaigai Nihon no Shihō* vol. 1, Tokyo 1980, Fig. 100, and pp. 160–62.

37.
LITERATURE: Sherman Lee, "Japanese Art at Seattle," *Oriental Art* 2:3 (Winter 1949/50); John M. Rosenfield and Elizabeth ten Grotenhuis, *Journey of the Three Jewels: Japanese Buddhist Art in Western Collections*, New York 1979, pp. 168–70; Helmut Brinker, *Shussan Shaka Darstellungen in der Malerei Ostasiens*, Zurich 1983, pp. 54–55.

38.
Acquired from the late collector and dealer Inosuke Setsu, Tokyo, prior to 1951 the Seattle *tebako* was in the Masuda collection, Odawara, and earlier in the collection of Baron Kawasaki (Tokyo 1913). Arakawa (1969) describes a similarly decorated box bearing the date 1228; the Seattle box must have been produced about the same time.
LITERATURE: Yoshitarō Kawasaki, *Chōshunkaku Kanshō* vol. 5, Tokyo 1913; Hirokazu Arakawa, in *Nihon no Bijutsu* no. 35, Tokyo 1969, Fig. 113; Sir Harry Garner, *Chinese Lacquer*, London 1979, pp. 19–24.

39.
LITERATURE: Hirokazu Arakawa, "Kinen-mei Negoro-nuri ni tsuite," *Museum* 92 (Nov. 1958), Pls. 10–11 (color), 90–91, Figs. 10, 90 (dated inscriptions), and pp. 146ff; idem, *Negoro*, Atami 1966, pp. 147, 166; Miyeko Murase, *Japanese Art: Selections from the Mary and Jackson Burke Collection*, New York 1975, No. 101, and pp. 326–28; Beatrix von Rague, *A History of Japanese Lacquerwork* (trans. A.R. de Wassermann), Toronto/Buffalo 1976, pp. 85, 255n34; Ann Yonemura, *Japanese Lacquer*, Washington, D.C. 1979, Pl. 6, and pp. 14–15; Henry Trubner and Tsugio Mikami, *Treasures of Asian Art from the Idemitsu Collection*, Seattle 1981, No. 72, and p. 137; Sadamu Kawada, *Negoro*, Kyoto 1985, Pls. 112–26, and pp. iv, 272–77.

40.
A painting recovered from Dunhuang, now in the Fogg Museum, Harvard, depicts the Chinese pilgrim Xuanzang carrying a number of scrolls strapped to a kind of *oi*, which he carries on his back (Trubner 1948). An interesting exhibition in Nara (1985) was devoted to the arts and crafts associated with the mountain religions, including many recently excavated relics. It included a number of *oi* of different types, the earliest dating from the Muromachi period. Several *oi* in Japan, all from the northeastern region, are similar to the Seattle *oi* (Tokyo 1965–1966; Nara 1985). Murase (1975) reproduces an *oi* also belonging in this group and given a date in the late Muromachi period.
LITERATURE: Henry Trubner, *Chinese Paintings*, Los Angeles 1948, No. 3, and pp. 4–5; *Art Treasures from Japan*, Tokyo 1965–1966, No. 88; Carmen Blacker, *The Catalpa Bow: A Study of Shamanistic Practices in Japan*, London 1975, pp. 196–97; Miyeko Murase, *Japanese Art: Selections from the Mary and Jackson Burke Collection*, New York 1975, No. 100, and pp. 323–25, 325n3; *Tōyō no Shikkōgei*, Tokyo 1977, Nos. 180–81; *Sangaku Shinkō Ihō*, Nara 1985, Nos. 2–1 through 2–5, and pp. 95, 229–30.

41, 42.
The word 'Rimpa' (school of Kōrin) derives from Kōrin's name and is now commonly applied to decorative artists who worked from the seventeenth to the nineteenth century.

41: A tiered food box in the Tokyo National Museum, decorated in a modified version of the highly ornate Kōdai-ji *maki-e* style of the late sixteenth century, also features a design of grapevines and squirrels. It has been variously dated late Momoyama–early Edo (von Rague 1976; *Oriental Lacquer Arts* 1977). Its decoration is more crowded and more complex than that of the Seattle cabinet, with vertical and diagonal lines of a bamboo trellis and sweeping lines of vines breaking up the surface. Its grapevine-squirrel motifs are richer in decorative quality than the Seattle piece, suggesting that the latter, lacking some of the sophistication and refinement of the Tokyo box, dates slightly earlier.

The Seattle cabinet may also be compared with a contemporary *sage-dansu* in the Yamato Bunkakan collection (1983), which is slightly larger and similarly fitted with hinged door, lock, and curved handle on top. Decorated with a design of flowers in gold *maki-e*, its date and similarity in type and concept provides further evidence supporting a Momoyama date for the Seattle cabinet.

42: A writing box by Kōrin, the Sumino-e (Sumiyoshi Bay) *suzuri-bako* in the Seikadō collection (said to have been copied after an earlier now-lost writing box by Kōetsu) illustrates the relationship of the two artists (von Rague 1976; Pekarik 1980).

LITERATURE: Harold P. Stern, *Rimpa, Masterworks of the Japanese Decorative School*, New York 1971, No. 24, and p. 54; Sherman E. Lee, *Japanese Decorative Style*, New York/London 1972, Figs. 127, 127a, and pp. 98, 114, 149; Beatrix von Rague, *A History of Japanese Lacquerwork* (trans. A. R. de Wassermann), Toronto/Buffalo 1976, Pls. 136, 148, 163, and pp. 170–71, 181, 203, 262–63n14; *Oriental Lacquer Arts*, Tokyo 1977, Nos. 215, 597–98; Andrew J. Pekarik, *Japanese Lacquer, 1600–1900*, New York 1980, Figs. 63, 69, Color Pl. p. 9, and pp. 57, 60; Henry Trubner and Tsugio Mikami, *Treasures of Asian Art from the Idemitsu Collection*, Seattle 1981, No. 73, and p. 138; George Kuwayama, *Far Eastern Lacquer*, Los Angeles 1982, No. 43, and p. 108; *Lacquer Wares from the Yamato Bunkakan Museum Collection*, 1983, No. 120, and pp. 56, 64, 91.

43.

Examples similar to the Seattle tray are in the Suntory Museum, Tokyo, the Museum für Ostasiatische Kunst, Dahlem West Berlin (*Oriental Lacquer Arts*, Tokyo 1977), and the Los Angeles County Museum of Art (Kuwayama 1982). Tokugawa (1977) also shows a nearly identical plate. All these trays, including that in Seattle, are related by their design of strident dragons amidst clouds chasing a flaming pearl, the border motifs, and colorful iridescent inlays applied in a technique specifically associated with Ryukyu lacquer.

LITERATURE: Sir Harry M. Garner, *Ryūkyū Lacquer*, London 1972, Pls. 2–4, 6, 11, and pp. 9–10; *Tōyō no Shikkōgei*, Tokyo 1977, No. 354; Yoshinobu Tokugawa, *Ryūkyū Shikkōgei*, Tokyo 1977, Pl. 139; idem and Hirokazu Arakawa, in *Shikkōshi*, Tokyo 1978, No. 47; George Kuwayama, *Far Eastern Lacquer*, Los Angeles 1982, No. 44, and p. 110.

44, 45.

All paintings believed by Shūbun, even those registered as National Treasures, are attributed without firm identifications (see Matsushita 1974; Tanaka 1972). Japanese authors conjecture about Shūbun's experiences in Korea and the impact of Korean contemporary ink painting on his work; however, any influence from the nervous line in Korean painting, so often pointed out, seems to have been eradicated relatively quickly from Japanese *suiboku-ga* (see *Ogura Korekushion Mokuroku*

1982; *Kankoku Bijutsu Gosennen* 1976). Shūbun's compositional influence appears in Shōkei Tenyū's *Kozan shokei*, where a detail shows the foreground portion of the Seattle scroll in reversed configuration (see Shimizu and Wheelwright 1976). Hiroshi Kanazawa has offered valuable suggestions in relation to this painting (conversation, Kyoto 1985).

Saiyo's name appears in a variety of documentary references; however, there still remains some confusion of identities through the possible use of similar names by different painters. Shimada lists Saiyo's earliest known work as the portrait of priest Ikkyū Sojun (1394–1481), which bears an inscription dated 1452. Other dated works include *fusuma* paintings of 1465 and *shōji* paintings for a Buddhist altar in 1469. Shimada accepts Hyōbu Bokkei and Bokkei Saiyo as identical and also accepts the fact that he died at Ise in 1473. Other paintings include such Zen themes as Hotei, Daruma, and Kanzan and Jittoku.

LITERATURE: Ichimatsu Tanaka, *Japanese Ink Painting: Shūbun to Sesshū*, New York/Tokyo 1972, pp. 67ff, 72, 85–94, 145; Takaaki Matsushita, *Ink Painting*, New York/Tokyo 1974, Nos. 37, 63–64, and pp. 60, 65ff, 98–99; Richard Stanley-Baker, in Yoshiaki Shimizu and Carolyn Wheelwright, eds., *Japanese Ink Paintings*, Princeton 1976, Nos. 10–11, Fig. 36, and pp. 97, 124ff, 126–27; *Kankoku Bijutsu Gosennen*, Tokyo 1976, No. 105; Takaaki Matsushita and Takeji Tamamura, *Josetsu, Shūbun, San Ami*, *Suiboku Bijutsu Taikei* vol. 6, Tokyo 1978, Nos. 10, 14, 68, 76; Teitoku Toda, *Bokkei/Gyokkan*, *Suiboku Bijutsu Taikei* vol. 3, Tokyo 1978, Nos. 18–20; Shujirō Shimada, ed., *Suiboku-ga, Zaigai Nihon no Shihō* vol. 3, Tokyo 1979, pp. 94–95, 128–29; *Ogura Korekushion Mokuroku*, Tokyo 1982, No. 938; Shin'ichi Miyajima and Yasuhiro Satō, *Japanese Ink Painting*, Los Angeles 1985, Fig. 2, and p. 20ff.

46–48.

46: The iconography is somewhat ambiguous; the mounted figure has also been identified, though less convincingly, as the poet Li Bo.

Yoshiaki's five-year rule (1568–1573) was the work of the powerful daimyo Oda Nobunaga (1534–1582). When Yoshiaki turned to him in 1568 for support in claiming the shogunate, Nobunaga invaded Kyoto, displaced the incumbent shogun, and installed Yoshiaki. Their relationship deteriorated into open warfare, however, and in 1573, as the final blow in a series of battles, Nobunaga encircled and set fire to Kyoto, precipitating Yoshiaki's surrender and exile and ending the Ashikaga shogunate.

In a three-line colophon to his poem, Yoshiaki states his belief that his ancestor Yoshimochi (1386–1428) had painted the picture. He then added the date of his own inscription, 1575, and his signature and seal. Shimizu and Rosenfield suggest the painting was also by Yoshiaki. It is possible to reach this conclusion based on a particular rendering of the inscription. Several brushed characters are somewhat distorted, which has led to differing interpretations of their identity and consequently to variant translations. This is particularly true in the first and last characters, seventh column from the right.

Yoshimochi's known paintings reveal him to have been an amateur painter of taste who could project personal intensity in his brief depictions. His simple renderings — figures of the white-robed Kannon, a profile portrait of Daruma — are typical Zen-inspired exercises that strive to transcend subject matter to become symbols of spiritual value; however, based on the clearly attributable works, it is improbable that a disinterested person would confuse Yoshimochi's ink renderings with the work of talented and trained monk-painters of the Zen monasteries.

The weight of legitimacy of a shogun's inscription has been most responsible for the polite acceptance of this painting as an early fifteenth-century work by Yoshiaki's ancestor. This attribution is encouraged in a seventeenth-century biography of painters which notes that Yoshimochi painted such a theme; he had in fact painted several. The *Honchō gashi* (published 1678), edited by Kanō Einō, was based on notes made by his father, the painter Kanō Sansetsu (1589–1651); possibly the information Sansetsu recorded was already a long-held tradition known also to Yoshiaki.

A seemingly unimpeachable example of this theme by Yoshimochi is in the Nishi Hongan-ji collection. While the subject, a Chinese figure on a donkey, is the same in both paintings, its treatment in the Nishi Hongan-ji painting is directly related to the untutored, flat depictions of other Yoshimochi paintings, and quite different from the deliberate and well-modulated treatment of the Seattle work. Writing in *Suiboku-ga, Zaigai Nihon no Shihō* no. 3 (1979), Kanazawa seemed to sense that the Seattle painting did not fit with Yoshimochi's known oeuvre; he remarked, one must think almost incredulously, that the work was so well done it should be considered Yoshimochi's masterpiece. He also alluded to the misleading inscription, and later reiterated his reservations (conversation, Kyoto, 1985).

47: The immigrant Zen priests in Japan remained closely linked to southern China. Through continued contact, they were able to maintain the purity of their Zen Buddhism and the benefit of trade with the Chinese. They introduced religious paintings of Buddhist figures in landscape settings; these meager sources provided valuable stimulus to the Japanese artists.

In Kyoto, Kei Shoki studied with Geiami, an artist of high rank though not of the Zen ateliers, who held the prestigious position of superintendent of the shogun's Chinese painting collection.

The artists Nōami (1397–1471), Geiami (1431–1485), and Sōami (1455–1525) were not Zen Buddhists. Their names, incorporating the element *ami*, marked their belief in the Pure Land sect. They and their similarly named associates maintained a special relationship with the Ashikaga shoguns and exerted considerable influence on the development of garden design, tea ceremony, and the Nō theater.

Among Kei Shoki's followers, Shikibu Terutada (fl. mid-sixteenth century), also known as Ryūkyō, was particularly outstanding. His work is in museum collections in Tokyo and San Francisco. A seal similar to one used by him was mistakenly added, sometime in the past, to the Seattle screen, probably because of the association of Ryūkyō with landscape screens and the shared general characteristics of the two artists' work (see Shimizu and Wheelwright 1976; Takaaki Matsushita 1974; and Yamashita, in *Kokka* no. 1084, 1985).

48: The oldest known ink landscape painting by a Japanese artist is a scene from the Eight Views and is datable to no later than 1317 (Kanazawa 1979).

Unkoku Tōgan, born into a samurai family in northern Kyushu, abandoned that status to become a painter. Following a model established by Sesshū Tōyō (1420–1506), he served the daimyo Mōri Terumoto (1553–1625), a descendant of the family who had welcomed Sesshū in western Honshu. The family still possessed a number of Sesshū's paintings, in particular the so-called long handscroll, which embodied the culmination of Sesshū's mature ink painting style and had been painted on his return from China almost a century earlier. Terumoto encouraged Tōgan to live and work in the Unkoku-an, Sesshū's studio located within the Mōri fief, and gave him the long handscroll. Tōgan made a copy of it and inscribed it, vowing to make Sesshū's style his own. He chose Unkoku for his name as a mark of respect and commitment.

Tōeki, Tōgan's second son, became the next head of the Unkoku school after his elder brother Tōōku died before he could assume the role. Perhaps Tōeki had not been properly prepared for the burden of leadership; his style seems disappointing in comparison to his father's and suggests a self-conscious preoccupation with his responsibility. Tōeki and the artist of the Seattle screens possess several Unkoku school traits in common. Further, between them but unlike Tōgan, they exhibit a pronounced pointillistic technique. But Tōeki's usual stiff structuring of the dots is quite different from the gentle Mi-dot quality of the Seattle screens.

Each of these screens has two intaglio seals. The upper is in the shape of a gourd and reads *Unkoku*; the lower is square and reads *Tōgan*. Although badly damaged, the two square seal impressions retain enough to determine the intent of the two characters. Neither character is consistent in shape, size, or arrangement with published seals of this type; it is probable they were added later. There is no written signature.

LITERATURE: *Kokka* nos. 100 (1898), 153 (1903), 820 (1960), 827 and 828 (1961); Shujirō Shimada, ed., *Bukkyō Kaiga, Yamato-e, Suiboku-ga, Zaigai Hihō* vol. 2, Tokyo 1969, No. 74; John Rosenfield and Shujirō Shimada, *Traditions of Japanese Art: Selections from the Kimiko and John Powers Collection*, Cambridge, Mass. 1970, No. 74; Shun Etō, "Ashikaga Yoshimochi Jigasan Daruma-zu," *Kobijutsu* no. 35, Tokyo 1971, p. 104ff; Takaaki Matsushita, *Ink Painting*, New York/Tokyo 1974, No. 112, and pp. 48ff, 117, 119; Yoshiaki Shimizu and Carolyn Wheelwright, eds., *Japanese Ink Paintings*, Princeton 1976, Nos. 3, 9, 23, 25, 37, and pp. 54ff, 194; Ichimatsu Tanaka and Taniō Nakamura, *Sesshū/Sesson, Suiboku Bijutsu Taikei* vol. 7, Tokyo 1977, Nos. 133–35, and p. 191; Takaaki Matsushita and Takeji Tamamura, *Josetsu, Shūbun, San Ami, Suiboku Bijutsu Taikei* vol. 6, Tokyo 1978, Nos. 1, 27–28, 138–49, and p. 169; *Chūsei Byōbu-e*, Kyoto 1979, No. 72, and pp. 239–41; Hiroshi Kanazawa, in Shujirō Shimada, ed., *Suiboku-ga, Zaigai Nihon no Shihō* vol. 3, Tokyo 1979, p. 125; idem, *Japanese Ink Painting, Early Masterpieces*, Tokyo/New York/San Francisco 1979, No. 89; *Kyūsei Hakone Bijutsukan/Kyūsei Atami Bijutsukan, Meihin Mokuroku* vol. 1, Atami 1979, No. 58; Masatomo Kawai, *Yūshō, Tōgan, Nihon Bijutsu Kaiga Zenshū* vol. 11, Tokyo 1981, Nos. 39–41, 46, 52, 55–56; Masato Ōzaki, "Unkoku Tōeki-hitsu Shurenka—shihon Sampukutsui no Seiritsu to Kaikei wo Megute," *Kobijutsu* no. 60, Tokyo 1981, p. 25ff; Stephen Addiss and G. Cameron Hurst III, *Samurai Painters*, Tokyo/New York/San Francisco 1983, Nos. 3–4; *Exhibition of Japanese Paintings from the Museum of Fine Arts, Boston*, Tokyo 1983, Nos. 32, 53; Shin'ichi Miyajima and Yasuhiro Satō, *Japanese Ink Painting*, Los Angeles 1985, Nos. 12, 26; Yoshiaki Shimizu and John Rosenfield, *Masters of Japanese Calligraphy, 8th– 19th Century*, New York 1985, No. 54, and p. 150; Yūji Yamashita, "Shikibu Terutada no Kenkyū," *Kokka* no. 1084, Tokyo 1985.

49–51.

The Kanō school painters enjoyed the position of official painters to the ruling military family throughout the Edo period; however, Kanō artists had first attracted official attention in the fifteenth century, when the Ashikaga shogun, on a hunting trip in the Izu area, was impressed by the painting of a young warrior named Kanō Masanobu. Masanobu (1434–1530) was later called to Kyoto where his painting received considerable favorable notice, and he was ultimately appointed painter to the shogunal court. His son Motonobu succeeded him in the post. Motonobu (1476–1559) codified the esthetic enunciated in his father's works and organized a family-centered studio.

Motonobu successfully fused the *kanga* (Chinese-style ink painting) with the ancient *yamato-e shōheki-ga* (colorful wall and panel painting). The *yamato-e* style, though popular since the Heian period, had been largely displaced during the Muromachi period by the Zen-inspired ink painting of the *kanga* school. Of particular significance was Motonobu's incorporation of gold into his compositions; this became a central element in the work of later Kanō artists. Early gold-ground screens, apparently part of the *yamato-e* genre in the fifteenth century, have largely been lost, creating the impression that they were an invention of the Momoyama period (Doi 1977).

Several dates are put forward for Mitsunobu's birth; those used by Takeda (1977) and Doi (1977, 1978) do not agree. Even though Doi's dating makes Mitsunobu very young at the time of the Azuchi project, he points out that at age fourteen Kanō Yasunobu was helping his older brother Tanyū with a commission at the imperial palace (1626) and that Mitsunobu, although only eleven or so but already Eitoku's acknowledged heir, would likely have been included in the Azuchi castle project for Nobunaga, an undertaking that continued for several years.

Among Takanobu's commissions for shrines for the imperial family are: a set of panel paintings (1613) now in the Ninna-ji, Kyoto; the portraits of the Thirty-six Immortal Poets (1618) originally at the Daihō-ji, Nagoya; and the two scrolls of *rakan* painted at the request of emperor Goyōzei (1571–1618) for the Tōfuku-ji, Kyoto, to replace lost originals from a set of fifty scrolls by Minchō showing the five hundred *rakan*; and the portrait of Goyōzei (probably 1611) at Sennyū-ji, Kyoto (ill. Doi 1978).

49: The Seattle *fusuma* bear no signatures or seals, a common practice in the sixteenth century which has led to much confusion and misattribution. These *fusuma* were attributed to Kanō Sanraku before they left Japan. Doi (1978) later recognized these panels as being by Takanobu. No documentary evidence from the Danzan shrine has been offered to support the assertion that the Seattle *fusuma* were once there. Doi and others base this belief on remembrances of when the screens came into the hands of a Kyoto dealer, and when they were displayed at the Osaka Municipal Art Museum (c. 1934–1935). At the time the dealer obtained the panels, they are said to have had on their versos bird and flower paintings which were subsequently separated and are now, some say, in the British Museum. These are described by Basil Gray in the *British Museum Quarterly* (XII:2, 1938). In correspondence dated 1950 in Seattle Art Museum files, then-Keeper of Oriental Antiquities Gray stated he believed the British Museum panels to be from a companion series done for the same room as the Seattle Art Museum screens. Gray seemed to confirm this idea in 1955 (correspondence, SAM); he felt at that later date that he should identify the artist no more precisely than "School of Eitoku."

Takanobu's handling of the *kinki shoga* theme contrasts sharply with Eitoku's early, conservative, *kanga*-influenced treatments at Reiun-in and Jukō-in, Kyoto. Yet he seems to have borrowed some elements from his father's version, in figure poses and the vertical rock backdrop, the *go* players, and the triangular rocks rising from the immediate foreground (Doi 1978; Takeda 1980).

50: Information on Shigenobu's life is extremely limited and sometimes confusing; his birth and death dates are not known, and the name appears in records in a way suggesting there may have been more than one person of this name. Tsugiyoshi Doi, authority on Momoyama-period painting, has resurrected Shigenobu as an artistic personality by re-attributing works previously thought to be by other artists, or by anonymous artists (Doi in *Kokka* no. 1025, 1979). Christine M. E. Guth (1986) identifies Shigenobu as a follower of Mitsunobu, based on the qualities of style; she discusses the influence of the currently popular botanical books on contemporary painting.

Other Shigenobu works are a single six-panel screen with a similar composition of poppies, bamboo, and also wheat (Kimbell Art Museum, Fort Worth), and a set of portraits of the Thirty-six Immortal Poets (Danzan shrine, Nara prefecture). Shrine documents and corroborating evidence date these poet paintings to between 1619–1621. Doi (1979) also attributes to Shigenobu *kimpeki fusuma* paintings at Nijō castle, Kyoto, done as part of its refurbishing in preparation for the 1626 visit of emperor Gomizuno-o. Examples of the Eight Views of the Xiao and Xiang Rivers (Suhara collection, Japan) and a painting of a pheasant on a plum branch (private collection, Hyōgo, Japan) are also given to Shigenobu. This latter work carries the same seals as on the Seattle screens, which also appears on the Danzan shrine poet paintings. These seals appear in artist dictionaries along with Shigenobu's signature.

51: By the latter part of the century, there were also *machi-eshi* who had trained with one of the studios but who had been granted permission to establish independent studios (see Nos. 52, 53). The Edo Kanō painters are always regarded as important in the development of later Japanese painting, but little has been written on them (especially in English). A special exhibition at the Tokyo National Museum brought together perhaps the largest number of Kanō school paintings, and the catalogue gives substance to the contention that the Edo Kanō were important painters and is a convenient source of information on the school and the individual artists (*Kanō-ha Kaiga, Tokubetsu-ten*, Tokyo 1979).

The studios of the *oku-eshi* became known by the names of the locations in the city of Edo. Tanyū, the first to set up residence, established his studio in Kaji-bashi, followed by Naonobu in Kobiki-chō, then Yasunobu in Nakabashi, and Minenobu in Hama-chō (established only in the early eighteenth century).

LITERATURE: Will H. Edmunds, *Pointers and Clues to the Subjects of Chinese and Japanese Art*, London n.d., p. 201; Henri L. Joly, *Legend in Japanese Art*, London/New York 1908, ills. opp. pp. 44, 270, and pp. 41, 267; Basil Gray, "A Recent Acquisition of Japanese Painting," *British Museum Quarterly* XII:2 (1938), Pl. XVI, and pp. 47–48; Tsugiyoshi Doi, *Momoyama Decorative Painting*, New York/Tokyo 1977, Pl. 83, and pp. 37ff, 66–67, 74, 131ff, 143–44; Tsuneo Takeda, *Kanō Eitoku*, Tokyo/New York/San Francisco 1977, pp. 43ff, 118ff; Tsugiyoshi Doi, *Kanō Eitoku/Mitsunobu, Nihon Bijutsu Kaiga Zenshū* vol. 9, Tokyo 1978, No. 43, Pls. 10, 36–41, and pp. 112, 120, 141; idem, *Motonobu Eitoku, Suiboku Bijutsu Taikei* vol. 8, Tokyo 1978, Pls. 5, 10, and pp. 52, 178–79; Teisuke Toda, *Bokkei/Gyokkan, Suiboku Bijutsu Taikei* vol. 3, Tokyo 1978, Pls. 71–72; *Chūsei Byōbu-e*, Kyoto 1979, Pls. 65–68, 70, 75; *Kanō-ha Kaiga, Tokubetsu-ten*, Tokyo 1979, Pls. 144, 147, Appendix Fig. 15, and p. 25ff; Tsuneo Takeda, ed., *Shōhekiga, Zaigai Nihon no Shihō* vol. 4, Tokyo 1980, Pls. 58–61, and pp. 98–99; George Elison, "The Cross and the Sword: Patterns in Momoyama History," in George Elison and Bardwell L. Smith, eds., *Warlords, Artists, and*

Commoners: Japan in the Sixteenth Century, Honolulu 1981, pp. 55–85; Carolyn Wheelwright, "A Visualization of Eitoku's Lost Paintings at Azuchi Castle," in ibid., Honolulu 1981, pp. 87–111; Shin'ichi Miyajima and Yasuhiro Satō, *Japanese Ink Painting*, Los Angeles 1985, No. 10, and p. 61; Christine M. E. Guth, "Varied Trees: An I'nen Seal Screen in the Freer Gallery of Art," *Archives of Asian Art* XXXIX (1986), pp. 48–61.

52–54.

52: The prototype for the Seattle screens can be found in a pair of screens by Tosa Mitsunobu (d. 1522). No longer extant, they are recorded in a diary entry dated to 1506 which states Mitsunobu had created a pair of screens with a new kind of picture showing the city of Kyoto (Yamane 1973; Murase 1975). Compositions of depictions of the city fall into four main types, in which the city is seen from characteristic angles or incorporating typical portions. Arrangement and grouping of elements became more or less standardized in the early Edo period, which saw the essential development of the type (Yamane 1973). The Seattle pair are of the type which divides the city into eastern and western views (Tsuji 1976).

The Gion Matsuri was suspended during the Ōnin War. It seems probable that the now-lost Mitsunobu screens of 1506 were commissioned in its wake when Kyoto was virtually reborn and the festival resumed in 1500 (Yamane 1973).

A main feature of the festival is a great parade of decorated carts sponsored by local neighborhoods. On the night before, the streets are alive with happy crowds; homes are opened on the street side, and the families' prized possessions are displayed. These frequently include decorative folding screens. This tradition seems to be very ancient; the prominence of the Gion Matsuri parade in the *rakuchū rakugai-zu* theme strongly suggests a connection. When placed parallel rather than side-by-side, the screens display the city spread out from side to side, bracketing and protecting the family's treasures.

Each screen bears a seal of the type used by Tosa Mitsuoki (1617–1691). The seals are not authentic; however, Mitsuoki was a highly successful artist who eventually, in 1654, became painter to the emperor. This prominence might well have encouraged the painter of these screens to append spurious seals for their appeal to potential patrons. Because the seals trade on Mitsuoki's fame at mid-century, they offer evidence for dating them after 1650.

Dating is also indicated by the configuration of Nijō castle which dominates the left-hand screen. Completed in 1603, its keep was not part of the original structure but had formerly belonged to Fushimi castle which was dismantled and portions distributed around the country in 1623. Its keep was reassembled as part of Nijō castle in time for the emperor's visit in 1626. The suggestion of a garden with pond, also constructed for this visit, further indicates that the screen depicts the castle subsequent to that time.

53: The Genji story had been copied in handscroll format in the early twelfth century, alternating text and illustration. This set of scrolls, existing today only in a few fragmentary rolls in two collections in Japan, is a classic of *yamato-e* painting. In addition to these scrolls, a few fragments of Genji paintings survive from centuries before the Muromachi period; however, mention of such paintings is found in documents, and it is clear the Genji theme was popular in painting. Three sets of fans dating to the Muromachi period, when sets of fan paintings of the Genji story were popular, also remain. Beginning in the Momoyama period, the number of surviving examples of Genji paintings increases dramatically. Artists of the sixteenth and seventeenth centuries decorated fans, scrolls, and

albums with scenes from *Genji monogatari* and also adapted the composition formulas to accommodate the folding screen format.

Akiyama (1985) pinpoints the Muromachi period as the time Genji scenes were standardized. Murase (1983) notes that the two chapters illustrated on the Seattle screens were typical choices for screens illustrating one scene each. By order of appearance in the story, the screens would be arranged with Chapter 33 at the right (reading right to left, as in Japanese books). Arranged by season the screens reverse their positions, which is how they appear compositionally correct to modern Western viewers. The open-roof scene and the simple dash of ink for an eye and a hooked line for a nose (*hikime-kagihana*) became stylizations firmly linked to the *yamato-e* vocabulary of painting techniques. When in the early Edo period the Tosa school painters emerged, building on a tradition of *yamato-e* techniques and motifs they took up the Genji theme. Somewhat earlier, during the Momoyama period, head of the Kanō school Kanō Eitoku is believed to have painted the Genji theme, giving subsequent Kanō artists precedent to depart from their usual Chinese imagery. Painters of other schools also took up the Genji theme.

54: Typical of this black-on-black technique (right-hand screen, third panel from right) are the flying bird with turned head, at first seemingly a headless silhouette which reveals at close range the head, beak, and eye, and below it two birds fighting in midair and fully rendered in black-on-black, even though they largely overlap.

Other screens with the crow theme exist; however, comparable works, particularly with gold ground, seem very rare. A convenient comparison of similar works shows only really close screens at Sambō-in (Tsuji et al. 1978). A single six-panel screen with crows in ink only, identified as late sixteenth century of the Hasegawa school, is in The Minneapolis Institute of Arts (Jacobsen 1984).

LITERATURE: Donald Jenkins, *Ukiyo-e Prints and Paintings: The Primitive Period 1680–1745*, Chicago 1971, Nos. 62–71; Yūzō Yamane, *Momoyama Genre Painting*, Tokyo/New York 1973, Pl. 44, and pp. 29ff, 33, 54–55; Miyeko Murase, *Japanese Art: Selections from the Mary and Jackson Burke Collection*, New York 1975, p. 45; Nobuō Tsuji, *Rakuchū Rakugai-zu*, *Nihon no Bijutsu* no. 121, Tokyo 1976; Tatsusaburō Hayashiya, in John W. Hall and Takeshi Toyoda, eds., *Japan in the Muromachi Age*, Berkeley 1977, p. 27ff; Nubuō Tsuji et al., *Kachō-ga, Kaki Kachō, Nihon Byōbu-e Shūsei* vol. 6, Tokyo 1978, Nos. 63–70, and p. 99; Kawai Masatomo, *Yushō, Tōgan, Nihon Bijutsu Kaiga Zenshū* vol. 11, Tokyo 1981, No. 39; *Kokka* no. 1056, Tokyo 1982; Stephen Addiss et al., *A Myriad of Autumn Leaves: Japanese Art from the Kurt and Millie Gitter Collection*, New Orleans 1983, No. 48, and p. 149n1; Miyeko Murase, *Iconography of the Tale of Genji: Genji Monogatari Ekotoba*, New York/Tokyo 1983, Fig. 1, ills. 33–3, 35–5, and pp. 7ff, 15, 27ff, 187, 205, 317, 328–29; Robert D. Jacobsen, *The Art of Japanese Screen Painting: Selections from The Minneapolis Institute of Arts*, Minneapolis 1984, No. 3; Terukazu Akiyama, "Muromachi Fan-shaped Paintings of the Tale of Genji: Focusing on the Jōdo-ji Fan Screens," *Kokka* no. 1088, Tokyo 1985 (with trans. by Maribeth Graybill).

55–57.

56: Without signature or seals to indicate order, either screen could be positioned left or right. To the modern viewer, the best composition has the boating scene on the right. However, traditional order by season puts spring (cherry blossoms) to the right. This interchangeability suggests wholesale preparation of themes suited, as it were, to mixing and matching.

Precedents for such screen compositions reach back at least to the Momoyama period, and probably all such scenes of blossom viewing or maple leaf viewing ultimately evolved from *yamato-e* art of the Heian and Kamakura periods. Surely they are tied to the seasonal themes and pleasure in nature basic to *yamato-e* art. The Kanō Hideyori (d. 1557) screen paintings of popular outings (now in the Tokyo National Museum) and the paintings by Kanō Mitsunobu (1565–1608) of Toyotomi Hideyoshi's large entourage in 1594 to Yoshino to view the blossoms were important Kanō school paintings which could have been known to *ukiyo-e* artists. Such paintings were part of the *fūzoku-ga* origins of the *rakuchū rakugai-zu* also.

Precedents of a more recent date and more directly associated with the Seattle screens can be found in prints and paintings of Hishikawa Moronobu and his pupil Morohisa, artists whose work would have been known to Chōshun.

A folding screen with Chōshun's signature in The Minneapolis Institute of Arts offers a strong parallel with the Seattle screen, although its subject is maple leaf viewing. A second unsigned screen at Minneapolis attributed to Chōshun portrays a cherry blossom viewing party and seems to occupy an intermediate position between the Seattle unsigned screen and the Minneapolis signed one (Jacobsen 1984).

57: The shift to greater complexity and psychological depth in Hokusai's painting, exemplified by the *Five Beautiful Women*, is easily traced in his book illustrations, both because of their large numbers and the fact that continuing series were published over a period of years. Hillier (1955) includes two illustrations to the play based on the story of Chūshingura, which cover exactly this period of change. A far larger series, of a Chinese heroic novel set in the Northern Song period (Japanese: *Suikoden*), was published between 1805 and 1827. This set of books, the *Shimpen suiko gaden* (The Illustrated New Edition of Suikoden) was done in collaboration with the author Bakin, who served as translator (later replaced by Takai Ranzan); the completed series ran to some ninety volumes, of which Hokusai created designs for the first sixty-one (a student then finished the series) and production stretched over more than twenty years. Hillier (1980) notes that "... with that book Hokusai established new standards both in the artistry of his designs and the pertinence of his illustrations to the text.... The volumes are full of virile and energetic compositions...." He also compares the "artificially frail beauties" of Shunshō's print of forty years earlier with a similar motif by Hokusai (cf. Narazaki 1982). An unpublished doctoral dissertation by Mark Howard Sandler (1977) traces the warrior-hero genre and Hokusai's pivotal role in the nineteenth-century manifestation of the theme, discussing the influences of Buddhist guardian figures and continental woodblock-printed books that were entering Japan. He sees Hokusai's *yomihon* (popular fiction) experience as critical to his later development. The *Shimpen suiko gaden* is noted as a turning point: "Hokusai had reached a new level of maturity in dealing with human figure in motion," noting a developmental pattern that moves from fitting the illustrations in with the text, to leaving unfilled the space formerly occupied by text, to dropping all setting for his figures, and eventually to letting the figures fill the entire space.

If this pattern is applied to Hokusai's *nikuhitsu ukiyo-e*, the Seattle painting, in relation to other paintings of the Bunka era, might well be seen as the end point in a similar development, where Hokusai has decided to let the figures proclaim their own physical existence independent of setting and filling the entire space of the painting. We are grateful for suggestions and information on this subject shared by *ukiyo-e* authority Roger Keyes in a conversation (1986). Keyes sees the *Suikoden*

work as pivotal in Hokusai's career, and points to the violence and the supernatural nature of many of the exploits of the heroes of the story as a possible source for Hokusai's interest in bizarre subject matter in his own work in later years.

Earlier descriptions of this painting have tried to identify Hokusai's five women as representing the five so-called feminine virtues with their symbolic attributes. From the bottom, they are: Education reading her book; Entertainment, a courtesan; Domesticity, a bride; Art with her flower arrangement; and Calligraphy with her brush and paper. Narazaki (1969) repeats a description in Young and Smith (1966) where the painting is so described, no doubt based on information supplied from museum files (also see Trubner et al. 1973). The "bride" is really a shrine pilgrim. Hayashi (1968) depicts a young lady in attire appropriate for a *godaisan*, one who visits shrines or temples in place of another (so identified in the accompanying text). The *tsunokakushi* headdress, fancy kimono, et cetera, are the same as the figure in the Seattle painting; this headdress, now associated with bridal attire, probably led to the mistaken identification of the figure.

A painting with a similar composition of five figures by Katsukawa Shunrin, Hokusai's fellow student in the Shunshō studio, is in the Shin'enkan collection, Los Angeles. Shunrin's painting, clearly a *mitate*, parodies the theme of *kinki shoga*, the Four Gentlemanly Pursuits (see No. 49).

An unsigned article in *Kokka* no. 671 (1947) states that Hokusai bestowed his name and seal on Hokumei on the twenty-fifth day of the fourth month of the tenth year of Bunka (1813) and suggests the date for the painting as Bunka 8 or 9 (1811–1812). Narazaki (1982) has dated it on stylistic grounds to circa 1811.

LITERATURE: [unsigned], *Kokka* no. 671, Tokyo 1947, p. 38; Jack Hillier, *Hokusai*, New York 1955, Figs. 22–23; Tōru Mori, *Kokka* no. 852, Tokyo 1963; Martie W. Young and Robert J. Smith, *Japanese Painters of the Floating World*, Ithaca, New York, 1966, p. 5ff; Muneshige Narasaki, *Masterworks of Ukiyo-e: Early Paintings*, Tokyo 1967, Nos. 18, 53–54; Sumiko Hashimoto, *Keppatsu to Kamikazari*, Nihon no Bijutsu no. 23, Tokyo 1968, pp. 52–56; Yoshikazu Hayashi, *Hokusai, Empon Kenkyū* vol. 12, Tokyo 1968, ill. p. 214; Muneshige Narazaki, ed., *Nikuhitsu Ukiyo-e, Zaigai Hihō* vol. 3, Tokyo 1969, suppl. pp. 24, 90; Henry Trubner et al., *Asiatic Art in the Seattle Art Museum*, Seattle 1973, p. 256; Mark Howard Sandler, "The Yumihon Illustration of Katsushika Hokusai" (Ph.D. diss.), Seattle 1977, p. 277ff; *Kyusei Hakone Bijutsukan/Kyusei Atami Bijutsukan* vol. 3, Atami 1977, Nos. 30–32; Howard Link, *The Theatrical Prints of the Torii Masters*, Honolulu 1977, No. 1, and p. 55; Akira Morikawa, *Teitoku, Saikaku Shueisha, Haijin no Shoga Bijitsu* vol. 1, Tokyo 1979, ills. 16–21, and p. 99; Jack Hillier, *The Art of Hokusai in Japanese Book Illustration*, Berkeley/Los Angeles 1980, pp. 73ff, 155ff; Richard Lane, *Images from the Floating World: The Japanese Print*, New York 1982, pp. 169ff, 255ff; Muneshige Narazaki, *Hokusai, Nikuhitsu Ukiyo-e* vol. 7, Tokyo 1982, Pls. 1–9, 12–13, and p. 40; Leon Zolbrod, *Haiku Painting*, Tokyo 1982, No. 1, and pp. 6, 24; *Exhibition of Japanese Paintings from the Collection of the Museum of Fine Arts, Boston*, Tokyo 1983, Nos. 67, 69; Robert D. Jacobsen, *The Art of Japanese Screen Painting, Selections from The Minneapolis Institute of Arts*, Minneapolis 1984, No. 13, and p. 64ff; Roger Keyes, *The Art of Surimono* vol. 1, London 1985, p. 194ff; *A Selection of Japanese Art from the Mary and Jackson Burke Collection*, Nagoya 1985, No. 65; *The Shin'enkan Collection*, Osaka 1985, No. 48, and p. 56; Roger Keyes, conversation with WJR 1986.

58.

Along with Kōetsu, the two other calligraphers of great stature were Konoe Nobutada (1565–1614) and Shōkadō Shōjō (1584–1639). Kōetsu's fame as a calligrapher overshadowed Sōtatsu's accomplishments until modern times, when scholarly research firmly identified Sōtatsu's contributions.

Sōtatsu's family name is sometimes given as Nonomura or Kitagawa; however, the name of his studio has become accepted as the name by which he is known. His successors were named Nonomura Sōsetsu and Kitagawa Sōsetsu.

Increasingly Kōetsu's removal to Takagamine is seen as a polite exile. Because he was a devotee of the Nichiren sect, it is possible he came under suspicion owing to its associations with the troublesome militant *Hokke ikki*. In a time of extreme political comformity, with authority newly in the hands of the Tokugawa military leadership, a more probable direct cause for sequestering Kōetsu at Takagamine would have been his strong ties to the imperial palace and the circle of nobles in Kyoto, of whom the shoguns were always suspicious. This idea of banishment is further supported by the fact that Kōetsu's land grant at Takagamine did not become hereditary; sometime after his death, it was returned to the control of the shogun.

The second largest portion of the *Deer Scroll* is in the MOA Museum of Art, Atami, and approximately ten others, remounted as hanging scrolls, are now scattered among private collectors and museums in Japan. The scroll was divided in 1935 by the owner, Baron Masuda. The Seattle portion was acquired in 1951.

Among Sōtatsu's works demonstrating his familiarity with ancient *yamato-e* painting are the two copies of the handscrolls depicting the life of the poet-priest Saigyō (1118–1190). The original paintings were done in the thirteenth century, but a copy done in 1500, the most popular version, is the one Sōtatsu followed. The version by Sōtatsu in the Mōri collection is dated by inscription to 1630. A pair of hanging scrolls at the Chōmyō-ji, Kyoto, shows two bulls done in ink washes. Not only are they executed in the *hori-nuri* technique of the Kamakura-period painters, in which outlines, highlights, and volume are created by leaving exposed layers of light ink and building up areas of darker ink, but they repeat bulls identifiable in scenes in existing Kamakura-period handscrolls (see No. 27; see Yamakawa 1979).

It has been widely accepted that there is a second hand in painting the deer. There seems to be a distinct difference between the silver deer and the more painterly gold or gold and silver forms. Yūzō Yamane has published his opinions on several occasions, and others have voiced similar questions, although no one seems willing to accept the additional deer as by Kōetsu's hand. David Waterhouse has argued that the deer painted only in silver have a highly calligraphic quality which could be explained by Kōetsu's having supplemented the herd in order to fill in excess space between motifs, and to bring better balance to the groupings in relation to the number of poems. The complete lack of accepted paintings by Kōetsu is a serious difficulty in making an attribution to him here (see Waterhouse 1966).

Yamane (1977) dates the *Deer Scroll* to 1605–1610. Sōtatsu's *kingindei-e* in it recalls qualities of the 1602 frontispiece of the Heike Nōkyō. Datable works by Kōetsu from the early years of the century are rare; yet, consistent with the 1605–1610 dating, the strength of the hand would suggest a time during the Keichō era (1596–1615). David Waterhouse (1966) argued that Kōetsu had actually held the scroll some years before inscribing it: he seems to be alone on this point.

LITERATURE: Yūzō Yamane, ed., *Sōtatsu*, Tokyo 1962, No. 4, and p. 208; David Waterhouse, "Tawaraya Sōtatsu and the Deer Scroll" (unpublished ms., Center for Asian Arts, University of Washington), Seattle 1966; Tatsusaburō Hayashiya with George Elison, "Kyoto in the Muromachi Age," in John W. Hall and Takeshi Toyoda, eds., *Japan in the Muromachi Age*, Berkeley 1977; Yūzō Yamane, *Kōetsu, Sōtatsu, Kōrin, Suiboku Bijutsu Taikei* vol. 10, Tokyo 1977, Nos. 11–12, 38, and pp. 149–50; Hiroshi Mizuō, "A Portrait of Hon'ami Kōetsu," *Chanoyu Quarterly: Tea and the Arts of Japan* no. 34, Kyoto 1983, pp. 21–52; Donald Keene, "Jōha, a Sixteenth Century Poet of Linked Verse," in George Elison and Bardwell L. Smith, eds., *Warlords, Artists, and Commoners: Japan in the Sixteenth Century*, Honolulu 1981, p. 113; H. Paul Varley and George Elison, "The Culture of Tea: From Its Origins to Sen no Rikyū," in Elison and Smith, ibid., p. 187ff; Takeshi Yamakawa, ed., *Rimpa, Kōetsu, Sōtatsu, Kōrin, Nihon Bijutsu Zenshū* vol. 21, Tokyo 1979, Nos. 47–48, and p. 201.

59, 60.

Hōitsu's signature on the screen reads *Hōitsu Kishin hitsu*; the circular red seal reads *Hōitsu* and the small, gourd-shaped seal, *Monsen*. These are all well known, as is the *Hōitsu* signature on the fan. The rectangular seal on the fan, however, is too blurred to read clearly and seems not to correspond to any published seal. Translation of the poem on p. 175 is quoted in Murase (1971) from Helen Craig McCullough, *Ise Monogatari: Lyrical Episodes from Tenth-Century Japan*, Stanford 1968, pp. 74–75.

LITERATURE: Miyeko Murase, *Byōbu, Japanese Screens from New York Collections*, New York 1971, p. 30; Teiji Chizawa, *Rimpa*, Tokyo 1973, p. 14; Motoaki Kono, *Ogata Kōrin, Nihon Bijutsu Kaiga Zenshū* vol. 17, Tokyo 1976, No. 13; Stephen Addiss, *The World of Kameda Bōsai*, New Orleans 1984, p. 56ff; Teiji Chizawa, *Sakai Hōitsu, Nihon no Bijutsu* no. 186, Tokyo 1984, pp. 18-21; Shigeru Matsubara, "Beni-girai no Hassei to sono Haikei," *Museum* no. 408, March 1985, p. 4ff.

61.

The date for Buson's death used here is that given in traditional biographies; see French et al. 1974.

LITERATURE: Okisada Asaoka, ed., *Zōtei Koga Bikō* 2nd ed., 3 vols., Tokyo 1912, pp. 1114–15, 1118–19; Akira Sawada, *Nihon Gaka Jiten, Rakkan-hen*, rpt. Kyoto 1970, pp. 666–68; Calvin L. French et al., *The Poet-Painters: Buson and His Followers*, Ann Arbor 1974, p. 7, and Appendix III, "Reproduction of Signatures and Seals," s.v. Buson; Jōhei Sasaki, "Buson in his Tango Period," *Kokka* no. 971, Tokyo 1974, pp. 38–42; James Cahill, *Yosa Buson and Chinese Painting*, Institute of East Asian Studies, Berkeley [1982], pp. 252ff, 256ff, 259n23; idem, *Sakaki Hyakusen and Early Nanga Painting*, Berkeley 1983, pp. 4ff, 45–53.

62–64.

63: A companion painting to Baitei's *Plum Branch in Snow* in the Seattle Art Museum's collection, with the same theme and treatment, shows a crescent moon hanging low in a murky sky. Possibly one half of a pair, the similarity of handling and subject matter in the two scrolls suggests that the theme, and particularly its novel expression, was of special interest to Baitei. He seemed often to be intentionally shocking in order to bring new vitality to ancient themes, like plum blossoms. The scroll is unsigned; however, a pair of seals clearly identifies the artist (see French et al. 1974).

64: Kinkoku came from Ōmi province, and had traveled extensively. He lived in Kyoto and also for a while in Nagoya, where he married. He visited Nagasaki and, like Baitei before him, he was dubbed "Ōmi Buson." The signature on *Sage in a Rose Pavilion*, Kinkoku Dōjin, is known after 1799 and the seal *Kinkoku* is known from the years 1824–1830; therefore we can accept this work as a painting from the last years of his life while he lived in Ōmi (cf. French et al. 1974).

LITERATURE: Calvin L. French et al., *The Poet-Painters: Buson and His Followers*, Ann Arbor 1974, No. 33, and Appendix III, "Reproduction of Signatures and Seals," s.v. Baitei, Nos. 4, 6, 15, Kinkoku, No. 2, and pp. 31, 34ff, 108; Kiichirō Kanda et al., eds., *Yosa Buson, Bunjinga Suihen* vol. 13, Tokyo 1974, Nos. 45, 50; Miyeko Murase, *Japanese Art: Selections from the Mary and Jackson Burke Collection*, New York 1975, No. 75; Susumu Suzuki, *Edo no Gajin, Haijin no Shoga Bijutsu* vol. 12, Tokyo 1980, No. 47; Chū Yoshizawa, *Yosa Buson, Nihon Bijutsu Kaiga Zenshū* vol. 19, Tokyo 1981, Nos. 4–5.

65, 66.

Occasionally Chinese nonliterati artists were accepted as models. This second contradictory current running simultaneously with the demand for orthodoxy guided the Japanese painters to the late Ming- and Qing-dynasty academics, and bird and flower painters to the Qing artists at Nagasaki and their sinified Japanese followers, whose bird and flower paintings were in some respects static still-life studies. This tendency opened later Japanese literati painting to a new, more decorative mode. Yamamoto Baiitsu's bird and flower paintings are perhaps the most obvious examples of this tendency.

The nonliterati borrowing of these later *bunjin* artists, who were perhaps bored with old-fashioned styles in Japan, was somewhat at variance with the nonliterati borrowings of early *nanga* painters such as Buson (No. 61). The early Japanese artists selected models among such people as the late Ming-dynasty Wu school artists, partly because that is what they were exposed to but also because the warmly personal art of this school was frankly more attractive to Japanese sensibilities.

66: We are indebted to Wang Ching Hsien, Professor of Asian Language and Literature and Comparative Literature, University of Washington, Seattle, for examining the inscribed poem.

Interestingly, this inscription, though not dated, provides a clue to the date of the painting. The same four lines of five characters appear as part of a longer inscription on a set of *fusuma* paintings by Beisanjin. (The initial character here for "valley" is replaced by the character for "mountain"; otherwise the text is the same.) The Beisanjin *fusuma* are dated by inscription to 1810 and this fact provides a probable date for this Hankō painting which also bears a portion of the same inscription. Hankō was then only twenty-eight years old, a point relatively early in his career. Further, the seals used by Beisanjin, *Den Koku* and *Shi Gen*, appear to be the same as the ones impressed with the inscription on the Hankō painting (see Kanda et al. 1978, No. 18).

A group of duplicates mirroring Beisanjin's compositions, both in Hankō's paintings and possible later copies of Beisanjin's and Hankō's works, are known. One is a version of the Seattle Beisanjin landscape in the Gitter collection, New Orleans, and is dated to 1812 (see Addiss et al. 1983); an almost identical version of a second painting by Hankō in the Seattle collection is published in *Kokka* no. 227. Further, an almost exact duplicate of the present painting by Hankō, in terms of composition and calligraphy, exists in a private collection in California. The points offered to describe differences between the Gitter and the Seattle Beisanjin paintings can be applied equally to the Seattle and California Hankō landscapes. The difference in the presentation of the compositions is mainly a severe flattening of the already modest depth recession of the Beisanjin, and the heavy layering of brushstrokes, to the extent that some forms become opaque. These points all seem to suggest the hand of a copyist in the flatter, more loosely structured versions and the pronounced tendency to move to stronger outlines at the expense of modeling. Yet, even though the calligraphic inscriptions are remarkably close at first glance, the tightness evidenced in some of the characters in the Beisanjin inscription on the California Hankō painting stresses the gulf between the two paintings.

LITERATURE: Kiichirō Kanda et al., eds., *Okada Beisanjin, Bunjinga Suihen* vol. 15, Tokyo 1978, Nos. 2, 18, 94; Stephen Addiss et al., *A Myriad of Autumn Leaves: Japanese Art from the Kurt and Millie Gitter Collection*, New Orleans 1983, No. 57; James Cahill, *Sakaki Hyakusen and Early Nanga Painting*, Berkeley 1983, pp. 45ff, 52.

67.

Chikuden's poetry was especially dear to him. Along with his art criticism and theoretical writings, his work fills two books. He also wrote on flower arranging, *sencha*, incense judging, as well as miscellaneous observations on life and society, travel diaries, and critiques of *han* operations and economics of 1811–1812 (see Suzuki 1964).

Chikuden's cranes appear to represent *tanchō* or Japanese cranes (*G. japonensis*) with their black necks and wing tips and red heads. They usually winter in eastern Hokkaido; however, some still appear today, along with other cranes from Siberia, in Kagoshima prefecture (Izumu City), as well as at Yamaguchi prefecture, much nearer Chikuden's home. Thus it is possible the artist observed this type of crane firsthand. Today their numbers have dwindled, but in the Edo period, wintering cranes, protected by imperial decree, must have been numerous.

All crane species exhibit playfulness and a characteristic mating dance. Young birds amuse themselves by pecking at each other and wing-flapping in imitation of adult birds, as Chikuden's cranes seem to do here. As in his depictions of everyday life of the boatmen and fishermen of *Views from a Ship's Window*, with their charm and gentle humor, the artist here shows the intimate aspect of a great bird usually depicted as a staid, stately creature.

In Suzuki 1969, the first seal (*ken-in*) is misprinted in the transcription on p. 100 (cf. Kanda 1976, no. 59, and seal chart nos. 1, 18, 30. Also cf. Suzuki 1969, pp. 104, 107, 112).

LITERATURE: Susumu Suzuki, ed., *Chikuden*, Tokyo 1964, Pls. 16–18, 21–23, 75, 85–86, 106, and pp. 8, 79–81, 83, 104, 106–107, 112, 115; idem, "Shoka Yukaka-zu," *Kobijutsu* no. 28, Tokyo 1969, pp. 99–102; James Cahill, *Scholar Painters of Japan: The Nanga School*, New York 1972, Pl. 47, and pp. 97–100; Zauho Press, ed., *Sekai Tōji Zenshū, Edo (I)* vol. 6, Tokyo 1975, Color Pls. 76–91, Pls. 188–99, and pp. 259–65; Kiichirō Kanda et al., eds., *Tanomura Chikuden, Bunjinga Suihen* vol. 17, Tokyo 1976, Pls. 1, 41, 48, 52–54, 64, 89–101, 103–104, and p. 111; Stephen Addiss and Kwan S. Wong, *Ōbaku: Zen Painting and Calligraphy*, Lawrence, Kansas 1978, Pl. 13.

68.

LITERATURE: *Kokka* no. 889, 1966; Henry Trubner and Tsugio Mikami, *Treasures of Asian Art from the Idemitsu Collection*, Seattle 1981, No. 98; Stephen Addiss et al., *A Myriad of Autumn Leaves: Japanese Art from the Kurt and Millie Gitter Collection*, New Orleans 1983, Nos. 59–60.

69.

The painting bears an inscription in Taizan's hand, along with a number of his seals. The seal (at the right of the inscription) preceeding the inscription reads *Seiten hakujitsu; kōzan taisen*, and the seals following the inscription read (upper) *Sansei ji taiko* and (lower) *Hi chōjo shōnen*. At the lower corners are two more seals. The seal at the right reads *Zui-shi yō-nin*, and the seal at the left reads *Jijō ikke*. The large characters of the inscription are the title, *Hōrai kyokkō (no) zu* (Rays of the rising sun on [Mount] Hōrai). This is followed by the notation the painting was done in mid-winter 1864, followed by one of his art names, Dōraku-en. The last column bears the signature Taizan Hi Shōnen.

LITERATURE: Stephen Addiss et al., *A Myriad of Autumn Leaves: Japanese Art from the Kurt and Millie Gitter Collection*, New Orleans 1983, No. 64, and pp. 189–91.

70, 71.

Shifu, the woven form of paper fabric, appeared in Japan about the mid-seventeenth century and is said to have originated out of uses developed for threading armor. *Shifu* developed into a form popular among the samurai class, but soon, because of its simple technology, even the humblest peasant could enjoy *shifu* garments. Examples worn for work or everyday, like the Seattle coat, are perhaps the rarest; such pieces of any age are invariably in very poor condition. Representative of an old tradition, this coat dates only from the turn of the century.

LITERATURE: Sukey Hughes, *Washi, The World of Japanese Paper*, Tokyo/New York/San Francisco 1978, pp. 53–57; "Shifu to Kamiko," *Senshoku no Bi*, 23 (Summer 1983), pp. 81–89; Yoshiko Wada, Mary Kellogg Rice, and Jane Barton, *Shibori, The Inventive Art of Japanese Shaped Resist Dyeing, Tradition, Techniques, Innovation*, Tokyo/New York 1985, p. 58ff; Kyoto National Museum, *Special Exhibition: Japanese Textiles: Beauty and Silk*, Kyoto 1985, Nos. 210–11, and p. 165.

72, 73.

Cort (1979) has written an extensive study of the history of Shigaraki and the kilns that produced it. She illustrates *tsubo* in the Asian Art Museum, San Francisco, and the Burke, Packard, and Powers collections, in New York, providing comparative material for dating the Seattle jar. All Cort's cited examples except the Packard are given a fifteenth-century date, which seems appropriate for the Seattle example; the Packard piece she ascribes to the late fifteenth–early sixteenth century.

LITERATURE: Louise Allison Cort, *Shigaraki, Potters' Valley*, Tokyo/New York 1979, Figs. 10–11, 71, 74–76, and pp. 60, 62, 66.

74.

LITERATURE: Soame Jenyns, *Japanese Pottery*, London 1971; Tsugio Mikami, *The Art of Japanese Ceramics*, New York/Tokyo 1972; Masahiko Kawahara, *Karatsu, Nihon no Bijutsu* no. 136, Tokyo 1977.

75, 76.

A superb example of an E Shino bowl with landscape design is in the Idemitsu Museum of Arts (Seattle 1981). Two Nezumi Shino dishes relate in shape and design to the Seattle piece: one in a Japanese private collection (Hayashiya 1976) and one in the Cleveland Museum of Art, with a design of valerian and rocks (Cleveland 1978). The base of the Seattle dish is similar to that of a third example in the Museum of Fine Arts, Boston (Hayashiya 1976).

LITERATURE: Soame Jenyns, *Japanese Pottery*, London 1971, pp. 152–53; Seizō Hayashiya, *Momoyama Period II: Mino Ware, Chōjirō and Kōetsu*, Tokyo 1976, Color Pls. 96–98, and pp. 70–71; *Handbook of the Cleveland Museum of Art*, Cleveland 1978, No. 66.24, and p. 380; Henry Trubner and Tsugio Mikami, *Treasures of Asian Art from the Idemitsu Collection*, Seattle 1981, No. 47.

77, 78.

LITERATURE: Ryōichi Fujioka, "Shino to Oribe," *Nihon no Bijutsu* no. 51, Tokyo 1970.

79, 80.

LITERATURE: Soame Jenyns, *Japanese Pottery*, London 1971, Pl. 110B, and pp. 271–73, 283–85.

81, 82.

Although 1616 is the traditional date for the discovery of porcelain at Izumiyama, near Arita, and for the first firing of true porcelain at Tengudani, recent archaeological evidence and excavation of Tengudani and other kilns suggest porcelain may have been produced as early as 1600, or earlier (Mikami 1972).

LITERATURE: T. Volker, *Porcelain and the Dutch East India Company*, Leiden 1954; Soame Jenyns, *Japanese Porcelain*, London 1965, Pls. 1–3, 6A–6B, 14B, and p. 85; Tsugio Mikami, *Arita Tengudani Koyō. Shirakawa Tengudani Koyōshi Hakkutsu chosa hōkokusho*, Tokyo 1972.

83–87.

83: Jenyns (1965) illustrates a sander (for casting sand over writing paper to dry the ink), a shape probably derived from a Dutch original. In essence, except for its holes and recessed top, it resembles the rectangular headrest, including style of decoration and motifs. He dates it in Empō/Jōkyō (1673–1687).

84: Jenyns (1965) and Nagatake and Hayashiya (1978) illustrate similar faceted bowls with designs different from the Seattle bowl; Jenyns gives a date of about 1700. Ayers (1982) illustrates a bowl very similar in design to the Seattle bowl, and gives a late seventeenth-century date. It differs from the Seattle piece by its bamboo and rock design on one exterior side and a prunus on the reverse, but like it, features the two-phoenix roundel inside, the prunus and formal scroll border on the rim, and the brown iron oxide wash on the lip.

85: Jenyns (1965) illustrates a similar ewer with this design in the Sedgewick collection, London. The Seattle ewer is also from an English collection, confirming that this type was intended for export to Europe. Jenyns dates the Sedgewick piece in the late seventeenth century; a similar date, corresponding to the Genroku era (1688–1704), is appropriate for the Seattle ewer.

87: Jenyns (1965) publishes a similar plate in the W. W. Winkworth collection, England; Koyama and Pope (1976) illustrate another of the same type in the Freer Gallery of Art. The *daikon* mark and other underside decoration complicate attribution, for a well-known plate with identical mark and underglaze blue design of waves and blossoms in a Japanese collection is designated Kakiemon ware (Seattle 1972).

LITERATURE: T. Volker, *The Japanese Porcelain Trade of the Dutch East India Company after 1683*, Leiden 1959, Pls. IX, 13; Soame Jenyns, *Japanese Porcelain*, London 1965, Pls. 38b, 40a, 41a–41b, 43c, 65a, 67b, 94a, and p. 133; *Ceramic Art of Japan: One Hundred Masterpieces from Japanese Collections*, Seattle 1972, No. 67, and p. 135; Fujiō Koyama and John A. Pope, *Oriental Ceramics: The World's Great Collections* vol. 10, Tokyo 1976, Color Pl. 65; Takeshi Nagatake and Seizō Hayashiya, *Edo Period III: Imari and Nabeshima Wares, Sekai Tōji Zenshū* vol. 8, Tokyo 1978, Pl. 36; Takeshi Nagatake, *Kakiemon*, Tokyo/New York 1981, Pls. 8–9, and pp. 6–7, 34; John Ayers, *The Baur Collection, Geneva*, London 1982, Pl. E 27.

88, 89.

89: Imaizumi (1953, 1969, 1981) has observed that Matsugatani sometimes resembles Ko Kutani. Extant pieces such as the Seattle dish, a corresponding one in the Asian Art Museum, San Francisco, and two Japanese-owned pieces illustrated by Jenyns (1965) do not bear this out. Some shallow Nabeshima dishes resemble Matsugatani, but more in their oblong, foliate shapes than in design or enamel color.

A foliate dish in the St. Louis Art Museum (Cleveland 1970) relates to the Seattle dish. This delicately molded and painted Arita ware dish has a design of herons surrounded by water and waves drawn in dark underglaze blue; it is given a late seventeenth-century date.

LITERATURE: Motosuke Imaizumi, "Study of Matsugatani Ware," *Tōetsu* no. 50, 1953; idem, *Iro Nabeshima to Matsugatani*, Tokyo 1969; Soame Jenyns, *Japanese Porcelain*, London 1965, Pls. 100B, 100D, and p. 212; Richard S. Cleveland, *200 Years of Japanese Porcelain*, St. Louis/Kansas City 1970, Nos. 134–35, and p. 188; Takeshi Nagatake and Seizō Hayashiya, *Edo Period III: Imari and Nabeshima Wares, Sekai Tōji Zenshū* vol. 8, Tokyo 1978, Color Pl. 86, and p. 96; Motosuke Imaizumi, *Nabeshima*, Tokyo/New York 1981, Pls. 31, 44–45, 48, 50, and pp. 6–9, 19, 22–23, 35, 37.

90.

A Chinese covered water jar of Shonzui type in the Idemitsu Museum of Arts is decorated with roundels comparable to those on the Seattle Ko Kutani dish (Seattle 1981).

In 1983 the author visited the Yamanaka area and the Kutani kiln site and was able to examine sherds recovered from it, through the courtesy of Tenshu Hirata and the Ishikawa Prefectural Center for Cultural Assets of Buried Treasures. None of the sherds examined showed any evidence of overglaze enameling associated with Ko Kutani. In other words, there is no certain evidence Ko Kutani was ever produced at the Kaga kiln site, nor any satisfactory answer to where it was produced, if not in Ishikawa prefecture.

LITERATURE: Tsugio Mikami, *The Art of Japanese Ceramics* (trans. A. Herring), New York/Tokyo 1972, p. 175; Seizō Hayashinya, Henry Trubner, et al., *Chinese Ceramics from Japanese Collections*, New York 1977, Nos. 71–75; Sensaku Nakagama, *Kutani Ware*, Tokyo/New York 1979, p. 104ff; Henry Trubner and Tsugio Mikami, *Treasures of Asian Art from the Idemitsu Collection*, Seattle 1981, No. 34; Board of Education, Ishikawa Prefecture and Town of Yamanaka, Excavation Report, March 1981; Tsugio Mikami and Seizō Hayashiya, *Edo Period IV: Kutani and Miscellaneous Wares, Sekai Tōji Zenshū* vol. 9, Tokyo 1983.

SELECTED BIBLIOGRAPHY

Brinker, Helmut. *Shussan Shaka Darstellungen in der Malerei Ostasiens*. Zurich, 1983.

Colcutt, Martin. *Five Mountains — The Rinzai Zen Monastic Institution in Medieval Japan*. Cambridge: Council on East Asian Studies, Harvard University, 1981.

Cort, Louise Allison. *Shigaraki, Potters' Valley*. Tokyo and New York: Kodansha International, 1979.

Dumoulin, Heinrich. *A History of Zen Buddhism*. Boston: Beacon Press, 1963.

Elison, George and Bardwell L. Smith, eds. *Warlords, Artists, and Commoners: Japan in the Sixteenth Century*. Honolulu: University Press of Hawaii, 1981.

Famous Ceramics of Japan. 12 vols. Tokyo and New York: Kodansha International, 1981.

French, Calvin L., et al. *The Poet-Painters: Buson and His Followers*. Appendix III: *Reproduction of Signatures and Seals*. Ann Arbor: The University of Michigan Museum of Art, 1974.

The Heibonsha Survey of Japanese Art. 31 vols. New York and Tokyo: Weatherhill/Heibonsha, 1972–80.

Japanese Arts Library. 11 vols. Tokyo and New York: Kodansha International and Shibundo, 1979.

Jenyns, Soame. *Japanese Porcelain*. London: Faber and Faber, 1965.

———. *Japanese Pottery*. London: Faber and Faber, 1971.

Kageyama, Haruki, and Christine Guth Kanda. *Shinto Arts: Nature, Gods, and Man in Japan*. New York: Japan Society, 1976.

Kidder, J.E., Jr. *The Birth of Japanese Art*. New York and Washington: Frederick A. Praeger, 1965.

Kitagawa, Joseph M. *Religion in Japanese History*. New York: Columbia University Press, 1966.

Kodansha Encyclopedia of Japan. 9 vols. Tokyo and New York: Kodansha International, 1983.

Kurata, Bunsaku, ed. *Horyū-ji: Temple of the Exalted Law: Early Buddhist Art from Japan*. New York: Japan House Gallery, 1981.

Matsunaga, Daigan and Alicia. *Foundation of Japanese Buddhism*. 2 vols. Los Angeles and Tokyo: Buddhist Books International, 1974–76.

Matsunaga, Reiho, trans. *A Primer of Sōtō Zen*. Honolulu: University Press of Hawaii, 1971.

Murase, Miyeko. *Byōbu, Japanese Screens from New York Collections*. New York: Asia Society, 1971.

———. *Iconography of the Tale of Genji: Genji Monogatari Ekotoba*. New York and Tokyo: Weatherhill, 1983.

———. *Japanese Art: Selections from the Mary and Jackson Burke Collection*. New York: The Metropolitan Museum of Art, 1975.

Oriental Ceramics: The World's Great Collections. 11 vols. Tokyo and New York: Kodansha International, 1975.

Pearson, Richard. *Image and Life: 50,000 Years of Japanese Prehistory*. Vancouver: University of British Columbia Museum of Anthropology, 1978.

Pearson, R., G. Barnes, and K. Hutterer, eds. *Windows on the Japanese Past: Studies in Japanese Archaeology and Prehistory*. Ann Arbor: Center for Japanese Studies, University of Michigan, 1986.

Pekarik, Andrew J. *Japanese Lacquer, 1600–1900. Selections from the Charles A. Greenfield Collection*. New York: The Metropolitan Museum of Art, 1980.

Rague, Beatrix von. *A History of Japanese Lacquerwork*. Translated by Annie R. de Wassermann. Toronto and Buffalo: University of Toronto Press, 1976.

Rosenfield, John M., and Elizabeth ten Grotenhuis. *Journey of the Three Jewels: Japanese Buddhist Art in Western Collections*. New York: Asia Society, 1979.

The Saint Louis Art Museum. *Ōkyo and the Maruyama-Shijō School of Japanese Painting*. St. Louis, 1980.

Shimizu, Yoshiaki, and Carolyn Wheelwright, eds. *Japanese Ink Paintings*. Princeton: The Art Museum, Princeton University, 1976.

Shimizu, Yoshiaki, and John M. Rosenfield. *Masters of Japanese Calligraphy, 8th–19th Century*. New York: Japan House Gallery and Asia Society Galleries, 1985.

Trubner, Henry, and Tsugio Mikami. *Treasures of Asian Art from the Idemitsu Collection*. Seattle: Seattle Art Museum, 1981.

Yonemura, Ann. *Japanese Lacquer*. Washington, D.C.: The Freer Gallery of Art, 1979.

Japanese-Language Publications

Bunjinga Suihen. 20 vols. Tokyo: Chuo Koronsha, 1974–79.

Ienaga, Saburō, Akamatsu Toshihide, and Tamamuro Taijō, eds. *Nihon Bukkyōshi.* 3 vols. Kyoto: Hozokan, 1967.

Kawada, Sadamu. *Negoro.* Kyoto: Shikosha, 1985.

Kobijutsu. Tokyo: Sansaisha, 1963–.

Kokka. Tokyo: Asahi Shimbunsha, 1889–.

Museum. Tokyo: Tokyo National Museum. 1951–.

Narazaki, Muneshige, ed. *Nikuhitsu Ukiyo-e.* 7 vols. Tokyo: Shueisha, 1982.

Nihon Bijutsu Kaiga Zenshū. 25 vols. Tokyo: Shueisha, 1976.

Nihon Emaki Taisei. 26 vols., supplement. Tokyo: Chuo Koronsha, 1977–.

Nihon Emakimono Zenshū. 24 vols. Tokyo: Kadokawa, Shoten, 1958–69.

Nihon no Bijutsu. Tokyo: Shibundo. 1966–.

Rimpa Kaiga Zenshū. 5 vols. Tokyo: Nihon Keizai Shimbunsha, 1977–80.

Sekai Tōji Zenshū. 22 vols. Tokyo: Shogakukan, 1975.

Suiboku Bijutsu Taikei. 15 vols. Tokyo: Kodansha International, 1978.

Suzuki, Susumu, ed. *Chikuden.* Tokyo: Nihon Keizai Shimbunsha, 1964.

Tokugawa, Yoshinobu. *Ryūkyū Shikkōgei.* Tokyo, 1977.

Tokugawa, Yoshinobu, and Hirokazu Arakawa. *Shikkōshi.* Bulletin of the Academy of Lacquer Research, vol. 1, May, 1978.

Tsuji, Zennosuke. *Nihon Bukkyōshi.* 10 vols. Tokyo: Iwanami Shoten, 1960–61.

Zaigai Hihō. 3 vols. Tokyo: Gakken, 1969.

Zaigai Nihon no Shihō. 12 vols. Tokyo: Mainichi Shimbunsha, 1979–81.

A Thousand Cranes

Designed by Ed Marquand Book Design

Composed by Eclipse Typography
in Patina with display lines in Bauer Text Initials

Printed and bound by Nissha Printing Company